'This matter of women is getting very bad'

To my family

'This matter of women is getting very bad'

Gender, Development and Politics in Colonial Lesotho

MARC EPPRECHT

University of Natal Press
Pietermaritzburg
2000

'This matter of women is getting very bad': Gender,
Development and Politics in Colonial Lesotho

ISBN 0 86980 953 9

Editor: Andrea Nattrass
Cover designer: Brett Armstrong

Published by University of Natal Press
Private Bag X01, Scottsville, 3209, South Africa
E-mail: books@press.unp.ac.za

Typeset by Alpha Typesetters cc, New Germany, South Africa
Printed and bound by Interpak Books, Pietermaritzburg

Contents

A note on language and abbreviations

Lesotho (pronounced Le-soo-too) is the nation of the Basotho (singular, a Mosotho). Things pertaining to the country or the people take the adjectival form Sesotho, for example, Sesotho custom. Sesotho can also stand on its own to mean the language or the culture in its entirety.

Like the other Sotho-Tswana languages spoken across the southern African highveld, Sesotho has different classes of nouns which are pluralized by adding the appropriate prefix, for example, *letsema* becomes *matsema*, *morena* becomes *marena*. In some instances this involves adding another syllable and transforming the appearance of the word. In such cases I have anglicized the plural form (as indeed, Basotho commonly do in conversation with anglophones). Thus, *lipitso* is rendered *pitsos*, *likopano* as *kopanos*, and so on. Similarly, rather than introducing sometimes complex verb tenses, I have anglicized the grammar in a few cases (such as 'she was *kenelaed*' instead of *keneloa* as would be grammatically correct). I have also opted for the anglicized form of proper nouns (Sesotho rather than the technically correct SeSotho). Not only is this the form used most commonly in Lesotho, it also, in the case of women's names, allows me to avoid the implication that female identity arises primarily from her role as mother of her eldest child (namely, 'Mantsebo – a person in her own right – as opposed to 'MaNtsebo – mother of the 'real' person).

The orthography of Sesotho in Lesotho throws a few pronunciation curves at anglophones which are worth pointing out. Among the most common mistakes, 'l' before an 'i' or 'u' is pronounced as a 'd' sound. Thus, *liretlo* sounds like 'dee-ray-tlo' (and indeed, is spelled *diretlo* using the orthography that was developed in the 1950s for use in South Africa). 'Th' sounds like 't' and 'ph' like 'p'. The click sound in Sesotho is represented by a 'q' (as in *Senqu*), usually pronounced by English-speakers as a 'k' sound.

For the sake of maximum comprehensibility in Lesotho and a region where French is not widely spoken or read, I have taken the liberty of translating all the French documents into English, indicating wherever my translating skills came into play.

Abbreviations used in the text and footnotes

ANC African National Congress
BAC Basutoland African Congress
BCC Basutoland Constitutional Commission
BCP Basutoland Congress Party
BNC Basutoland National Council
BNP Basutoland National Party
BPA Basutoland Progressive Association
CAR Colonial Annual Report
CR Criminal Court Records, Lesotho National Archives
DAM Deschatelets Archives Microfilm, Ottawa
HC High Court Proceedings, Lesotho National Archives
JC Judicial Commissioner Records, Lesotho National Archives
JME Journal des Missionaires Evangéliques
LEC Lesotho Evangelical Church
LLB Lekhotla la Bafo
LNA Lesotho National Archives
LNCW Lesotho National Council of Women
LSA Ladies of Ste. Anne
MFP Marema-tlou Freedom Party
MMO Missions de Missionaires Oblats
NUL National University of Lesotho
OFS Orange Free State
OMI Oblates of Mary Immaculate
ORC Orange River Colony
PC Paramount Chief
PRO Public Records Office
PEMS Paris Evangelical Missionary Society
RCM Roman Catholic Mission

Key Sesotho terms used in the text

bafo the people, commoners
bohali bride price or lobola
bahlalefi educated or wise ones, the 'petty bourgeoisie'
batsoelopele 'civilized people', petty bourgeoisie
chobeliso abduction or forced elopement
hiki home brewed liquor fortified with noxious intoxicants
joala 'kaffir beer', strong home brewed sorghum beer
ho kenela the levirate marriage
khotla (pl. *makhotla*) court
ka'nete and *k'ore* interjections
leboella (pl. *maboella*) 'spareveld', land reserved for conservation

lebollo initiation

lefielo a 'broom', a junior wife attached to the senior wife's household as a servant

letekatse (pl. *matekatse*) prostitute, unattached woman

letsema (pl. *matsema*) tribute labour, corvée

lira the lands reserved for the chief's use

liretlo 'medicine murder'

mafisa system of cattle ownership based on loans

mohlanka (pl. *bahlanka*) a young man, servant

morena (pl. *marena*) chief

ho ngala for a wife to abscond back to her own family

ngoetsi (pl. *lingoetsi*) a junior wife 'loaned' out to a friend or subordinate for hospitality, a 'concubine'

ntlafatso 'development' or 'betterment'

nyatsi (pl. *linyatsi*) extramarital lover or 'paramour'

pitso (pl. *lipitso*) a meeting called by the chief or government to discuss public affairs

seantlo sororate marriage, when a man takes the sister of his deceased wife as a new wife

sekoata (pl. *likuata*) 'squatter', rowdy, unattached man

sethepu polygyny

setsualle extramarital sexual intimacy

tsoelopele progress, civilization

Acknowledgements

Many people assisted me in the creative process which has led to this book. First and foremost, I need to praise my partner, Allison Goebel, and my first daughter, Jennifer, who set me on a personal quest to understand how gender relations are constructed and, more importantly, can change. Intellectual rigour was brought to my early fuzzy idealism in this quest through my excellent teachers at Dalhousie University, above all Jane Parpart, Mary Turner, and John Flint. In Lesotho, I owe an obvious debt of gratitude to my informants but would also like to acknowledge the staff and students of St. Agnes High School, Teyateyaneng, who welcomed me among their number.

May I extend the same thank you to the many scholars and activists in Lesotho, in southern Africa, and in the wide arena of gender studies who encouraged or assisted me in sharpening my arguments from my first crude attempts. I particularly appreciated the guidance and critical input of Elizabeth Eldredge, Stephen Gill, Fr. André Dubois, David Ambrose, Khabele Matlosa, Matseliso Mapetla, John and Judith Gay, Richard Weisfelder, Deborah Gaitskell, Kate Showers, Sheila Meintjies, Andrea Nattrass (my present editor), and the anonymous reviewers of early drafts and articles. Translation from Sesotho to English for some interviews in the Morija area and for some of the vernacular press was done by Thato Sibolla.

Finally, I would like to acknowledge Dalhousie University, the World University Service of Canada, the University of Alberta, and the University of Zimbabwe for their material support at various stages in the research process.

Introduction

Lesotho is a land-locked country with but a single border – an enclave totally embedded within the Republic of South Africa. Seen from the air that border provides one of the most dramatic illustrations of unequal development anywhere in the world. The sprawling, irrigated farmland of the Free State to the north and west ends abruptly where the tumble of Lesotho's eroded hills begins. Those hills contain as many as a thousand people per square kilometre of arable land and yet, strikingly, much of it lies fallow. So precipitous has been the decline in soil fertility over the past five decades that many rural dwellers no longer even bother to plant. Yet industrial and tourist or other services development remains minimal. Lesotho's urban environments appear decrepit and depressed even when compared to South Africa's nearby 'bantustan', Thaba Nchu. The grinding, often desperate poverty for so many of the country's two million citizens has undermined efforts at political stability, which in turn has exacerbated the economic malaise in recent years. Most recently (September 1998), a 'rescue' operation by South Africa and Botswana sparked a paroxysm of looting and destruction that set hopes for development back for years.

Along with poverty and political instability there is another striking feature of underdevelopment in Lesotho. Before the early 1990s, when it began to normalize, the population ratio between men and women was hugely out of balance. This imbalance arose out of the predominant strategy employed to offset poverty for most of the twentieth century – migration to work on the farms, and in the mines and industries of South Africa. At the peak of labour migrancy in 1960, over 200 000 legal residents of Lesotho worked in South Africa at any given time, that is, over a quarter of the *de jure* population. Most of these migrants were men and the effect of their absence was dramatic. In the lowlands along the western border, for example, despite large numbers of female migrants as well, some districts had as many as one hundred females to every sixty-eight males of all ages.[1] For the prime ages of migrancy (eighteen to fifty-four years old) the sex ratio was even more dramatically skewed, reaching as high as one hundred-to-twenty. Entire villages were virtually depopulated of healthy, mature males.

Common sense, as well as even the most casual observations in contemporary Lesotho, suggest that such extreme and prolonged gender imbalances must have had an impact upon Basotho society. An abund-

1

ance of excellent sociological and anthropological studies confirms this.[2] The studies show, for example, that men's physical absence opened up new spaces for women's assertion of autonomy and achievement. Thus, unique to Africa, Basotho women have for several decades now had a higher literacy rate than men. Partly as a result of this high literacy rate, they are visible at high levels of the civil service and at the university, as managers of institutions ranging from schools and hospitals to parastatal enterprises, and even in their own 'women's party' during the transition to democracy from 1992–94. Also unusual to Africa, women comprise a large minority of the traditional chieftaincy. Their presence in large numbers in the townships and farms of South Africa meanwhile attests to a long-standing assertion of freedom of movement in pursuit of economic opportunity. This is all, of course, in addition to their primary responsibility for 'reproduction' in its manifold senses in African society. As the British Resident Commissioner saw it back when the country was still known by its colonial name of Basutoland, women are 'the breadwinners [since] the bread is usually earned by the women and the fields are cultivated by them'.[3]

Basotho women's achievements stand out in a context of legal disabilities, pervasive sexual violence, and structural economic dependency upon men. In the words of one Basotho woman, 'The work belongs to men but we do all the work.'[4] Many of the scholars in the studies noted above acknowledge this and, indeed, often remark favourably upon Basotho women's resilience, strength, and ingenuity. Unfortunately, few of those scholars provide a sense of history to Basotho women's struggles. Historians, with a few notable exceptions, have meanwhile tended to overlook or understate women's specific contributions to Lesotho's development in favour of more dramatic men's activities. The scholarship about Lesotho thus tends to create an impression of timelessness to women's suffering, a backdrop or footnote to 'real' historical events. A corollary to this is the implication that gender inequity, injustice, and violence are somehow natural and unsurprising except in their degree.

The first objective of this study is to challenge that implication through the collection of empirical data about women's history and gender struggle in Lesotho. Such empirical data should be of interest beyond the country's constricted borders. Lesotho was, in fact, one of the most important outposts of South Africa's labour 'empire'. As such, its history can help us understand how the region's 'patchwork quilt of patriarchies' was stitched together and implicated in the development of racial capitalism throughout southern Africa.[5] In addition, the recovery of Basotho women's history corresponds with a worldwide effort to gain a fuller appreciation of the social dynamics of development and underdevelopment than conventional, androcentric histories allow.

A second objective of this study is to problematize the androcentric discourses and analytic concepts that prevail in modern scholarship about Lesotho. Historians of gender relations elsewhere in the world have long cast doubt upon some of the most common characterizations of modern scholarship. In the case of Lesotho, these include binary oppositions such as 'conservative' versus 'radical', 'traditional' versus 'modern', and 'Christian' or 'progressive' as opposed to 'pagan' or 'feudal'. These dualistic constructions deny nuance, obscure people's often contradictory behaviour, and impose inappropriate and misleading Western assumptions. They also often serve to reify the very hierarchies of power they critique or describe, above all the power of 'rational' or 'political' Man over 'irrational', 'domestic' Woman. By drawing out women's hitherto silenced or neglected perspectives on the state, politics, development, and culture, this study aims to enrich our understanding of the gendered nature of the dominant modes of academic analysis and discourse.

Women and gender in the historiography

The historical literature on Lesotho centres on the twin themes of how the Basotho first came to be, and then how they came to their present parlous state. On both questions, Great Men tend to dominate the narrative. A relatively huge literature details the life and genius of the nation's founder, Moshoeshoe I, for example. The early missionaries, European traders, and colonial officials also feature prominently in the historiography of the period leading up to the imposition of imperial rule. Similarly, the history of subsequent struggles by the Basotho for justice and eventually for independence, tends to be told with a heavy emphasis on the careers of male political leaders. [6]

This is not to assert that Great Men stand alone as the engines of change in Lesotho's historiography. On the contrary, historians writing in southern Africa's radical tradition have closely scrutinized the economic and political structures underlying the activities of Great Men. The most common interpretation of the colonial era, for example, is a version of dependency theory. In this view, Britain's cynical policy of 'benign neglect' or 'laissez-faire' betrayed the Basotho to the profit of British companies and to the advancement of British interests elsewhere in the region. Above all, the British sought to ensure the smooth flow of cheap male Basotho labour to the mines in South Africa. A succession of decidedly less-than-great bureaucrats achieved this by restructuring the traditional Basotho chieftaincy into a compliant class of 'compradors' and 'discourteous feudal fanatics'.[7] Aided and abetted by the 'conservative' Roman Catholic church, these men then assumed control of the state at independence to continue, and in many ways even intensify, the debilitating and violent patterns of the colonial era.[8]

As fascinating and well-argued as this historiography often is, it commonly neglects gender and minimizes or misrepresents women's contributions to historical change. Many accounts of Basotho history barely even acknowledge the existence of females, great or otherwise. 'Mamohato, for instance, who was said by the contemporary missionary D. Frederic Ellenberger to have been left in charge of the capital Thaba Bosiu when Moshoeshoe I travelled, appears in subsequent accounts only as the begetter of heirs or as a congenial server of food. That Moshoeshoe apparently killed her in a fit of anger at her alleged infidelity is almost nowhere held against his reputation as a caring husband and peace-loving man.[9] A similar double standard also appears to be at work in historians' assessments of 'Mantsebo Seeiso Griffith, Lesotho's Paramount Chief Regent from 1941–60. Not only has she been treated cursorily or even libellously in the literature of that period, but casual assertions that she was a 'client' of the British continue to be made, unsupported by the type of evidence that historians normally demand when making strong statements about male leaders.[10]

The cases of 'Mamohato and 'Mantsebo illustrate a broader tendency to conceive and portray Basotho women as either pawns of male power-brokers ('commodities' and 'objects' in Judy Kimble's terms) or in stereotyped 'roles', above all, Wife, Mother, or Prostitute.[11] These portrayals are rife with unsubstantiated clichés about women's purported nature, including their supposed 'weakness' (physical and moral), their 'conservatism' (by implication, a parochial or short-sightedly 'bread and butter' grasp of politics), and their 'religiosity' (implicitly irrational or gullible). Periodization in the historiography meanwhile has emphasized events of special significance to males, particularly elite males. Hence battles, male migrant labour, constitutional developments, and partisan politics have tended to be the sun and moon. Key events for women such as the criminalization of their mobility (1915), the establishment of the Homemakers Association (1935), women's *de jure* recognition as adults (1943), and the closing of the South African border to Basotho women (1963), are scarcely mentioned let alone considered for their impact on the development of Lesotho as a nation.

To some extent, both the presumptions in favour of men's activities as well as the androcentric assumptions about women's (and men's) purported natures in the historiography can be accounted for by the androcentrism of conventional archival sources. The simple fact is that the authors of government reports, censuses, travelogues, church records, diaries, official correspondence, newspaper articles, and such were overwhelmingly male. The same is true of the keepers of 'official' oral traditions. These men did not normally discuss women and gender relations except when females disrupted the spread of civilization as they

knew it. Information pertaining to women therefore generally appears in the conventional sources only in snippets. Moreover, these scraps are often couched in a language which hides direct reference to women. For example, 'African', 'Native', 'farmer' or even 'person' were virtually by definition male. 'Everybody should attend these meetings on pain of prosecution' advised an official circular in 1953. 'All women and children should also attend.'[12] Translation from Sesotho has been a further factor in erasing Basotho women from the historical record. Notably, where the pronouns *oa* or *o* can mean he or she, they were almost always rendered 'he' in English, even when they clearly designated a woman (as in the case of female 'headmen'). Basotho women's own widespread acceptance of androcentric discourses and their discretion around potentially controversial issues have also almost certainly contributed to their invisibility to historians. This could, for example, explain Maloka's otherwise improbable justification for basically ignoring women in his study of migrant labour: he was unable to find any female informants.[13]

The dominant paradigm of Western scholarship enhances the archival invisibility of women.[14] Modern metanarratives of historical change generally purport to be gender-blind. In fact, the activities of men and women are typically differentiated by discourses which imply greater or lesser value. Predominantly female activities can almost always be found on the devalued side of this discursive fence. Thus, men discuss politics (public sphere), while women gossip (private sphere); men work or farm (acquiring class consciousness), women do homemaking (parochial, conservative); men are chiefs (the real thing), women are chieftainesses (diminutive copies); men are migrants, women are prostitutes, and so on. Even when feminist scholars have explicitly announced their intention to investigate women and gender they have to a noteworthy extent been drawn away from realizing that goal by the conceptual tools that they have used. For example, Martha Mueller, in her study of Basotho women in politics, remains focused on male-dominated partisan politics to the exclusion of women's pious associations although, as she herself recognizes, these were demonstrably political (about power) in important ways.[15] Judy Kimble, devoting her energy primarily to the exploration of class structures as defined by men's economic activities, similarly neglected the opportunity to amass empirical evidence on women and gender, despite the fact that this was for her an oft-stated priority. Androcentric assumptions about what is real or what is important and which are deeply embedded in modern metanarratives seem to have occluded these scholars' vision.

That said, Mueller, Kimble, and a number of subsequent scholars did at least raise pointed questions about the androcentric assumptions and priorities that underlay the historiography. Mueller found that women's

withdrawal to domestic or family affairs was not the result of their polit-
ical ignorance, apathy, or supposedly domestic nature as had hitherto
been assumed. On the contrary, becoming an exemplary wife and mother
was the most rational political choice available to women in circum-
stances where partisan politics were not only manifestly 'impotent' but
also often invited alienation from the community or violence and retribu-
tion.[16] This finding accords with that of anthropologist Judy Gay, and
with the concept of 'exit' discussed by Robert Fatton in relation to
women in sub-Saharan Africa as a whole.[17] The concept of exit implies
that the loyal wife (or nun) is a political actor whose decisions and
strategies need to be considered as such. Kimble, meanwhile, argued that
neither male migrancy nor the present class structure of Lesotho could be
understood without first clarifying the ways in which the subordination of
women (and through them, young men) took place in pre-capitalist soci-
ety. She also showed that Basotho women did not passively accept the
'triple squeeze' upon them by colonial rule, Basotho patriarchs, and new
commodity relations. On the contrary, Basotho women struggled to take
advantage of opportunities created by colonialism and emerging capitalist
relations of production, especially by 'running away'.[18]

The theme of women's resistance to patriarchy and colonialism
through 'domestic struggle', and the effects this had upon the develop-
ment of the regional political economy, was taken up in subsequent
studies of Basotho women by Sandra Burman, Phil Bonner and Tshidiso
Maloka.[19] Burman analyzed magistrates' court records to find Basotho
women trying to maximize the benefits of new legal rights in the 1870s.
This, she argues, was a key factor in undermining Cape Colony rule and
sparking political reaction. Bonner's accounts of Basotho women's illicit
presence and 'undesirable' activities in the locations of Johannesburg and
Brakpan also suggest that domestic struggle was an important factor in
confounding the intentions of colonial, customary, and mission author-
ities alike. Basotho women's unruly behaviour helped prepare the polit-
ical grounds for the emergence of apartheid. Maloka also considers
female Basotho migrancy and prostitution with a focus on the border
camps within Lesotho. He aims at once to humanize the women (with
names and testimony) and to lionize their practices as 'resistance' to
colonialism and racial capitalism.

These studies fit within a growing historiography from throughout the
continent. To the Comaroffs, for example, the contest by Europeans to
'colonize consciousness' in Bechuanaland took place largely through
symbols, rites and implicit language, while one of the principal battle-
fields of imperialism lay in the struggle to reconstruct the African house-
hold in these quiet ways. It was a battlefield where African women were
central players and where the European triumph was much more equi-

vocal than in the military or political sphere. For Parpart and Staudt, gender struggle was 'at the heart of state origins, access to the state and state resource allocations' in colonial Africa. Jeater and Barnes (in the case of Southern Rhodesia) and Cooper (in a general overview of Africa) have developed this notion to periodize the colonial era according to how the state intervened to restructure the African family. Bozzoli with Nkotsoe also employ the concept of domestic struggle in their examination of the lives of Bafokeng women, introducing important nuances to the structuralist interpretation of the migrant labour system. Other empirical studies have sought materialist explanations for women's 'false consciousness' or failure to respond to market incentives. They have demonstrated, among other things, that African women at times clung to or invented 'traditional femininity' not because of an irrational conservatism or essential domesticity, but as a strategy to win economic and broadly political advantages in situations of extreme structural vulnerability.[20]

The historian who to date has most successfully woven together these strands of gender struggle and women's history in Lesotho is Elizabeth Eldredge. She has shown how Basotho women's strategies to win or enhance their (and their families') economic security stimulated the commodification of agriculture in pre-colonial and early colonial Lesotho. They did so, however, in ways that tended to exacerbate women's structural disadvantages. This contradiction was grounded in women's acute perception of the dangers and difficulties of 'progress' in the context of racial and patriarchal capitalism – too much individual financial success or emancipation invited men's reaction. In such a context, Basotho women's supposed passive acceptance of male privilege was at least partly a facade, a selective, often conscious attempt by women to avert male reaction against change while at the same moment seeking to gain advantage from an exceedingly vulnerable position.[21]

This study asks many of the same types of question carried into the formative four decades prior to independence in 1966. In this period the contradictions of colonial rule and missionary paternalism sharpened to create sometimes dramatic new opportunities and predicaments for Basotho women. There was a near-catastrophic economic collapse, the state was reformed and made a relatively vast commitment to development expenditures, the nationalist movement was born, and the Catholic church radically revitalized itself. Across the border, racial segregation gave way to more brutal forms of discrimination and eventually apartheid, even as economic opportunities flourished. How did Basotho women respond to the changing circumstances in this modernizing era? How did their activities affect those circumstances? And how did gender and domestic struggle shape the very conceptualization and implementation of political reform and economic development strategies? Under-

lying these questions is the assumption that we cannot properly under-
stand decision-making processes in the realm of public discourse without
casting a critical eye upon decision-making processes within the realm of
household negotiations.

Sources, methods and structure of this study

Researching largely invisible historical subjects (women) and ineffable
processes (such as decision-making within households or change in ideo-
logy and consciousness) raises acute practical difficulties.[22] My initial
approach to finding Basotho women in history involved casting as wide a
net as possible over published and archival sources which potentially
contained relevant material. For example, prior to the 1950s the principal
documentary source of Basotho women's voices is in the civil and crim-
inal court records. Perhaps the best source of Basotho men talking about
Basotho women can be found in the Basutoland National Council debates
and commissions of inquiry, while the testimony given before the
Basutoland Constitutional Commission in 1963 is unusual for the number
of women who speak directly to the historical audience. All of these
records are kept in the national archives in Roma. A comparative colonial
perspective on 'runaway' wives and Basutoland canteens can be found in
the Free State archives, Bloemfontein. The different churches also pre-
served Basotho women's voices to varying degrees in, for instance, their
respective newspapers and other periodicals (many of which can be found
in the Morija Museum and Archives). Of particular interest to me were
the almost totally silenced voices of nuns. A rich source for these voices
can be found in the Deschatelets archives in Ottawa, both as interpreted
by Roman Catholic priests in their mission diaries and in the Sisters'
sometimes combative correspondence with the Fathers of the Oblates of
Mary Immaculate. Female chiefs speak to us primarily through their
appeals to and discussions with colonial officials (found in the national
archives and in the Public Records Office, London). Other correspond-
ence relating to 'Mantsebo and the administrative reform process can be
found in the files of colonial officers located in Rhodes House, Oxford. A
final and often surprisingly rich archival source is the Bachelor of Arts
dissertations of history honours students at the National University of
Lesotho which were based primarily on oral interviews.

These documentary sources allowed me to identify gaps in know-
ledge as well as individuals who could fill them through my own oral
interviews. By no means was this a systematic survey of opinion. Rather,
I identified informants either through archival references, personal con-
tacts, or by recommendation – an informant mentioning that so-and-so of
'X' might know more about such-and-such – why don't I go see her? The
informants came from a wide spectrum of society with a bias towards

those whose voices are under-represented in the historiography (women, nuns, Catholics). A further class bias was insinuated by the fact that I conducted most of the interviews in English. My informants tended to be well-educated, fluently bilingual and courteously familiar with the eccentricities of 'Europeans' such as myself.[23]

The basic principle which guided me in pursuit of this kind of knowledge was to make the interview enjoyable and rewarding to the informant.[24] This was not hard given how rarely most of my informants had ever been asked about the *real* (that is, women's) history of the country or had had a *lekhoa* (professional white man) ready and willing to listen interestedly for hours on end. Further to encourage the informants' feeling of 'ownership', I emphasized that the ultimate intention of my research was to contribute to social transformation (a more just society, especially one free from discrimination and violence against women and children). Few could disagree about the need for this, or about my insistence on the exceedingly modest degree to which I could do so.

In terms of the actual conduct of the interviews, I sought to 'empower' my informants by, principally, allowing them to emphasize matters and interpretations of greatest importance to themselves (rather than feeding them questions that suggested answers and interpretations of prior interest to me). After the initial introductions, often with my children present to break the ice, I conducted my interviews with pen and paper only. I did not abjure tape recorders on principle but, in the context of a military regime and significant state violence, I judged it impolitic to collect interviews in that potentially incriminating way. I asked open-ended questions and discreetly jotted down the replies in shorthand. Immediately following the interview, I wrote these up in long-hand which captured if not a strictly verbatim record, then as accurate a reconstruction as feasible. In the single case where my 'transcript' was subsequently challenged by the informant, I corrected it in consultation with that individual. I also invited my informants to request or suggest ways they would like me to use the data. This book is part of my efforts to fulfil the promises I made to try my best in that regard.

As exciting and satisfying as these interviews felt to me – and appeared to be to my informants – they ultimately comprised just one more problematic source. Indeed, neither women's oral history nor a 'herstory' approach to androcentric documents are necessarily radical or even feminist at all. Some critics have argued that 'herstories' may actually be counter-productive to feminist politics in that they create a patina of gender sensitivity and 'politically correct' discourse while leaving patriarchal structures and intellectual traditions unchallenged. Moreover, as pointed out earlier, Western epistemology and academic practice contain pervasive gender, culture and other biases which may undermine the best

radical research intentions. These biases impinge upon the process of production of knowledge at every level: the formulation of questions, the choice of sources and informants, the conduct of interviews, the translation, the interpretation of data, the choice of words to articulate that interpretation, and even the nature of the media used to publicize research findings. Of particular concern to 'Third World' feminists has been the tendency of Western feminists to portray Third World women monolithically as victims and to 'mine' this compelling archetype to advance a specifically Western political agenda. Western feminists have also been accused of imposing inappropriate assumptions about the paramountcy of sexual liberation as a political objective and of asserting a hierarchy of oppressions in which gender supercedes race, class, ethnicity and all other types of unequal or exploitative relations.[25]

Various terms have been applied to describe the methodologies that have been developed to make researcher subjectivity more visible and hence to work against such 'colonizing' tendencies. These terms include materialist feminism, postmodern feminism, Third World feminism, and 'practical realism'.[26] Despite nuances, these approaches all draw heavily upon the ideas of Antonio Gramsci and Michel Foucault. They lay particular stress upon the need to become aware of and to address the power imbalance inherent in the researcher/researched relationship. The relative power the researcher enjoys typically blinds her or him to elements of rationality in the behaviour of the less-powerful and opens the door to 'colonization'. Cultivating awareness of that power/blindness, however, cannot be done by strength of will or theory alone. Rather, it requires a unity of intellectual engagement (self-criticism, reflection, theorization) and political activism (participatory or action research that draws the researcher into real-life political struggles of the researched). This unity of engagements must extend throughout the entire production process.

Materialist feminism does not prescribe a set formula to 'cure' the power differential between researcher and researched, nor even to ensure consistent consciousness of it. The methodology merely asks that an honest effort be made within the limits of reason and safety as judged according to each research situation. It also asks that those efforts be identified rather than allowing readers to assume that they come naturally or are instrinsic to professional integrity or intention. They are not. Indeed, the potential contradiction between power on the one hand and integrity and intentions on the other needs to be pointed out again and again, including to oneself as researcher. In my specific case – a white, middle-class, expatriate male – the power imbalance in the interview relationship was especially wide. I chose to address it by engaging on three political fronts simultaneously: participatory research, pro-feminist activism, and domestic labour. These activities, however removed from

actual data collection, were part of the research process and deserve brief explication.

First, participatory research was a pre-condition for my fieldwork. My sojourn in Lesotho thus began not as a researcher but as a co-worker, specifically, a teacher at a rural high school where I was one of only four males on a staff of twenty-two (not an unusual ratio for Lesotho). This period (six months) was all too short to master anything but the rudiments of Sesotho language and culture. However, it was long enough to impress me with the complexity of Lesotho's social relations, and the dignity and courage of its people in the face of objectively demoralizing conditions. The illegal national teachers' strike of May 1990 was a particularly enriching experience in which to participate. (On a darker note, the terrifying experience of a gang attack while walking in the fields near the school taught me more about male youth alienation than a thousand academic tomes ever could.)

Secondly, I recognize that a vast array of social and political advantages tend to accrue to me as a heterosexual white male – relative freedom from sexual harassment, for example. These advantages are so deeply embedded in culture and language that they are often virtually invisible from my position of privilege. As a strategy to make them visible, and to conscientize myself about power implicit in the dominant discourse, I therefore committed myself during the writing-up phase of the research to ongoing volunteer work in practical struggles against patriarchy, racism, and capitalism. This book, in the form it has emerged, could no more exist without my ongoing involvement in men's pro-feminist groups in North America and Zimbabwe than it could without my empirical research in Lesotho.

Thirdly, I want to re-affirm the old feminist argument that the personal is political and that research or activism in the so-called public domain must go hand-in-hand with revolution in the private domain. Again, materialist feminism does not prescribe a set formula to achieve this. Domestic struggle, broadly defined, will necessarily be different in every individual case. Materialist feminism does, however, insist that failure to reflect on the role of personal domestic struggles in the process of knowledge production can falsely imply that knowledge springs in a disembodied way from the brain of the researcher. The knowledge I gathered and am communicating in fact is embodied in my commitment to gender equity within my personal relationships. I do not wish to claim that I have succeeded in that. I do, however, wish to assert that this book would not exist without years of cleaning nappies and other forms of so-called reproductive labour that men normally aver. 'Family time' in other words, was mutually inclusive with research and writing time. Resisting the pressures to conform to more conventional models of mas-

culinity – pressures that can be intense upon academics and radical activists alike, including women – has been a key element of the research process.

This book is structured into three parts. The first provides the historical background to the options that became available to Basotho women and men in the later colonial period. This includes an examination of pre-colonial Sesotho gender and class relations, the contradictory dogmas and effects of the early Christian missions, and Lesotho's evolving position in the regional political economy and the bureaucracy of the British empire.

Part Two examines the ways gender struggles affected and were in turn affected by the changing policies of the colonial state, including the role of gender in the formation and demise of the Cape Colony regime (1868–81) and in the subsequent establishment of the system of 'parallel rule' (1884). The behaviour of 'loose women' thereafter is discussed as a factor in precipitating the economic and political crises of the late 1920s and early 30s. More respectable women, such as Paramount 'Chieftainess' 'Mantsebo, are also considered for their roles in shaping the particular forms of modernization and development that the British sought to impose from the 1930s to 50s.

Part Three shifts focus from the colonial state to different sites of women's struggles for dignity and security in the period from the Great Depression up to independence. These range from Basotho women's earliest organized initiatives to achieve material self-reliance, (the Homemakers Association) to the pious associations (*manyanos* or *kopanos*) of the major Christian missions. This section also casts a close, critical eye upon an alternative model of development known as 'social action' that was propagated by the Roman Catholic mission, particularly from 1933 to 1965. The themes of development, Christianity, migrant labour and women's self-reliance are then brought together in the whirl of partisan politics in the late 1950s and early 60s. How and why did women become involved in this characteristically masculine activity? How did the nationalist parties seek to exploit or channel gender conflicts and ideologies to their advantage? How were the contradictions in men's political behaviour perceived by different Basotho women, and how did this affect their participation in the political process?

Highlighting hitherto neglected women's voices, including those of Basotho nuns, female politicians, chiefs, prostitutes, runaways, and homemakers, provides a challenge to the models of development, politics, and community that have been predominant in Lesotho in the modern era. Women's perspectives on these issues at turning points in Lesotho's history should not be romanticized. However, given the masculine models' self-evident failure to prevent Lesotho's slide into its present poverty and political malaise, they bear good listening to.

Part One

Culture, Christianity and Capitalism

The background of social change in the nineteenth century

CHAPTER ONE

Sesotho custom

Whatever reproach one may level against the ancient social system of the natives, it was nevertheless an order of real value.[1]

Our customs though, we like them. We can't ignore them . . .[2]

The Basotho as a people coalesced after 1824 from at least thirty different groups of refugees, Bushmen, and hitherto independent chiefdoms. Sesotho as a distinct body of custom uniting them thus simply did not exist when the first Europeans arrived in 1833 to begin recording it. On the contrary, Sesotho developed fitfully over subsequent decades. At times it was hotly contested and at others coolly, even cynically, manipulated to advance or protect the interests of specific groups or individuals. In the tumultuous formative years of the Basotho nation, 'custom' or 'tradition' was frequently appealed to as a means to cloak otherwise naked power and land grabs against rivals. Gender relations were central to this process of invention of tradition and nationhood, as they were throughout the region in the *mfecane* era.[3]

Struggles over what constituted 'real custom' were also reflected in the divergent judgements upon it by European missionaries and colonial officials. With regard to gender relations, European observers have left a voluminous record of opinion about Sesotho, ranging from revulsion and scandal to begrudging or even outright admiration. They picked their local favourites. The Tembu in the south-west of the country, for example, were held by one Resident Commissioner to be 'moral in a different [superior] way' when compared to other Basotho on account of the men's relatively greater ability to control their wives.[4] The Batlokoa in the north-east, by contrast, had a reputation for strong-minded and political women, with an early and pronounced 'tradition' of placing women in the position of regent. Invented traditions which served to consolidate the power and prestige of the preferred collaborative class and lineage were eventually codified as the Laws of Lerotholi (1905).

Scholars have not always been sensitive to the localized, fluid, and often contradictory interpretations of Sesotho asserted by the people they have studied. Indeed, tradition has been advanced as an explanatory factor in the literature on Lesotho in startlingly different ways. Until recently, the dominant school of thought has been along the lines opined

15

by Hugh Ashton in his influential anthropology: women were 'more conservative than men and jealous of their traditions'.[5] Being 'traditionally oriented', and 'generally more attached to the existing moral and social fabric [than men]' women later naturally inclined to purportedly conservative political parties, an assumption which is widely cited as an important factor contributing to the outcome of the 1965 elections.[6] By contrast, Lapointe makes precisely the opposite contention. Other scholars such as Eldredge and Showers and Malahleha have meanwhile shown that the most ostensibly traditionalist sectors of Basotho society at times evinced an acute, materialist rationality and legitimized radically new behaviour in the name of custom.[7]

This chapter does not aim to provide a definitive resolution to such disparate views, nor even to periodize changes in tradition over time (an exceptionally difficult task given the erratic nature and other problems with the sources prior to the late nineteenth century). Rather, it aims to show how specific contradictory claims about custom in the pre-colonial era both oppressed and empowered women. It will be argued that Sesotho on the one hand defined and limited people's choices about sexuality, the sexual division of labour, the socialization of children, and the proper ways of relating to elders, yet on the other hand could be a source of strength and inspiration in redefining these same matters. This protean and contested nature of Sesotho in the pre-colonial period was in itself an important element in women's 'arsenal' of options in subsequent eras of rapid social and economic change.

1.1 Sesotho and gender

Key aspects of customary gender and class relations were in a state of flux on the southern African highveld even before the disruptive wars and migrations of the early nineteenth century brought the Basotho together as a nation. Large-scale polygyny, notably, apparently only emerged as a practice among senior Sotho/Tswana patriarchs during the reign of Monaheng in the 1760s. His successor Mohlomi expanded upon this innovation to build up friends and allies among his neighbours, much as other nation-builders were doing in the pre-*mfecane* era. From his successful experience, Mohlomi is said to have advised the future Moshoeshoe to make polygyny one of the guiding principles of wise rule. Moshoeshoe certainly took the lesson to heart, acquiring dozens of wives within the first decade of his reign. Moshoeshoe also introduced new marriage arrangements of his own in order to consolidate the powers and class privileges of the Bakoena lineage.[8]

Such innovations, contests and local variations notwithstanding, by the onset of colonial rule the Basotho clearly shared a number of basic ideals regarding proper gender relations. We may therefore safely apply the term Sesotho to these ideals of customary behaviour which span

history (even if actual practices do not).[9] Perhaps first and foremost, Sesotho enjoined and justified the possession by men of extensive legal and moral rights over women. In this regard Sesotho is completely in keeping with the cultures of other cattle-based societies of the southern African highveld. Because women's labour and fertility both created people (through birth) and attracted people (through economic surpluses which could be redistributed to win the loyalty of new male subjects), control of women secured for men the means to amass the principal measurement of wealth in pre-capitalist society – people.

Men's power to control women stemmed from several clearly ancient sources, above all, their ownership of the principal means of production. With few exceptions, Sesotho banned women from owning cattle, the major source of food, clothing and transferable wealth. Land also could not generally become available to women except through men, normally upon marriage. Food distribution was also a male prerogative, so a woman could not even guarantee a share of her own food production. Rather, she remained largely dependent for her subsistence upon the good will of the head of the household. Surplus grain, for example, although grown predominantly through female labour, was stored in pits and baskets in the cattle kraal where women were not supposed to venture. In times of famine, women would normally be the first to be reduced to foraging for starvation foods. This was reputedly the case in the 'famine of female servants' in 1802–03, when Sesotho-speaking women were simply 'freed' from marriage to fend for themselves.[10] Court records from the earliest colonial regime also attest to this practice in a way which makes it quite clear that leaving a woman to starve was an accepted and long-standing prerogative of the male head of the household in times of exceptional hardship.[11]

Male control over women was principally mediated through the custom of *bohali* or bridewealth. *Bohali* was an amount of cattle or other beasts which was delivered from the family of the groom to the family of the bride. This exchange took place with a number of ceremonies extending from betrothal to sometimes years after co-habitation. Traditionally, *bohali* was set at ten to twenty head of cattle, but the amount was negotiable. The daughter of a chief would normally warrant more, while a daughter who was 'spoilt' by pre-marital pregnancy would be worth less. This consideration gave parents every incentive to guard their daughters' behaviour closely (although in the case of lapses, it was the boy who was blamed). *Bohali* also empowered parents to demand compensation from the family of a man who seduced, abducted or otherwise 'damaged' their daughter before marriage (normally five beasts). Daughters had no say in either the amount or timing of *bohali* payments or compensation for 'damage' which, like the betrothal itself, was a parental responsibility.

Men's authority over women also had roots in an ideology which valued males over females. Girls, like boys, were cherished by parents but only boys could grow up (hence the assumption that boys were responsible for 'damage' to girls, the latter assumed to be incapable of initiative). Women then remained 'children' throughout their lives, legal minors subject to the will of their senior male relatives until marriage and to their husbands thereafter. As 'children', they could not own or make independent decisions about property, including how or what to cultivate on the fields they worked. Nor could they make independent decisions about the welfare of their own children who belonged to the husband. Even widows with children, while given greater latitude for autonomous decision-making and entitled to take part in some public affairs, could still be compelled to dispose of their deceased husbands' property as demanded by their male in-laws, younger brothers, sons, and even more distant male relatives. A woman was expected to serve her menfolk, get pregnant, raise the children and do as she was told. She was required to show deferential respect (*hlonepho*) to her social seniors, the latter including her mature sons. Women, as 'children', were normally not allowed to address public political gatherings (*lipitso* or *pitsos*).

Giving substance to this ideology was men's control of the means of violence. This extended to the recognized right to use physical discipline against women up to and including manslaughter if suitably provoked. As the examples of 'Manthatisi and 'Mamohato indicate, deadly force or terrorization by a husband or son against even the most senior and respected women was more or less socially acceptable if their disobedience was construed as a challenge to the man's sense of honour.[12] Phoofolo's contention that wife assault was 'common' among the mass of the people in the nineteenth century is therefore almost certainly warranted, as is Eldredge's claim that forcible kidnapping and other forms of abuse of women were 'taken for granted'.[13] Early colonial courts also strongly attest to a widespread acceptance of 'thrashing' as a normal, perhaps even desirable, aspect of a husband's proper relationship to his wife. In the words of Tebela:

> He hated me from the first and beat me saying I was black and my mother was a witch. He was always telling me to go away. He used to rouse me at night and drive me away and he wanted his cattle back to marry a light coloured woman – I was too black for him . . . I persevered. *I thought that it was the way all men behaved to their wives.*[14] (emphasis added)

Upon marriage and the payment of the first instalments of *bohali*, a Mosotho woman was required to leave her own family and move to her husband's village. In effect, she married the family, not the man himself.

Consequently, if he died she could be 'inherited' by the man's most senior brother (*ho kenela* or '*kenelaed*'). If she died before producing children, the man's family had the right to demand a younger sister she might have to take her place (*ho seantlo*). A man could take as many wives as he wished (polygyny or *sethepu*), provided he could make proper *bohali* payments for them. A man might also swap wives with another as a sign of friendship (*ho kenyana matlung*), or 'loan' a junior wife as a 'concubine' (*ngoetsi*) to another in reward for services rendered. In all of these cases, the principle that children were 'belched by the beast' secured his legal rights over his wife and her offspring – *bohali* payments guaranteed that children belonged to the husband and his family regardless of either the actual biological paternity or of negligence in caring for the children.

With all these powers, rights and privileges for Basotho men, it is hardly surprising that the first European commentators considered Sesotho to be demeaning and oppressive to women. In denouncing the 'enslavement' of women under Sesotho custom, however, they erred in overlooking features of Basotho patriarchy which mitigated male power. To begin with, junior men as well as women were subject to numerous restrictions upon their autonomy. A father exercised control over his son by paying *bohali*, while the maternal uncles (*malome*) of a new bride retained a life-long commitment to monitor her marriage and to intervene on her behalf should the young husband appear negligent or abusive. Dependent upon senior men to get a wife, fields and status in the community, young men were subject to arranged marriages, required to perform labour in their fathers' and chiefs' fields, and generally expected to do as they were told. They could be summoned at any time to perform services such as carrying messages or going on cattle raids. They could be told to perform 'women's work' such as threshing or weeding. Even after initiation, marriage, and paternity, when they had definitively ceased to be boys, men were still expected to show *hlonepho* to their elders, including elderly women. It is no accident that the Sesotho word for 'young man' (*mohlanka*) is synonymous to 'servant'.

The early missionaries and their zealous converts also overlooked elements of custom which served to protect Basotho women from gross abuse or neglect, which allowed for women's expression of grievances, and which provided for significant areas of relative autonomy from male control. For instance, men were morally obliged to respect women's dignity and autonomous needs. They were also restrained from consistently exercising their full theoretical powers by practical considerations. Women's crucial role in the production/reproduction process meant that it made economic, not simply ethical, sense for men to ensure that their 'children' were happy and productive.

A man's economic power over his wife was balanced by, in the first place, his obligation to provide her with two out of his three fields and any other productive resources necessary for her and her 'house's' up-keep. Women also had usufructory rights to a garden plot attached to their huts, could raise their own poultry and, after their introduction by mis-sionaries, keep their own pigs (or 'women's cattle' as they came to be known). Women were entitled to exchange their labour as well as special-ized crafts such as pots and baskets for grain or services. These gardens, livestock and income from trade were intended for the support of the woman and her children. As such, they were outside the sphere of a husband's legitimate concern and he consequently had no right to inter-fere. Moreover, while decisions about planting, harvesting, investments, and later the sale of produce were theoretically his to make, he had a strong moral obligation to consult with his wife on all these questions. Failure to consult was grounds for his wife to make a complaint to her *malome* or to the chief. Should the man continue to 'neglect' her in this way, a woman was ultimately entitled to seek a divorce. Indeed, so strong were women's moral rights to claim a share of surplus production that Protestant missionaries later denounced them as a disincentive to men's hard work and thrift.[15]

A women's letsema *to harvest the maize. Note the women in the middle 'entertaining the others by gesturing and signing'.* (Deschatelets archives)

Men's obligations to provide women with the means to support them-selves and their children were powerfully backed by the simple fact that hard-working wives could enrich a man significantly. Women ground the grain, prepared food, collected fuel and water, dug for salt and the red ochre used in decorating houses, made clay pots and certain kinds of baskets and mats, washed clothes and even built certain types of hut.

Although women could not help with the cattle, their labour in all three of the family fields (hoeing, weeding, scaring birds, harvesting, threshing, winnowing) was essential to the general household's welfare. Surplus grain was not only assurance against famine the following year, it could also be exchanged by the man for cattle. In that way, he could build up his herd in order to acquire *bohali* for another wife, to pay *bohali* for male clients (and so gain rights to the labour or future income of their off-spring), and to advance his sons' social status through attractive marriages.

Women also brewed *leting* and *joala* (sorghum beers). These moderately alcoholic beverages were an integral part of every family gathering and celebration. They were also a way for a man to attract other men to assist him in his own agricultural tasks, especially preparing fields for cultivation and harvesting. A husband could direct his wife to brew *joala* and 'could thus exchange the woman's labour for the labour of other men, effectively decreasing his own workload'.[16] Fear of the loss of women's productive labour was clearly a powerful incentive for men to respect their marital obligations.

Men's control over women was also offset to an important degree by a societal recognition that female sexuality was normal, healthy and, within limits, desirable. A husband was expected to provide his wife with sexual satisfaction, then understood primarily in terms of frequent intercourse resulting in pregnancy. If he failed to do this, she was within her rights either to humiliate him by making her grievances known publicly, to seek a divorce, or to look for sexual intimacy (*setsualle*) elsewhere. In cases where the counselling of her *malome* failed to solve the problem, *setsualle* was the much-preferred alternative. Indeed, in legitimate cases of neglect and to the extent that it allowed useful fictions to be maintained, a wife's adultery may even have been condoned by the family and community. Secure in the knowledge that *bohali* payments unequivocally rendered any offspring his, a negligent (or impotent) man or his family might positively encourage his wife to take lovers. A wife's infidelity thus did not threaten inheritance, nor even, necessarily, honour. As a result, in one early missionary view:

> Immorality has indeed always been penal by law and usage, but that has hardly checked it. Public opinion winks at it, and it is thought no disgrace for a man or a woman to have *setsualle* (intimacy) with a person of the opposite sex. If they are caught by the woman's husband, a cattle payment is indeed exacted from the man, but there is no social stigma left on either party.[17]

If 'a married woman cannot have a bastard',[18] conversely, a man who had not undertaken to pay *bohali* had no rights over his offspring. When an

unmarried or unpledged woman had been seduced or raped, the children were raised by her and belonged to her family. *Bohali* also accorded options to widows. For instance, if a woman was beyond child-bearing years and if she had the resources, she could herself 'marry' another woman by paying *bohali* to the family of a young girl. This new female wife would then take a lover (or be given as a lover to a preferred relative or client) to produce children who belonged to the widow's household. *Bohali* payments received for any daughters which resulted would accrue to her household to be used in consultation with her deceased husband's male relatives. *Bohali* could thus provide the means for women to advance the economic interests and social standing of their house.[19]

Bohali also had the effect of enhancing the value of female children otherwise devalued by patriarchal ideology. Because daughters represented a potential source of income to the family, they were, in the Sesotho aphorism, 'the bank of the nation'. Daughters, knowing their value at this level, were in some cases able to assert their will upon their parents in ways which the colonial rulers and missionaries later interpreted as evidence of 'extremely slack' parental discipline.[20] The most common serious offence in this respect was when girls confounded the ideology that held boys responsible for pre-marital sex, that is, the girls themselves chose lovers and even got pregnant in defiance of their parents' wishes. Girls could in rare cases even refuse the marriages their parents had arranged for them: 'That is a terrible thing to do but luckily our parents are very meek and mild. In the end, if we stand firm, they will never allow a break in the family.'[21]

Perhaps above all, *bohali* provided women with a 'limited warranty' against mistreatment by her husband in that it gave material weight to her right to protest against legitimate cases of neglect or abuse. Specifically, an aggrieved woman could return to her family (*ho ngala*) where she was entitled to stay until her husband came to ask for her back. Getting her back normally entailed a public apology, a fine paid to her male relatives, and a promise to behave himself better in the future. If he did not do these things, and if the grievance was judged substantive and if previous attempts at reconciliation had failed, the woman's family was not required to return the woman or the *bohali*. The abusive husband thus not only lost his wife's productive labour but also forfeited his or his family's investment of cattle in her. The parents' willingness to support the daughter in such difficult cases was strengthened by an ideology which equated abuse of a daughter with shame of the father. As Ramokoele told the court in 1874: 'I take my daughter away because of constant ill-treatment and beatings. *Plaintiff doesn't respect me – he beats my daughter very often with a stick'*[22] (emphasis added).

Fear of this loss, combined with public shaming, appears to have been generally sobering. Thus, while *ho ngala* was relatively common, permanent divorces were exceedingly rare. Notwithstanding cases of women being forced to return to violent and negligent husbands, the overwhelming tendency inherent in this custom was to put pressure on husbands to be accommodating to their wives' legitimate desires. For that reason it seems even to have softened the dogmatic hearts of Lesotho's first missionaries. As Henri Duvoisin saw it in 1885:

> Whatever reproach one may level against the ancient social system of the natives, it was nevertheless an order of real value . . . By the importance which it gave to all the family kin, by the meticulous care with which it regulated the mutual relationship, as well as the rights and duties of every member of the community, this patriarchal organization was a mighty rampart against every kind of irruption. If it tolerated many things which are reproved by divine law; if the sacredness of the matrimonial bond, in particular, was disregarded; if it even closed its eyes to certain positive violations of the seventh commandment [adultery], at least the evil was confined within well defined limits which it was not allowed to transgress; young men were subjected to an almost Spartan discipline, the conduct of young women was strictly controlled . . . 'marriage by cattle', was in this order of things, a guarantee of morality.[23]

The stereotype of *sethepu* as oppressive and exploitative of women, and in particular the missionary image of the Mosotho polygynist as a sensuous and autocratic acquisitor of women, also needs to be qualified. To begin with, and without denying that polygyny was rife with conflict and indignities, *sethepu* could also hold real material advantages for women. For widows, becoming a junior wife through *kenela* strongly reinforced a family's obligations to support them, and in that way was an important hedge against poverty. A senior wife might also encourage her husband to marry again in order to benefit from the labour of junior wives or concubines. One type of the former was even known as *lefielo* or 'the broom', a reference to the fact that, while she was also sexually available to the husband, the *lefielo* was actually attached to the household of a senior wife primarily to perform domestic labour. A senior wife who was barren or who had no sons could also benefit from a second wife who could bear the children that the household needed for labour and for inheritance. Cases are recorded in the earliest colonial period where women actually urged their husbands to become polygynists, even to the point of paying the *bohali* from their own resources.[24]

A polygynist had a strong moral obligation not to neglect his senior wife or play favourites with his new wives. He absolutely could not 'eat'

the resources of one house for use in another by, for example, taking cattle from one to pay *bohali* for the sons of another. Where he did, a woman could appeal to her family or to the chief and even take recourse to *ngala*. Wives also had recourse to the time-honoured means of withholding the domestic or sexual services that men depended upon. However exaggerated it may have been, Moshoeshoe's lament to the missionary Eugene Casalis is telling in that respect:

> you cannot imagine how these women afflict us with their mutual quarrels and the rivalries which they foment amongst our children! See, in spite of all my cattle and my hoard of grain, there are days when I run the risk of dying of hunger, because all my wives are sulking and refer me from one to the other, 'until', as they say, 'until you find your favourite who will certainly have a juicy morsel in store for you.'[25]

Beyond such private channels for the expression of discontent, institutions and customs existed in Sesotho which gave women a political voice. The 'women's court' or *thakaneng* was usually presided over by the senior wife of the chief. Although it generally dealt with exclusively female issues (such as girls' initiation), women could bring grievances against their husbands here. As late as the 1930s, when *thakaneng* was observed to be dying out, men could be disciplined or fined 'anything up to a beast' for rude behaviour towards women. Women were also observed to be very influential at 'family court' (*lekhotla la lelapa*) where '[e]ven if they do not actually attend the meeting they will nearly always be consulted by the men'.[26] If the *lekhotla la lelapa* failed to resolve a dispute, it could then be taken to the chief's court (*khotla*). A woman could, through her male relatives, pursue her grievance right to the court of the Paramount Chief. In cases of neglect, a *khotla* which found in the woman's favour could impound up to five-sevenths of the total production from a man's fields to support her and her children.[27]

Although rare, women could also act politically as regents (or 'caretakers') for minor sons, and as representatives of their husband's authority in his absence.[28] Women could also influence the public decision-making process as 'prophetesses'. 'Mantsopha is the most renowned example of such a woman. She not only played a major role as advisor to Moshoeshoe I but in the early 1850s 'travelled up and down the country' organizing the military campaign against the British.[29] She would go into a trance, or *botheketheke*, where she railed against Christianity, European clothing, and other signs of loss of independence. Among less prominent women, *botheketheke* was a 'spiritual' recourse available to them to demonstrate in public their unhappiness or feelings of neglect. Since *botheketheke* could only be cured by special attention,

some men came to regard it as a cynical tactic by women 'to get meat'.[30] Nonetheless, the spirits had to be appeased and the woman so possessed (*mothuela*) usually got solicitous attention, if not a hearty meal. Missionaries later observed that some women used *botheketheke* as a tactic to win consent from their husbands to convert to Christianity or even to win sexual attention.[31]

A final point to make about customary gender relations regards child socialization. Primary responsibility for infant care was with the mother and her female relatives – the husband was not even allowed to see the child until several days after birth. Very young boys and girls could play together but, by the age of four or five, they began to learn their vocations separately. Girls helped around the house while boys were taught to care for the cattle, including through the development of martial skills by stick-fighting and mock battles. Among the older boys, herding could involve long periods away from home up in the highland pastures, exposed there to the dangers of predatory animals, cattle raiders, hunger, and Lesotho's often dramatic weather. As the anthropologist Judy Gay observed, girls' and boys' radically different vocations profoundly affected attitudes towards relationships. Where girls learned 'patterns of co-operative work and labour pooling' in the village, boys were socialized towards self-containment and the ability to endure pain silently. As if herding itself were not hard enough, for example, boys could expect to be 'flogged' for allowing cattle to stray. According to one venerable Mosotho man, the effect of childhood socialization was that 'a man is a sheep, a woman is a goat. A woman always cries no matter what you do to it; you can cut the throat of a sheep and it does not make a sound.'[32] We may be justifiably sceptical of this self-flattering assertion. Nonetheless, it is recorded that the French missionary Thomas Arbousset found Basotho men's 'impassivity' to pain noteworthy in his travels in the 1830s. In colonial times, the characteristic positively endeared Basotho men to the mine owners of South Africa.[33]

Young boys would also have been vulnerable to coercive homosexual attentions from their older peers. According to Sesotho, calculated or persistent homosexual behaviour was reprehensible, perhaps a sign of witchcraft. Up in the mountains, however, away from the gaze of the community, anything could happen. Evidence from elsewhere in the region and my own oral informants suggest that Basotho boys were as prone to experiment or 'play' in this regard as any others.[34] We cannot know how common such play was. The salient point, however, is that the 'victims' were expected to keep quiet about it, even if it meant violence done against them or the repression of their own ambiguous feelings. The same type of repression of sexual ambiguity appears not to have been expected of girls. According to a Roman Catholic priest privy to confes-

sion secrets in the 1920s, girls could maintain intimate same-sex relationships (including genital manipulation) without attracting social opprobrium.[35]

Initiation school (*lebollo*) traditionally served both to reinforce distinct gender identities and to mitigate the anti-social implications of the more stoic forms of 'machismo' among boys. In the first instance, the songs and lessons taught to boys emphasized their transition to men through war, conquest of rivals, and conquest of internal 'weakness' (such as fear and other supposedly feminine characteristics). This undoubtedly contributed to their later reputation for producing wild and violent young men. Yet *lebollo* did not only inculcate heroic virtues in a militaristic sense. It also included lessons for initiates on the limitations of male authority and how to treat future wives with respect, including admonitions against premarital sex and adultery. Girls' initiation school, meanwhile, included lessons on both how to please their future husbands and avoid their wrath. This involved learning domestic chores and *hlonepho*, as well as, reputedly, how to give their husbands and themselves sexual gratification. Failing the latter, and principally in the event of male infertility, there were also secret lessons on how to conceal adulterous affairs that could preserve the all-important appearance of the husband's virility. Girls' initiation songs meanwhile also reinforced an ideology of femininity which, in Wells' terms, stressed 'the communal solidarity of women as opposed to the heroic individualism to which male graduates aspire'.[36]

1.2 Sesotho and class

If customary Sesotho patriarchy was more nuanced and filled with the potential for negotiation and innovation than has conventionally been acknowledged, then much the same can be shown with regard to the pre-capitalist class structure. The fundamental division in that respect was between hereditary chiefs (*marena*, singular *morena*) and commoners (*bafo*), whose differential ability to control and exploit women's labour and fertility was the main mechanism by which socio-economic stratification took place. Put simply, *marena* possessed the means to 'buy' the best wives for themselves. Through polygyny, they then gained control over a disproportionate amount of the productive and reproductive labour of Lesotho's young women. This labour could be turned to produce a surplus that was appropriated by the *marena* and used either to acquire more cattle and more wives or to offer generosity and hospitality that would attract and hold the loyalty of male subjects. The sexuality of these women and their daughters could likewise be used to attract new subjects. *Marena* could offer sexual favours or wives to men in recognition of their loyal performance of services. In other cases, *marena* might subsidize the

acquisition of a wife or wives of loyal subjects by paying *bohali* on their behalf.

A growing population of loyal male subjects was not only the major measurement of wealth and prestige. It also provided the *marena* with the means to augment their wealth further. *Marena* commanded from their male subjects both tribute and tribute labour (*letsema*, plural *matsema*). Land, moreover, was not individually owned or inheritable but vested in the hereditary chiefs. As such, they had the power to redistribute the fields worked by individuals and to reserve the best lands for themselves and their wives. Chiefs also controlled the exploitation of special resources such as fields of grass for thatching, reserved lands (*maboella*), trees, reeds and clay. In times of plenty, men were expected to give informal gifts (*limpho*) as a sign of respect and appreciation of their chiefs. The *marena* also kept for themselves the fines levied in court arising from any disputes among their subjects. They could also call upon men for compulsory military duty, primarily raiding the neighbours for cattle or defence against the same. Cattle obtained in such a way belonged to the chief. Through the *mafisa* system, these cattle were loaned back to commoner men who could use the beasts for draught power and keep the manure and milk, but could not slaughter them for meat. *Mafisa* beasts could be recalled by the chief, while a portion of the offspring went to the chief's herd.

The tendency for the rich to get richer was evident among Sotho/ Tswana societies even before the founding of the Basotho nation. However, socio-economic stratification was enormously abetted during the years of drought, wars and migrations from the 1810s to 20s. Slaving-raiding by Boers and their Griqua and other 'droster' allies in particular created populations of impoverished, dispossessed people across the highveld who sought the protection and patronage of powerful chiefs such as Moshoeshoe I.[37] Throughout the subsequent decades of his reign, Moshoeshoe extended his control over the national wealth, in part through the strategy of marrying dozens (some have asserted hundreds) of women of varying status and employment as wives. A further widely emulated marriage practice of his was cross-cousin marriage, whereby *bohali* would be paid from one branch of the family to another rather than leaving the lineage.[38] Despite his cultivation of a relatively democratic political culture and an ethos which emphasized the role of chiefs in the redistribution of wealth, Moshoeshoe I in these ways actually increased the gulf between the chieftainship and the commoners. His personal herd was estimated at twelve thousand to fifteen thousand beasts in 1840, and was subsequently reputed to have grown considerably larger.[39]

Further evidence of the economic gulf between chiefs and commoners can be found by looking beyond missionary propaganda against *sethepu* as

a widespread abuse. No statistics are available prior to the early twentieth century, but according to the census of 1911, only about one in five married men was actually polygynous. Of those, 80 percent had two wives, most of whom could probably be accounted for by *kenela*. Grand polygyny, that is, more than four wives, was practised by only 178 men in the entire country, a scant 0,03 percent of the total married male population. This cannot be attributed to the dominance of Christian values as Christians were still at that time a small minority. Rather, it reflects the extent of class divergence inherent in the traditional political economy.[40]

As with men's powers over women, the chiefs' theoretical powers and privileges as a class were closely circumscribed by custom. Above all, chiefs were obliged to be both accessible and accountable to the people according to the aphorism *morena ke morena ka sechaba* ('a chief is a chief by the people'). Thus, tribute labour could only be called for certain lands and commoners could legitimately refuse an order to work any others. These *lira* lands were specifically intended for communal use, especially to amass a stockpile as protection against war or famine (*lira* means 'enemies'). In times of peace, *lira* crops were intended to feed the poor and distressed. During a *letsema*, moreover, workers expected compensation for their time and labour as a right, primarily in the form of cooked food and beer.

Custom also limited the powers of the *marena* by dictating set fines which continued to be honoured long after monetization (and inflation) had altered the value. For instance, it cost a transgressor six head of cattle for seduction and ten for murder, fines that were the same in 1948 as they were in 1873.[41] Custom also accorded commoners the right to appeal a decision by their chief to a higher level. Male commoners of even the meanest standing could challenge the decisions of the chief at a *pitso*, a public gathering which chiefs were expected to call to discuss affairs of state and to garner people's opinions prior to effecting important decisions. The freedom of speech allowed at these *pitsos* made them highly democratic (for men), with even Moshoeshoe at times humbled by the criticism of his subjects. As Arbousset noted with evident surprise, commoners even had an informal veto power over the inheritance of the chieftainship.[42]

Prior to the development of acute land shortages in the early twentieth century, commoners could also 'vote with their feet' against an unsatisfactory chief, moving their homesteads and pledging their loyalties to a neighbouring chief with land to spare. As a result, and in much the same way that husbands had strong material interests in promoting their wives' willingness and ability to contribute to household wealth, the chiefs had strong material interests in redistributing wealth and in respecting the wishes of their subjects. A wise chief thus gave generously to the poor,

and visibly if not ostentatiously employed his wealth for the benefit of the community as a whole. He did so in the knowledge that such generosity would redound to his prestige and enhanced wealth.

Within this 'feudal welfare state' (as Eldredge has termed it), commoners maintained the right to accumulate wealth and social standing through their individual hard work and thrift. A good chief enabled and recognized individual accumulation provided it did not appear to be the result of witchcraft or upset the social equilibrium of the community. In practice, fields were normally inherited within a family and the chiefs' right to redistribute fields was invoked only in cases of obvious neglect or misuse. This *de facto* inheritability was a significant incentive for innovation and agricultural improvement, especially after Moshoeshoe decreed an end to the practice of 'smelling out' witches. Sesotho thus contained the seeds for class differentiation among commoners. Ambitious individual men, through their own and their wives' hard work, could produce surpluses for trade or towards winning their chiefs' favour. In some cases, they could establish marital alliances which advanced them in the social hierarchy. The prize of upward social mobility and political influence was even attainable for hard-working, ambitious commoner women through their sons. As Eldredge notes in the case of Ngoanamokone in the late eighteenth century, an impoverished widow turned her labour at growing and trading commodities into a sizeable herd of cattle. With this, she paid *bohali* for her son to marry an influential chief's daughter. Their children became prominent chiefs in their own right.[43]

1.3 Conclusion

In sum, Sesotho defined clear hierarchies of gender, class and age, many of which were objectively oppressive and exploitative to women, commoners and youth alike. On the other hand, pre-colonial Basotho society afforded considerable scope for negotiation, innovation, and the assertion of rather impressive, modern-seeming rights and freedoms by individuals in all social groups. In that respect, therefore, Sesotho tradition was much more than simply a 'mighty rampart' against change. In it can be found explanations for Basotho responsiveness to new ideas and market forces, including the assertion by Basotho women of increasing *de facto* autonomy from men and the relatively receptive ear among the Basotho to Christianity. The eager embrace by the Basotho of secular aspects of Protestant ideology such as the value of accumulation and individual achievement, including by commoners and women, also has its roots in 'tradition'. Thus, while in some cases Sesotho did positively impede social change, in other important ways it opened the door for the revolutionary transformations that accompanied the introduction of cash, Christianity and colonialism.

Christianity

The internal dynamics of Basotho society were profoundly altered by entirely new external influences beginning in the 1830s. These included Christianity, cash, the aggression of neighbouring settler regimes, and, after 1871, colonial rule. These external influences radically transformed the broad parameters of domestic struggle by engendering new 'customs', class relations, political structures, technologies, and even a different (degraded) physical environment. All of these transformations held specific ramifications for Basotho women, creating – and delimiting – new options, conceivabilities, constraints, and ideals to shape their choices in life. This chapter begins the examination of how and why external influences unfolded as they did upon Basotho society in the nineteenth and early twentieth centuries, and how they may have affected women's behaviours and decisions up to the crisis of colonial rule in the 1930s.

2.1 Protestantism and 'progress'

The first Christian missionaries in Lesotho were French and Swiss belonging to the Paris Evangelical Missionary Society (PEMS).[1] They arrived in 1833 at the invitation of Moshoeshoe, who bade them set up their first church at a place they named Morija, a day's walk from his capital. Moshoeshoe frankly hoped to obtain from them the diplomatic connections and military hardware which could enhance Lesotho's security. Yet notwithstanding this nakedly utilitarian objective, and in spite of Moshoeshoe's resolute refusal to convert, the PEMS soon came to regard Moshoeshoe as a leader and the Basotho as a people for whom they were willing to take considerable diplomatic risks. The reasons for this included Moshoeshoe's personal willingness to listen and engage in serious intellectual and theological debates. A political culture which allowed for the expression of dissent and for the relative freedom of women to assert their independence from 'tradition' also gave the missionaries cause to be optimistic. For example, in an extraordinary coup in 1841 they managed to convert two of Moshoeshoe's senior wives. 'Masekhonyana and 'Mamosebetsi subsequently insisted upon and were granted divorces despite vociferous opposition from some of Moshoeshoe's subjects. Such respect for the independence of the mind of women was very promising

for the success of the PEMS mission when compared to the other 'tribes' the society had encountered.

The openness of the Basotho to many of the missionaries' secular ideals about individual enterprise, capitalism and liberal democracy were also encouraging to the mission. Indeed, so impressive were the early reports from Morija that in the 1840s John Philip, of the sister church the London Missionary Society, described the Basotho as a 'Godsend' against the evils of both Boer intolerance and slave-trading, and the militarism of other African nations such as the Zulu and Ndebele.[2] In all, and despite shock and disgust at certain aspects of Sesotho culture, the PEMS missionaries were confident that Lesotho's existing elite could be transformed into 'civilized ones' (*batsoelopele*) who would be the vanguard of African Christianity in the region.

The PEMS understanding of 'civilization' at that time derived from the Calvinist tradition of protest against the luxuries, superstitions, corruption, and abuses of power which had characterized the Roman Catholic church in the European Middle Ages. This tradition included the notion that discipline, self-denial, and achievement in this world were signs of predestined salvation in the next. Financial success obtained by moral means (hard work, good sense, prayer, and thrift) was thus evidence of God's approval. In the PEMS view, prosperity among the Protestant populations of their own countries proved this point. In tandem with proselytizing Protestant faith, therefore, the PEMS missionaries also sought to foster the cultural traits of their own specific national backgrounds among the Basotho. They believed that progress towards prosperity and 'civilization' in these terms was also progress (or *tsoelopele*) towards salvation. Indeed, making such a close identification between religion and culture, the PEMS missionaries could not accept the simple profession of faith as sufficient for conversion. Rather, they demanded the adoption of a full panoply of French Protestant bourgeois mores, dress, food, and architectural style as well. Their belief was that these outward signs of *tsoelopele* would introduce the inner discipline necessary to become stalwart Christians. The outward signs of 'progress' and prosperity among the *batsoelopele* would also serve to make them visible and attractive as role models to the 'pagan' masses.

Many of these arguments in fact resonated well with Sesotho. The fact that the PEMS took an active, and in the context quite courageous role in defending the Basotho against the encroachments of European settlers and land speculators, also won it a more respectful audience than comparable missions elsewhere in southern Africa. As a result, the PEMS quickly won a handful of prominent converts, including Moshoeshoe's son Molapo and his two wives mentioned previously. However, its strategy to transform the chiefs into 'civilized ones' ultimately proved disap-

pointing. The chiefs on the whole remained perceptively sceptical of the claims and demands of the new religion. Why, Moshoeshoe is reputed to have asked, should he give up polygyny when the patriarchs of the Old Testament had many wives? How was polygyny sinful when it not only served such honourable purposes as providing hospitality to visitors but also was often the request of the senior ('lazy') wives?[3] How did conversion to Christianity abet good government and ethical behaviour when it was abundantly evident that Christians, including some Christian missionaries then in the region, were at least as prone to dishonesty as the most recalcitrant 'pagan'? And why should the Basotho desist from raiding their neighbours for cattle when their neighbours showed no such restraint? PEMS insistence on the latter actually sparked Molapo's apostasy in 1848, followed by a more generalized reaction against Christianity. Over half the converts so painfully recruited over the previous fifteen years abandoned the church.

In view of this demoralizing setback, the PEMS in the 1850s changed strategy to direct its proselytizing efforts away from the chiefs towards the commoner population. The missionaries hoped that they could in this way foster the development of a new social class who achieved financial success, salvation, and happiness in a Westernized lifestyle. It was hoped that as commoner *batsoelopele* prospered, and a 'meritocracy' of monogamous, market-oriented Christians subverted the chiefs' monopoly over resources, the loyalty of the mass of the population to the chiefs and their 'pagan' values would then wither away.

In practical terms, nurturing such a meritocracy involved a three-track approach. First, education and leadership skills had to be cultivated among Basotho commoner men. Towards that end, the PEMS built schools which emphasized the attainment of literacy, knowledge of 'progressive' agricultural methods, and self-reliance – both intellectual and economic – among Basotho converts. The PEMS first translated the Bible into the vernacular, then set up a printing press to publish it. Between 1860 and 1864, the mission established a grammar school in Morija and commenced printing one of Africa's most venerable weekly newspapers, *Leselinyana*. The PEMS also made very early and significant moves towards the Africanization of the mission, appointing the first Mosotho evangelist in 1864. Before the end of the century, it had established a democratically-organized synod (the *Seboka*) in which the majority of elders were Basotho and business was conducted in Sesotho. In addition to establishing an industrial school to cultivate artisan skills such as masonry and carpentry, the PEMS encouraged the emergence of an indigenous literature and intelligentsia. The cream of its graduates went to Lovedale College in the Cape and, after 1915, to Fort Hare University. By the 1930s, alumni from Morija comprised an average of 10 to 20 percent

of the student population at Fort Hare University ('our university' in the view of *Leselinyana*).[4]

Secondly, along with education, *tsoelopele* required the use of money and the introduction of private property, preferably owned by males. One of the first PEMS missionaries, Eugene Casalis, went so far as to defy the explicit instructions of Moshoeshoe not to pay wages to his Basotho workers. His reasoning was simple: pay was essential for 'otherwise, how could they progress?'[5] The missionaries believed that cash facilitated the internalization of industrial discipline and other 'civilized' values such as thrift and individual enterprise. Together with private property, cash would hasten the demise of some of the perceived customary disincentives to agricultural improvement and efficient use of resources. Among these perceived disincentives were the powers of chiefs to re-allocate fields (hence undermining confidence that improved fields would remain in the family or be inherited). Chiefs' demands upon the labour of commoner farmers through *matsema* was also seen as a block to the adoption of a free market in land and commodity exchange, impeding 'progressive' men's rational economic decision-making and, hence, their salvation.

Thirdly, the post-1850s strategy of the PEMS required a revolution in women's status and rights. Indeed, the missionaries and early converts astutely recognized that *bohali* and *sethepu* (polygyny) were not simply immoral by their lights but were the cornerstones of the chiefs' power base. Moreover, men's power over women undermined the work ethic in men. Together with such customs as *sethepu*, *kenela* (leviritic marriage), and women's brewing of *joala*, *bohali* allowed if not positively encouraged men indulgently to enjoy the benefits of their wives' productive work. Men's idle hands then did the Devil's work. The important chiefs were especially prone to amassing wives, 'woman farming', and doling out their female property, including daughters, as sexual hospitality. This not only supposedly made women's lives miserable and promoted male licentiousness, but the incessant bickering and jealousies in a polygynous household weighed the men down with anxiety. The 'emancipation' of women, therefore, would not only provide the potential for salvation to the female half of the population. It would also emancipate Basotho men from the habits and attitudes which impeded *tsoelopele*. With this in mind, the PEMS attested in 1871 that:

> When a native talks of 'Sesuto' . . . he refers especially to marriage, the property in women, and the consequent rights and customs . . . Take them away and the whole fabric is broken in pieces – the native heathen customs become meaningless . . . In our attempts to introduce and propagate Christianity, our chief blows should [therefore] be struck at this system.[6]

The Protestants were also concerned that Sesotho cut women off from the possibility of realizing their full humanity/salvation. *Bohali* was powerfully symbolic of this, supposedly turning marriage into 'a mere commercial transaction', and reducing women to the status of any other 'property' purchased with cattle.[7] Marriage itself, meanwhile, appeared to the missionaries as little more than a life of drudgery and servitude for women. Looking back on his life's work among the Basotho, Dieterlin lamented the lot of women in typical terms: 'Marriage is for her largely made up of chores and duties and she enters into it without illusions or emotion.' The female initiation ceremony could be understood (but not tolerated) in the light that it was 'almost the only illusion which brightens the threshold of the married life which awaits them, so devoid of love and happiness, so full of weariness, of disappointments, of unpleasantness'.[8]

In the paradoxical manner of modern patriarchy, the 'progressive' Protestant eye not only regarded Sesotho as oppressive and degrading to women, denying them their God-given rights. At the same time it also saw Basotho women enjoying too many (but inappropriate) rights under the customary regime. Scandalously, for example, Sesotho appeared to condone female 'sensuousness'. Women of all ages brewed and drank 'kaffir beer' and participated in (in missionary eyes) disreputable drunken revelries. Young women, perhaps legitimately frustrated at being married off to an aging dotard, engaged in *setsualle* with not-so-secret lovers. *Bohali* shielded them from much of the shame of having illegitimate children and so made 'sin' that much more affordable. Such female 'sensuousness' clearly detracted from the discipline and straightforward inheritance patterns deemed necessary for the transition to capitalism and Christianity. Even men's obligation to consult with women over the disposal of agricultural surpluses was seen as problematic. In a suggestive letter published in the Orange Free State, one of the pioneers of the Anglican mission lamented how Basotho women's power to insist upon the purchase of luxury goods with their husbands' earnings not only put Basotho masculinity to shame but was detrimental to long-term, 'sensible' household budgeting.[9]

Armed with such attitudes, the young zealots of the PEMS agitated with impressive consistency against the core aspects of 'heathen' gender relations. No cattle were allowed to be transacted in a Christian marriage. A polygynist was required to divorce all but his senior wife if he cared to enter the church and, since *bohali* was immoral, he could hardly expect a 'refund' for the women he so emancipated. Women, if married to a polygynist, were also required to seek a divorce before they could be considered as candidates for the church. Upon divorce from customary marriage, both women and men surrendered all rights and obligations inherent in it. Moreover, a husband's claims over children born by his

wife and secured by *bohali* were forfeit in favour of the more 'natural' presumption that children should belong to the mother. A female convert thus ideally not only kept her *bohali* but her offspring as well. The missionaries also preached against the evils of alcohol to the point of suggesting that Christian women were within their rights to refuse to obey their husbands when ordered to brew *joala.*

As evidence of the benefits of conversion, the PEMS from the beginning possessed capable female missionaries who were welcome and indeed encouraged to speak up at church meetings, to write in the missionary journals, and to participate in the administration of mission affairs. The outspoken and self-confident public personae of the ministers' wives was quite intentionally supposed to inspire Basotho converts with the proof that 'women too had a mind that could understand, a soul that could be saved'.[10] This implied that girls should be equipped with literacy skills on a par with boys. Towards that end, classes for Basotho girls began at Morija in 1870. As early as 1890, this had led to the creation of a cadre of educated women who could meet the church's high standards of ability to read and independently interpret the Bible. On this basis, and given the persistent shortage of male converts, some of the more remote mission stations relied upon women for such responsible tasks as leading public prayers and evangelizing 'pagans'.[11] Young women were also prepared for professional careers if they showed the aptitude. In 1918, Laura Motebang, a graduate of Morija, became one of the first two African women to enter university in southern Africa.[12] By the late 1920s, Ellenberger proudly pointed out how in PEMS schools 'boys and girls, agriculturalists and sons of chiefs sat together obeying equally and for the first time the same rules and subject to the same discipline, all equal before God'.[13]

This remarkably liberal ethos was clearly attractive to the women who were marginalized in Basotho society. For junior or 'barren' wives and widows in particular, the mission's promise of dignity and worth in the eyes of God was compelling. Sesotho for these women could indeed mean exploitative labour, betrothal to a polygynist against their wishes, abuse, neglect and interference by husbands and male relatives, the tyranny of senior co-wives, or the shame of infertility. To a significantly greater degree than men, the PEMS offered such women a refuge from the oppressive aspects of custom. Hence, by 1898 fully 76 percent of PEMS members were female. By 1921, approaching a century of mission work that had been primarily directed at winning men to the church, women still outnumbered men by a ratio of over two-to-one.[14]

The second Protestant mission to arrive in Lesotho was the Church of England or Anglican mission in 1878. At first the Anglicans primarily catered to colonial officials, and as such were an obvious target for

anti-colonial violence during the Gun War. Yet after peace was restored, the Anglicans quickly earned a reputation for moderation, sharing many of the same assumptions about modernity and progress as the PEMS, while eschewing the Evangelicals' austerity. With relatively high quality schools close to the tiny urban centres, and with continuing close social and political ties to the colonial and merchant elite, the Anglican mission soon became the preferred church for socially ambitious commoners. Although it remained small – by 1936, just over 17 500 Basotho had been educated by the Church of England, or 3 percent of the total population[15] – it did help to consolidate Protestantism as the religion of the *batsoelopele*. Together with the PEMS, the Anglican mission was one of the main conduits into Lesotho for new technology, exotic animals and commercial crops, for Western, petty bourgeois consumption standards, and for modern ideas about society including women's emancipation from overt forms of male tyranny.

The modern ethos of the Protestants with regard to women's rights nonetheless remained rife with contradictions. Not only did embracing the Protestant vision often entail onerous risks for women, including social ostracism and violence by husbands and families who resented the loss of their female 'children' and the potential wealth they represented. The gains of 'emancipation' into the Protestant ethic were also far from self-evident. The emphasis on self-discipline, for example, created an atmosphere of repression and intolerance which was profoundly at odds with the more joyous and eclectic spirituality of Sesotho. Perhaps more importantly, for all their 'emancipation' Protestant women were still expected to be good wives and mothers first and foremost. In a general sense this undoubtedly commended the religion to most Basotho as commonsensical. Yet in several specific ways it could be intensely alienating and burdensome to female Christian converts. Educated women, above all, were heavily burdened by the missionary obsession with taming the Mosotho male. Long into the twentieth century, the attitude persisted in the PEMS that Basotho men were possessed of an 'exasperating', childlike impetuosity ('nearly always so contrary to what we call common sense').[16] This quality supposedly made them prone to drunkenness, violence and whoring, predilections which actually seemed to increase with higher education and the stress of alienation from the wider community. For the PEMS, therefore, the attentions of a suitably polite, domesticated and conversationally adroit African female were essential to advancing the causes of sobriety and civilization among educated men. This was, in fact, quite explicitly the logic behind admitting women to Fort Hare.[17]

As preparation for the onerous task of 'taming' the Mosotho male, the first PEMS school for girls focused almost entirely upon cultivating 'the

womanly arts' of 'housecraft'.[18] Thus, notwithstanding lessons in literacy and ideals about emancipation, Protestants maintained a profound bias against female intellectual development. Education beyond domestic basics was regarded as a positive liability, 'a curse rather than a blessing', in the words of one Basotho girl's first Anglican teachers.[19] The curse centred on the extent that education rendered women discontented or incompetent at their 'traditional' domestic tasks.[20] In 1935, the headmistress of the PEMS Thabana Morena Girls' School lamented the 'fatal tendency' of educated girls becoming so 'proud and conceited' that they resisted manual (that is, domestic) labour intended to improve their ability to service their future husbands' needs.[21] For the educated Basotho woman the mixed message meant that she should always regard her literacy or other achievements as subordinate to her principle vocation: housework, raising moral children, and offering the kind of demure companionship and desire for material goods which would restrain her husband's wilder instincts.

Protestant expectations of Christian women's roles were in some ways actually more narrowly focused upon husbands and children, more pressing in responsibility, and less tolerant of social autonomies and sexual 'indiscretions' than Sesotho. The fury that PEMS men could unleash against women who interpreted emancipation otherwise could be most dramatic. Not only could such women expect summary excommunication from the church, but also public shaming in the most strident terms. Emille Rolland, a PEMS stalwart who became a magistrate in the first colonial regime in the 1870s, demonstrated this fury against a Mosotho woman who had dared challenge his vision of modern gender relations. Her principal 'crimes', it appears, had been to refuse to remain shackled to an abusive husband and to use the courts to advance her own independent interests:

> I notice with severe blame the remarks and manner of the Defendent Makubutu who has in open court charged the magistrate with being the persecutor of a widow woman . . . It is highly unbecoming of her to crow in the manner she did . . . and amounts to contempt of court, for which, if she were not an ignorant woman and beneath contempt she would be punished. She should remember that she is a miserable harlot . . .[22]

The contradiction between Protestant ideals of meritocracy on the one hand and domestic subordination and dependency upon their husbands on the other was sometimes difficult to swallow, even, as time went on, among the European missionary women who preached it. A telling insight into this contradiction is revealed in the words of Suzanne Christeller, an unmarried teacher at the PEMS Housecraft school at Cana:

The life of a housecraft school is made up of a lot of small, mono-
tonous things; sewing, cooking, keeping house; keeping house, cook-
ing, sewing, and then (perhaps more than any other school) the
fatigue that comes from always having to demonstrate once
again . . . One starts anew, with a fist in one's pocket and a smile on
one's lips . . . I whiled away the tasks of each day by running over
melancholy thoughts. 'Are you going to fill your life passing your
finger along the mantle to see if it was well dusted and to twist your
spine trying to discover some grains of dust under the piano? Poor
you! Here you are yoked to housework without even having the
compensation that other women find in a husband.'[23]

For all its sometimes radical claims about the need for women's eman-
cipation, the PEMS clearly enforced both a glass ceiling on women's
advancement to equality with men and glass walls around their 'respect-
able', domestic femininity. Lesotho did not, of course, possess a fem-
inist lobby at the time to point out this contradiction. Basotho women
seem, however, to have been on the whole acutely conscious of both the
high risks of joining the church and the dubious returns. Thus, although
it is true that more women than men became Protestants, overall the rate
of conversion remained a trickle throughout the nineteenth century.
After ten years of evangelical work, the PEMS could claim only 151
baptized members. Three decades later (1871), that number had risen to
approximately 2 000, still scarcely 1 percent of the total population.[24]
Moreover, even among this small number, secret dissent against PEMS
dogma was expressed by 'progressive' women in a number of ways. A
common practice was to insist upon marriage with cattle in addition to
the proper church ceremony. Families of the groom minimized the risk
of excommunication by herding their beasts to the bride's family after
sunset, hence the term 'Twilight Christians'. Judging from the debates
which took place in the early 1950s, when the PEMS finally dropped its
dogmatic opposition to *bohali*, these appear to have been the majority of
church members. A majority may also have been privy to an even more
secretive institution, the *Thapelo ea Sepiri*. This was a church within
the church which as early as the 1890s was rumoured to be holding
night-time ceremonies. In them, respectable Basotho converts meta-
phorically let their hair down with boisterous singing, dancing, drum-
ming, animal sacrifices and other rituals more in keeping with traditional
spirituality. The majority of members were women. Suspicions about
their activities and the sentiments which gave them life may well have
been behind the periodic dire warnings by PEMS leadership against
resurgent paganism.[25]

2.2 Catholic patriarchy

The first Roman Catholic missionaries arrived in Lesotho in 1862. They belonged to the Oblates of Mary Immaculate (OMI), an ecclesiastical order which had been established three decades earlier with a mandate to evangelize the poor (*'oblatum'* in Latin means 'gift'). Like the PEMS missionaries, they hailed from France, bringing with them the long history of sectarian rivalry in that country. Indeed, the OMI immediately launched an aggressive campaign to win converts among Basotho 'pagans' and also to undermine the achievements of the PEMS – 'Calvinists', 'Huguenots' and 'heretics' in the eyes of the Catholic fathers. Their first mission, at a place they called Roma, was closer to Moshoeshoe's capital than was Morija, and their efforts to win the aging man to their cause were relentless. Although they did not succeed in converting Moshoeshoe, they did lay the basis in their first few years for a lingering bitterness between the two major missions in Lesotho.[26]

Despite this competitive attitude towards the gathering of souls, and despite fundamental theological and philosophical differences with the PEMS, the OMI did not at first particularly distinguish itself from Protestantism in its social and economic views. Like their 'Huguenot' brethren, the Oblate missionaries brought with them from France a strong European chauvinism and petty bourgeois condescension for peasant culture. Father Gérard, for example, denounced Sesotho in such terms as 'depravity', 'stupidity' and 'savagery', and was absolutely intolerant of beer-drinking, polygyny and marriage-by-cattle. Not surprisingly, he won few converts outside a handful of widows and disgruntled junior wives.[27] Even among the exceptions, such as Moshoeshoe's niece, the Oblates suffered discouraging setbacks because of their refusal to countenance manifestations of what they considered 'pagan' behaviour. Helena, the 'queen' of St. Michael's village, simply left the church when she was denounced by the priest for her pride.[28]

The Roman Catholic Mission (RCM) also at first alienated itself from the Basotho on account of its radically different and in some ways quite threatening ideas about sex. From the perspective of Sesotho, the requirement of celibacy for aspirants to Catholic religious orders was particularly bizarre. Voluntary abstinence from sexual relations for both men and women was considered physically unhealthy among the Basotho, while foregoing marriage was economically, politically and socially nonsensical. The celibacy rule was therefore a major obstacle in the recruitment of a native clergy. Where the PEMS ordained its first Mosotho minister in the 1880s, not until 1931 did a Mosotho first qualify as a priest. The celibacy rule in practice gave the mission a strong appearance of being racially discriminatory to ambitious Basotho.[29]

Strong, not infrequently violent, opposition to the church also came from families whose daughters sought to join the Catholic religious orders. The first of these (Sisters of the Holy Family) arrived from France within three years of the start of the mission. Although they did not actively recruit Basotho into the vocation, their very existence as unmarried women was a challenge to traditional patriarchy. Indeed, in their first year in Lesotho, the Sisters gave 'asylum' to girls escaping family pressure to marry against their will.[30] Such runaways not only threatened the principle of parental rule. In material terms, they also represented a loss to the family of the ten to twenty head of cattle which could normally be expected in *bohali* payments when the girl got married. Well into the twentieth century, cases occurred of girls absconding to convents only to be forcibly abducted by their male relatives, not least of all brothers who needed their *bohali* in order to get married themselves. Adding to hostility to the church among aggrieved families, such runaways did not always take the prospect of abduction lying down. Some hid or successfully appealed for mercy while others fought back. Sister Corsini, touring the mountains in 1947, noted with approval one girl's use of weapons to defend herself and drive her would-be abductor away.[31]

Sensational as they were, such cases were in fact extremely rare. Moreover, in other ways the RCM quickly began to distinguish itself as less threatening to Sesotho than Protestantism. As such, it began to attract a slow but steadily growing number of converts in the late nineteenth century. Crucial to this growth was the softening of the first missionaries' hardline against certain Sesotho practices. Most importantly, in 1888 the RCM adopted the position that *bohali* was not a sin as long as the traditional wedding ritual was accompanied by a proper church ceremony as well. This change in attitude arose from the recognition that *bohali*, though 'pagan', actually aided a key Catholic goal. Divorce was anathema by Catholic dogma and its rarity among the Basotho was attributed to *bohali*. Father Gérard, a founding member of the mission, was actually disciplined by his superiors for maintaining too unbending an attitude towards this aspect of 'pagan' life.

The Catholics also adopted a more tolerant – enemies said indulgent – attitude toward polygyny. Although the RCM adamantly denounced *sethepu*, it welcomed the wives of polygynous men without demanding that they divorce first (which is what the PEMS did). Rather, the mere act of profession of faith was taken as a *de facto* annulment of marriage to a polygynist.[32] The RCM even baptized polygynists themselves provided they promised to cease cohabiting with junior wives. It was widely believed that the church turned a blind eye to breaches of such promises, especially among important chiefs.[33] In other ways as well, the RCM was accommodating to important Sesotho beliefs and practices. The first

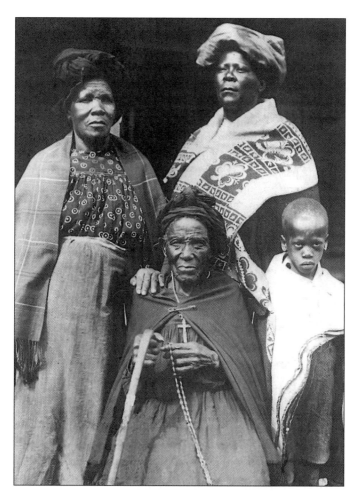

*The woman in the foreground centre is probably Lihlong or
'Ma-Gabriel, one of Moshoeshoe I's granddaughters and one of
the first two converts to the RCM in 1864.* (Deschatelets archives)

Canadian bishop, for example, Gérard Martin, declared in 1934 that
women's 'superstitions' surrounding birth, especially the ban on the
father's attendance, were on the whole beneficial to the women.[34] The
RCM attitude towards the brewing and consumption of *joala* illustrates
another such instance. Provided it did not lead to excessive drunkenness,
the Oblates regarded *joala* as contributing to social cohesion. As such,
they may at times have actually encouraged women's brewing, especially
to mark festivals and church celebrations. PEMS missionaries noted with
disgust that malt, used almost exclusively in the brewing process, was one
of the biggest selling items in the Catholic cooperatives in the 1930s.[35]

Perhaps the clearest recommendation of the RCM from the perspective of Sesotho, however, was its more overtly patriarchal expectations of women's proper role in society. The Protestants, while they shared the assumption that a woman's primary role in life was as a mother and companion to her husband, also valued and encouraged female literacy. The RCM, by contrast, had little interest in women's brains. In the view which predominated in the mission right up until the 1950s, female souls would not be saved, indeed may even be endangered, by undue intellectual enquiry. Moreover, the RCM had no need to provide genteel companions for its male graduates who were, after all, intended for a life of celibacy. The pinnacle of achievement for a lay Catholic woman was therefore neither to be a civilizing influence on an achievement-oriented husband nor to possess an independent career. Rather, fully in keeping with Sesotho, Catholic patriarchy envisioned the ideal woman as a prolific breeder and competent mother. Bishop Bonhomme, in his blunt way, described 'to be fecund' as a family 'obligation' in his sermon to the mission in 1941.[36]

Such education as was offered to girls was consequently almost entirely utilitarian. The first Bishop, Jean-François Allard, argued in 1864 that a Catholic education for girls should teach them to clothe their future families without having to buy from the European-owned shops. Girls could also be taught how to prepare wool so that it could fetch fair prices (rather than selling raw wool to the traders at exploitative prices).[37] A dutiful wife and mother could also increase subsistence production. By making the home attractive, she could keep her husband rooted to the family where he could help with farm production and to discipline the next generation of yeomen farmers, his sons.

In this approach to education, for both girls and boys, the acquisition of literacy was under-emphasized or even neglected. In his submission to the Sargant commission on education in 1905 Bishop Cenez actually requested the government to 'décharger' (reduce or dismiss altogether) its literacy programme for girls.[38] Even as late as the 1940s literate Catholics were dissuaded, and in some cases outrightly forbidden, from reading the PEMS translation of the Bible for fear that they might misinterpret it. Bishop Bonhomme reiterated this ancient attitude in the baldest of terms in his circular to the mission in 1942: 'Ignorance is preferable to error.'[39]

As a direct result, the RCM was slow in developing a serious commitment to academic education. Until 1910, it lagged behind even the much smaller Anglican church in the number of schools it operated. Its academic standards were also notoriously poor. This was due in part to the fact that many of the Sisters to whom primary education was largely entrusted were francophone and could themselves barely speak English. They simply refused, when pressed after stinging criticism by both the

government and the mission hierarchy, to teach above the level of Standard Four.[40]

This relative disinterest in offering quality academic education gave early rise to the strong alignment in Lesotho between class and church, the 'educated elite' being almost entirely Protestant. Some ambitious Catholics risked excommunication to send their children to better Protestant schools, and this in fact belatedly stimulated the RCM's drive to improve its school system in the late 1940s. In the early period of the mission, however, the RCM's low educational standards may have actually met with approval among many Basotho. For girls, the RCM's inability or disinclination to teach more than simple, domestic and practical skills was certainly a positive attribute.[41] For boys, meanwhile, Western-style education was frequently seen by Basotho as a liability: 'Many people have educated their sons but these sons are the most useless, mannerless and they are worse than those who have not been educated. Most of them wander about and are drunkards.'[42] In that sense, once again, Catholic education was less of a danger to customary gender and class relations than that offered by the Protestants.

Even the nuns began to win trust among the Basotho through their indefatigable work, their unassuming humility, and their public deference to male authority. Nuns moved among the people to proselytize by word and deed. They could be seen on horseback, wending their way up to the remotest villages, or labouring in the fields of the poor they visited. Much of the nuns' work was charitable and involved the practical demonstration of solidarity with the poor by, for example, helping widows to set out a garden. Moreover, the Sisters were able to recruit Basotho women to the vocation much earlier than the priests and Brothers were able to recruit Basotho men. By the time the first Mosotho priest was ordained, there were already sixty-five Basotho nuns, almost as many as Europeans.[43] What Ian Linden has noted in a very similar situation in Nyasaland seems to have been true of the RCM in Basutoland as well. Nuns, by definition free of ambition for themselves or husbands and sons, gave the Catholics 'an important advantage in evangelization by working through the female population and its leading women'.[44] The gender imbalance in the churches is suggestive in this regard. All Christian missions reported significantly more women than men in their congregations. Yet, whereas 60 percent of the pupils who had been educated in PEMS schools were female in 1921, the comparable figure for the RCM was 72 percent.[45]

The Catholic vision of economic and social development also contrasted increasingly sharply with the Protestant vision of *tsoelopele*. In the early twentieth century, *tsoelopele*, through individual hard work and the trickle down effect of capitalist enterprise, seemed to hold real promise for the Basotho. Despite growing land shortages and soil destruction in

A Basotho Catholic nun. (Deschatelets archives)

the lowlands, exports of wool and mohair were booming and prices on the world market for Basotho commodities were exceptionally high. Basotho with an entrepreneurial spirit, of whom there were plenty, stood to make good profits from commercial agriculture, wagon transport and the sale of crafts. On the seamier side of free enterprise, women had 'lucrative' opportunities for the sale of sex, domestic comforts and home-brewed liquor in the camps and locations of South Africa. Many of these women invested their earnings in the education or upward marriages of their children in the hope that the next generation would be better placed to enjoy the ripening fruits of *tsoelopele*.

The RCM in Lesotho had never favoured progress in these terms, nor the development of a 'progressive', capitalist elite. In its view the latter had long been associated with liberalism, 'that baneful doctrine' in the words of Pope Pius IX at the turn of the century.[46] Capitalist 'progress' in Catholic eyes unavoidably intensified conflict between rich and poor while class conflict in turn generated atheistic, materialist, or exaggerated nationalist political movements and violence. The RCM in Lesotho sought to avert these tendencies by fostering a 'yeoman' as opposed to 'progressive' farmer class. This Catholic peasantry would be kept honest – and undifferentiated – by a redistributive leadership with roots in the

community. The RCM therefore had no basic quarrel with either communal land tenure or the traditional chieftaincy. Rather, it saw these as essential bulwarks against the proliferation of acquisitive individuals who would dispossess and exploit the mass of the peasantry and necessitate, in the process, increased levels of male migrancy and all the evils associated with it.[47]

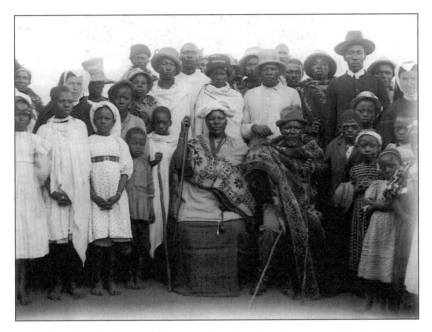

At the baptism of a 'powerful sorcerer' and family who converted to the RCM in 1917, soon after that other big 'catch', Paramount Chief Griffith Lerotholi.
(Deschatelets archives)

The breakthrough for the RCM came in 1912 when Chief Griffith Lerotholi converted to Catholicism. He became Paramount Chief the following year and from that position used his authority to facilitate the church's expansion, sometimes in controversial ways. Many lesser chiefs subsequently converted to Catholicism. Whether they did so under pressure from, out of fear of, or to curry favour with the Paramount, the fact remains that they invited the RCM to establish its presence and to propagate its vision throughout the country. In the next two decades, over one hundred Catholic schools were opened, some provocatively within well-established Protestant districts, but many in the hitherto largely unevangelized highlands. Here the Catholic vision found a receptive audience, particularly as economic conditions worsened. The number of

Catholic adherents rose nearly eightfold over this period, while Basotho Catholics, so declared to the census-takers, surpassed Evangelicals for the first time in 1936 (112 000 to 87 000).[48]

2.3 Conclusion

Although a small and often bitterly divided minority prior to the 1930s, Christians in Lesotho had an influence upon the development of the economy and society which was disproportionate to their numbers. Perhaps most importantly, the differing visions of what constituted 'progress' and what was to be valued most in a Christian community led the different missions to concentrate their proselytization efforts upon different social classes – commoner *batsoelopele* in the case of the Protestants, and chiefs in the case of the Catholics. As we shall see in subsequent chapters, this alignment was to have enormous ramifications for Lesotho's political development. The differing gender ideologies of the churches also introduced new role models and arguments for Basotho women. For all their contradictions, rival Christian ideals could be employed by Basotho women to renegotiate customary roles in ways which, again, had profound repercussions upon the development of the colony.

Class formation and the emergence of racial capitalist patriarchy

Cash, and the values which tend to accompany it, began to flow into Lesotho about the same time as Protestantism, but with considerably faster and more widespread acceptance. Moshoeshoe had originally forbidden the PEMS from paying wages to its Basotho employees for fear that cash would undermine *hlonepho* among his subjects. However, both he and the lesser chiefs quickly realized the potential of cash to enhance chiefly power and the security of the nation. The latter was of increasingly urgent concern as white settlement encroached first upon surrounding territories and then upon Lesotho itself. It was not just Boers and their Griqua allies who hived off land, stole cattle, and raided for slaves. The British also briefly invaded Lesotho in 1850–51. Although they subsequently withdrew, the consolidation of British power at the Cape and the expansion of its international market-oriented economy continued apace. The defeat of the Batlokoa, their dispossession by British settlers, and their return to Lesotho as dispirited refugees in 1857 sent an especially clear signal to Moshoeshoe. Unless the economic transformations taking place around Lesotho could somehow be harnessed, they could engulf or destroy the nation.[1]

Despite their initial fears about the disruptive effect of cash upon the body politic, therefore, Moshoeshoe and his fellow chiefs were subsequently instrumental in abetting the organized flow of young men to find waged employment in the neighbouring territories. Basotho men, largely idle during the agricultural off-season, first began to appear as individuals on farms and to provide domestic service in the Cape as early as the 1830s. By the 1860s, chiefs were organizing parties of their *bahlanka* to travel abroad. In 1866, over one thousand Basotho men passed through the Newcastle district on their way to jobs in Natal alone. The discovery of diamonds in Kimberley the following year then caused the number of migrants to swell enormously. Chiefs and the men themselves were attracted by the relatively high wages that could be earned in Kimberley and also by the ease with which Africans could purchase weapons there.

The migrants returned home with guns, horses, cattle and other livestock, ploughs, consumer items, and cash, 'donating' a portion to their chiefs.[2]

Cash also began to flow into pre-colonial Lesotho as a result of the export of grain. Again, while the PEMS heartily approved of the commodification of agriculture (and portrayed it as a response to their civilizing influence), the thrust of this process came from non-Christians encouraged by their pagan chiefs. By the 1850s, when there were scarcely a few hundred Christians in the entire territory, Basotho farmers had expanded the production and sale of agricultural commodities to such an extent that white settlers in the Orange River Sovereignty were dependent upon them for their grain needs.

These economic changes gave rise to new forms of class and race conflict which in turn created both new opportunities and new dangers for the Basotho in the negotiation of gender relations. This chapter examines how the extension of commodity relations unfolded over the period up to the crisis of capitalism in 1929, and the consequences this had upon Basotho society.

3.1 The role of Basotho women

Basotho women played an important role in Lesotho's engagement with the market economy from the mid-nineteenth century. They did so both directly, through their predominant input in the agricultural labour process, and indirectly, by urging their husbands to invest in ploughs. Ploughs were then used to expand the area exploited for commercial production and increase the earnings of Basotho men. To the satisfaction of Cape Colony officials in the late 1870s, African women were refusing to marry unless their prospective grooms possessed a plough and could show that they knew how to use it.[3]

Eldredge has argued that Basotho women's openness to new ways in this regard can be partially explained by their structural vulnerability. That is, if women were often the keenest proponents of new technology, crops and livestock (such as donkeys and pigs), this was because they were often the first to starve in times of famine. Agricultural innovations could raise the general prosperity of the household or could provide an independent source of food and so protect them from famine or neglect. At the same time, women also directly embraced opportunities to earn cash and barter goods independently of men. Thus, by the late 1870s 'a lot' of women were gathering every morning at the doorstep of administration officials in the 'camps' to barter cow dung, pumpkins and other produce.[4] By the turn of the century, the grain exported from the country was brought to the border trading centres and mills by 'troops' of women and was 'principally sold by women'.[5] Entirely new options also arose to earn cash as the number of trading posts, 'pro-

gressive farmers', and large-scale stock-owners in the country in-
creased. By 1911 there were fifty-two women 'herds' and twenty-five
years later, over eight hundred women engaged in the poorly-paid but
unequivocally masculine task of herding.[6] By the early 1920s, women
were portering forty- to fifty-pound loads of trade goods to isolated
mountain stores. In this way they could earn three shillings for a day's
work, excellent wages at a time when twenty shillings was considered
adequate for a month's salary.[7]

The spread of cash throughout the country removed one of the main
physical barriers to women's accumulation of wealth. Unlike cattle,
cash could be carried in one's pocket or between one's breasts. Also
unlike cattle, cash lacked long-standing cultural prohibitions against
female ownership. By its very nature, therefore, cash opened an array of
non-traditional avenues for women to escape from or to renegotiate
patriarchal controls. Cash could not only provide a hedge against fam-
ine, but was significantly more effective than either colonial law or
moral obligations in protecting women against male abuse, neglect or
economic incompetence. As early as 1876, a woman is reported to have
earned enough cash by selling needlework in the Orange Free State to
pay off her husband's debts.[8] Throughout the period of Cape rule,
women also used cash to buy property (normally in their eldest son's
name), to buy cattle for their sons' *bohali*, to refund the *bohali* paid to
their families in order to escape an abusive husband, to finance court
cases, and to acquire 'brooms' (*mafielo*, either junior wives for their
husbands or, if they were widowed, 'wives' of their own).
'Ma-Mathetsa, with savings from hawking in the Cape, acquired the
means to legitimize her own marriage and to 'buy' her husband (and
herself) not one but two junior wives as well.[9]

Basotho women also played an important role in urging men to put
their cash earnings towards the acquisition of arms, especially after a
series of disastrous conflicts with the Orange Free State in the 1860s. War
and related famine, as well as the experience of earlier British duplicity,
made it abundantly clear to the Basotho that household, as well as na-
tional security required strong defenses. Even after Moshoeshoe pur-
chased peace in 1868 by requesting British military protection, and after
the return of good rains and the opening up of the Kimberley labour and
grain markets brought renewed prosperity, Basotho prepared for the
worst. Sensibly distrustful of the assurances of the new Cape administra-
tion, for example, Basotho women not only urged their sons and hus-
bands to leave for work at the mines, but joined in the public mockery of
those who returned without guns in hand. According to one account of
the return of such a group of unarmed migrants in 1881: 'the whole party
were scoffed at by men, women and children, and exposed to all kinds of

indignities; in fact were expelled from what was considered "respectable" Basotho society'.[10]

Notwithstanding this influx of weaponry and its potential to strengthen the powers of the most reactionary elements of the chieftaincy, the new colonial administrators and PEMS missionaries alike had good reason to be satisfied with the Cape Colony's new territorial acquisition. The Basotho paid their first poll tax (1872) entirely in cash. In that year, an estimated 15 000 men left the territory to work in Kimberley, while grain production and exports surged. Ploughs, wagons, harnesses, and other items poured into the country in return. Indeed, so robust was economic recovery in the 1870s that European observers confidently assumed that loyalty to pre-capitalist authorities and mores was quickly withering away. They believed that a new and more profound loyalty to Britain was arising in its place with the diffusion of cash and the rise of unambiguously pro-capitalist, pro-British *batsoelopele*. Hungry for British-manufactured products, appreciative of the 'dignity of labour', and weaned from 'native sensuality', this emergent capitalist-oriented Basutoland augured to be the model for the 'civilization' of Africans throughout the region.[11]

This rosy perception remained true even after the embarrassing and costly setback of the Gun War of 1881–84. In taking up arms against colonial authorities in this war, large numbers of Basotho rallied behind their traditional chiefs, destroyed Anglican missions, attacked *batsoelopele*, absconded from their contracts in Kimberley, and otherwise behaved in the most 'uncivilized' manner. The Cape administration was expelled and ultimately replaced with rule from the British Colonial Office. The new regime made no secret of its desire to accommodate the most reactionary segments of the population at the expense of progressive elements if necessary. Even so, once peace was restored the Basotho quickly regained their reputation as 'the Jews of South Africa',[12] meaning, people who valued rational business calculation over ancient custom or savage passions. Basotho wagon drivers and their ponies were much sought after by Europeans, and they comprised an important element of the Pioneer Column which occupied Mashonaland in 1890. During the Anglo-Boer War of 1899–1902, the Basotho also sold their transport services and animals at lucrative wartime prices. Notwithstanding the government's effective abandonment of earlier ideals of assimilation to the Protestant ethic, Lesotho at the turn of the century had (in the view of the Resident Commissioner) 'the truest form of riches, viz that which lies in a multitude of contented taxpayers, who tender their dues of their own accord, and in the individual propriety of the masses who possess all they require'.[13]

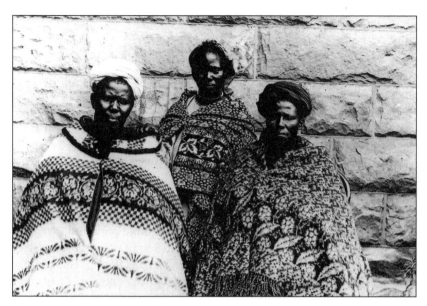

Respectable matriarchs. (Deschatelets archives)

3.2 The reversal of economic fortunes

Lesotho's initial phase of relative prosperity through the embrace of cash and capitalist relations of production did not last long. As a matter of fact, even before Lagden's glowing account was published, the 'granary' of the Free State began to suffer what later developed into chronic food shortages. By the early 1920s, the number of men away at labour centres in South Africa had not only far surpassed the level deemed safe and consistent with social harmony (approximately 16 percent of the total male population, versus the 'recommended' 5 percent),[14] but they were staying throughout the year, year after year, their labour power permanently removed from the internal economy. Meanwhile, as the population grew, new villages were established in areas hitherto reserved for seasonal herding. Exceedingly fragile mountainside soils felt the plough for the first time while delicate pastures were gobbled up and trampled by the burgeoning herds. Weeds proliferated as the soil eroded, often in sudden, gruesome gullies. By the 1930s, this irreversible environmental damage contributed to famine, the spread of hitherto unknown poverty-related diseases, and consequent social breakdown. Combined with a nascent anti-colonial movement, it made the once model territory an increasingly acute embarrassment to the British. Far from progressing to capitalist prosperity under benign British guidance, Lesotho was underdeveloping to a degree that was apparent to all.

In interpreting this dramatic reversal of economic fortunes, historians have tended to emphasize Britain's low level of investment and a 'laissez-faire' attitude to its colony during the period of indirect (or parallel) rule after 1884. In this way the imperial power allowed the most egregious tendencies of the free market to work their magic, notably, that the rich got richer and the poor poorer through short-sighted plunder of resources. I should not like to dispute this. Indeed, even the chiefs themselves conceded that British policy had the effect of turning them from fairly effective redistributors of wealth into sometimes avaricious accumulators.[15] However, I would also like to draw attention to a number of factors which have tended to be overlooked or understated in the 'development of underdevelopment' historiography. These are especially pertinent to understanding the parameters of gender struggle and Basotho women's unique perspectives upon 'progress'.

First, the wealth accumulated by even the most avaricious chiefs in the period of supposed laissez-faire paled in relation to the wealth drained from the country by the monopoly practices of the white trading community. Prior to the 1880s there had been many small, often itinerant, traders many of whom were Afrikaners and some of whom were Africans. The Gun War and the business tactics of the better-connected English traders served to eliminate most of these poorly capitalized men and women. In their place, the Frasers emerged with virtually monopolistic control over the commercial life of the nation, with most European traders, bankers, speculators and labour agents corporatively linked and subordinate to that family.[16] This commercial 'bourgeoisie' (about 250 men by the 1920s) came to exercise an inordinate degree of economic power. Not only did they have the resources to buy out or co-opt their trade rivals, but, as 'the unofficial economic advisors' of the government,[17] they urged, and generally won, colonial policies favourable to their interests. For example, they were able to restrict tightly the number of trading licences available to Africans, limiting the Basotho to the least profitable itinerant or other restricted sales.[18] They brought pressure to bear to prevent 'Native Traders' from employing white clerks (who might 'unfairly' increase the competitiveness of Basotho entrepreneurs).[19] As the Catholic church and even the government were later to find out, the Frasers et al. were able to thwart the development of farmer and consumer cooperatives which might undermine their profits. Meanwhile, cheap foreign goods marketed by European retailers were 'flooding the place' and driving Basotho artisans out of business.[20] Production and even knowledge of indigenous crafts among the Basotho withered in the face of this racially-charged commercial onslaught.

While some members of the new trading elite took pride in their paternalistic concern for the Basotho, others had a nakedly exploitative

attitude which the government appeared to condone or even promote. Most painful in that respect was the requirement that the Basotho pay their taxes immediately after harvest (when the market was flooded and the price offered by the traders for their cash-crops was at its lowest). Many households were then forced to purchase re-imported grain, at inflated prices, in the lean months before the next harvest came in. Such practices made the chiefs, however corrupt, look good in comparison. Chiefs led popular boycotts against the traders on a number of occasions in order to win better prices for the produce of their people, as well as complained about trading practices in the Basutoland National Council, and Chief Joel insisted on allowing Indians to settle in Butha Buthe precisely as a means to break the European trading monopoly.[21]

Far from demonstrating a laissez-faire attitude, British administrators in this period consistently defended their commercial kith and kin. However, even they eventually admitted the damage that European traders were causing to the economic health of the territory. In the 1930s, legislation was specifically designed to protect Africans against the more exploitative practices of the traders. Yet two decades later officials still estimated that the Frasers et al. were costing the Basotho an estimated £1 million per year in excess retail prices, a sum which far exceeded both migrant labour remittances and 'development' expenditures.[22]

As for the chiefs themselves, it is indisputable that pre-existing tendencies towards the consolidation of wealth and power in fewer hands were exacerbated and transformed by Lesotho's particular engagement with capitalism and colonial rule. As early as the 1870s observers had already begun to note that chiefs were turning traditional rights and privileges towards the pursuit of personal financial advantage or indulgence to the detriment of their subjects' well-being and the wise use of national wealth. They were, for example, ordering *matsema* for cash crop production, using communal *lira* or *maboella* lands for personal profit, increasing or arbitrarily imposing court fines, and exploiting the labour of young men whom they compelled to migrate to South Africa. A great deal of the profits so obtained was allegedly squandered on alcohol, contributing to the abuse of justice and scandal at the chiefs' courts. As the Assistant Commissioner for Teyateyaneng observed in 1880, 'Most of the principal chiefs are drunk nearly every day and totally unfit to attend to the affairs of the tribe.'[23]

Whatever the actual extent of these practices before 1884, the Colonial Office certainly gave them a fillip thereafter. The Bakoena lineage in particular was able to consolidate its powers and expand its wealth – in people, in beasts, and in cash – under parallel rule. It did so principally through the practice of 'placing' a direct descendent of Moshoeshoe I over the chiefs of distant wards, demoting the latter from an almost

confederal relationship to the paramount chief to clear subordinates. For half a century the British condoned this practice so that, by 1938, fully twenty-seven of the thirty-two ward or principal chiefs were Bakoena. The trend towards inequality and the struggle among chiefs resulting in the creeping dispossession and impoverishment of non-Bakoena must be borne in mind in any discussion of 'the chieftaincy' as an institution.

3.3 The role of the Basotho chiefs

A further concession by the British to assure the loyalty of the senior Basotho chiefs (or 'Sons of Moshesh') came with the establishment of the Basutoland National Council (BNC) in 1903. Until 1938, chiefs held ninety-five of the one hundred seats in this advisory body. The BNC possessed no real powers but it did provide a forum for the senior chiefs to influence colonial policy in ways which protected or advanced their class interests. This they did by codifying the customs most agreeable to themselves (the so-called 'Laws of Lerotholi' first published in 1905). They also consistently vetoed liberal reforms which might have facilitated the development of a rival elite of commoners (such as the introduction of private property, or expanding the number of commoners allowed to sit in the council). The British were more than happy to indulge such obstructionism as it saved them from the embarrassing need to veto disturbing, implicitly anti-colonial *batsoelopele* ideas themselves.

So-called parallel rule also provided chiefs with entirely new means to enrich themselves. First and foremost, *marena* were given responsibility for collecting taxes. As an incentive to be efficient, they were allowed to keep 10 percent of the total take and encouraged to confiscate the cattle or lands of tax defaulters. The enticements to corruption in this system were rife. Notably, chiefs directly profitted by dispossessing widows (who by law did not pay tax) from one of the two fields to which they were entitled by customary right. The fields so liberated were given to young men, purportedly even boys as young as fifteen. The chief gained from his cut of the expanded tax base as well as any 'donations' which expressed the youths' and their families' gratitude. The fields and livestock of subjects, meanwhile, could now legitimately be 'eaten up' by chiefs as punishment for tax default, further to increase the wealth of the chiefs and their retainers. The chiefs' power to redistribute land was also used by some to appropriate the increased productivity of fields which had been improved by progressive agricultural methods and investment.

Such abuses only increased as the ability of commoners to resist chiefly exactions declined. Decisively important in eroding commoner rights was the growing land shortage. Population growth and soil degradation in particular reduced the availability of land and curtailed commoners' freedom to migrate away from a bad chief. Under such

conditions, the mere allegation by a chief of non-payment of tax threat-
ened a man and his family with economic catastrophe. The man therefore
had every incentive to bribe his chief to avert such a judgement. Reflec-
ting this, the customary practice of giving voluntary gifts to the chief
(which could be expected to be recycled when the chief in turn showered
hospitality upon his subjects) changed in nature to deliberate attempts to
grease the wheels of justice.

By these means some chiefs grew rich far beyond the limits of cus-
tom. Letsie II, for instance, caused some surprise when he died in 1913
and left £20 000 to his widow. Surprise turned to consternation over the
next two decades as ownership of livestock was 'tending to be in fewer
hands' and 'avaricious' chiefs neglected their moral obligations to sup-
port the indigent.[24] Moreover, along with wealth and avarice came ar-
rogance. Among the sons of chiefs, 'young bloods' showed a brazenly
exploitative attitude towards their subjects, including, allegedly, raping or
kidnapping young women with impunity.[25] By the 1930s such abuses
were rampant and had exceeded even the limit of official tolerance. The
'cupidity' of the chiefs was denounced by missionaries, the government
and vocal elements of the commoner population alike to be 'leading the
country to destruction'.[26]

The concentration of wealth and power in the hands of the senior
chiefs in this period was not only detrimental to the welfare of com-
moners. On the contrary, it also effectively displaced and impoverished
many lesser chiefs and headmen in the process. Minor chiefs (of whom
there were over a thousand by 1936) and their widows and junior sons
were in increasingly frequent cases reduced to begging simply to survive.
In contrast to the growing wealth of the Sons of Moshesh, the majority of
these men and women continued to live in modest and often radically
deteriorating circumstances. Many sought to resist the disruptive effects
of cash and parallel rule. So close to poverty themselves, they spoke out
about the plight of the poor, and particularly the poor women for whom
they were ultimately responsible. As male migrancy grew and poor
women comprised an ever-increasing proportion of their *de facto* sub-
jects, the lesser chiefs forwarded their grievances to higher authorities.
They did so with considerably more regularity and sympathy than either
colonial officials, missionaries, or even commoner associations. Indeed,
chiefs' harsh criticism of themselves for failing to meet their customary
obligations to women emerged as a dominant theme of the BNC debates
in the 1920s and 30s. This rarely translated into more sensitive policy, nor
did it compensate for the abuses of power perpetrated by some chiefs.
However, it does suggest that the lower echelons of the chieftaincy (at
least) remained in relative terms one of the most responsive institutions in
the country to poor women's grievances.

3.4 The rise of the *batsoelopele*

Capitalism and parallel rule also gave rise to an entirely new class of commoners, the 'middling class' of *batsoelopele*, also known as the *bahlalefi* ('wise ones') or *makhomacha* (the 'people in between' or 'dressed people').[27] As with the chiefs, ambiguities and struggles within this class had important implications for gender struggle. To begin with, teachers and ministers or evangelists comprised the bulk of this Westernizing, educated elite. However, the most successful among them (such as Thomas Mofolo) juggled careers with astonishing dexterity. Some were progressive (that is, commercial or export-oriented) farmers, some traders, some artisans, and some entrepreneurs in such businesses as butcheries, restaurants, and the transport of grain and people to South Africa. Some were all of these, simultaneously or alternatively. Although by the 1920s they came from all religious backgrounds, including a few Catholics and 'pagans', PEMS members were disproportionately represented in their number. They tended to cling to the assimilationist ideals of the Protestant missions – and the belief that hard work, thrift, and self-discipline would win them material rewards and respectability – long after these had become a source of wry amusement to colonial officials.

The progress of the 'middling class' was, as noted above, actively thwarted in the period of parallel rule by the white traders, by government reluctance to upset the senior chiefs, by colonialist racism, and by the policies of South African governments to which the Basutoland administration almost always 'kowtowed'. Indeed, after an initial burst of prosperity and optimism under the Cape regime, opportunities for the 'middling class' were strongly curtailed. As early as 1896, the Orange Free State erected tariffs to exclude Basotho grain, dealing a critical blow to progressive farmers who relied upon exports. This was followed by the decimation of livestock in the rinderpest epidemic of 1897. Employment and entrepreneurial opportunities within the territory also dwindled in the first decade of the new century as the white stranglehold on wholesale trade tightened. Few Basotho gained more than menial clerk work in the government while in the missions, promising candidates for responsible positions fell by the wayside ostensibly on account of 'moral lapses'.

As these frustrating tendencies became clear to prominent *batsoelopele*, they joined together to form a political association that would give voice to their grievances. The *Kopano ea Tsoelopele* or Basutoland Progressive Association (BPA) was formed in 1907. Through the BPA members politely pressed the government for reforms that would substantively recognize their achievements and aspirations. Above all, they sought securely inheritable land, a meritocratically-constituted advisory council, and even the abolition of the chieftaincy. The BPA also

argued that the cultural changes urged by the Protestant mission (such as an end to *bohali*) would free the productive energies of the people from the dead hand of the past. Members wrote eloquent letters to the press urging the government to take steps to end such 'barbarisms'. They also advocated the protection of widows and the expansion of education and legal rights for women.[28]

These campaigns, like the economic ambitions of the *batsoelopele*, came to little during the era of parallel rule. Rather, the cultural and political pretensions of the *batsoelopele* were commonly dismissed by the British with patronizing contempt. Those educated Basotho who most eloquently protested the imperial or racial privileges which the British reserved for themselves often met with outright harassment as 'Bolshies' or 'lunatics'.[29] Under such hostile conditions, only a very small number of *batsoelopele* succeeded according to their own terms of progress, including, we may surmise, the single Mosotho 'farmer' and the single Mosotho 'gardener' recorded in the 1911 census.[30] Only slightly less rare in that year were the twenty-one Basotho merchants, traders, general dealers and shopkeepers. By 1936, men in identifiably petty bourgeois occupations numbered only slightly more than five hundred. Together with a similar number of 'housewives', this amounted to less than 1 percent of the total population.[31]

The frustrations of the 'wise ones' with their progress in the circumstances of parallel rule contributed to fracture in their numbers. Reflective of this, a rival commoner association was established in 1918 by a school teacher and small shop-owner named Josiel Lefela. The *Lekhotla la Bafo* or the League of the Common People (LLB) adopted a much more strident tone in expressing its grievances than the BPA. It tended as a result to find its staunchest supporters among the lower ranks of teachers and civil servants, apostates or excommunicants from the Christian missions, displaced minor chiefs, widows and others of the 'middling class' most discernibly affected by colonial paternalism and the workings of racial capitalism. Like the BPA, its numbers never exceeded more than a few thousand.[32]

3.5 Cash and the 'peasantry'

The class and cultural transformations which accompanied the spread of cash also profoundly changed the 'peasantry'. Colonial census-takers and even more contemporary experts would have us believe that this class remained not only the vast majority of the economically active population but also its most stable component – 90 percent of Basotho were designated as 'peasants' from 1911 right up to independence.[33] A closer look, however, reveals that cash and colonialism abetted enormous differentiation within the rural population which the term 'peasant' obscures. A

closer look at the trends and nature of this differentiation is essential to understanding trends and the nature of choices available to women.

In the first place, where both subsistence and commodity peasant production had unquestionably been the norm up to 1900, in the first decades of the twentieth century only a dwindling number of so-called peasants could actually continue to support themselves in this way. The vagaries of the export market and land degradation combined with the rising expense of inputs needed to maintain fields with the result that agriculture or pastoralism alone lost economic viability. A small number managed to survive and a small number even to prosper by turning to new agricultural exports. For example, while the grain market had largely disappeared by 1900, and while the Basotho pony had been exported to virtual extinction in Lesotho, high prices for wool and mohair brought relatively easy profits to even casual sheep and goat owners. Yet here too, this new peasant option progressively disappeared as the quality and availability of land diminished. By the 1920s, peasant life in the sense of predominant dependence upon agricultural production within Lesotho meant growing poverty, nutritional disease and even starvation. Young male peasants in this specific sense had to wait longer and longer for their parents to get *bohali* and so to get a wife and so to get fields and so to get sons and social standing in the community. A small but growing number had virtually no hope of getting any of these by customary means. Some, rather than remain perpetual 'boys' at home, drifted to the nascent urban areas to eke out a living by begging, odd-jobs, and petty crime. There they became known as *likuata* (or 'squatters'). The first effort to enumerate them (1949), found that such landless 'peasants' within Lesotho accounted for over 7 percent of all households.[34]

For the majority of those Basotho who retained access to fields and livestock, peasant production was increasingly supplemented by wage labour. As early as 1903, a drought year, male migrant labour became a survival necessity rather than a consumer-driven option as it had predominantly been in earlier years. By 1921, border districts such as Leribe were sending nearly one in four males out to work at any given time, a figure which rose in the 1930s to one in three.[35] The ability of Basotho men to earn cash from a short stint in South Africa was meanwhile also steadily diminishing, bringing with it the necessity for longer and more frequent absences. After the 1913 Land Act in South Africa, for instance, tenant farming for the Basotho began to be reduced and conditions on the farms of the Free State in particular to deteriorate to the level of virtual plantation slavery.[36] Real wages at the mines were also relentlessly pressed downwards in this period. By 1922, they were a third lower than they had been in 1889. As a result, the average length of contracts among Basotho miners rose from three to nine months over

the period of 1900–30. Men who had formerly been absent during the agricultural slow season only were now gone even during peak labour times. A new type of migrant began to emerge as well: *sebhunu moroa*, those who turned their backs on Lesotho for years on end or simply never came home.[37]

The rise of this new class of men in the region – one foot in the cities and one foot in the countryside (or assumed to be in the countryside whether or not that was actually the case) – has been the focus of considerable scholarship. Inventive terminologies have been developed to describe it, including 'oscillating migrant labour', 'rural-based proletariat' and even 'peasantariat'. However, the specific ramifications for women of class formation along these lines need to be elucidated more explicitly than such androcentric terms imply. Notably, Basotho men's increasingly prolonged or even permanent absence steadily increased the workload for women to maintain the household and fields. In the absence of their male guardians, 'children' often had to make crucial decisions about planting, harvesting, children's behaviour and other aspects of family welfare. To this onerous responsibility was added the anxiety of possibly incurring a husband's or his relatives' wrath if they interpreted her independence and initiative as threatening. In addition, the absence of husbands exposed women to loneliness, the predatory sexual advances of other men (including chiefs) and to forced prostitution by husbands, relatives and other 'pimps'.[38]

Some of Basotho men's specific experiences and attitudes towards migrancy also had an impact upon Basotho women and gender relations among so-called peasants. For example, unlike most other Africans at the mines, the Basotho were never militarily conquered. They thus clung tenaciously to the erroneous belief that they were independent. As a result, the Basotho were among the most notorious of all the African workers at the mines for their sit-down strikes, mass desertions, and refusal to sign the long-term contracts favoured by the mining companies. Basotho men preferred to 'free lance' as much as possible. They were also most recalcitrant in accepting what they perceived as colonial encroachments upon their right to dispose of their wages as they themselves desired. One effect of this attitude was a studious resistance to colonial propaganda about the need to remit money home. In 1919 only 4 percent of the Basotho miners deferred their wages back to Basutoland compared to 31–72 percent among the other 'tribes'.[39]

By the early twentieth century Basotho men had established a reputation on the mines for exceptional skills, literacy and bravery. On the surface, they were sought after as 'readers', below, as 'shaft-sinkers'. Among the latter (who formed the majority) ability to withstand pain, to achieve feats of endurance, and to risk danger in the maw of the 'canni-

bal' (the mine) became a source of chauvinistic pride. Successful recruits loaded into trucks in the 'camps' near the border or entrained in Maseru, singing praise songs boasting of their masculinity and independence. To many, the journey to the mines became equated with *lebollo*, initiation into manhood. This equation did not escape the notice and condemnation of contemporary observers. *Batsoelopele* women and their husbands were particularly upset that the dignity of respectable Christians was constantly in peril on the trains to Johannesburg.[40]

Recent scholars have preferred to interpret miner machismo as a form of resistance to capital, an ideology which gave the men a sense of integrity in the face of often horrific working and living conditions.[41] Be that as it may, miner machismo also posed insidious dangers to the men and their families, perhaps no more so than by recklessly endangering their health. Partly due to the men's refusal to seek medical treatment for disease or injury until they were totally incapacitated and incurable, and partly due to their apparent preference for the most dangerous (and 'manly') work in the mines, Basotho men until 1938 had the highest mortality (and mutilation) rate of any 'tribe' at the mines.[42] 'Phthisis', a generic term which included tuberculosis and other pulmonary diseases contracted in the mines and hostels, reached epidemic proportions. In those days before pensions, the burden of workers' disability was passed directly onto the men's wives and mothers.

The specific conditions of labour and life at the mines did little to instil 'typically' proletarian ideas in the men. For example, prior to employment, men had to undergo degrading physical examinations, including *mothetho e moholo*, the greatest test. By this, youths and elders, the circumcised and uncircumcised, were forced to stand naked together while a white doctor examined their penises and anuses. After work, the men were locked up inside fenced areas and housed in dreary hostels with no privacy. There, probably beginning in the early years of the twentieth century, young men were coerced or bribed into homosexual servitude to their seniors. By taking young men as lovers and domestic servants, the senior partners protected themselves against entanglement with township women and against sexually transmitted diseases. By agreeing to be 'breathed upon' in this way, young men could double their earnings and so speed up their acquisition of *bohali* and a real wife. We cannot know just how much rationality actually entered into such decisions about sexual behaviour, nor how much homosexual experiences could be forgotten or repressed in later heterosexual relationships. It seems clear, however, that the practice of mine marriage was both a widespread, shameful secret and, as Harries and Moodie with Ndatshe have suggested, a significant brake upon the development of modern industrial consciousness and gender relations.[43]

Those men who ventured out of the hostels in search of women or alcohol in the townships were visible and vulnerable targets for professional thieves and jealous local men. To defend themselves, some formed gangs and cultivated fiercely criminal reputations. The 'Russians' (BaRashea) became especially notorious both for their violence against men of other 'tribes' and for their predatory, proprietary attitude towards women.[44] For others, work at the mines evoked an almost fatalistic, self-destructive escapism through alcohol and nostalgia for idealized 'traditions' of black male power and dignity. Contemporary observers throughout the region noted how this tended to have the effect – exploited by mining capital – that 'the hand of tradition weighs perhaps even more heavily in town than in tribal society'.[45]

Far from acquiring a progressive proletarian consciousness, the 'semi-proletarian' thus became renowned as the custodian of custom. One startling illustration of this occurred as late as 1961, three-quarters of a century after Basotho men had begun migrating to Johannesburg. The government, seeking clarification of customary inheritance laws, consulted the BNC. Admitting his uncertainty, one 'traditional' chief directed the Resident Commissioner to enquire of the miners at the Rand, 'the ones who love custom more than any others'.[46]

Paradoxically, the migrant labour system also combined with the monetization of the economy to break down customary respect (*hlonepho*) by the young for their elders within Lesotho. Cash, as Moshoeshoe had originally correctly recognized, by its very nature contributed to the growing autonomy and 'insubordination' of junior men. With cash in hand, for instance, a young man was no longer dependent upon his father or chief to gain *bohali*. With cash he could take a wife of his own choosing or reject an arranged marriage. As the average wait until marriage lengthened, impatient young men increasingly took recourse to *chobeliso*, or 'elopement' without paying *bohali*. Most young men mitigated the scandal by eventually paying the requisite *bohali* out of their own earnings from migrant labour. Some, however, simply absconded from the country with their new 'wife'. Others used force, even organizing gangs to carry out the kidnapping of their brides. By the 1930s, a quarter to a third of all marriages began in such scandalous ways.[47]

Colonial officials worried about the assertion of independence by young males. They were acutely aware that the breakdown of the tradition of *hlonepho* undermined the authority of the patriarchs upon whom parallel rule depended for what passed as 'stability'. At the same time, however, the government in its enthusiasm to maximize tax revenues actually encouraged young male rebellion. Any male who went to work, aged fifteen or even less, was deemed 'a man'. As 'men', they acquired legal rights hitherto unheard of for *bahlanka*, including the right to spend the

money they earned in defiance of their seniors' wishes. Moreover, if remitting back to Lesotho, they might send it to friends or their wives' rather than their parents as custom required. As access to cash became ever more crucial to maintaining even subsistence levels of production on tired and eroded fields, or to buy food and clothing, a son's failure to support his family could have disastrous consequences.

However much they sympathized with Basotho chiefs and parents in this regard, the British were unwilling to jeopardize the flow of migrant labour and taxes by imposing restrictions on the migrants' freedom to dispose of their wages as they saw fit. Indeed, a number of potential strategies to deal with the problem were simply ruled out of discussion from the beginning. It was the chiefs, for example, who first proposed that the government introduce compulsory deferred pay, ensuring that a portion of men's wages at the mines would be docked and automatically remitted to the family back home. 'Out of the question', the Resident Commissioner curtly informed them.[48] Even to exercise 'strong influence' upon the men to get them to remit more was 'quite impossible',[49] as was any interference in the labour and recruitment practices of either the Chamber of Mines or local recruiting agents. The chiefs, Basotho parents, and Basotho women were on their own and this showed in the breakdown of customary moral obligations to family and community.

In all, by the 1920s the emerging class structure was widely perceived as producing almost the worst possible combination of poverty and 'neo-paganism' among ostensible peasants.[50] The 'unquestionably bad' effects of migrant labour upon men's behaviour and psychology were noted in the Native Economic Commission in South Africa in 1930 and echoed in the Pim Report two years later.[51] Basotho elites clearly shared these views as well. Chiefs feared the semi-proletarian man and *likuata*, *batsoelopele* worried. While we should be cautious in relying upon elite views of unruly masses, it does seem safe to say that the specific circumstances of migrant labour for Basotho men engendered a crisis of meaning in their masculinity which was commonly expressed or resolved in anti-social ways. For Basotho women, this often meant having to cope with husbands and sons who returned from the mines full of anger, alienation, and shame, in addition, of course, to debilitating diseases or physical injury. As one visiting academic observed in the early 1920s, the influx of cash in this context had led to 'the marked growth of individualism'. The 'social bond of a common blood', he asserted with some hyperbole, 'seems to have largely broken up'.[52]

3.6 Conclusion

Cash and capitalism engendered profound transformations in the class structure, in the physical environment, and in the culture of the Basotho.

Initially, many people assumed that these changes were inevitable and for the best, stimulating production and the adoption of new technology. By the turn of the century, Basutoland was thus widely regarded as a model of progress and civilization for the region. Yet scarcely three decades later, even colonial optimists recognized a tarnish on this model: an exploitative white trader elite, increasingly corrupt senior chiefs, a high number of absent, alienated and violent or self-destructive men, a dispirited and potentially 'Bolshie' Westernized elite, a rapidly degrading environment, and an evidently inept government. It was a climate conducive to intense, bitter struggles over household resources and the women's labour that had hitherto been the mainstay of production and political stability.

Part Two

Women and the State

Colonial rule, 1868–1929

Basotho women were hardly passive witnesses to the many changes taking place in Lesotho before and during the first decades of colonial rule. As we have seen, they were the first to convert to Christianity, comprised the bulk of church membership, and in many ways enabled the missions to survive in an often hostile climate. They put pressure on their sons and husbands to migrate in order to earn cash to advance the interests of the household. They provided a major stimulus to the widespread adoption of the plough and other Western consumer items. There is also no reason to assume that girls were simply victims of changes in gender relations induced or abetted by the influx of cash. On the contrary, evidence suggests that girls themselves may have had a major part in the growing frequency of *chobeliso* (abduction), eloping with their lovers 'to throw their parents overboard and to have their own way'.[1] One Mosotho father who was defending himself in court in 1876 for the hasty way he had married off his daughter claimed to have done so in order to pre-empt her. As he put it, 'the modern girl' simply elopes or 'gets in the family way among the pots' to force her preference for a husband upon her parents.[2] Such an admission of female agency is all the more striking given that the Basotho normally assumed males to be at fault in cases of sexual transgression. To admit that a girl owned blame was to concede in public one's incompetence as a father and as a man. This is also implicit in Dieterlen's complaint in the 1880s:

> In former days a Mosuto's marriage was an affair arranged between his parents and his prospective bride's, without any one regarding himself bound to consult the young people concerned . . . [Nowadays the young people] have taken from our European customs only that which would be harmful to them, placing the accent on liberty . . . They have no thought but for their flirtations. They write love letters to one another, which are all stereotyped and which we look upon as unmitigated nonsense. They talk together, they make plans for the future, they see each other home, and then one fine day, the youth informs his father: 'I am grown up,' in other words, 'I am old enough to marry.' And in many cases the poor father thinks it is his duty to toe the line with his son and to say yes and amen to whatever the two lovers may have organized.[3]

Neither such individual acts of rebellion nor women's embrace of cash, new technology and new forms of production fundamentally tipped the gender balance of power. They also did not necessarily guarantee economic security or respite from hard labour. Women's workload, in fact, generally increased in the late nineteenth century as the plough expanded the area under cultivation for which women were responsible. Moreover, men retained ultimate control over income and decisions about investment or production. Much of the surplus created by women was thus invested by their husbands in technology which reduced male labour. Reflecting this, thousands of ploughs were imported to make a traditionally male job easier, while the harrow, a tool which would have reduced women's labour time weeding, was hardly imported at all.[4] The cash earned by women's increased production was also disproportionately spent on consumer items of interest to men, some of which increased women's household labour into the bargain. European clothes, for instance, relieved men of their traditional task of sewing (skins) while burdening women with laundry (cotton). And while girls may have asserted more choice over whom they wished to marry than in the past, this did nothing to alter the heavy expectations upon them as wives and mothers.

Against this background, a small but ultimately influential number of women seized upon the opportunities offered by the introduction of colonial rule in order to enhance their security and to press for new freedoms and rights. This chapter examines how, over the period from 1868 to the late 1920s, Basotho women of diverse classes and religious beliefs found in the state an ambivalent ally in their struggles. It examines how, in particular, women both enlisted the power of the new courts directly, and invoked novel combinations of colonial law and Sesotho custom. The role of women and gender in the collapse of the first colonial administration and the restructuring of the state on more explicitly patriarchal lines thereafter are also considered.

4.1 Cape rule, 1868–84

When Basutoland was first declared a protectorate in 1868, social policy in Britain and its established settler colonies was imbued with a strongly interventionist spirit. The belief was that the state should play a direct role in 'bettering' the unruly lower classes at home (and analogous heathen hordes abroad) by, for example, public schooling, social welfare, and moral edification. In the case of Africa, certain specific 'evils' required state attention to eradicate, and were cited to justify the risks and costs of extending colonial rule: the slave trade, the lack of a capitalist work ethic, the belief in sorcery, the tendency towards autocratic rule, and the oppression of women, to name the main ones held to be prevalent in African

societies. Phasing out these perceived evils by the state-backed application of culturally assimilationist policies was widely accepted to be the most efficient and 'humanitarian' way of promoting successful colonial rule. By happy coincidence, it would also result in Britain's own material gain. That is, an assimilated or 'civilized' African population would constitute a lucrative market for English goods. From the perspective of the Cape Colony, an assimilated African population would stabilize the frontier and ensure a disciplined labour force for the production of export commodities.[5]

In the new colony of Basutoland, where there was no slave trade, where there was a relatively democratic political culture, where the smelling-out of witches had already been banned by Moshoeshoe decades before, and where the peasantry was demonstrably, eagerly profit-responsive, the administration latched upon the oppression of women as the major obstacle to the assimilationist enterprise. Heavily influenced by the PEMS and other Protestant missionaries, the new government perceived Sesotho as retrograde in this respect, impeding in particular the development of a modern ('civilized') masculinity. Women's emancipation from traditional controls and 'superstitions' thus became one of the principle focuses of state policy. The logic went as follows: Christianized women upholding or aspiring towards European standards of propriety and comfort would demand cloth and domestic wares imported from England. To acquire these accoutrements, African men would have to go to work for wages in a disciplined manner, something they were otherwise uncooperative about. Polygynists, meanwhile, would no longer be able to rely on their many wives to sustain their supposedly slothful lives. African boys would also be better socialized for wage labour in Christian, monogamous, nuclear families. African girls, inculcated with an abiding fear of sex outside marriage and dedicated to the domestic and sexual satisfaction of their legal husbands (only), would be their prize. In Comaroff's irreverent phrase, the Cape ideal of assimilation involved 'upward mobility for men, upward nubility for women'.[6]

The first High Commissioner to assume jurisdiction over Basutoland, Sir Philip Wodehouse, was influenced by the recommendations of the PEMS missionary Emile Rolland. Rolland advised Wodehouse in a long memorandum that the new colonial government could best advance its interests in the territory by launching an all-out assault upon the power base of the chiefs, namely, their control over women through cattle.[7] Wodehouse's temporary regulations for the new colony, issued at a national *pitso* in April 1868, reflected this advice. They established the principle of a dual legal system of customary and Roman-Dutch law, the latter to be applied to Europeans and any Africans who adopted Christianity and other European mores. The intention was that the new property, inheritance

and marital rights available under Roman-Dutch law would provide an incentive for commoner men and women to abandon custom (and subservience to their chiefs). For Christian men, for example, the new courts provided a means to resist chiefly exactions and the demands of 'pagan' relatives upon their property. Conversion to Christianity was thus transformed from a simple question of conscience to a potential strategy to make individual financial gains. Yet even non-Christians could benefit from legal dualism. As long as they had the money, men could appeal a decision from the 'Native courts' to the colonial courts. They could contest even the Paramount Chief by taking their cases to a magistrate (later, Assistant Commissioner). An unfavourable decision at this level could, in turn, be appealed to the High Court in Maseru, thence to the Colonial Secretary in Cape Town and, ultimately, to the Privy Council in London.[8]

Sandra Burman has shown how the introduction of legal dualism had potentially revolutionary implications for women.[9] For example, through Roman-Dutch law mothers gained the right of child custody in the case of divorce or widowhood, a complete inversion of Sesotho. Girls were recognized as legal majors at the age of sixteen (and boys at the age of eighteen), while the equality of women and men before the law was established, including the right of widows to inherit property and to remarry according to their own choice. The new laws also empowered women, even girls, to refuse to submit either to arranged marriages or to *lebollo* (initiation). After the actual administration was established (1871), Cape rule also created other positive incentives for Basotho to abandon loyalties and customs of Sesotho, which potentially emancipated women from the abuses to which they were vulnerable. For example, it effected a *de facto* tax on each wife as a means to discourage polygyny, and required registration of each and every marriage to ensure that the woman had freely consented to it. Four magistrates were meanwhile given undefined powers to intervene in Basotho marital affairs. Showing impressive confidence in view of their inability to speak Sesotho and their lack of formal legal training, these men barged into Basotho society like the proverbial bull in a china shop. Often upon their own initiative, they began granting divorces in both Christian and Sesotho forms of marriage, fined Basotho men who violated 'civilized' standards of behaviour towards women, punished 'bigamists' (men who married by cattle after they were already married by Christian or civil rites) and even offered their own interpretations of 'proper' custom. In addition, certain acts which were seemingly tolerated by the Basotho but were held by the British to be 'repugnant to natural law' were criminalized, notably abortion, infanticide and child concealment. Corporal punishment against women convicted of crimes was banned.

Basotho women were not long in seeking to take advantage of these new laws, nor the magistrates in claiming credit for emancipating women from customary oppression. Indeed, scarcely two years after colonial rule had begun, John Austen boasted of having sparked a veritable revolution:

> Many girls asked me for protection, and I stopped many forced marriages. Women who had been ill-treated by their husbands, and his relatives, also came for protection. The result is that at present a forced marriage is seldom or ever attempted, nor do you hear of many cases of flagrant degradation or oppression of women. Men of all tribes and classes are found with their hoes side by side with their wives cultivating or weeding the fields.[10]

Austen's claims in this regard must be treated with caution. Indisputably, however, the courts did make a number of remarkable judgements throughout the 1870s which gave Cape ideals the substance of legal precedent. Men's rights to property and child custody through *bohali* were a particular target. In the first such case, Josefina, in 1874, successfully sued for divorce and won both custody of her children and the right to remarry (LNA HC 4/1874). In the same year, Carlotta alias 'Malepolesa won a divorce and the right to take up independent employment in the Cape Colony (LNA HC 21 August 1874). Machebane also won restitution of her children and the property she had earned independently while in the Cape Colony but which her husband's family had seized as theirs. Although she had run away from her legal husband, and so under custom his family was correct, the fact that it had been a forced marriage was taken by the magistrate to nullify the family's claims upon her (LNA HC 14/1878). Women were also able to win divorces on account of 'persecution' by mothers- and sisters-in-law, something *ho ngala* does not seem ever to have allowed (for example, LNA HC 8/1877 and 46/1877).

The vast majority of wives who preferred to remain married also gained a potential ally in the colonial magistrates in their struggles for marital peace: Ntsuka, Mapitso, and Noelina alike sued their husbands in the colonial courts and won compensation for assault and indignities. Their husbands were ordered to behave better (LNA Civil Records, 13 April 1877; 8 August 1877; 17 July 1880). Nthlakala, meanwhile, found the magistrate sympathetic to her refusal to obey her husband's command to return home until he promised not to take a second wife. She had run away in protest at his neglect of her and his obvious polygynist intentions. 'I will not live with a polygamist and still less as an inferior wife,' she told the court to its whole-hearted approval. Ruling in her favour, the magistrate berated her husband for his 'stupid arrogance' and warned him of a potential five year stint in prison should he defy Nthlakala and the court by

marrying again (Bereng Molomo v. Nthlakala LNA Civil Records, 7 July 1875).

Widows also successfully used the colonial courts, principally to resist the claims of their deceased husbands' families to take custody of their children, and to establish their independent right to dispose of inherited property (for example, LNA HC 2/1877, 4 March 1880). Daughters, too, won important legal victories in the early years of Cape rule, including the right to choose their own marriage partner and to divorce against their parents' wishes. Ramolawa, for example, obtained a *de facto* post-mortem divorce from her violent husband against her father's will. In this case the father wanted her children as custom warranted. The court ruled, however, that he had forfeited any customary rights because his behaviour invalidated his moral authority. Specifically, when the husband was still alive and mercilessly beating Ramolawa, he (the father) had repeatedly 'thrashed' her to force her return from *ho ngala* (so that he could keep the *bohali* that had been paid for her). In granting her a post-mortem divorce, the court protected the widow Ramolawa from impoverishment by an obviously mercenary father (LNA HC 38/1877).

In another even more remarkable case, seventeen-year-old Thope turned to the colonial magistrate to resist a marriage arranged by her grandfather. She told the court flatly that 'I refuse to be sold for cattle . . . I ask the court to protect me' – which it obligingly did (LNA Civil Records, 2 June 1875). Another young girl, in a case brought to court by her mother, was rescued from her father's forcible attempt to have her initiated. 'I ask the court to deliver me – I want to leave heathenism.' The judge (Rolland *encore*) informed her that since she was seventeen years old she was 'free to choose her own course' (LNA 23 Oct. 1874).

This embrace of the colonial courts was not exclusive to Christian women seeking the protections available under Roman-Dutch law. On the contrary, Basotho 'pagans' also came to the magistrates for assistance when men neglected their customary obligations. Such cases included the widow 'Mapule, whose stepson was refusing to provide her with maintenance as custom enjoined. The magistrate took her side (LNA 8 Dec. 1874). Similarly, the courts took the side of 'pagan' fathers who sought to defend their daughters' customary right to *ho ngala* and divorce from violent husbands. These fathers may not have been entirely motivated by concern for their daughters' welfare. Rather, they sought the colonial state as an ally against sons-in-law who drove their daughters to flight yet were demanding the reimbursement of *bohali* (most likely already committed by the fathers elsewhere, see for example, LNA Mafeteng Civil Records 9 Dec. 1874; HC 19/1878).

Magistrates in the Cape era did always not wait for women to come to them with grievances. They also actively intervened in domestic disputes, even against powerful chiefs. The magistrate in Quthing district notoriously sought to arrest the son of Chief Moroosi for having used violence against a widow who was refusing *kenela*.[11] Major Charles Bell, magistrate of Leribe district, also expressed the state's assimilationist intentions by advocating the establishment of state-funded, compulsory, secular education for girls, complete with European women as teachers and role models. In his eyes, this would promote the demise of the 'heathen' way of life by giving Basotho girls the ability and confidence to resist the oppressive demands of Sesotho.[12]

In retrospect, such self-assurance seems absurd and arrogant. Indeed, the arrogance of Cape officials in these and other matters is often cited as provoking the Basotho into the series of rebellions from 1879–84 which culminated in the ignominious demise of Cape rule. Yet it would be a mistake to over-emphasize the element of reaction against Cape social policy in these rebellions, as Burman arguably does. As far as women's emancipation was concerned, Cape arrogance was in fact significantly humbled long before 1879. In the first place, for all its civilizing bluster, from the beginning the regime trod very cautiously in publicizing women's new legal rights. The victories for women cited above were likewise unpublicized beyond the narrow coterie of *batsoelopele*. The government also did little to enforce women's legal victories against husbands and families who simply ignored decisions made in court against them. State passivity in this regard may have been due as much to financial constraints as to lack of will. The budget, for example, provided for only four magistrates to cover the entire territory (population at that time approximately two hundred thousand), two doctors, two minuscule public schools, and a skeletal police force. The first woman to be found guilty of infanticide (1874) was given a suspended sentence on the grounds that there was no facility in the territory to incarcerate her.[13]

The confidence of men like Austen and Bell in their civilizing mission also belied an unease among higher Cape officials at the manner in which women's emancipation was unfolding. Charles Griffiths (the Governor's Agent or chief magistrate) in particular quickly recognized the need to slow down or back down altogether on the enforcement of laws which offended or threatened the chiefs. Hence, while agreeing in principle with the Protestant missionaries that polygyny and *bohali* were 'most injurious to the people, morally, socially, and politically, [and] retard them in the progress of civilization', Griffith publicly criticized overzealousness in attacking Sesotho customs.[14] To the missionaries' frustration if not fury, he actually ruled against PEMS members in several important test cases. Notably, in 1872 Griffith refused to back the PEMS

contention that Christian divorcees should not always be allowed to keep custody of 'their' children. No, Griffith decided, if *bohali* had been exchanged in the original marriage and had not been refunded upon divorce, the children rightfully belonged to the extended family, however dark their pagan hearts.[15] In a similar vein of appeasing traditionalists, the legal age of majority was raised in 1877 from sixteen to twenty-one. The obligatory fees to register marriages (the polygyny tax) were also abolished.[16]

Griffith's concessions to Sesotho in these ways were possible because, fundamentally, neither he nor his magistrates actually disagreed with the chiefs on the principle of female subordination to men. On the contrary, to an extent arguably even greater than Sesotho custom, the Cape vision of a 'civilized' woman was one who assented to the wise rule of her husband. The two state schools established for girls focused overwhelmingly on training for this role. The syllabus consisted of: 'Washing, Mending, Plain Sewing, Plain Cooking, and Domestic Labour generally.'[17] Austen, that self-described revolutionary, put it this way: 'Education alone can place the woman in her proper position . . . the centre of domestic comfort and happiness.'[18]

Roman-Dutch law was similarly highly ambiguous about women's emancipation. For all the legal rights and equality between the sexes it enjoined, it also contained the concept of 'community of property' which upheld the husband's power to dispose of his wife's property without her consultation. This was a clear regression from the moral obligations inherent in Sesotho and backed by usufructory rights to land enjoyed in custom. Roman-Dutch law also extended to men the right to divorce wives on the basis of their wives' refusal of 'marital privileges', providing husbands with a powerful threat and effectively recognizing their right to rape conjugally uncooperative wives.[19] And for all their self-righteousness about the savagery of Basotho men, colonial officials similarly condoned the use of violence against women who deviated from or rebelled against their 'proper' role. Setona's case against her husband for assaulting her, for example, was dismissed by the magistrate on the grounds that she 'was rightly served' for intervening in his private matters (LNA Civil Records Mafeteng, 14 Dec. 1875). One Cape official even explicitly defended a husband's right to use corporal punishment against unruly wives, distancing himself from missionary propaganda about the supposed brutishness of the African male: 'I think the ill-treatment of wives has been very much over-rated. They get an occasional thrashing, but no more than they deserve.'[20]

These shared assumptions about women's subordinate status to men weaken the thesis that Basotho men were reacting against enlightened Cape rule when they finally took up arms against it. Indeed, the evidence

suggests that Cape officials themselves were actually becoming increasingly disillusioned with enlightenment or assimilation as a goal of the state. Particularly irritating – sometimes enraging – to the magistrates was that Basotho women were garbling the civilizing message, demanding more freedoms than Roman-Dutch law allowed and Cape ideals of feminine propriety intended. Indeed, the Basotho women who appeared before the courts often appeared acutely aware of the limitations of Cape-style emancipation and in many cases unabashedly demanded more. To the growing exasperation of Cape magistrates, they also began to assert combinations of the new laws with their own novel interpretations of Sesotho. Machebane, for example, attempted to justify running away to the Cape with three of her husband's children while keeping the *bohali* paid on her behalf in terms of custom. She had left one of her female children behind, explaining: 'I know that under the Sesuto law if a woman leaves a girl with her husband, the girl is considered enough for the cattle paid for the woman . . . My first child is now a young woman and can be married and the cattle given for her could replace those given for me.'[21]

The prize for the most *chutzpah* in inventing tradition in these years must, however, surely go to 'Ma-Maloi. She became a Christian and left her polygynist husband in 1858 without either reimbursing the *bohali* which had been paid for her or formally divorcing. She then moved across the border to the Orange Free State taking her daughter with her and took up with a new man. When her estranged husband ordered her to return, she refused, invoking Moshoeshoe (that is, custom) both to justify her leaving in the first place and to demand that her husband continue to support her. He 'laughed at [this interesting interpretation of] Moshesh's law' but his humour turned ill when she married off his daughter with *bohali*. This (eight beasts) she naturally kept for herself as belated compensation for her husband's failure to live up to his marital obligations. She defended herself against his protests with the claim that 'although she is a Christian, she had as much right to get cattle' as anyone. The judge upbraided her for this 'most unheard of piece of dishonesty and impudence' (LNA Civil Records Mafeteng, 22 Nov. 1876).

Those women taking emancipation to mean more than humble and narrow domesticity also invited stern warnings and in some cases harsh discipline by the state. The case of 'Ma-Mookho (1877) offers a telling example. A widow and a Christian (thus legally an adult), she was originally awarded custody of her children under Roman-Dutch law. She maintained them for several years after entering into an evidently stable – but unofficial – relationship with a new man. When this was brought to the attention of the court, the magistrate overturned the original decision and granted child custody to her father-in-law. The grounds for denying

her the rights which her 'civilized' status should have warranted were that she was living 'an immoral life and in vice'. In other words, she disqualified herself from legal emancipation by having sexual relations outside of institutionalized marriage.[22]

If 'moral looseness' rendered women unfit to enjoy their legal rights, so too did undue assertiveness. This was undeniably the case for the widow Makubutu who, with her son, sought to resist her legal guardian's proper claim over her children. 'I am as good as he and have a right to mine,' she told the court. 'I also deny that he is the *malome* of these children. I myself am both father and mother to them. *Kia gana, kia gana* [sic, meaning "I absolutely refuse"].'[23] She then claimed that the Governor's Agent had already ruled on her behalf and implied that being dragged before the magistrate again was malicious. The judge, none other than Rolland, was furious. For a famous 'liberal', his judgement was most revealing. Makubutu was found guilty of illegally taking the children and was ordered to return them at once to the extended family. In a virtual admission of naked patriarchal opportunism, Rolland declared that 'the Court is bound to decide this case according to Sesuto law', a sudden discovery of prudence he had rarely shown before that almost certainly stemmed from his fear of female rebellion.[24]

4.2 'Parallel rule', 1884–1929

Cape officials by the mid-1870s were clearly becoming anxious about the socially destabilizing effects of legal dualism. Even the more radical assimilationists were backing away from the full application of their ostensible principles. In the event, however, Cape officials did not choose to abandon assimilation as a policy but were compelled to do so. War first broke out in the Quthing district in 1879 but spread throughout the territory the following year. Among the many casualties, the magistrate John Austen suffered decapitation, an unusually gruesome fate that may reflect his special unpopularity as an 'emancipator' of women. The Cape administration was forced to withdraw.

Women played an important role in sparking the violence which led to the rout of Cape rule. Throughout the 1870s the female prophet 'Ma-Lethunya preached against the corrupting influences of Christianity and the dangers of colonial reforms, tapping into growing popular dissatisfaction with the imperiousness of Lesotho's ostensible protectors. Then, in 1879, it was Baphuthi women who shamed their men to take up arms against British attempts to arrest the chief's son: 'I don't produce children for the white man,' Moorosi's wife is reputed to have said. 'You take this skirt and give me your trousers.'[25] Reports of Basotho women urging men to arm themselves in the 1870s also suggest that women played a signi-

ficant role in the defence of Sesotho and the Basotho nation against colonial encroachments.

Whatever their motivation, few Basotho women could have anticipated or been satisfied with the eventual outcome of the military struggle against the Cape regime. When the dust finally settled, the new regime which emerged was decidedly hostile to women's emancipation, even of the limited and contradictory sort favoured by Cape officials. The Disannexation Act of 1884, which removed Lesotho from Cape jurisdiction and placed it under direct Colonial Office rule, made this quite explicit. Abandoning the Cape's assimilationist goals and abandoning even a pretence of developing Lesotho beyond a cost-free migrant labour reserve, the new regime sought instead to cultivate the loyalty of the chiefs and to buttress 'custom' in order to maintain social order, as well as tax and labour flows at minimal expense. As an inducement to loyalty, many of the local powers of the *marena* were discreetly enhanced. This period of extreme indirect rule (or 'parallel rule', as it was termed in 1935) lasted until the late 1930s.

Colonial discourse was certainly not totally divested of 'civilizing' or 'emancipating' rhetoric after 1884. On the contrary, posturing and puffery about moral standards and duties may have been even thicker than ever. The willingness and ability of British officials to intervene in domestic affairs was, however, sharply circumscribed. One of the clearest signals that the Colonial Office wished for harmonious relations with the chiefs at the expense of women was Section 61 of the new administrative regulations. In it, Basotho men's authority over women, including Christian women, was explicitly affirmed: 'No native woman residing in the Territory of Basutoland shall leave the said Territory without the consent of (a) if she be married according to European law or according to native law or custom of her husband and (b) if she be unmarried of her father or natural guardian.'

Meanwhile, customary law became something to support rather than to fulminate against. Related to this, much stricter criteria for the application of Roman-Dutch law were applied, meaning that only the most demonstrably 'civilized' appellants could expect a hearing (let alone a favourable judgement). Divorce by this route then became virtually impossible, demanding as it did, concrete proof of the husband's adultery or 'malicious desertion'. As a result, as late as 1911, there were only eight divorcees in the entire country.[26] Centralized control over the divorce procedure was meanwhile tightened up so that rogue liberals among the Assistant Commissioners (ACs) would not establish inappropriate legal precedents. As a directive sternly insisted in 1917, it was 'manifestly illegal' for ACs to make judgements in divorce cases as some had been doing. All cases were directed to the capital, Maseru.[27]

As part of this policy of appeasement of the local patriarchs, the post-1884 administration purportedly turned a blind eye to the chiefs' 'concerted campaign' to revive *lebollo* in order to curtail the spread of Christianity.[28] It demurred as well in extending its protection to girls or women who sought to escape from customary patriarchy by running away to the missions. Along with more rhetoric about girls' education for domesticity (with perhaps a stint of service in a European home to 'polish' them), officials also trumpeted a curious form of 'upliftment' for boys in this era. As one Anglican Bishop expressed it, civilization meant primarily 'respect for authority and reverence for order' something which could safely be admired about Sesotho but which liberalism clearly endangered.[29] In the frank words of the Resident Commissioner at the turn of the century, 'Rapid improvements are not to be looked for; they are rather to be deprecated.'[30] On this principle, the government began cautioning the missionaries against offering Basotho children too academic an education.

Lesotho's peculiar position within the wider empire exacerbated some of the most cautious tendencies of the post-1884 regime. Especially after the Union of South Africa was created in 1910, a clear conflict of interest emerged between authorities in Basutoland and the office to which they were responsible, the High Commission in Pretoria. The latter was headed by one and the same man as the South African Governor-General, and there can be little doubt as to which of his two hats weighed most heavily upon his brow. Conflicts between the Union and Basutoland were also resolved (or disappeared altogether) by the simple expedient of staffing the colony primarily with South African-born British subjects and other white South Africans. These men naturally tended to import the values of the society which produced them. From the late nineteenth century onwards, that society was increasingly and explicitly racist in orientation. The liberalism which had formerly characterized the Cape Colony was on the wane.

One indication of this in Basutoland which further reflected the demise of the assimilationist ideal was the fact that officials who came to Basutoland were less and less tolerant of racial mixing. John Austen, for all his faults, had been a Coloured, and both he and other Cape magistrates appeared to tolerate, if not actually condone inter-racial marriage. By the 1890s, however, the very idea of miscegenation was a source of scandal. Indeed, the wife of one colonial official couched this issue almost in terms of treason. Mrs. Minnie Martin exhorted her intended readers (English-speaking South Africans for the most part) to keep their 'morals and manners', to uphold the empire, and to abjure sexual contact with African women.[31] In 1905 the Resident Commissioner even toyed with the idea of making 'illicit sexual intercourse' between the races a

criminal offence, proposing to draft a law in line with the Rhodesian example (the Immorality and Indecency Suppression Act of 1903).[32] Although this was never enacted, white men who openly consorted with Basotho women were ostracized and could be summarily deported from the country by other means. G.C. Greyling met that fate in 1932 for posing 'a danger to the peace, order and good government of the Territory'.[33]

The post-1884 colonial government's 'respect' for Sesotho gender relations and sexuality was clearly only possible when these were cordoned off from the white community – Europeans could look but not touch. In looking, they could reap a heady sense of self-satisfaction. Indeed, 'respect' for traditions was unmistakably a form of condescension, an 'otherization' of the Basotho that acted as an important buttress for the white community's belief in its own moral superiority. This in turn helped to justify to whites the many powers and privileges that they enjoyed. Not surprisingly, when racism and misogyny were so implicit in parallel rule, the 'others', Basotho women in particular, were generally unimpressed. As the new century unfolded, they turned increasingly to 'vote with their feet' against the regime by leaving Lesotho altogether. In response, the colonial state turned more and more of its explicit attention to enforcing women's subordination to male controls.

'Loose women' and the crisis of colonialism

From the previous chapters we can see that Lesotho in the late nineteenth and early twentieth centuries was experiencing relatively rapid social and cultural change. In a regional context of capitalist development skewed by racist ideologies, new forms of class conflict and a trend towards environmental degradation in the 'native reserves' were emerging. In these circumstances, Basotho women possessed a number of options to secure or enhance their lives materially, socially, and spiritually. These options presented both opportunities and dangers which varied according to the specific circumstances of each woman – notably her age, marriage-ability, fecundity, and family connections. For some women, clinging to or even strengthening patriarchal 'tradition' was the best way to ensure access to fields and respect as they grew older. For others – a majority it would appear – seizing upon the new technologies, crops, livestock, and market relations was more promising. The different strands of Christian-ity and secular colonial law meanwhile introduced a veritable horn of ideological, intellectual, and legal plenty from which women drew select-ively to protect or advance their interests. Yet these innovations could also put women's security and dignity at risk. To convert to Christianity was to invite possible ostracism and even violence from family and husbands. To appeal to fickle colonial authorities was both expensive and highly uncertain. And to trust in men living up to their customary obliga-tions to women was to expose oneself to men's growing structural inabil-ity to be proper men in the traditional sense.

In this context Basotho women increasingly opted for another strat-egy – running away. Scholars have neglected this aspect of Lesotho's history but, as this chapter shall argue, Basotho women migrated in large numbers both within and beyond Lesotho. Controlling this migration and its perceived detrimental effects upon the nation became a central organ-izing feature of the colonial state in the era of parallel rule.

5.1 Female migrancy

The first Basotho women to migrate to the neighbouring colonies gener-ally travelled with their husbands. As early as the 1850s, women not only

supported their migrant husbands in their usual domestic tasks but in some cases earned income themselves which they pooled into the household. After sometimes years of service in the Cape or Orange Free State, they returned to Lesotho with livestock, consumer goods and even additional wives. By the 1880s and 90s, wives also accompanied their husbands on shorter cross-border expeditions, accomplices in the illicit importation of brandy, among other things.[1] By the first decade of the twentieth century they were known to be leaving Lesotho specifically for a life of prostitution in South African towns.[2]

As early as the 1850s, women also began to slip away from Lesotho independently of men. They went primarily to the farms and towns of the Orange Free State, territory which had hitherto been considered part of Lesotho and which continued to be populated largely by Sesotho-speakers. Some women left their proper homes in search of husbands who had left for employment but had not returned. Others were widows whose families did not live up to the moral obligation to support them or who sought to enforce *kenela* against their wishes. 'Ma-Moloi claimed to have left her husband in 1858 to take up employment in Platberg because he refused to allow her to convert to Christianity. Carlotta alias 'Malepolesa left on account of her husband's inability to consummate their marriage and after enduring years of neglect. 'I have been wandering about for many years as an ownerless animal', she testified in court. Although eventually compelled to return to Basutoland by her father-in-law, she remained adamant that she would not stay there under such conditions: 'I still intend to go and reside in the Colony where I am in regular service and can support myself.'[3]

Some women absconded to escape their husband's or in-law's violence – Matashe, for example, arrived in the Zastron district in 1908 with a broken jaw inflicted by her husband. Some women ran away only after trying *ho ngala* but being forcibly and repeatedly returned to abusive husbands or relatives by their own families. 'Mamonnamoholo Pitso (born 1898) claims to have been motivated by almost all of these factors:

(Husband number one): My husband who [*sic*] I loved, left me and went to the white man's place. I was troubled, no person helped me. He spent years there without coming home until I got angry. I left my children at home and I went.

(Husband number two): Starvation was there, my husband had gone to war, I could see that my children would die inside the house, then I left. I went to the farms because I heard there was life. There was money during the harvest season.

(Husband number three): The man was making me lead a terrible life, he beat me day and night. It was then that I decided to leave, I crossed.[4]

Such acts of rebellion came with serious risks and it is important to draw attention to the courage of the women who made them. Historians have rightfully emphasized the courage of male migrants who tramped hundreds of kilometres in harsh weather to face brutal overseers, dangerous working conditions, and murderous *tsotsis* (bandits). Women's migration is all the more remarkable in that they often faced equally or more dangerous and exploitative conditions without the benefit of a supportive culture. Life on the farms of the Orange Free State, for example, included near-starvation rations, squalid quarters, polluted water, and outright robbery by employers. Wives and daughters who accompanied men were commonly required to supply their labour for free at harvest or other peak times. Even when paid, and even when they performed exactly the same tasks as men, women invariably earned less than men. In 1932 the Native Economic Commission found Basotho women in the Orange Free State earning as little as five shillings a month, or less than half the men's wages, and less than one-quarter the estimated minimum cost of living.[5] Only by investing their meagre earnings and additional labour could 'real money' be earned. Thus, after a hard day in the fields, often with babies on their backs, the women would walk to the shops, buy sorghum, and brew beer. Long days, squalor, and police harassment were likely even more common features of life in the urban centres.[6]

Away from their families and husbands, women were also exposed to forms of men's sexual violence which had been rare in the village context – rape above all. The brutality of husbands and fathers who caught runaway women could be even more horrific. Although Basotho women appear deliberately to understate their history of fortitude in dealing with such violence, hints of the cool courage of individual women come through in their occasional testimony before the colonial courts. No case more clearly casts doubt on the highly dubious assertion that women are the 'weaker sex' than that of Elizabeth Manapo. In 1908 she ran away from her abusive husband to join her mother in Ladybrand. She was arrested and returned by the police to meet her fate: 'I was beaten by three men, relieving each other when one is tired . . . with an exceptional big sjambok.' Near death, she took five months to acquire the strength to abscond once again. When re-arrested, her calm dignity and the scars on her back seem to have shamed the police into letting her remain with her mother.[7]

As well as such 'push factors', and despite the sometimes horrendous conditions and risks they undertook in South Africa, Basotho women

were increasingly pulled from Lesotho by the attraction of an independent income, consumer goods, and relative social freedom. By the 1930s, according to 'Mamonnamoholo's oral testimony, she and her friends 'believed that working on the farms was quite prestigious' and that they often went for 'the sheer eagerness of acquiring new ideas, such as new ways of dressing'.[8] Indeed, without glamourizing the life of 'prostitution', it is clear that it was not without rewards. In short supply themselves, but with their traditional skills of brewing *joala* and taking care of lonely, domestically incompetent men in high demand, market forces gave women significant leverage over men in the locations. Compared to back in the village, for example, it was relatively easy for women to leave – or to make credible threats of leaving – an unsatisfactory relationship with one man in favour of another man who promised more. The 'Babylonian' atmosphere of the locations and, in particular, the shebeens where men came to drink and fornicate, also allowed space for some women to experience a type of sexual independence, if not indulgence, that would have been unthinkable in the villages back home. *Famo* dances, re-nowned for their lewdness, were a hallmark of such places.[9] This applied even on the farms. As 'Mamonnamoholo recalled: '[I]t was enjoyable. We even forgot our own homes, we had children with different men, we stayed with men who were not ours. We made *litokofele* ['stock fairs', here apparently used as a euphemism for 'parties'] . . . Our entertainment was beer . . . Our life was just like the shebeen queens.'[10]

Women could also earn money to bring into their own or their daughters' marriage household. Mothers were reportedly 'hiring themselves out' for just long enough to be able to buy trousseaux for their daughters' weddings, while others worked a short stint in the locations to earn school fees or pay *bohali* for their children. The acquisition of such a 'proto-dowry' not only gave women a greater say in the choice of their marriage partners than was customary, but could also be used to marry their daughters upwards.[11] Some women left their proper homes precisely on account of their husbands' refusal to let them earn such an independent income: 'When I say, "I am leaving", I leave and go. My mother and father, I am going to the wheat farms. Can I afford to stay with a man here looking each other in the face, while he refuses me permission to work? I went alone.'[12]

Whatever the dangers and whatever their motivation, the number of Basotho women migrants grew rapidly after the Gun War. In 1898 nearly one thousand women left from the border camp of Mafeteng alone, approximately a third of the total number of migrants, and by the 1920s, women were reportedly 'flooding' out of Basutoland to take up life in the locations.[13] Official statistics record a sevenfold increase in the number of passes issued for women to go to South Africa between 1911 and 1936 –

from 2 972 to 22 669.[14] This represents an increase from 5,8 to 15,3 percent of the *de jure* population, or, to put it another way, the virtual doubling of the female component of the registered migrant population to 22,4 percent. In places like Vereeniging and Brakpan, the 'massive jump' in the female urban population after 1925 was due to the influx of single women 'principally from Basutoland' according to the Union's Director of Native Labour.[15] But Basotho women also showed up even further afield in this period, to the consternation of local authorities. For example, Annie of Basutoland appeared before the court in Salisbury in 1924. She was accused of setting fire to the hut of a rival for the attentions of her unfaithful 'husband'.[16]

To colonial eyes Basotho women appeared to be 'cleverer and more enterprising than the average urban African woman'.[17] This was not simply due to their ability to manipulate relationships with men or to dodge the police, but also due to their skills at concocting powerfully addictive new recipes for the liquor they brewed. By adding new ingredients – like kerosene – they turned *joala* into ever-more potent brews and extended their commerce from Basotho expatriates to other 'tribes' as well. By the 1930s, Basotho women had in this way 'acquired a sad reputation' as purveyors of the most intoxicating 'poison' on the Rand.[18] They also acquired a reputation for prodigious consumption of the liquor themselves, for ribaldry, and for their ability to corrupt native constables. The women frequenting the bridge at Ficksburg impressed even the hardened constable in charge of the Basutoland Mounted Police there. As he wrote to the Government Secretary in 1919:

> The whole night was made horrible by such noises as I have never heard before. It is utterly impossible to describe them on paper. To attempt would prove a failure. A start was made about 1:0 p.m. on 16.8.19 and carried through the whole night, on until Sunday. The Sunday (18.8.19) was not much better. People from the location at Ficksburg came and helped those who were already there to keep up the din. Among them I noticed a policeman named Jim who was in company with a woman not his wife. This woman he was trying to drag along by the arm. She was very drunk. Another woman came to my house and complained that Jim had knocked her about . . .

> It is a very common sight to see females run out of the hovel for about 20 paces and then squat down. Having eased themselves of their water they then go back again and start drinking. The men walk about the same distance and stand up and ease themselves, the nearness of a female apparently no difference whatsoever.[19]

In this case, also typical of brawls following *matsema*, the women were vulnerable to victimization by drunken men: 'I myself have seen men hit women with sticks until they fell to the ground . . . I find that the other people standing there seem to take such behaviour as a matter of course.'[20] To defend themselves against such violence, and to defend their profits as liquor-sellers, the women who frequented shebeens began to acquire the skills of how to handle a knobkerry or knife. As one missionary later lamented, women in the locations 'grow fierce and lawless, even more so than the men'.[21]

This explosion of unattached women whose femininity so radically differed from customary ideals necessitated the invention of several new Sesotho words to describe them. *Matekatse*, a noun derived from the verb meaning simply 'to wander', came to mean 'loose' women, with the connotation of prostitutes or 'sluts' who moved from man to man without morals. Other terms included *matlola-terata* ('those who jump the fence'), *mahure* (from 'whores'), and *machuchutha* ('those who go by train'). *Matekatse* need not go as far as Johannesburg, however. There were opportunities to earn cash in the 'camps' and border posts closer at hand. Indeed, '*o ile campong*' – literally 'she has gone to camp' – came to be synonymous with 'she has gone to prostitute herself'.[22]

All of these tendentious terms reflect the shameful nature of female independence in Sesotho. Yet the word 'prostitute' does not do justice to the diversity of activities and relationships the women engaged in. Certainly, some exchanged sex for cash on a very short-term basis, 'openly servicing clients' on the lorries carrying migrants to Maseru according to one account.[23] Yet prostitution could include relatively stable, long-term relationships as *linyatsi* (or 'paramours'), which might more appropriately be termed common-law marriages. Derogatory stereotypes also belied the fact that brewing and sex were not the only activities *matekatse* pursued. According to Maloka, women in the 1920s worked in relays to accompany men on their journey from the hinterland to the camps, as porters and cooks at least as much as sex partners.[24] 'Mamak'hanakisi, to give a more renowned example, ran a butchery, eating house and delivery service on the outskirts of Maseru. 'All who knew her attributed at least a major part of her success to the fact that she never drank beer herself.'[25]

5.2 The threat posed by 'loose women'

'Loose women' were regarded by the Basotho with a contradictory mixture of scandal, resentment, anxiety, and awe. Thus, for all of society's disapproval of the excessive alcohol consumption and adultery which accompanied her trade, Basotho largely accepted that the shebeen queen provided a valuable service. European-style liquor was illegal in

Basutoland and expensive either as contraband or in the brandy-shops of the towns across the border. As late as the early 1960s, one could get as drunk on sixpence worth of 'Hlotse special' as on fifteen shillings' worth of store-bought brandy.[26] Basotho also tended to put the onus of responsibility upon the men who neglected their wives and so compelled the women to seek a living on their own. Not even the patriarchs of the National Council could blame a woman for turning a sack of sorghum worth three shillings into a pot of *joala* worth three pounds. Indeed, by the time Judith Gay conducted the first serious investigation into the economics of brewing (mid-1970s), she found that women brewers earned on average four times as much as domestic servants.[27]

The contradictory nature of Basotho perceptions of these women is illustrated by the alternately admiring and disapproving words of an Anglican nun:

Many women own shebeens and rob lots of men (laughter). This is bad. It robs other families since men go there until they are blind and stupid. You could always see them coming across at the bridge at Ficksburg where the women wait. After, the men are so ashamed to be empty-handed that they go straight back to the mines without even seeing their families. It's not fair but you can see how it is profitable to women. We don't know how to stop it since the men insist.[28]

Whether or not they ultimately blamed the men, and however much they appealed to customary obligations and traditional channels of authority, Basotho women remained largely powerless to change men's irresponsible behaviour. They could, however, turn against each other as a strategy to control men. Basotho mothers, mothers-in-law, and wives in fact had strong reasons to be fearful of and to agitate against *matekatse*. As daughters, *matekatse* were 'damaged goods' bringing not only shame to the family but reduced, or altogether lost, *bohali*. A runaway daughter-in-law could mean a critical loss of labour to the household while, as rivals for men's affections and earnings, *matekatse* were direct threats to the welfare of proper wives. Therefore, in addition to the traditional means of disciplining daughters, Basotho women as well as Basotho men sought the assistance of the colonial state in re-asserting control over 'loose' women.

The first channel for doing so was through their chiefs, who had their own obvious reasons to take complaints about *matekatse* to the British. Women's uncontrolled mobility was an indisputable threat to the principle of male power over women, the principle from which chiefly power and wealth primarily derived. The post-1884 regime in its turn was amenable to oblige the chiefs, not only because its officials held the view that *matekatse* behaviour was scandalous. The Colonial Office was also seek-

ing cheap and agreeable ways to win the loyalty of traditional elites. Promises (such as Clause 61 of the Disannexation Act), sympathetic words, and a handful of legal judgements against runaways seemed at first to suffice in that respect. As early as 1892, for example, the government listened sympathetically to chiefs' complaints that Section 61 was not of any practical use.[29] For one thing, it placed the burden of legal expenses on the men who were seeking to retrieve 'their' women or the property which women carried off. Such legal costs were typically beyond the means of aggrieved men to pay or exceeded the value of the property which had been lost, strong disincentives to pursuing the case. Therefore, in 1898, the chiefs sent a petition to the High Commissioner appealing for legal aid. Lord Milner conceded to this the following year, accepting that 'in reasonable cases' the government could give some financial assistance to Basotho men seeking to recover wives and property. In fact, however, no case ever appears to have been adjudged 'reasonable'.[30]

This policy of merely appeasing Basotho patriarchs on domestic matters gradually elided into one of active involvement by the state in efforts to restrict women's mobility. From a relatively minor concern of the colonial state (making promises and shuffling a few papers), controlling women's unruly behaviour became a source of increasingly urgent concern. *Matekatse*, by the end of the 1920s, had become a positive threat to social stability, 'a nuisance and a danger to the community' in the words of the AC-Maseru in 1928.[31] The fitful and contested way the transition occurred sheds light on the power dynamics of the region.

This transition actually began in 1898 when four of Paramount Chief Lerotholi's wives absconded to Rouxville.[32] In that year, the potential for female independence to lead to generalized civil unrest was forcefully brought home when 'Mankeane absconded across the border. She was a junior wife of one of Chief Masupha's sons, Maketa. When she refused to return as bidden, Maketa attempted to abduct her, and was caught and imprisoned in Ladybrand. Masupha then sent men to assist his escape, compounding the crime by declaring that he would resist any British attempt to recapture his son. Although Masupha's rebellion quickly crumbled, prominent officials recalled it for years afterwards in the form of a lesson to the chiefs: 'the Basotho', the Resident Commissioner Sir Herbert Slolely sternly abjured the first session of the National Council in 1903, 'must do something to prevent their women from running away for this sort of thing led to the Masupha disturbance'.[33]

The senior chiefs did not dispute this advice. Rather, they disputed the paltry assistance the British were giving them either to prevent wives and daughters from absconding or to retrieve runaways. The flight of 'several' married women to Ladybrand in 1903, their adamant refusal to

return, and their apparent adoption of 'immoral lives' was the specific topic of concern in that first sitting of the BNC. In light of the known costs and dubious likelihood of successful legal action, the aggrieved husbands had approached Paramount Chief Lerotholi for permission to cross the border to recapture their wives by force. Lerotholi in turn appealed to the Resident Commissioner for help in averting an international incident:

> Another thing which I am afraid may cause trouble between us and the Orange River Colony is the matter of women running over to that territory. We also call your attention to it, and ask you to see into it for us, Chief, and also about those women from Bereng's place, who are now in Bloemfontein and who you have been promising to fetch.[34]

Sloley offered to take the matter up with the Lt. Governor of the neighbouring colony. In the meantime, however, he admonished the chiefs that without a specific law empowering the government to arrest runaway women, the onus remained with chiefs themselves to prevent 'their' women from leaving.

In the event, the Orange River Colony (ORC) did agree to limited cooperation with Basutoland on this issue and, as a goodwill gesture, carried out a number of *ad hoc* measures of admittedly dubious legality. The most prominent of these was expressed in Circular 4742/03 of March 1904. This empowered ORC police in four frontier districts (Rouxville, Wepener, Ficksburg and Ladybrand) to round up and bring to the border such Basotho women as they were requested and able to catch. In 1906 the net was expanded to include the Harrismith and Bethlehem districts, and by 1908 Basotho women were being arrested as far into the colony as Bloemfontein. No formal record was kept of the number of successful handovers but miscellaneous correspondence from the border camps suggests that they occurred with mundane regularity.

This informal cooperation did not endure for long. Indeed, from the beginning the ORC officials were uncomfortable with what they termed the 'special procedure' and anxiously debated the repeated requests from Basutoland to expand upon its original spirit. They declined, for example, to return the sister of one Mosikama on the grounds that the 'special procedure' applied only to wives. Later they remonstrated with Basutoland authorities about the return of an elderly Mosotho woman and her children on the grounds that the procedure was intended for young wives only.[35] By 1908, they entirely balked at cases involving domestic violence or children. The Colonial Secretary bridling at both the illegality of the procedure and the 'objectionable' way Basotho men treated their women and children in general.[36]

The change of regime – from British colony to Afrikaner-dominated province – allowed these qualms to take precedence over any desire to assist a neighbour. The deportations ceased. Indeed, by 1910 it had become quite clear to the Basutoland authorities that influential elements within the new Union not only tolerated but positively favoured a degree of freedom for African women to move from the 'reserves' to the locations and farms. Afrikaner farmers were crying out for the cheap labour. The mine owners were also coming to appreciate the benefits of Basotho women's mobility, particularly in that their labour on the farms had the effect of depressing wages there. This then made agricultural work a less viable option for men than a stint underground, helping to ensure the flow of labour from the border areas to the mines. The Chamber of Mines also appreciated the direct role *matekatse* had in inspiring Basotho men to sign longer contracts. 'Robbed' of their meagre earnings by the women, men had little choice but to re-engage. As South Africa's townships boomed, local businesses also profited from 'loose' African women. *Matekatse* recycled some of the mine payroll into the merchants' pockets by purchases of consumer items and the raw materials needed for liquor brewing. As one Catholic missionary from Basutoland later remarked bitterly, even after the laws were significantly tightened in 1930, South African municipal authorities were not so much interested in stopping women's brewing and prostitution as in 'taxing' these activities through arbitrary raids and fines.[37]

Respectable white opinion in southern Africa rationalized the growth of African prostitution in this era as a much preferred alternative to the 'Black Peril' which they imagined would result were there not an outlet for black male lusts.[38] Appeals from Basutoland in the name of 'morality' (among Africans) thus tended to fall on deaf ears. Indeed, when added to the economic motives to allow some African women into the townships, this putative concern for the safety of white women meant that South African cooperation in staunching the exodus of *matekatse* quickly dwindled into non-existence. In 1914 the Union Department of Native Affairs informed the Basutoland authorities that it was annulling the pertinent ORC circulars and that Free State police would no longer respond to requests to arrest and deport Basotho runaways. The Basutoland government was left to ponder the unhelpful advice to 'urge Basuto men to take matters to native court'.[39]

By this time Basotho men knew well enough how singularly useless that advice was. The chiefs therefore grew progressively more strident in their demands that the colonial government do something, unilaterally if necessary. According to Chief Motsoene, the women flagrantly: 'deny their husbands when they have gone to [South Africa] to bring them back.

This is an important matter to the Basotho, one of my wives has lately deserted, she was seen in the very train by which I came to Marseilles.'[40]

Faced with such brazenness, with the evident inability of Basotho chiefs, fathers and husbands to control 'their' women, and with unco-operative bureaucracies in South Africa, the government of Basutoland finally decided to develop its own coercive means against female mobility. These will be discussed in the next section. First, however, we need to consider why the government moved in that direction, that is, how it determined that much more was at stake in controlling runaway women than merely the appeasement of retrograde indirect rulers. This realization progressively dominated official thought over the next three decades. In more panicky moments, the costs of Basotho women's non-traditional behaviour were seen as not just irritating but as a threat to the very viability of the colony.

First and foremost among these threats was the danger of Basotho men's permanent emigration and 'detribalization'. The burgeoning population of Basotho women at the Rand reduced the social and sexual incentives for Basotho men to return to the territory. If they could find a 'wife' in the locations, so the argument went, why should they return to Basutoland, a country where their chances of obtaining fields to support a wife adequately were in any case declining? As Pim observed in 1935, Basotho 'prostitutes' in Johannesburg 'played a considerable part in inducing men to stay abroad for long periods'.[41] This may have been desirable from the point of view of the Chamber of Mines, but it was potentially a mortal peril to the Basutoland administration – 'detribalized' men were lost as tax-payers. In addition, even for those Basotho men who did continue to pay tax and who did intend to return home, the presence of women in the Union and at the border camps was a powerful temptation for them to spend their few extra pounds inappropriately. If the workers in the mines spent all their remaining wages on 'bad drink and worse women', there would be nothing left to remit to their proper homes. 'Fleeced' and 'looted' of their earnings, the men often went straight back to the mines rather than face the shame of going home penniless. This then threatened a vicious cycle: if women starved in Basutoland, more than ever would they be forced to leave for the Union and, when they did, Basotho men would have even less reason to come home.[42]

Aside from interrupting the flow of scarce resources into the colony to maintain its established role as a migrant labour reserve, women's liquor brewing and prostitution had direct consequences in the rural areas. In 1930 one French missionary reported: 'They go into the fields, purportedly for their work there, with a child on their back, a little one in hand and a jug of beer on their head.'[43] A flag on a pole announced 'Open for business' right there among the maize stalks. From her vantage point

on a ridge, the beer seller could see the approach of disapproving authorities and disappear with her wares before she could be apprehended. Somewhat earlier, the Resident Commissioner had expressed his concern to the High Commissioner, that, in a context where traditional sexual and marital mores were under heavy strain because of high levels of male migrancy, such uncontrolled alcohol consumption by men and, increasingly, women as well, contributed to 'those besetting sins to which the native is particularly susceptible' – infidelity and violence.[44] The easy accessibility of cheap and strong liquor was thus seen to be the cause of unending social problems, marital conflict, and ill-health.

The latter issue – health – moved into colonial consciousness around this same time. *Matekatse*, it seems, were to blame for a significant economic loss to important people, the labour recruiters. Syphillis and other sexually transmitted diseases had first been reported among migrants as early as 1887. These spread rapidly. Possibly because of Basotho slowness to embrace the practice of homosexual 'mine marriage' common among other migrant workers, the Basotho by the end of the 1920s were among the most 'heavily syphillized' of all the African peoples on the Rand.[45] In order to control mounting losses from a sick workforce, men who arrived in South Africa with syphillis were rejected for work in the mines and the costs of treating or repatriating them assumed by the recruiters. Health checks were instituted at the border but in 1929 the government of South Africa increased the stakes. It decreed that it would no longer pay for the treatment of men who contracted the disease between the border and their arrival at work, offering instead the cool advice that 'you would be well-advised to adopt the most stringent measures . . . to protect natives contracting venereal disease en route to the Mine'.[46] With the numbers of Basotho involved as high as one thousand cases per year, at £2–3 per head, this brought pleas for financial aid from the labour agents in Maseru who had to absorb the cost. In response to such requests, the administration promised to do its best to 'safeguard' the men from 'women and beer'.[47]

Finally, 'women and beer' had political costs. On the one hand, *matekatse* exacerbated tensions with the border communities, nowhere more so than at Ficksburg. Shebeens on the Basotho side of the bridge were not only creating unholy disturbances on the weekends (to use the language of the police). Enterprising Basotho women were also crossing the bridge with calabashes of their wares during weekdays, wreaking havoc with the sobriety of garden and domestic workers in the South African town. The effects of this commerce were not taken lightly by the municipal authorities. For years they appealed directly to the Basutoland government to clamp down on the women – without success. Finally, in 1923, the MP for Ficksburg took the issue up with the Prime Minister of

South Africa, Jan Smuts. Smuts in turn lodged the complaint almost as high as he could go, with the Imperial Secretary in London. At a time when Basutoland was supposed to be a model of enlightened British rule in the region, it was intensely embarrassing to suffer criticism from an Afrikaner-dominated government.[48]

Internally, women and beer also entailed growing political costs. Women's non-traditional behaviour was, above all, clearly contributing to the further corruption or 'inefficiency' of the chiefs. For all their patriarchal bluster many chiefs appeared to enjoy and sometimes profit from the services of 'loose women'. Again, nowhere was this more glaring than at the bridge to Ficksburg. Chief Jonathan on the Leribe side was allegedly 'personally financially interested' in the canteens and so proved remarkably intransigent in his duty to repress them.[49] For a period in the early 1920s, an ambitious female 'headman' of the area complicated matters even further by attempting to carve out a niche for herself in the trade, bringing disputes between Jonathan and his neighbour Motsarapane to the edge of violence. As the AC-Leribe wrote, the widow Makhatisa was 'endeavouring to cut herself adrift from Motsarapane' and 'practically defies' explicit orders to repress the beer shops in her village.[50]

In other ways as well, chiefs and families who may have disapproved of *matekatse* behaviour condoned it in practice, or at least recoiled from their rhetorical hardline attitude when the implications of enforcement against women's mobility became clear. The fact is that 'loose women' did not only sell liquor and sex. They also performed legitimate economic functions such as carrying grain for sale and importing cash and other items of benefit to their communities. *Matekatse* caught in the police net could thus often get their fathers and chiefs to testify on their behalf, even fraudulently, if they needed shelter from the claims of husbands or in-laws who sought to restrict them. This led one traditionalist to complain bitterly to the government: 'Our wives elope with our people and go to Johannesburg, and when we inform Your Honour, you say the running after them is not the work of your Officers. In the days of my fathers, when a woman had run away she was sent back to her husband; *the present day Chiefs keep their deserting daughters*' (emphasis added).[51]

Even the local officials responsible for enforcing pass laws advised against interfering with this movement of women across the border, however exasperated they may have been with the chiefs' contradictory requests. As the AC-Quthing phrased it, 'it would in many cases entail great hardship on people if we stuck to the law'.[52]

Notwithstanding such local or particular perspectives, the mood at the top of the administration grew less and less tolerant of women's mobility. In political terms, the existence of the *matekatse* and the chiefs' futile or

half-hearted campaigns to repress them contributed to a general under-mining of respect for native authority. Tighter controls over such women through the police thus promised to have direct political benefits by shoring up the preferred indirect rulers. After proposing to ban the sale of beer altogether and to arrest the women responsible for it, the Resident Commissioner in 1928 appealed to the chiefs in almost precisely those terms: 'My object in bringing up this matter was not in any way to weaken the chieftainship but to urge the chiefs to consolidate themselves in the only way that can be lasting, namely by constituting themselves as the most enlightened portion of the community, the most progressive and the most deserving of respect.'[53]

5.3 The law and the movement of women

As early as 1911, the government of Basutoland enacted a law to prohibit the sale of *joala* in order to control 'brawling and disturbances'. Police were encouraged to catch liquor sellers with the promise of a reward – as much as half of any fines collected.[54] Such measures were not specifically directed against *matekatse*. However, they did in practice tend to hit women hardest. Ironically, this kind of repression may have actually driven some women over the border and contributed to the growing exodus of women to 'greener pastures' in South Africa. When the under-standing between the Orange Free State and Basutoland with respect to the capture and return of female runaways was annulled in 1914 the problem threatened to spin out of control. The Basutoland authorities therefore decided to adopt an ambitious strategy to restrict the movement and economic activities of *matekatse*.

The Resident Commissioner first proposed to the chiefs to enact a law 'that would make it an offence for a girl or a woman to leave the country without the permission of her father or husband'. The new law would be modelled upon Natal's Native Pass Regulations, notorious among Basotho men whose lives had been made miserable by them when tramp-ing to Durban. To assuage their concerns, the Resident Commissioner informed the BNC that his proposed law would be 'more directly against the women themselves' than in Natal. This assurance was greeted with cheers by the Council members and praise for Britain as 'deliverer of the Basuto'.[55]

The Basutoland Native Women's Restriction Proclamation (BNWRP, Number 3 of 1915) was immediately drawn up to enter the statute books the following year. Its preamble declared that it was 'expe-dient to prohibit native women residing in the Territory from leaving the Territory against the will of the husbands, fathers or natural guardians as the case may be'. Women desiring to travel to South Africa would there-fore require written permission from their chiefs in order to qualify them

for a pass. Without such documentation – and police were empowered to demand it of any black woman they happened to suspect – women were liable to a fine of '£5 or in default of payment to imprisonment with or without hard labour for a period of three months'.[56]

The promulgation of this unprecedented law came with considerable risk. An attempt to impose pass laws on women in the Orange Free State had evoked a storm of protest there and had been abandoned only two years before. Moreover, as we have seen, the chiefs were far from clear about the benefits of restricting women's mobility. Vocal cheers notwithstanding, they were not at all unanimous in their support for the legislation. Even an advisor to the Paramount, presaging deep divisions within the ranks of Basotho patriarchs on this matter, warned the chiefs that the BNWRP would only exacerbate social tensions: 'some will blame you, Sons of Moshesh, some of these women will say they have no blankets, they have no homes, or are denied conjugal rights'.[57] A further risk was that 'Mrs. Pankhurst' (the feminist lobby) back in England might hear of it. The threat of embarrassment in parliament was real enough that the Colonial Office quite consciously sought to keep the legislation out of the public eye.[58]

As it transpired, no immediate scandal arose. Neither, however, did the BNWRP live up to the intentions of its creators. In part this was due to the almost complete impossibility of enforcement of the law. Not only did the government lack the resources to go searching for, to identify correctly, and to capture the accused runaway, but transporting her back across the border against her will (and quite possibly against her employers' wishes) remained illegal. Even if the dirty work of 'arrest' were done by the concerned Basotho men and the truant woman were physically produced in a Basutoland court, it proved virtually impossible to secure a conviction against her. Explaining his powerlessness in this regard to the Paramount Chief in 1929, the Resident Commissioner asserted that the law could only be enforced 'provided the applicant himself has been blameless in the matter'. If the husband had given his wife just cause to desert (such as neglect, adultery, excessive violence, or 'causing her to be the village whore'), the woman was fully within her rights to leave him. Under Roman-Dutch law, she even possessed the right to take her children with her.[59] The BNWRP could do nothing about it.

The BNWRP as framed also did nothing to prevent women from using a legitimate pass to go shopping in the border towns as licence to spring onwards to the Rand where they then disappeared. It also proved remarkably easy for women to obtain forged or otherwise fraudulent documents. Poor white farmers across the border reputedly cashed in on the demand by selling passes to Basotho women.[60] For those willing to

risk travel with no documents at all, it was easy enough simply to walk across the unguarded mountain passes or fordable rivers which divide Lesotho from South Africa. As before, the law did nothing whatsoever about chiefs who said one thing yet did another. A typical case occurred in 1928 when it was rumoured that the Orange Free State might try again to impose pass restrictions upon Basotho women. Far from greeting this as finally making it possible to enforce the BNWRP, Chief Mokhele wrote to the Resident Commissioner that 'this has frightened me'. He had to be politely reminded that several years previously it was the chiefs themselves who had requested the imposition of passes.[61]

New laws were enacted in successive years to strengthen the coercive powers of the colonial state to plug these loopholes. Proclamation 25 of 1922, for example, enabled police raids to round up anyone in possession of liquor with over 2 percent alcohol content. The contraband, usually called 'Hiki' or 'qhadi', was destroyed and the women either fined (up to £15) or imprisoned (for up to three months with hard labour). Proclamation 32 of 1928 was also useful in harassing 'loose women' by forbidding a woman to 'wander from her village without lawful occasion or excuse'.[62] If a woman could not produce proof of her husband's or guardian's permission to be away from home, or if she defied an order to return to her village, she was presumed to be 'idle and disorderly' and hustled back to the rural areas. There, Paramount Chief Griffith's 'great activity and considerable ruthlessness [to] suppress canteens' earned him the warm appreciation of the administration.[63]

Again, however, these measures entailed mounting political as well as financial costs as the numbers of women involved continued to rise. Basotho progressives took particularly strong exception to a policy that put their own respectable wives and daughters at risk of police harassment. *Batsoelopele* therefore joined with some of the chiefs to protest the victimization of women brewers within Lesotho. For example, in 1916, Simon Phamotse and other commoners living in the village of Hlotse pleaded for the government not to close down canteens there. A people, they argued, must be allowed 'to increase the profit of the sale of its produce from the land' or else it will never 'progress'.[64] In a subsequent petition, they maintained that the canteens must not be harassed: '[I]t is our food and the means of our self-helping, as it is where we poor people get our living.'[65]

This issue also became one of the pet grievances of Josiel Lefela and the Lekhotla la Bafo (LLB). Although the LLB was marginalized from power, Lefela was highly articulate and had connections outside Lesotho (notably the South African Communist Party) which could be intensely embarrassing to colonial officials.

The strategy of repression was not only costly in terms of popular goodwill towards the government and in compromising the authority of ineffective chiefs. Even the enhanced coercive powers of the state proved laughably ineffective. The women who were caught perjured themselves, they got friends and family to assist them in evading the law, they even managed to persuade Basotho constables to look the other way. This cost the administration dearly in image. Indeed, with all its panoply of new laws proving incapable of repressing *matekatse* activities, European police and judges by the late 1920s were coming into as much or more disrepute as the chiefs on this issue. 'Our present means of dealing with these women is hopelessly inadequate', complained the Assistant Commissioner of Maseru in 1928. 'It is the proceedure [*sic*] here – a periodical clearing out by the headman and police of the prostitutes – and these return at night. It is a most unsatisfactory and undignified performance.'[66]

A decade later, the Resident Commissioner explained that 'police have had a very difficult time in this work because whenever they closed this beer shop today another one was opened the next morning and the following day again another one'.[67] The flagrant and disrespectful attitude of women accused of vagrancy, prostitution, or illicit brewing even called into question the majesty of imperial authority: 'Five buxom ladies were put in the dock beaming all over and quite prepared to pay the fine as they could well afford to out of the profits.'[68]

Such hardcore *matekatse* could be incorrigible: 'One embarrassing situation I found as Assistant Commissioner Maseru [admitted J.H. Sims in his memoir], . . . was sentencing these buxom wenches for breaches of prison regulations . . . [W]hen I looked severe and put them on short rations or some minor punishment, they roared with laughter and marched out!'[69]

5.4 Conclusion

Basotho women of all classes left their proper homes and rejected their ascribed roles as women from at least as early as the 1850s. By the 1880s, their ever-more audacious behaviour was an offence against propriety as expected in Sesotho, in Christian ideology, and in secular colonial opinion alike. Lamenting this brought British and Basotho men together across race and class lines. Colonial officials in Basutoland and the Orange River Colony, white traders, and senior Basotho chiefs arrived at a cosy and profitable consensus in 1884 predicated on the need to stop women's independent movement.

As time passed, however, Basotho women's 'looseness' increasingly threatened the status quo. By the 1920s, female migrants outside Lesotho at any given time were a substantial minority of the total population (one in six) even compared to world standards of male migrancy. The adminis-

tration was increasingly placed in the degrading position of attempting to control Basotho women's movements when neither the traditional patriarchs behind nor the South African government ahead, cooperated. The women themselves were ever-more brazen in flaunting the laws of the Empire, giggling before the august presence of the magistrates and ingeniously, mendaciously evading the police. The need to deal more effectively with such behaviour and to contain the damage perceived to be caused by *matekatse* ultimately spurred the government to rethink its relationship with the chiefs and to develop a more efficient, 'modern' administration.

Gender and the modernization of the colonial state

The Great Depression hit Lesotho and the region with calamitous impact. First came a catastrophic drop in the world market prices for Lesotho's chief commodities. Export earnings fell by nearly two-thirds between 1929 and 1931. Over the same period, government revenues fell by a quarter. At this moment of economic crisis, the assertively nationalist regime of General Hertzog gained power in South Africa and began to apply often crude political and economic pressure upon its neighbours. State subsidies to commercial agriculture in South Africa increased by 400 percent over the 1930s, virtually eliminating the already slim opportunities for Basotho farmers to export their grain surplus and even to sell locally. South African monopolies on the transport of labourers to and from the mines were tightened to exclude Basotho wagoners. To add to these pressures, severe drought and famine in 1933 caused an estimated 35 000 to 40 000 deaths from starvation, typhus, and a host of other new, poverty-related diseases, including an unprecedented outbreak of bubonic plague. The territory became, in Sir Alan Pim's words, 'a desert'.[1]

Under such conditions, the number of Basotho who left the territory increased dramatically. By the late 1930s, female migrancy in particular was rising 'alarmingly' each year.[2] The number of women from Lesotho on the Rand alone was estimated to be as high as 30 000 or 10 percent of the territory's total female population, while over the decade from 1936–46 the female population remaining in Lesotho actually dropped by over 5 000.[3] As before, such female 'looseness' was blamed for men's deteriorating health, violence, rural impoverishment, loss of tax revenues, and bringing imperial and Native authority into disrepute. Problems which had been worrisome in the past, however, now threatened to spiral entirely out of control. One confidential government report on the exodus of Basotho to South Africa concluded that if something radical were not done to anchor Basotho women more firmly at home, Basutoland could expect annually to lose £100 000 in lost tax revenue, £250 000 in lost remittances from men in South Africa, and up to £500 000 lost in the value of goods brought back to the territory by migrants. Loss of revenue on this scale would quickly bankrupt the government, would depopulate

the territory by half, and would bring British colonialism into serious discredit before the international community. Indeed, the economic and social crisis in Basutoland was used by the South African government to justify its demands for incorporation of the territory into the Union, demands which had to be resisted at the highest level of diplomacy.[4]

These events combined finally to shake the colonial government out of its complacent belief that tinkering with laws and making occasional stern speeches would suffice. A commission of inquiry was launched, headed by Sir Alan Pim, into Basutoland's financial and economic condition. Almost immediately following the publication of its recommendations in 1934, the government embarked upon a two-pronged strategy to lay 'the foundation for the regeneration and rehabilitation of the country' (as the government grandly phrased it).[5] On the one hand, administrative reforms were introduced with the intention of doing away with the perceived abuses and inefficiencies of the old system. On the other hand, the state embarked on a Keynsesian programme of economic development, principally focused on containing soil erosion. Gender was a central, if understated, aspect of both these 'modernizing' initiatives.

6.1 The chief problem

By the mid-1920s, the British had begun to realize that parallel rule as it had been constituted since 1884 was not working. The system seemed to be abetting a 'thirst for cash' among the chiefs resulting in abuses of power, in proliferating, byzantine disputes over succession and placing, and in a growing loss of confidence in colonial authority. Unwilling and unable to challenge the other structures which were contributing to the breakdown of social harmony (above all, inordinate levels of male migrancy), the government grew increasingly irritable with its ostensible collaborators. After half a century of assisting the Bakoena to consolidate their position as the preferred local rulers, the British faced a group of men and women who could not or would not maintain social order, who could not or would not consistently enforce either law or their own 'traditions', and who could not or would not agree to even the most benign proposals for reform. An initial attempt in 1927 to bring the chieftaincy more into line with indirect rulers elsewhere in Africa was simply rejected out of hand. In the Pim Report's terms, parallel rule as it had evolved allowed the senior Bakoena chiefs to exercise their authority 'in a state of detachment unknown in tropical Africa'.[6]

The stubborn opposition of the chiefs to agricultural improvement was a case in point which became increasingly worrisome as the highlands were opened up to settlement. Excellent pasture land was rapidly being degraded by the plough and the poisonous weeds which followed. Yet the chiefs either did little to protect this land or else they exacerbated

the problem. Notably, chiefs were opening hitherto sacrosanct *maboella* lands to short-term exploitation. The resultant erosion was physically wearing away the long-term capacity of the colony to support its population.

Another major disillusionment the colonial regime felt with regard to the chiefs was their inability or unwillingness to enforce their legal powers over women. The chiefs themselves had for decades requested that these powers be clarified and enhanced by colonial law. Government officials had been very solicitous in this regard, risking international criticism and incurring considerable expense to hunt down and punish 'loose women' at the request of aggrieved Basotho men. Yet the chiefs were utterly unreliable in holding up their end of the deal. Despite their constant complaints about runaway women, and despite their sometimes brutally sexist language, many chiefs actually seemed to be encouraging women's non-traditional behaviour. Some even rebuked the British for the unfairness of colonial laws to women. Tellingly, after decades of pleading for stricter crackdowns on *matekatse* by both the Basutoland authorities and South Africa, when such a crackdown appeared to be imminent the chiefs voted overwhelmingly against it.[7]

What made the chiefs so 'corrupt, fantastic, deficient, inefficient', as one exasperated official later described them?[8] The government, in fact, itself provided some of the strongest incentive in this regard by, for example, rewarding chiefs who evicted widows from their lands and replaced them with tax-paying males. The chiefs were also given compelling material and social reasons not to be too strict about letting women leave their villages. In cases where a widow was evicted from her fields, the chief remained ultimately responsible for her welfare. The same applied in cases where migrant husbands or sons disappeared or otherwise failed to support their wives and mothers. If the woman stayed in the village her very destitution was a source of shame to the chief. Such women could be quite active in demanding that the chief live up to traditional obligations, including by such customary means as *mathuela* or spirit possession. Chief Malebanye, in calling for fairer laws which would protect women from impoverishment and harassment, put it this way: 'Women are very weak people and if there should be any differentiation in their treatment they will soon begin to grouse and you will hear the noise that will be made.'[9]

Since fairer laws were not forthcoming, the chiefs had an economic interest in seeing destitute women either remove themselves from the district or support themselves by whatever means. This lay behind the chiefs' repeated requests to the government for the introduction of compulsory deferred pay from migrant labourers as well as their proposals for draconian punishments against men who failed in their familial obliga-

tions. The chiefs' responsibility to the poor also lay behind their willingness to tolerate, if not actively encourage, women who pursued alternative survival strategies. Along with the LLB, chiefs tended to be the most vigorous defenders of the rights of poor women, especially widows, to brew and sell liquor. As early as 1916, one chief took the Resident Commissioner to task for pressing the chiefs to crack down on 'bad women' flocking to the camps. In Chief Josiel's words: 'Although I do not drink, yet I think people should be allowed to sell their beer so that they may live. When the country is full, people will do worse things than the sale of beer.'[10]

Chief Qhobela Joel went even further in a subsequent debate in his request for tolerance of women's rights to live by whatever means they could. He gently pointed out the hypocrisy of the British enthusiasm for restricting the sale of beer:

> Sale of beer is not a custom of the Basuto, the practice has been borrowed from Europeans who sell liquor in their bars. The people continue selling beer because this helps those who cannot earn a living otherwise, such as widows. Although fights result, some protection should be given to the poor and the weak who can no longer work for themselves.[11]

As well as this *de facto* encouragement of women's 'looseness', the chiefs also abetted the expansion of women's *de jure* rights under Sesotho, albeit probably unwittingly. Under the system of parallel rule chiefs had an incentive to maximize their income by hearing cases or appeals by women which had hitherto been dealt with in family or women's court. As G.I. Jones later expressed it, by '[d]eveloping the money making side of his [their] office', chiefs were actually encouraging women to litigate so that they could reap fines from abusive or negligent men in the process.[12] Women certainly took to litigation with gusto, constantly pushing the envelope of custom. And for all their apparent traditionalism, the chiefs often proved surprisingly willing to condone innovative interpretations of women's rights and to frustrate colonial efforts to codify Sesotho definitively. One of the most striking examples of this came during the 1937 BNC debate over whether widows should be allowed to receive cash compensation for husbands who had died in the mines (the motion was that such money should instead go to the parents for otherwise the widow might use it to run away). Chief Malebanye was eloquent in rejecting the motion *in the name of custom*. To restrict widows' freedom, he argued, would be an offence against their traditional right to make decisions as more or less honorary adults:

> I do not see why the widows should not receive the estate of her husband as compensation ... The woman who leaves her house and

goes to Johannesburg is still under her first husband's people even if she bears an Indian child in Johannesburg. According to the law, the woman should use the estate of her late husband with her husband's relatives. *It should not appear as if something other than the usual procedure should be adopted in the case of money.* Though the motion is not quite pointed it would seem to me that the suggestion is that these monies should be paid to the parents of the deceased. But this cannot be because even the livestock do not belong to the parents but to her husband. *She had every right to the money to use in consultation with her husband's people.*[13] (emphasis added)

Chiefs may in such cases have had their most sectarian class interests at heart when defending women's non-traditional behaviour. In the case of sons of polygynists – the large majority of chiefs at this time – they could find themselves responsible for literally dozens of dependent 'mothers'. Some of these women may well have been involved in court intrigues while, as widows, their comparative sexual licence caused scandal and the proliferation of 'illegitimate' children. These children actually belonged to the chief whoever their biological father may have been. The fact that they could have commoner blood, however, added a potentially dangerous element to succession disputes. In such cases, a chief would be relieved to see his (or in the case of female chiefs, her) father's widows (or co-wives) leave the territory. He or she might even encourage them to do so by neglect or active abuse. Several impassioned debates arose in the BNC on this subject of neglected women. In 1932 Leloko Lerotholi, for example, inveighed against his fellow chiefs:

> I don't understand a woman roaming about as if she is a pig . . . Women should not be neglected for no reasons [*sic*]. A daughter of a Chief has to return to her people, what a disgrace it is when she gives birth to an illegitimate baby. This child will claim that he is the heir because his mother was not divorced. Troubles begin, and ill-feeling because people know that he is not of their blood. All this is the result of neglected women. I do not refer to the children of Chiefs only; at present in all villages of Basutoland you find a loose woman who has deserted her husband . . . Our country should not be turned into a country of whores.[14]

A final factor contributing to the chiefs' unwillingness or inability to impose their patriarchal authority was their recognition that women had outgrown the fictive childishness of custom. They were now sometimes formidable 'political' actors in the broad sense of the word. As early as 1914, Chief Mokhethi warned both his fellow councillors and the British against underestimating women's role in promoting such practices as

chobeliso. 'Do not look upon girls as animals, they are also responsible human beings. There are some bad women who teach our small boys bad things, these women should be punished and not the boys.'[15] By the early 1930s, the behaviour of some of the women involved was so outlandish and unruly, and the breakdown of traditional *hlonepho* or respect so great, that many Basotho men were confounded. Women in the camps swore, they shamelessly mocked authority, they even carried knives and used them. In 1930, for example, it was reported that a female brewer had actually killed a customer for not paying for his beer.[16] Hut-burnings, poisonings, stabbings, while often between female rivals for men's attentions, exacerbated men's sense of loss of control over their 'children'. Women's provocative behaviour was also blamed for the dramatic rise in the number of homicide cases – from 25 in 1931 to 156 in 1934.[17] These murders were almost entirely men killing men, but the violence was seen to be sparked by women. As Chief Moloko Bereng explained at the start of the 1932 session: 'These women who have no husbands are responsible for many cases of bloodshed', above all, by inviting 'interference' (that is, sex) with rival men. Thabo Lechesa concurred: 'This matter of women is getting very bad.' Fellow chief Bolokoe Potsane straightforwardly demanded of the Resident Commissioner: 'There should be a law on this subject to protect us in connection with our wives.'[18]

Fear of women's potential for violence had its clearest expression in the BNC session of 1936. In that year a plague of rats proliferated throughout the territory and the government proposed to distribute rat poison to every farmer in Lesotho. During the debate which followed, several council members worried that women would use the poison against their husbands.

> MAKHOBOALO THEKO: With regard to poison for rats, we request that it should not be issued to Basotho women . . . We say that women have weak hearts and can finish off the whole nation if they be given the poison.

> LETLASA THEBE: Though we live with women, they have strange manners . . . you may have occasion to rebuke her and if she knows she has poison she may use it.[19]

In even raising this sensitive issue, a number of chiefs worried that their words would return to haunt them. Chief Sekhonyana appraised them of reality: 'Some people say we should not discuss this matter lest women hear it. Just now as we leave the Council, they shall have known it. Even those that are not in Maseru read newspapers.'[20]

The Resident Commissioner's amenability to the paranoia of a few senior chiefs in this debate is almost as remarkable as the chiefs' fears

themselves. In response to Chief Thebe's request, he hastily agreed: 'An order can be given that poison is not to be issued to women. (LELOKA: What about widows?) It could be ordered that no women except widows should be given poison.' Only after the majority of Basotho councillors had discredited this idea as impractical and discriminatory to women did the Resident Commissioner agree to drop the matter.[21]

6.2 Parallel rule to 'indirect rule'

Before examining the specifics of the administrative reform movement it is important to reiterate that truly substantive reforms were ruled out from the beginning. Throughout the 1920s Basotho progressives and their missionary mentors had argued with increasing vigour for the introduction of private property and the full panoply of Western political rights and cultural mores, including the abolition of the chiefs altogether, the breaking of the white trader monopoly, and the emancipation of Basotho women from oppressive laws and customs. These *batsoelopele* were willing and eager to assume an active role in addressing the territory's social and economic problems. Yet their ideas were patently untenable from the British perspective. Indeed, progress in *batsoelopele* terms would open the way for an 'unbalanced section of the population' to acquire wealth and influence to the supposed detriment of 'social stability'. Particularly worrisome from the British perspective was the possible emergence of a 'Cleon' – a demagogue of commoner background and potentially Bolshevik politics.[22] With the goal of preventing this from happening, Basutoland authorities clung to their belief that 'traditional' chiefs could be made to 'evolve on lines which are not open to such easy attack and just criticism' as they then were. By bringing the system of government in Basutoland in line with indirect rule as it was deemed to function in Northern Nigeria and Tanganyika, they hoped that 'tradition' could be 'harnessed as an instrument of progress':[23]

> We want to strengthen the Chieftainship and do away with the causes of complaint against it. We consider the Chieftainship as the cement binding the Nation together. We want to work with and through the Chieftainship and to strengthen it; not destroy it nor substitute something else in its place.[24]

The first attempt at reforming the chieftaincy actually came as early as 1927. In that year, Resident Commissioner J.C.R. Sturrock proposed sharp limitations on the numbers and judicial powers of the chiefs. The latter included replacing the chiefs' customary right to retain court fines by their payment directly to the government, and abolishing the payment of fines in kind. To compensate for this loss of revenue, approved chiefs

would be paid a salary, bringing the Native Administration in line with 'all nations as they progress'.[25] These proposals were quietly shelved in 1929 in the face of near-unanimous opposition from the chiefs and the LLB.

The Great Depression provided a new opportunity to pick up the reform agenda once more. Pim's investigation at this time revealed not only the depth of the territory's malaise but also the close connection that existed in the official mind between that malaise and the 'looseness' of Basotho women. The Resident Commissioner, for example, from whom Pim drew heavily to formulate his recommendations, seemed almost nostalgic for the lost old order. He bemoaned the 'immorality' of the Basotho in general, but praised the virtues of the Tembus (an ethnic group in the south-east of the country notorious for their resistance to Christianity and their continued loyalty to the practice of large-scale polygyny). He also maintained that the modern Mosotho male suffered from the demise of 'pagan' initiation schools:

> The old hardening processes of the school which formed their chief merit are not continued. Discipline is no longer knocked into the pupils, and the Mosotho emerges having learned a lot of filth but no restraint, full of himself and the idea that he is a man and can take his place in his tribe as such. In reality, he is a callow youth, with no sense of responsibility and ignorant of what his new status implies.[26]

It was, of course, impossible for the British publicly to advocate bringing back lapsed pagan rituals. What could be done, however, was to subject the chiefs to formal bureaucratic discipline and structures. These were designed to provide clear incentives for the chiefs to adhere to the law and to pass the requisite discipline down the line to their subjects. To the satisfaction of the administration, therefore, the Pim Report essentially resurrected Sturrock's earlier proposals. Acting Resident Commissioner J.H. Sims then informed the High Commissioner in 1935 that a chieftaincy reformed in this manner promised an effective means to accomplish the long-desired objective of keeping migrant labourers, women, and beer apart:

> In the past efforts have been made to get rid of the menace of women of ill-repute by having them removed to the villages not far from the boundaries of the Reserves where they have been able to continue their practices with little or no interference by the Headmen of the villages. Once the proposed system of indirect rule is introduced, it should be possible to exercise more control over persons of this type.[27]

It took three years of intense pressure, enticements and compromise to win Paramount Chief Griffith to the cause of reform on these terms. The first step was the Native Administration and Native Courts Proclamations of 1938. These reduced the number of chiefs from 1 331 to 107 and abolished the practice of placing. Subsequent proclamations included the introduction of 'advisory and consultative' District Councils (1943), the institution of payment by salary through a Native Treasury (1946), and the compulsory appointment of government-vetted advisors to the Paramount Chief (1949). In 1950 the chiefs' power to call *matsema* (compulsory labour) was abolished, while in 1954 the number of gazetted and salaried chiefs was further reduced to 63. In these ways, the British reformists believed that they were transforming the chieftaincy into a rational, disciplined, authoritative – in short, manly – institution. With such men at the helm of local authority, the territory could once again become a model for the whole region. 'If we press on with our policy we have an opportunity in Basutoland of showing others, including the Union of South Africa, what modern British policy can make of a proud and progressive African people.'[28]

At the same time as a bureaucratized chieftaincy was constructed, more 'efficient' laws were introduced to empower the chiefs to crack down both on agricultural offences and on the creeping liberalization of Sesotho. With regard to the latter, ambiguities in customary law which Basotho women were interpreting to their advantage were tightened up, removing the leeway for innovation which women and chiefs were using to their advantage. In addition, women's ability to move between customary and Roman-Dutch law in pursuit of favourable legal decisions was restricted. For example, in 1938 the Resident Commissioner stated that from then on custom (according to the codified version) took precedence over Roman-Dutch law in ambiguous cases. In practical terms this meant that even if a woman had been married in church and lived in a demonstrably Christian manner, she was barred from pursuing a case in Roman-Dutch law if any cattle had been exchanged. In a similar vein, the BNC approved an amendment which made it illegal for widows to remarry unless they had originally been married by Christian rites (that is, regardless of whether they had since converted to Christianity). The Resident Commissioner disingenuously expressed his satisfaction with this hardening of the law against women's freedom: 'I am sure that no Church or District Officer would wish to perform a marriage which is against native custom, and, therefore, this amendment should be welcomed by everybody.'[29]

'Me Mamosala was one of the first victims of this process of legal tightening up. She argued in 1942 that she should not be subject to her son as her guardian on the grounds that she was a Christian and therefore

(she felt) not subject to customary law. Moreover, she was an independent woman: 'Mosala cannot state anything which he did for me all his life, even a stick of matches to scratch my ear.' The court rejected both arguments. Since she had married with cattle, she had to obey custom, and she was ordered to obey her son's wishes.[30]

Even in cases of simple interpretation of customary law, the colonial administration commonly took an interventionist stance to ensure that 'tradition' be adhered to. This could be taken to extremes of injustice, not to mention the absurdity of British officials overturning the decisions of chiefs who erred against 'tradition'. For example, in 1943 *Mofumahali* Mamohlalefi Bereng had ruled that the daughter of a widow should be allowed to inherit half of the latter's property in recognition for her long years of providing care to her mother. The other half of the estate was given to the proper legal heir, a nephew who had totally neglected his customary responsibilities to the widow. The daughter appealed against this ruling, seeking the full inheritance on the grounds that she deserved it. The High Court first rejected her non-traditional argument for deservedness and then over-ruled Mamohlalefi's compromise decision. The full inheritance was awarded to the man since under codified Sesotho a daughter could never inherit anything.[31]

Over the years, there were many other such cases. Women were chastised by the colonial courts for 'using unnecessary force' to defend themselves from violent husbands,[32] for ploughing without first getting their guardian's permission,[33] or for causing their murderous or child-stealing husbands 'extreme provocation'.[34] 'Manako, a widow who accused her son of disposing of the family sheep without consulting her (as was, in fact, his moral obligation under customary law) was upbraided by the judge for asserting her rights: 'It is not in order for you to speak in that manner', he declared before ruling against her and throwing her case out.[35] At other times, colonial magistrates even supported the right of the husband to use violence against his wife. After being ordered to go back to her husband, despite scars and witnesses to the severity of the beatings he had given her, Emma Teiso scoffed at British justice: '[These] assaults prove that a person should live like a slave if at all she were married . . . The court says it is not an uncommon thing among the Basotho women to have quarrels with their husbands. Is this the protection which the court exercises to us the women of Basutoland?'[36]

Nor were the British shy about informing the Basotho what their 'real customs' were. In some ways this worked to women's advantage, as in the courts' tendency to support the withering away of forms of marriage which exposed women to exploitation as pawns – compulsory *kenela*, for example, or *ho ngala lebitla* ('marriage to the grave'). Many such 'customs' had in fact been invented or embellished by ambitious chiefs since

Moshoeshoe I. Interestingly, in supporting their demise, and in other cases by making women's rights in Sesotho more explicit, the colonial courts were often only responding to trends and pleas emerging from the chieftaincy, reinforcing (not initiating) 'an indigenous tendency to turn against the "exotic" forms of marriage'.[37] For example, Chief Justice C.W.H. Lansdowne in 1942 countenanced 'Mantsebo's refusal of *kenela* on the basis that it was a 'dying and decadent custom' (and from this ruling it followed that women could hold administrative office, act as guardians of children and control and administer property as legal adults).[38] Subsequently, the government recognized widows as an 'other relative' with legal rights to property but again only after being urged to do so by the BNC. Chief Samuel Matete had led this debate saying that women were 'crying for justice'.[39] When the Judicial Commissioner finally admitted that 'pagan' women should be allowed to appeal cases against their husbands to the colonial courts, he conceded that he was simply extending *de jure* what was already *de facto* commonplace: the 'native Courts are full of cases of a wife suing her husband for maintenance'.[40] In other words, it was embarrassing for the modern colonial state to appear to be less liberal than the traditional court system.

Yet the colonial courts' rulings on custom could also work against women. 'Woman-woman' marriage, for example, which in many cases served the interests of widows by providing them with heirs and labour, was ruled to have 'insufficient evidence in custom' in 1950.[41] The High Court sometimes even rejected the advice of its own Native Assessors if it deemed them to be too liberal-minded on the question of women's (and youths') rights. The Native Assessor was generally relied upon both to interpret from Sesotho to English for the magistrate and to render trustworthy accounts of legal or customary precedents among the Basotho. Yet in at least one case the judge rejected his Assessor's interpretation of Sesotho, the woman's argument, *and* her subsequent appeal. The woman, a widow, had come to court seeking compensation from a man who had seduced her daughter. The Assessor had advised simply and uncontroversially that 'a widow in this position has a right to claim damages. She takes her husband's place and is in the same position as a man.' The judge, however, ruled that because she was not living at her late husband's kraal, as should have been proper under Sesotho, she forfeited her rights. She, not the 'seducer', was culpable.[42]

Colonial magistrates were clearly not uniformly reactionary nor did their rulings in individual cases reflect a coherent policy. The liberal tendencies of colonial rule and reform were, however, fundamentally compromised by often unconscious sexist assumptions and anxieties about women. No issue revealed this as clearly as the march of women into the chieftaincy.

6.3 'A woman is a woman': the problem of female chiefs

The ambitious attempt to strengthen or modernize the chieftaincy did not succeed for several reasons. First and foremost, Pim's other key recommendation was never acted on – massive investment in economic development. The fact that the men in charge of modernizing the chiefs tended themselves to be rather feudalistic in mentality did not help the matter. As Lord Harlech, the assertively reformist High Commissioner during the Second World War assessed his Basutoland staff in 1942: 'The spirit of Lugard, Clifford, Cameron and Hailey has not yet reached them. They are in some cases too set in their ways to change in their declining years.' It seems that the local representatives of imperial authority and the modern world were, even to the eyes of their superiors, 'an inherent brake on the wheels of true progress'.[43]

Ultimately, however, the chiefs could not be reformed because they did not share the same narrow, masculinist vision of efficiency to which they were being urged to conform. The British may have sincerely believed that the chiefs were 'corrupt, fantastic, deficient, inefficient' but the fact is that their own notions of efficiency and justice were hardly less so, particularly when it came to matters of women and gender. The 'feminization' of the chieftaincy brought this most dramatically to the fore, and, indirectly, became a crucial contributing factor to the collapse of indirect rule.

Women had been appearing as 'caretakers' in growing numbers since the 1920s, acting as regents until their minor sons were old enough to become chiefs. This practice was well-known to have a long pedigree in history. 'Manthatisi was the most famous case (a powerful regent from 1813–22) but there were precedents even before her in the late eighteenth century.[44] The increase in the frequency of female caretakers in the 1920s was therefore originally of no particular concern to the British, for whom the marital and succession affairs of the Basotho were best left alone. While they noted that some of the new female regents were clearly incompetent or passive tools of scheming men, this was also true of some male regents. Female chiefs therefore seemed to be no more than yet another eccentricity of the 'Natives', and tolerance of them reflected well on the beneficence of imperial rule. By the mid-1930s, British officials were even finding cause to praise the work of female regents. Ma-Lerotholi was singled out for particular praise in 'Confidential Reports on Native Chiefs in Basutoland (1935)', while 'Makopoi, according to no less than the High Commissioner 'performs her many duties with success, esteem, and distinction'.[45] Judge Lansdowne interviewed ten female chiefs in 1942, finding them all of 'acute intelligence' and 'in no way . . . in a subject position'.[46]

This tolerant attitude towards women in the chieftaincy was possible up to the early 1940s because they comprised only a tiny minority of mostly minor chiefs. Female chiefs were also generally at least as well regarded as male chiefs among the Basotho. Of 'Makopela, for example, her fellow chief Jeremiah Moshoeshoe had this to say: 'There is not one man in the Mafeteng district who can say he conducts matters better than that woman. She can be pointed out in the forefront of men.'[47]

Indeed, women chiefs were 'men' in social terms. Their rights and dignity stemmed from the office and the relationships inherent in the institution of chieftainship rather than their biological femaleness. When 'Mantsebo became regent she emphasized this by insisting that she be addressed as *Ntate* (Sir).[48] When her authority was challenged by the senior Bakoena widow, Mahali, she explained: 'I call myself a man because I am the Paramount Chief . . . You are my wife because I was married to you by my father. I say you are married to me because I have taken the name of my husband your father and therefore all the upkeeping should be in my hands.'[49]

This assertion of 'manhood' was definitely not because of menopause: 'Mantsebo was a young and sexually active woman when she took power. This distinction between biological femaleness and social manliness may have allowed women to encroach upon the chieftaincy seemingly almost unnoticed. When finally asked to clarify the matter of women's right to rule as chiefs even some of the strongest opponents felt compelled to recognize a *fait accompli*. Women, rued Kelebone Nkuebe in 1949, had been acting 'contrary to custom . . . for at least fifteen years . . . [and] . . . have acquired rights which they did not have before'.[50]

For the British, tolerance of such quirky Basotho attitudes began to wane with the death of Seeiso Griffith in 1941. Since his designated heir was only two years old, a 'caretaker' was required. Seeiso's brother, Bereng, stepped forward claiming the customary right of *kenela* over his brother's widow, Amelia 'Mantsebo Seeiso. She, however, refused to be *kenalaed* and claimed instead the right to act as regent herself. The British strongly advised the senior chiefs against this and not-so-discreetly put their weight behind Bereng's claim. To their surprise, a large majority of the senior chiefs took 'Mantsebo's side, nineteen of the twenty-two Sons of Moshesh voting in favour of her accession to the regency. The dispute dragged on through a High Court appeal by Bereng but this too ruled in her favour in 1942. As Lord Hailey put it, a female regent 'was pressed upon us'.[51]

The British at first treated this development phlegmatically, assuming that 'Mantsebo would be a mere figurehead and that they would continue to deal primarily with her male advisors in pushing ahead with the re-

forms. Moreover, despite his concerns about the (unspecified) 'problem of women regents', the High Commissioner was compelled to admire 'Mantsebo's 'tact and dignity' through the sometimes bitter early challenges against her.[52] Rather quickly, however, the British were disabused of such tolerant views, and their worst prejudices and anxieties about women came to be realized. To begin with, and to the evident dismay of colonial officials, 'Mantsebo did not passively go along with the administrative reform proposals. On the contrary, when the British put forward their plans for a Native Treasury she persistently 'obstructed', 'sabotaged' and 'evaded' them. Between 1942 and 1945, surprise at her resolve grew to frustration and anger, driving experienced British officials literally to apoplexies of rage. At the same time, she kept demanding increased and sometimes entirely new powers. For example, she requested the right to veto *all* proclamations affecting the territory (including the taxation of Europeans, customs duties and the maintenance of law and order in the Government Reserves, areas under exclusive colonial administration).[53] To the fury of the Resident Commissioner, she even raised the issue of self-government for Lesotho with a direct enquiry to the Colonial Office on how the Atlantic Charter would be applied to Basutoland.[54] 'Mantsebo also publicly questioned the sincerity and integrity of the British by, for example, insisting on airing the reform proposals for public consideration and seeking outside advice or mediation (including from the United Nations, the Fabian Africa Bureau, and even King George himself). By doing so, she betrayed the 'old boy' rules of informal chats to decide the future of the colony which had worked so well to bring her predecessors onside. Her insistence on keeping written records of the communication between the Resident Commissioner and herself also infuriated the former. 'It seems as if the Chieftainess definitely mistrusts me', whined the man entrusted with pushing the reforms through, Colonel Arden-Clarke. 'I may say I have spent 25 years in African administration and never before have I been treated in this way.'[55]

When the British first encountered this type of opposition to their plans, they accused 'Mantsebo of a number of crimes. Because they could not believe she was acting out of her own political convictions, they expressed the view that she was 'moulded far too much by flatterers and intriguers', and exploited by 'low people'.[56] 'Immorality' was said to be rampant at her court to an extent which disgusted and demoralized the Nation.[57] She was accused of venality in placing her own financial interests above the needs of the people,[58] 'evasion' for deliberately misrepresenting facts,[59] and 'stupidity' for failing to understand the purported benefits of a Native Treasury.[60]

In fact 'Mantsebo opposed the administration's Native Treasury proposal because she understood quite correctly that it would undermine the

traditional power base of the chieftaincy (as the British fully intended it to do, public protestations notwithstanding). She also resisted the haste and secrecy with which the British sought to enact it. In urging Arden-Clarke to go slower and to allow her to consult the population before agreeing to any changes, she expressed herself this way: 'I desire that my people should carefully study these proposals and give their views fully and openly without fear as to their true opinions on the matter. After the Nation has thus expressed its views and I shall know what these views are I shall express my final views on the whole matter when it comes before Council.'[61]

That this was not simply a stalling tactic to win greater powers and privileges for herself and the senior chiefs is evidenced by the fact that she also took up one of the principal grievances of *batsoelopele*. She urged the Resident Commissioner that he should 'prove goodwill' by advancing more Basotho to responsible positions in the Administration.[62] An outraged Arden-Clarke accused her of 'speaking against custom'.[63]

Once it became clear that 'Mantsebo would not be the rubber-stamp they had initially believed, the government tried alternatively to out-manoeuvre, to co-opt, and to cajole her. It sought first to reason and then to compel her to accept an Advisory Council of three 'responsible' men. Selected by the government, these men would 'moderate' her behaviour (that is, advise her to be more cooperative). With such a Council, declared Arden-Clarke, 'there would always be a strong, influential man in charge at Matsieng [her home village and site of her court] and the matter [of her obstructionism] would tend to right itself.'[64] 'Mantsebo simply refused to accept this interference with her traditional right to choose her own advisors. The government's approach then quickly evolved from giving her a 'heart to heart talk' to attempting to 'dress her down'.[65] She was informed, in no uncertain terms, of the full weight of British disapproval of her morals and motives: 'This will probably shake her to the core, but I have no idea what her reaction will be. I hope she will crumble up but, of course, she may not do so. If she sticks to her guns then there can be only one line of action and that is to have a "show down".'[66]

The first step towards the latter was to re-establish in protocol who was the boss, abandoning the polite diplomacy (or chivalry) which had led Administration officials to go to her court at Matsieng rather than simply summoning her to Maseru: 'She must come to me. Judging by my previous experience of the Basuto, she will come to it – but, as she is a woman, and pig-headed into the bargain, she may not.'[67] She did not, 'definite instructions being absolutely ignored'.[68]

'Mantsebo continued in this way for another year, so 'maddeningly evasive' that she seems to have unhinged the Resident Commissioner. In November 1944 Arden-Clarke drove out to Matsieng to 'put the fear of

God into her'. The man who later went on to soften Kwame Nkrumah's radical nationalism in the Gold Coast delivered an explosive, insulting face-to-face rant to the Regent that even one of his own officials described as 'deplorable tactlessness'.[69] In front of the other senior chiefs, he accused her of 'rudeness, stupidity and obstructiveness', while threatening unspecified sanctions against her and all the chiefs. 'Mantsebo nonetheless appeared to remain both resolute and 'gracefully' inscrutable: 'She may in fact have parted from him [Arden-Clarke] feeling that the victory was hers: she had kept her temper throughout and managed not to show her hand, even under extremely strong pressure.'[70]

If 'Mantsebo remained resolute, the same cannot be said of her fellow chiefs, many of whom were shocked by the intemperate language used by the Resident Commissioner. Although the senior chiefs for the most part continued to profess their strong support for her, they feared the consequences of British ire. They therefore urged her to adopt a more conciliatory position.[71] Nonetheless, she held out against the introduction of the National Treasury until 1945 (and only agreed when the proposed salaries were significantly boosted). She resisted intense pressure for the Advisory Council for another four years and even then, to the exasperation of the government, she managed to retain the power to choose her own advisors from among eighteen nominees. Throughout the late 1940s and 50s, she also continued to oppose the government in embarrassing ways on diverse issues, most crucially on anything which could be construed as advancing South African interests or preparing the territory for incorporation in the Union. In 1949 she wrote directly to King George to protest against the number of white South Africans being appointed to the Administration. She also requested a reprieve for the chiefs convicted and waiting to be executed for *liretlo* ('medicine murder'), including her former nemesis Bereng. When the British rejected her nominations for the Advisory Council – including another woman, Chieftainess 'Mamathe Masupha – she simply renominated them.[72] When the British accepted a South African proposal to build a satellite tracking dish up in the mountains, she 'just said no, no, no and the British couldn't argue'.[73] Likewise, when the British proposed to grant concessions to South African companies to begin prospecting for diamonds, she resisted with such determination that they abandoned any further attempts to develop the territory's mineral potential.[74]

This 'growing arrogance' led the British to adopt another means 'to put the fear of God' into 'Mantsebo: the death threat. Twice she was accused of *liretlo* on apparently spurious grounds, the first time only months before the execution of Chiefs Bereng and Gabashane in 1949. According to one of her advisors:

'Mantsebo understood what was behind the *liretlo* accusations, no doubt, because it happened to her as well. There was the case of Boranyi, a shepherd from Mokhotlong who came here with 'Mantsebo. He used to steal her sheep to eat at night right in the kraal. Then, when he was caught, 'Mantsebo gave him such a thrashing that he ran away. A few days later a British officer and some Basotho officials came. He said that he had witnesses to prove beyond a reasonable doubt that she had murdered this boy for medicine. They gave her one week to produce him if she wanted to save herself. After that she was crying like a child, day and night. But people were sent out all over the country until, with only 2 days left, they found Boranyi down past Quthing there. He was brought back here as fast as the horses could carry him.[75]

When the police came to arrest her, 'Mantsebo had recovered sufficiently to mock their integrity. With handcuffs already on, she had the alleged murder victim produced and said, 'Look, this is how you kill us.' The police 'did not apologize but only said well, they had been misled and just left'.[76] 'Mantsebo appealed the matter to England, including a passionate letter to the King about the 'glaring false accusations' around *liretlo*: 'Your Majesty, this attitude has grievously pained me when I find that His Majesty's servants with whom I am working appear to have no more confidence in me. Further, to ignore a deed of this kind can have no other results but to encourage evil people . . .'[77] Three years later she was still protesting to the Resident Commissioner about 'the undistinguished action pursued in general by the Government and Officers in Basutoland'.[78]

'Mantsebo's techniques for thwarting British intentions included consulting her informal advisors about every issue which came before her. Despite her inability to speak English and occasional ill health, she also maintained a rigorous (and, to the British, disconcerting) scrutiny of government actions. Thus, for example, the Government Secretary advised the Resident Commissioner not to tamper with 'Mantsebo's recommendations for the appointed seats in the BNC. '[W]e heard a rumour that the Paramount Chieftainess was watching very closely to see if we made any changes', and so, to avoid 'a major row', her nominations were accepted.[79]

'Mantsebo also employed the licence of femininity with considerable effectiveness in her dealings with the British, using methods of obstruction which only a Basotho woman could resort to with dignity: 'throwing a fit'[80] or falling into 'hysterics'.[81] Part of her 'difficulty' lay with her tendency to break into tears at crucial moments of negotiation, something which clearly alarmed the British and contributed to their perception that she was a 'very uncertain quantity'.[82] In addition, she did not always play by the same rules of logical engagement or dialectic: 'She could really

stand up to them. She would just refuse something like a woman, you know, not giving a reason but just saying no.'[83] Aubrey Forsythe-Thompson, Resident Commissioner from 1948–52, seemed particularly susceptible to these tactics. Indeed, he eventually drew sharp criticism from the High Commission for failing to stand firm in the face of 'Mantsebo's histrionics. The 'dangerous' result of this was that 'the power of Matsieng [that is, the Paramount Chieftainess]' had grown to be the territory's most outstanding political problem. In the analysis of the High Commission, Forsythe-Thompson was:

> prone to purchase peace by acceding to all her demands. In the result, the power of Matsieng has increased, is increasing and ought to be diminished. I found that the Paramount Chieftainess persistently intervened in matters that are not her concern, between the District Council and field officer on the one hand and their local chiefs and councils on the other, that she arbitrarily overrides both the territorial rights of the chiefs and agreements with the Administration, and that appeals by District Councils to Maseru do not meet with the support they should.[84]

'Mantsebo unquestionably was actively expanding her powers through the Native courts and through intervention in disputes between her subordinates. At times she placed her own close relatives and trusted advisors in key positions of authority in the wards of rivals or potential opponents. She could also browbeat her subordinates, allegedly with threats of 'medicine' obtained by *liretlo*, but more likely through judicious use of the large assets at her disposal. Among those assets were the respect and loyalty of the senior chiefs. Rather than keeping them in a state of 'fear', as the Resident Commissioner maintained, she won that loyalty by adhering to the tradition, largely abandoned by her predecessors, of consulting them on political decisions:

> 'Mantsebo – she was a leader, she was a leader. Before you take note there, listen – I mean in the Basotho sense of a leader. That is, a person who listens well and judges according to the will and advice of her people. *Morena ke morena ka sechaba.* The Paramount Chieftainess followed that which is why the British called her weak. In fact, she frustrated them . . . They tried to pressurize her to make Lesotho a colony and they tried to get rid of her advisors, to castrate the chieftainship. Fortunately, they failed lamentably. By keeping to the traditional Basotho way of leadership, 'Mantsebo was able to resist these pressures so she was very much loved.[85]

In keeping with this observation, high priority was given to brief the incoming Resident Commissioner so that 'his first responsibility [would

be] quietly and firmly to curb the power of the Paramount Chieftainess'.[86] Yet two years later, when the Administration met to consider the reforms proposed by Lord Hailey in 1954, they still concluded that: 'the development of a healthy local government in the Territory depended on the elimination of the Paramount Chieftainess's power to interfere in local administration'.[87]

One manifestation of 'Mantsebo's power was her promotion or inspiration of other women to become regents beginning with 'Makopoi Api shortly after her own confirmation as one. By 1955 four of the twenty-two 'Sons of Moshesh' were women, while the proportion of female chiefs and 'headmen' rose to about 12 percent of the total.[88] In this regard, as much as anywhere else, the *marena* held a remarkably fluid concept of custom which offered women opportunities denied by British expectations. This fluidity allowed the chiefs in the BNC to argue both for and against allowing women to be chiefs (that is, to inherit the position as chiefs in their own right, rather than as regents only). Goliath Mohale, for example, held in 1943 that it was 'usual for a woman to reign' according to tradition, to the evident disbelief of the Resident Commissioner.[89] Nqhaei Selebalo described the succession of widows, and even of junior widows from senior widows, as 'an old and customary practice'.[90] Many other chiefs were amenable to the advance of women into the chieftainship, not only because they saw this as having a long historical precedent, but also because they saw that women chiefs made good administrators. The practicality of these men clearly overcame their otherwise deeply misogynist prejudices: 'I know the views of many Councillors who will say that women have not sufficient intelligence. I agree, but does that danger not happen because of the Basuto themselves? Are there not also men who have not sufficient intelligence?'[91]

This argument slowly won the day among the patriarchs of the BNC. In 1947, the BNC recommended that female chiefs be paid equal salaries to their male counterparts. During the 1950 debate, it then voted by a narrow margin to recognize women's rights to inherit chieftaincies. On this occasion, the men may have been responding to the threats of the progressive lobby in addition to any behind-the-scenes lobbying of 'Mantsebo or her fellow regents. MacDonald Phasumane of the BPA, for example, warned them that he would 'preach the entire length and breadth of the District that some men seek oppression and slavery of women'.[92] That the chiefs were unwilling to stand firm against such threats took the Resident Commissioner by surprise. Indeed, when the votes were tallied Forsythe-Thompson made a flustered response that is most revealing of the ambivalence of the modern man to gender equity:

> You will forgive me for saying this but I think this is a very bad decision. It certainly does not accord with practice in Europe, as some

speakers tried to make out, and experience in Basutoland since I have been here shows that while some Chieftainesses might be all right, a woman is a woman, and she has not the strength of character nor the force to enforce a good discipline nor is hers the sex mentally endowed with these necessary characteristics . . .[93]

Such public demonstrations of the private aversion by colonial authorities to the advance of women into the chieftainship were actually quite rare. More typically, and ultimately in this case as well, the British simply ignored Basotho recommendations which favoured enhanced powers and rights for women. This particular Council decision, for example, was quietly shelved – for fully seventeen years (that is, until after the British had left).[94] The government also tried to sidestep the Council recommendation for equal salaries with a neat rationale: 'women were ordinarily weaker vessels, and liable to be unduly influenced by a favourite or advisor'. In 1954 it was therefore proposed that every female regent be compelled to have an officially gazetted male advisor. This man would be paid one-third of the woman chief's salary which, in turn, would be 'reduced accordingly'.[95]

Why were the British out-traditioning the traditionalists on this matter? It appears that, in their obsession with good local government, the British simply could not believe that people with female bodies were capable of the tasks demanded of a modern, bureaucratic chief. It was not simply that female chiefs might be more sympathetic to the plight of poor women and therefore less heartless than men in the suppression of shebeens or 'loose women'. In colonial eyes, the select elite of reconstituted chiefs also needed to be more efficient tax collectors, fair judges, and 'almost without exception keen and progressive farmers themselves and keen stock improvers' who would inspire the mass of the people to responsible and productive behaviour.[96] At the same time, the new-style chief also needed ruthlessness to enforce 'the disturbance of agricultural routine' which anti-erosion campaigns demanded. As the former High Commissioner explained it, the 'local headman' was intended to be 'the real lynchpin in the soil conservation effort'. Only 'he' [*sic*] could ever be sufficiently alert to 'small agricultural offences' like ploughing too close to a *donga* or stream. '[I]f he cannot or will not perform his function, then Basutoland is doomed.'[97]

The Moore Report on Constitutional Reform in 1954 elucidated the administration's distrust that female chiefs could perform the tasks at hand: 'From the point of view of practical administration it is undeniable that under present conditions in Basutoland, a woman, whether regent or Chieftainess in her own right, is severely handicapped by reason of her sex in carrying out the strenuous duties of her office.'[98] Sir Henry's

obvious preference was to ban women from the chieftainship altogether. Regrettably to him, that had already been ruled out by a clear majority vote in the BNC in 1953.

In addition to anxieties about the professionalism or ability of female chiefs, Basutoland officials suspected that women and the feminization of the chieftaincy were behind the outbreak of *liretlo* murders which coincided with administrative reforms. *Liretlo*, it was claimed, involved the mutilation of victims to obtain body parts for 'medicine' which magically promoted the interests of the murderer. In the period from 1940–55, over 120 alleged cases occurred, women and men being almost equally victimized.[99] This gruesome 'epidemic' not only terrorized the populations in some districts but also brought British rule into serious international discredit. How could such an acclaimed model of modernizing indirect rule produce such barbarous behaviour? A respected anthropologist was imported and show trials were conducted to prove that 'anachronistic' chiefs were to blame. Two of the most senior chiefs in the land (Bereng and Gabashane) as well as several women (chiefs like 'Mathabo Tautona and 'Mamakhabane Boshoane and 'witches' who influenced male chiefs like 'Matsile Tsilo) were executed.[100]

In their private ruminations about the cause of this 'epidemic', British officials wondered whether women, not least of all the regent, were actually at the bottom of the whole affair. Ambitious female chiefs had in this view 'worn away . . . the patriarchal character of the chieftainship' and so given rise to the jealousies, uncertainty and unrest which led to *liretlo*.[101] Although the government did not find any evidence to suggest that female chiefs were guilty of *liretlo* in disproportionate numbers, the internal report on the persistence of the murders nonetheless concluded: 'There can be little doubt, however, that in most cases the fact of a woman being chief is bound to encourage intrigue.'[102] In a *faux pas* which caused an uproar in the BNC, the Resident Commissioner apparently confided to an American journalist that he personally believed 'Mantsebo to be the prime perpetrator of the crime.[103]

Some Basotho men clearly shared this belief that female chiefs were undermining good governance through their incompetence or hunger for power. Interestingly, some of the strongest voices against women as chiefs came from *batsoelopele* such as B.K. Taona of the BPA and Stimela Jingoes, a former trade unionist.[104] Many traditionalists, by contrast, did not share this view. Rather, they regarded women's purported spirituality as a powerful positive influence against *liretlo*. Some men even called for an increase in the number of female chiefs for that very reason.[105] There were also calls by Basotho men for women to take a leading role in 'vigilance committees' because, as Councillor Mangeola put it, 'we have more confidence in them than the male in matters of this nature'.[106]

Liretlo involved unusually gruesome violence. Yet while embarrassed by the publicity attending to such atrocities and therefore eager to stamp them out, the British also sought to profit from the murders by justifying an even faster pace for reform. In the words of the High Commissioner, 'the practice of ritual murder must be broken, but efforts must also be made to avoid breaking the [reformed] chieftainship in the process'.[107] 'Breaking the chieftainship' in this case was a euphemism for having to make concessions to the emerging nationalist movement. With such a double agenda, British attempts to suppress *liretlo* went awry. Indeed, far from proving effective, the anti-*liretlo* campaign served to exacerbate many of the underlying class tensions which were most likely at the root of *liretlo*. The police allegedly used physical torture to extract confessions, and were empowered to impose collective punishment on entire villages when they suspected a chief.[108] More insidiously, they accepted the evidence of accomplices to convict and hang chiefs. No corpse need ever be produced for charges of murder to be laid and upheld, which effectively allowed anyone with a grievance to come forward with a story of how he had carried out a murder on the chief's command. The self-confessed murderer was not only granted immunity from prosecution but given a monetary reward. As the judge responsible for prosecution reportedly remarked, there was in consequence 'an amount of perjury which is positively alarming'.[109]

Many Basotho today believe that the whole anti-*liretlo* campaign was a cynical, if not diabolical, plot by the British to destroy those elements of the chieftaincy which were resisting British plans for modernization or incorporation in South Africa.[110] If so, it had mixed results. Some recalcitrant chiefs were indeed removed while the threat of execution based on circumstantial evidence and perjured testimony may have terrorized others into 'moderation'. On the whole, however, the anti-*liretlo* campaign made the chiefs more determined than ever to fight for the defence of their independence. It also gave Lesotho's first political party a *cause célèbre* through which it rapidly gained a national following. This alliance of radical nationalists and chiefs achieved a major victory in 1955 when the government's proposals for constitutional changes which would have further undermined the traditional powers of the chiefs were unanimously rejected by the BNC.

In this, once again, the British seem to have fatally underestimated the regent. By 1955, the Chief Secretary considered her a 'broken reed' and 'catspaw' who could be used to 'force through the Moore constitutional proposals'.[111] Yet according to one of the pre-eminent nationalist leaders at the time, 'Mantsebo, in fact,

> was instrumental in the rejection of the Moore Report. In the Council she sat behind the Resident Commissioner and used sign language to

tell the members that he was lying when he told them she had agreed with him to accept Moore. In Sesotho that is what this means [demonstrates, fingers twiddling lips, laughter]. In others words, she got the chiefs to come along with her to reject that report.[112]

With that rejection, the administration was forced to concede that its hard-fought campaign to reform the chiefs into 'modern' indirect rulers was lost. Over the next few years the old guard of officials was quietly shunted off to retirement or 'promotion', while the High Commission set about to explore alternative avenues of constitutional development. In 1958 that which the old guard had most feared was expressly recommended – power should be devolved to democratically elected nationalist leaders. 'Mantsebo herself effectively retired from the political scene in these years, but her role in getting the process of political change underway should not be overlooked.

'Improving' women

7.1 The context of colonial development initiatives

Intimately connected with administrative reform in the modernization effort was the notion that government should assume a leading role in economic and social development (*ntlafatso*, also known as 'improvement' or 'betterment'). Prior to the Great Depression the state's stake in *ntlafatso* was limited by an apparently absolute ban against budgetary deficits. Most of the bridle paths and feeder roads in the mountains were built and maintained by private enterprise (the traders), just as health and education were left almost entirely in the hands of the missionaries. The government did maintain a few bridges and a few hundred kilometres of roads of, by its own admission, 'disappointingly low standard', but these were not only deteriorating as a result of poor construction. They were themselves known to be a major cause of erosion.[1] Erosion had long been identified as one of the most pressing causes of rural poverty in Lesotho. The first government efforts to tackle it, however, were largely token. In 1924 it sent four young men to South Africa to learn improved agricultural practices and then employed them to give lectures and demonstrations throughout the country. At a time when Lesotho had a population of approximately 350 000 'peasants', these men 'improved' twenty-five to thirty fields per year.

Such belated and miserly efforts reflected the government's pre-eminent concern with ensuring (and exploiting) male migrant labour to South Africa rather than internal development. The crisis of 1929–33, however, brought a major transformation in official thought. The change was made explicit in The Pim Report of 1935. Pim warned that efforts to reform the chiefs would certainly fail unless accompanied by concrete, visible, and sincere demonstrations of Britain's good intentions. For the latter, he advocated a Keynesian approach to fostering economic development and social warfare, beginning with an all-out assault in the battle to control erosion.[2]

Another turnaround appeared to be in state policies with regard to women. As we have seen, the state had largely ignored women in the first three decades of the century except to harass them when their behaviour threatened male migrant labour or the system of parallel rule. The govern-

121

ment had little notion and apparently even less interest in what productive activities women actually did. It was assumed, moreover, that women's interests were best safeguarded by their husbands and fathers. Colonial officials in the era of parallel rule did not want even to appear to usurp Basotho men's rights over their wives and daughters, let alone actually do so by offering women agricultural extension or credit. After Pim, by contrast, considerable attention and funds were directed towards the 'improvement' of Basotho women. The colonial government invested in better health care facilities, began training Basotho women as professional nurses and hygienists, built new schools and boarding facilities for girls, introduced modern and diverse syllabi for girls, and launched an ambitious 'home industries' programme designed to make life more attractive and economically viable in the rural areas (discussed below). In addition to these development initiatives, a series of new laws and legal decisions sought to extend state protection to women against undue exploitation, neglect or violence. The 1939 Employment of Women and Children Proclamation limited the conditions under which women and children could be employed and set a minimum wage. In 1949, the Basuto Women and Girls Protection Proclamation sought to target men for a change, in the effort to suppress prostitution, making it a criminal offence punishable by up to a £500 fine or six years in prison for a man to have 'unlawful carnal connection' with a woman. In 1955, the Deserted Wives and Children Proclamation made it an offence, punishable by up to £100, for a man to show 'wilful neglect' in his responsibilities to support his family.

These efforts were not without some successes. Changes to the laws, for example, trickled down in the form of more and more favourable decisions in the courts for women. One key legal innovation stemmed from the case of Monyake v. Monyake in 1953. This established the principle of a mature but unmarried woman's right to own land and make business decisions independently of her legal guardian. In the same year, widows won the right to inherit by virtue of a will and to make wills themselves.[3] Government propaganda about its modernizing intentions was given further credibility in 1956 when the little-used and by then frankly embarrassing Basutoland Native Women's Restriction Act was quietly dropped from the books.

For most of the parties involved, however, efforts to bring women into the modernization process ultimately proved to be disappointing in practice, and even fiascos in some cases. Most Basotho women remained ignorant of colonial law, and too afraid or too poor to challenge men and their families in the colonial courts. Also – as noted in Chapter Six – isolated liberal decisions had to swim against a profoundly reactionary tide in the men who interpreted and enforced the law on a daily basis.

Thus, while it entirely suited the administration that it publicly appeared to favour expanded women's rights and protections, judges actively discouraged all but the most 'blameless' women from taking advantage of them. The law to protect Basotho women against defilement, assault, and neglect, for example, for several years explicitly excluded women 'of known immoral character' or those who could be 'proved to have committed adultery'. Since women in the camps were assumed virtually by definition to be prostitutes, the state in this way extended an extraordinarily effective defence to abusive and negligent men – the victim's lack of moral standing. Not surprisingly, few charges and even fewer convictions were ever made. In 1955 only six men were convicted under the Women and Girls Protection Act.[4]

State efforts to 'improve' Basotho women also ultimately failed in their principal objective: to root contented, well-behaved, 'efficient' wives and mothers in the rural areas. The number of female migrants in fact soared over the period of modernization from an official estimate of 21 000 in 1936, to 30 000 in 1946, to 42 000 in 1956. Women accounted for more than a third of all known migrants in border districts such as Mamathe's (TY). Together with the many uncounted migrants, their exodus actually caused the population of Basutoland to drop over the decade of 1936–46. The health and social problems associated with female migrancy increased as well. Thus, the number of arrests for offences against liquor laws (mainly women brewing and selling hiki) rose nearly sevenfold between 1945 and 1958. Notwithstanding significant improvements in the health infrastructure, both nutritional and sexually-transmitted diseases became widespread throughout the country.[5]

Before examining some of the specific reasons for the disappointments and setbacks of ntlafatso for women, it needs to be emphasized that the forces and structures which were impoverishing Lesotho, and Basotho women in particular, remained untouched. In other words, behind all the post-Pim developmental flurry, business actually continued largely as usual. Above all, male migrant labour remained inevitable and untouchable in the planners' eyes despite the common knowledge that it was one of the main causes of rural poverty. Indeed, the government actually assumed a more active role in facilitating and policing the smooth flow of cheap male labour from the territory. In 1942, for example, the state assumed direct responsibility to catch and punish deserters from private contracts. Yet neither such additional administrative duties nor the costs of a salaried chieftaincy introduced at the end of the Second World War were allowed to detract from the healthy annual budgetary surpluses which gave Basutoland authorities such pride. On the contrary, by 1948 the little territory of Basutoland with its hungry population had accumulated savings of over half a million pounds, not counting £100 000 the

government had donated to England for the war effort. This impressive fiscal record was possible because tax revenues taken mainly from working men remained higher than expenditures.

Such parsimony contradicted the developmentalist propaganda. It also came at the expense of failing to meet Pim's erosion-control targets. Already in 1943, less than a sixth of the projects that had been identified as minimally essential actually were being carried out. Even these projects were effectively sabotaged as the government placed increased agricultural production and tax revenue foremost among its priorities. As the High Commissioner wrote to the Minister of Dominions Affairs, the government was clearly exacerbating the erosion problem by ignoring its own recommendations (and the traditional practice) of reserving spare lands: 'Let us frankly admit that because of the immediate urgency of the "battle of food" for human sustenance we are land mining in Basutoland.'[6]

The end of the war brought little respite from such tendencies. As an illustration, during the mineworkers' strike on the Rand in 1946 the government made its priorities quite explicit. Even as African strikers' demands for decent wages were being brutally repressed, the Resident Commissioner lectured the BNC on the advantages of low wages for miners. He declined, again, the chiefs' request to introduce compulsory deferred pay to ensure that a portion of those wages made it back to miners' dependents.[7]

Colonial efforts to improve conditions for Basotho women in the rural areas must also be understood in the context of an almost blithe disregard for the differential effects of 'improvement' upon men and women. Ostensibly gender-blind, the march of progress must in fact have sometimes seemed to hold a special animus against women's economic activities. Donkeys provide a case in point. With their destructive grazing habits, donkeys were an obvious contributor to erosion. Therefore, in 1933 the Basutoland Donkey Importation Restriction Proclamation was enacted in the name of erosion control. This made it a criminal offence to import the beasts without a special permit and it directed chiefs to impound 'illegal' animals. Yet donkeys were cheap and, unlike horses, culturally acceptable for women to own and ride. They were thus often the principal means available to poor women to transport their grain to the market or mill. Many chiefs were consequently reluctant to enforce the new restrictions upon them. Over the next decade, they continuously appealed to the government either to rescind the law altogether or to relax its provisions so that widows could import donkeys. The British stood firm with, significantly, the vocal support of the BPA. 'Progress', on this issue, clearly took on an unmistakenly brutal appearance to the women, like 'Me Jeminina, who stood in the way: 'I bought the donkeys as I have

nothing to convey grain for my children. I did not know that I had to have a permit. I did not know that I had to go through a recognized Port of Entry. I did not know that donkeys are not to be brought into Basutoland.'[8] For her ignorance, the three donkeys 'Me Jeminina had purchased were destroyed without compensation.

Similar agriculture 'improvements' fell disproportionately heavily upon Basotho women. The loss of land (without compensation) to create buffer strips was a particular burden on women since by the 1930s many had only a single field with which to support themselves and their children.[9] The campaign to eliminate Bitter Karoo was another gender-blind 'improvement' which imposed extra labour burdens upon women. Bitter Karoo was a small bush that spread like wildfire over Lesotho's pasturelands. From the point of view of the British and the BPA it was a poisonous weed which reduced the commercial value of sheep and horses. However, for many poor Basotho women, Bitter Karoo was a readily accessible source of firewood. The campaign to eliminate it significantly increased their workload both by the *matsema* (compulsory work parties) called to uproot it and by the increased time required to fetch more distant sources of cheap energy.[10]

Compulsory sheep dosing, introduced in the 1930s to control parasites on commercially valuable sheep, was another deeply unpopular 'improvement' among subsistence-level Basotho women. Not only did dosing sometimes result in the death of the sheep (again without compensation) but it was time-consuming and difficult. Khosimotse Ntaote saw it this way:

> It is always a pitiable sight to see a poor woman going up the hill and down the slopes trying to look into the question of dosing her small stock because if she fails doing so on the appointed day she will be prosecuted and punished. This poor woman is no longer able to do any work at home because at one time she has to be at the cattle post and the next time at another and yet she is expected to be at home to cook for her children and feed them. Further, she has to look after the ploughing of her lands as well as hoeing them.[11]

In some cases, the new burdens which *ntlafatso* imposed upon poor women were completely unseen by colonial officials. A poignant example occurred as a result of the government's attempt to control the theft of pigs from missions and trading stations. In 1944, each pig-owner was required to obtain a 'bewys' or certificate of registration. Among the Basotho, however, pigs were 'women's cattle' and at the time women in the districts of Leribe and TY were selling their animals to a soap factory in Ficksburg. To these women, a seemingly harmless bureaucratic procedure implied an assertion of legal ownership and age of majority status,

a dangerous move in their husbands' absence or against their opposition. Moreover, because their pigs often fell below health standards for human consumption, and perhaps with their experiences with the state over donkeys in mind, women had good cause to fear that registration would be tantamount to confiscation. Thus few women came forward either to collect their bewyse or to risk selling their pigs to the trucks that came from Ficksburg to collect them. As the Director of Agriculture later conceded, the issue of bewyse 'brought to a standstill' a 'very large export trade'.[12]

The return of Lesotho's 26 000 soldiers after 1946 in some ways made matters even worse for many women. Because they had been left alone for several years and praised by the government for their impressive productivity, many wives had grown accustomed to a *de facto* autonomy which affronted the returning soldiers. Indeed, for many of the men who had gone overseas, the military experience compounded a sense of their proprietorship over women and their right to use violence to reassert it. The press was full of letters by ex-soldiers criticizing the chiefs and the government alike for having let women get out of control in their absence. As one complained in the Catholic weekly:

> We left our families with an order from the Government to go to war. We trusted that our Chiefs would take care of our families. Now we are wondering of what is happening, because women go freely to South Africa, and there is no law which governs their movement . . . What happened to the sons of Moshoeshoe? Now it looks like women are not under control and nobody seems to care.[13]

One result of this type of attitude was an observable increase in violence against women as the men sought to reassert their authority. According to one doctor: 'There are so many cases of wife abuse. Wives are often beaten cruelly. A woman has been almost strangled to death by her husband. The same day I treat a woman whose husband broke her jaw.'[14]

The surge of violence against women in the post-war years was attributed by missionaries to the rise of a 'neo-paganism' which taught 'scorn of women' and which eroded those aspects of customary religion which had somewhat protected women from men's arbitrary power.[15] To some extent this 'neo-paganism' may have been an articulation of men's reactions against the 'emasculating' tendencies of colonial rule or the particular conditions of work in South Africa. As one Catholic priest lamented, 'all the men who return from the mines, above all the boys, are truly crazy'.[16] Yet it also reflected the progressive commodification of human relationships and the consequent erosion of women's customary protections. The war significantly speeded up that long-standing process by directly channelling the soldiers' (relatively) generous wages and

pensions to their wives and widows. A 'counselling' agency established by the government at the Rand also began to have an effect in encouraging men to keep up or increase their remittances home. Ironically, as more women gained direct access to cash and as it permeated the economy and culture, they increasingly lost the ability to appeal successfully to moral obligation. For example, the limited security which *bohali* had once provided against excessive abuse or neglect tended to disappear as parents increasingly denied their daughters the right of *ho ngala*. Fearful of the loss of *bohali* which divorce would mean, they compelled their daughters to return to the most brutal husbands. *Bohali* frequently became a straight cash transaction. Cases were also recorded of fathers who cynically encouraged their daughters or wives to take lovers in order to obtain 'compensation' for seduction. Mothers could be just as bad or worse in commodifying their daughters: 'Mothers are in the forefront of this ardent hunt for gain. The greed of such has earned them the nickname of *Bo-motho e ea koana, khomo tlo koano* [Daughter go away! Cattle come and fill her place].'[17]

Administrative reform undermined one of women's few hedges against victimization of this sort – the chiefs' customary obligation to protect the poor and vulnerable. This was already seriously compromised by the 1930s. Nonetheless, the chiefs remained defenders of women's rights and dignity in important instances. As administrative reforms progressed, the incentives to remain so evaporated. The Native Treasury in particular removed the right of 90 percent of the chiefs to collect income through their courts. In so doing, it also removed their ability to support sometimes numerous 'mothers' who had been made destitute by the loss of fields and male labour. Even those chiefs who were gazetted also commonly experienced a sharp decrease in their income in salary compared to what they had previously made from fines and *lira* lands. The four female ward chiefs in 1944, for example, were promised between £15 and £71 a month, that is, the market value of the amount of cattle they might normally take in as fines in a few days.[18]

The transition to cash salaries had the further intangible effect of undermining generosity towards the poor which payment in kind and 'feudal welfare' had customarily expected. Following the introduction of the Native Treasury, even one of its supposed beneficiaries complained bitterly that as a result 'the position of widows has become a disgrace'.[19]

7.2 The Home Industries Organization (HIO)

Improving the rights, health, and economic security of women was a growing concern internally and internationally, both for justice as well as for utilitarian reasons. By the late 1920s, the *batsoelopele* and the major

missions alike began to put mild pressure on the government to abandon its excessive caution with regard to female education and its obsession with repressing 'bad drink and worse women'. For instance, in 1928, the PEMS built a new girls' school in Morija, inspiring the government in 1931 to add facilities for girls at its new intermediate schools in Mafeteng, Matsieng and Maseru. The Protestants also took the lead in promoting women to act as school principals in the early 1930s (a precedent the government could not condone).[20] After the war, the PEMS protested that the government's supposedly practical domestic science syllabus (in fact, a glorified apprenticeship for cheap domestic labour in European homes) detracted from teaching really practical peasant skills such as gardening.[21]

To these internal pressures for a more enlightened approach to female education and women's rights came the increasingly liberal voice of the Colonial Office. In the late 1930s, strong critiques of colonial 'prejudice' against women were emerging not only from avowed feminists through the British parliament and the League of Nations but also from reputable physicians and top bureaucrats within the colonial edifice.[22] An advisory committee to parliament was created in 1939 in response to this critique, charged with finding 'means of accelerating social progress in the Colonial Empire by increased education of women and welfare work'.[23] The Sub-committee on the Education and Welfare of Women and Girls in Africa in 1943 found that 'the African woman' was clearly not satisfied with the enforced traditionalism of indirect rule but was 'demanding a part to play in fashioning the development of society'. Continued emphasis on 'narrowly interpreted' domestic science could therefore actually create a source of grievance that might redound to the benefit of nationalists, communists, or other anti-colonial demagogues. Indeed, noting that African women were primarily responsible for agricultural and household production, were traders, landowners and often had 'great political influence', the report argued that targeting educational resources at women and girls was a cost-effective way to cultivate 'moderation' in a rapidly changing milieu: 'Women are the stable, and from certain aspects, the central figures in society . . . It is thus clear that the education of women and girls may have an even greater effect for good or evil upon society than that of the men and boys.'[24]

The sub-committee's report concluded by recommending that girls be given educational opportunities equal to boys – 'Nothing in our intellectual equipment should be withheld from them.'[25]

By this time Basutoland was no longer under the aegis of the Colonial Office – it had become a sub-department of the new Dominions Office. Bureaucratically sheltered from the more enlightened winds which began to blow from the Colonial Office, the Basutoland authorities were left to

impart their peculiar sense of caution upon policy. Thus, at the same time that the Colonial Office in London was denouncing 'more and more domestic science', the Director of Education in Basutoland announced a new Standard VI course 'in which greater attention was given to domestic science and kindred subjects which it was hoped would interest girls and teach them how to look after their homes properly'.[26] When the Colonial Office explicitly called for 'general science and nature study' for girls, the government of Basutoland argued for even more domestic science subjects. The Education Department reasoned: 'Surely the study of man, his home and his happiness, is nature study of a very important kind.'[27]

The dogmatic emphasis on domesticity also persisted in the face of evident and growing dissatisfaction among the Basotho. The 'Housecraft' course set by the government 'has not proved popular or very successful', observed the Commission on Education in 1946. Nonetheless, it recommended more of the same.[28] The missions which deviated from this path, especially the PEMS, were publicly criticized for providing 'unsatisfactory . . . too book-oriented' education to girls.[29] The government imposed upon them the requirement that all girls had to pass exams in ironing, cooking, and laundry.

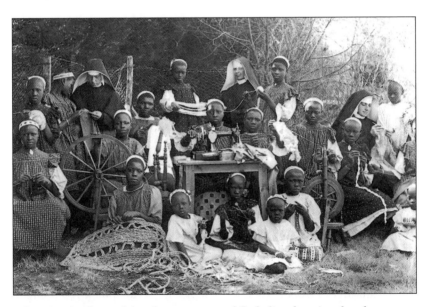

Education for domesticity, the one aspect of Catholic education that the government wholeheartedly approved of. (Deschatelets archives)

The government's narrow focus on improving Basotho women's 'mothercraft' through the schools was rooted in a profound contempt for

women's intelligence and morality. While not unusual in the colonial context, the racism and sexism of the Basutoland authorities may have been exacerbated both by the government's long years of futile struggle with *matekatse* and by the hunger for an easy scapegoat for its embarrassing developmental failures. The health crisis of 1933–36 was explicitly laid at the door of the 'carelessness and indifference', the 'ignorance and superstition' and the 'looseness' of Basotho women. As the Director of Medical Services breathlessly reported in 1933, only the worst could be expected from women who wore underclothing that 'may not have been washed for weeks', and who were ignorant of 'the elementary laws of hygiene and sanitary cleanliness'.[30] The spread of venereal diseases was, meanwhile, the result quite simply of 'beer shops conducted largely by women who have no morals' – an early version of supply-side theory if ever there was one.[31]

Possessed of such attitudes, colonial officials in the territory tended to be more solicitous to the paranoia of a few senior chiefs than to the needs and dignity of women. The training of nurses – educated, professional, economically-independent women – proved to be a particularly sensitive issue on this score. The government went out of its way to reassure the members of the BNC that by training nurses it was not encouraging 'girls to be let loose' and that nursing candidates were kept under 'very strict supervision'.[32] This heavy-handed moralistic regime could well explain why so few nurses were graduating. As the Director of Medical Services later regretted: 'the number would have been considerably larger had it not been for a considerable number having to be sent away because of insubordination and moral lapses'.[33]

Fear and loathing of women's 'looseness' also lay behind a quixotic attempt by the state to improve health and social conditions by the establishment of 'home industries'. The Resident Commissioner elucidated the problem in 1934:

> Sex has always played a large part in native life, and always will until the barrenness of their leisure is relieved. Being deprived by the absence of their husbands of the legitimate satisfaction of their needs, many women are driven to having intercourse with casual acquaintances passing through the village or to making alliances with the men of the village. Much is demanded of them and they willingly respond. The result of this is to prevent such men as are at home from living in peace and unity with their wives, without which family life is impossible.[34]

Since the 'the breaking up of family life' was one of the major impediments to the development of 'responsibility' in African men (an ostensible goal of colonial rule in general), and since nothing could be done about either

Basotho men's prolonged absences from the territory or their lusty nature, women had somehow to be gainfully employed so that they would desist from tempting men. This would have the additional advantage of silencing the proliferating critics of government policy. A commission was therefore set up in 1936. Led by a sculptor, H.V. Meyerowitz, its mandate was to investigate means to develop 'hygienic' leisure activities for women in the villages and to turn traditional craftwork skills into an 'industry'. The hope was that such cottage or home industry could generate enough profits to keep women on the farms. At the same time, it would give the women job satisfaction that would reduce their alleged propensity to while away the hours with extramarital sex.[35]

Meyerowitz discovered, to his frank surprise, that life in the villages was neither quite as sleepy nor as gonadial as he had been led to believe. Crafts were thriving and mainly carried out by women. He found women who provided traditional, utilitarian and decorative articles for their whole region, 'fanning throughout the district' carrying wares on their backs to their customers. Others marketed their crafts in the camps where they were regarded as a threat to the business of some of the European traders. In other cases, women travelled hundreds of miles to market their wares in the Union of South Africa. 'Mamatli of Quthing, for example, was reported to have earned enough from hawking far and wide to buy cattle for four sons' *bohali* and school fees for another. Her success, Meyerowitz remarked, was attributable to the fact that 'It is generally accepted that the Basotho make the best pots in South Africa.'[36]

Much of the Meyerowitz report must have given government officials cause for mirth, not least of all his call for an end to the 'abnormal and unfortunate' practice of male migrant labour and to ensure that in future 'workers derive all possible profits' from their labour. However, his recommendation that the state organize and harness Basotho women's creativity and resourcefulness was taken seriously, at least in principle. In practice, as usual, no funds were available for any specific project. Only after a special War Levy had produced an unexpected revenue bounty for the administration (1942) was an initiative taken, £10 000 being allocated to create the Gifts and Comforts Organization. The object of this was to employ Basotho women in their villages to knit socks, caps, and scarves for the soldiers then freezing in the Middle East. The government provided the materials, and the women provided the labour.

By 1944, the Gifts and Comforts Organization was regarded as a great success and officials veritably crowed at the sight of groups of women happily singing, laughing, and knitting together. If wartime morale could only be maintained or boosted with profit incentives in the post-war period, it seemed a model had been found for the goal of making 'village life more attractive'.[37]

The Colonial Development and Welfare Act in 1945 then supplied generous funds to pursue that goal. With £50 000 to be spread over ten years, the Home Industries Organization (HIO) was launched and a Home Industries Organizer appointed to lead the crusade. The Organizer's terms of reference were to:

> learn what Basotho are doing in such crafts as spinning, pottery or basket weaving, and to advise, in the light of his [*sic*] experience, as to how all this can be developed and improved so as to employ materials grown in Basutoland for the purpose of making articles for sale, and for improving the comfort of their homes.[38]

The HIO began its work by establishing training centres in nine camps throughout the territory. Each one offered a two-year course to train women in spinning, weaving and marketing skills. The intention was that graduates would return to their villages to set up a 'Home Unit' that would become the hub of a local cottage industry. The women would turn their new skills to personal profit. They would also impart their knowledge to their friends (or at the very least, inspire other women to the benefits of free and moral enterprise). A percentage of the income generated would be returned to the HIO to cover its recurrent costs and possibly allow it to expand as the scheme took off. An African Deputy Organizer was hired who would eventually assume the responsibilities of Organizer.

With something seemingly for everyone, the HIO was greeted by the enthusiastic approval of chiefs, missionaries, *batsoelopele* and women's groups alike. Yet it collapsed in acrimony scarcely five years later.

In retrospect, the HIO was fatally flawed from its inception. Whatever his skill and dedication, the male 'textile expert' brought in from England was hardly the best choice as organizer to revive indigenous handicrafts (mostly pottery in the case of Basotho women). Rather than adjusting to the fact that weaving was an alien craft to Basotho women (and actually closer to the traditional men's task of sewing than anything Basotho women did), he turned the general training centres into straight 'weaving centres'.[39] Moreover, his emphasis on producing articles for the luxury European market meant that the Home Units made virtually nothing of use to sell to Basotho customers. The 'bed spreads, hand bags, chair back covers and other types of fancy work' might conceivably have appealed to tourists. However, few, if any, of these ever got far beyond Maseru or the other border camps in those days. And while the scarves and blankets produced by the Home Units were potentially useful, they required imported chemical dyes and cotton and were generally more expensive than store-bought items.[40]

In attempting to teach 'improved' techniques to Basotho crafts-women, the HIO also apparently ignored Meyerowitz's earlier condemna-tion of the 'distinctly harmful' effect of European interference. Whereas Basotho women had traditionally made crafts with 'an extraordinary richness of invention, sense of pattern and balance' which 'could rival any object of applied art in the world', Meyerowitz had observed that European-coached Basotho women produced 'abominable', 'insulting' and 'unmarketable' objects of 'the worst European type'.[41] The earlier study had also noted that the crafts teachers at mission schools 'are open to ridicule from village craftsmen and women' precisely because of this. The HIO did nothing to address the problem. Indeed, the investigation to determine the causes of its collapse in 1950 concluded that 'a lack of competent teachers' critically undermined the quality of the courses. Low morale and a high turnover among HIO 'instructresses' could have been related to the fact that they earned only £42 a year, less than a well-paid domestic servant could earn at that time, let alone what a competent liquor brewer could earn.[42]

Finally, and perhaps most importantly, the HIO clearly suffered from confusion both as to whom it was directed and as to what precisely it was meant to achieve. In a revealing slip, the government boasted that the Home Industries Organization 'offers the Basuto a real opportunity to make money in the comfort of his [sic] own home'.[43] Notably absent from the discourse around the HIO were such terms as 'self-reliance', even then being employed by women themselves in their own homemaking groups. Evidently, the government had no intention that its centrepiece development project for women should emancipate them from male con-trol. On the contrary, it was intended to shore up the patriarchal home-stead in the context of great social and economic strain. Reflecting this dual mandate, the HIO was jointly administered by the Education and the Native Administration Departments, unlikely allies in the upliftment of women. Basotho women may perhaps be excused their 'regrettable' attitudes toward the project on this account. As one contemporary com-munity activist and successful businesswoman phrased it, this and sub-sequent 'women in development' projects suffered from the dis-empowering dual mandate behind them: 'We [Basotho women] tend to be submissive in these things. They just take it [foreign aid] even when it moves parallel to their needs. People would rather just leave the projects than speak up. They don't own it, they don't trust it. That's when we start arguing, there are squabbles, and so they just leave.'[44]

Given its contradictions and conceptual weaknesses, the grandiose plan of rooting women in the rural areas by developing home industry rapidly deteriorated into a shambles. By 1949 nearly half the money had been spent without accruing any revenue whatsoever. From 1947 to 1949

alone, the HIO lost over £10 000.[45] Worse, of the thirty-four graduates of
the course, only thirteen had actually gone back to their villages, and not
one of them seemed to have set up a 'home unit' as intended. The
majority of the graduates, presumably, had remained in camp or drifted
off to South Africa, the precise opposite of the project's objective.

Such dismal results and financial losses were clearly untenable. The
project was drastically scaled back (from nine to two craft centres) while
an expert 'craftswoman' was brought from Cape Town to assess the
mess. Despite the recommendation of a BNC commission of inquiry that
the scheme 'must, at all costs, be maintained as the good it will do the
Basuto is incalculable', her report was so damning that the following
year, 1950, the HIO was declared defunct. The remaining funds were
invested and the interest directed to finance craft courses at the mission
schools in Cana, Mazenod and Leribe.[46]

7.3 The end of indirect rule

Colonial *ntlafatso* in almost all of its contradictory, ill-funded, and ill-
advised manifestations, was by the early 1950s evidently failing in its key
objectives. It was also costing the government precious goodwill among
the Basotho. Together with the resentments arising from the govern-
ment's administrative reforms and the anti-*liretlo* campaign, the failure of
'improvement' to improve the lives of Basotho increasingly brought the
whole project of modernization into discredit. The Basutoland African
Congress (BAC) was formed in 1952 to articulate these grievances. Led
by Fort Hare graduate Ntsu Mokhehle, the BAC added enormously to the
power of criticism already emanating from the chiefs, the BPA and LLB.
It quickly won widespread popularity by attacking the anti-erosion
schemes. It also rapidly garnered support among the *batsoelopele*, espe-
cially nurses and teachers, by attacking the territory's unofficial colour
bar and government complicity in the white trader monopoly. By the mid-
1950s, Basotho women of that 'middling' class were already among the
party's most vocal supporters. As one such woman recalls:

> I first became interested in politics when I was too young to under-
> stand but we could feel something was wrong with the way the
> country was run. Of course I couldn't tell you how, but I felt inside
> that we were being denied our rights, especially by the whites. For
> example, at a *pitso* the whites would always get shelter while we
> stood in the sun and the rain. They were always placed above the
> Basotho in jobs, it doesn't matter how untrained they were or how
> educated the Basotho were, they automatically became the boss be-
> cause their skin colour was their passport. I felt this was unfair since I

felt people should be treated equally. A human being is a human being.

I realized that this was what I hated when I first heard the politicians of the BCP speak. The fire within me became excited also when I read articles explaining the oppression we were under.[47]

BAC pressure contributed significantly to the National Council's rejection of the government's gradualist proposals for constitutional reform in 1955, an ignominious defeat for the British and the death knell of indirect rule. Indeed, the following year the government was compelled to concede in principle what only four years earlier the High Commission had considered 'could only lead to disaster' – self-government for the territory based on a popularly elected Legislative Council.[48]

In making this concession, the administration assumed responsibility to ensure that the future Legco would be dominated by 'moderate' (that is, pro-British, pro-capitalist) elements. Towards that end, Basutoland's progressive elites could clearly no longer be ignored, sidelined, harassed, and humiliated as had been the tendency under indirect rule. Rather, the *batsoelopele* had to be consulted about and satisfied with any new power arrangements. They had to be encouraged to see the advantages of British rule and, ideally, co-opted away from the 'extremist' position of the BAC. As elsewhere in British colonial Africa, this belated cultivation of so-called moderates involved a step-by-step devolution of power through the erection of political and economic structures which trained Africans in 'good governance', financial management, and sound (that is, capitalist) development principles.

The Cowen Commission of 1958 was the first dramatic step in this direction in that it actually invited hundreds of submissions of opinion about constitutional change, listened respectfully to the divergent views, and distilled these into a report which recommended rapid democratization (at least for men).[49] This was overwhelmingly approved by the BNC and was followed up by discussions in London to draft a new constitution. The London talks led to the creation of District Councils elected by secret ballot based on a taxpayer (almost entirely male) franchise. The new District Councils were given greatly expanded powers to oversee local developments and to elect forty members, or half of a new Legislative Council. The Legco itself was empowered to elect three of four members of an advisory Executive Council. The Africanization of the colonial bureaucracy was meanwhile speeded up, with room in the civil service being created by the retirement or promotion away of some the more recalcitrant members of the expatriate old guard. Basotho were also given greater opportunities in the decision-making process at the national level, mainly through 'select committees' that were formed to investigate

and make recommendations on a number of specific reform questions (1961–62). A commission of inquiry was launched to consult the Basotho public about their views of constitutional development (1962–3). Negotiations with the political parties (1963–4) led to the promulgation of a constitution which proposed an elected parliament exercising full self-government, including discretion to request independence.

In conjunction with these political changes, new economic opportunities were created by the state for suitably capitalist-oriented Basotho men. These came through state sponsorship of cooperatives, agricultural mechanization schemes, and the liberalization of trade licence laws. Reflective of the latter, the number of Basotho with trading licences grew from an insignificant minority in 1940 to an estimated 3 000 in 1960.[50] Even the European trading community, particularly the Frasers, joined in this effort by promoting African managers and 'independents'.[51] Again, the objective was not only to appease or co-opt anti-colonial critics. The rapid pace of reform was sincerely intended to provide an apprenticeship for 'moderate' African men in the exercise of fiscal responsibility and the parliamentary process.

The change in policy toward granting self-government affected the administration's attitude towards the 'improvement' of Basotho women in several ways. First, long-standing recommendations of the Colonial Office were dusted off and began to be implemented. In 1957 the primary school syllabus was revised so that boys and girls would receive exactly the same 'wide general basic education' (as opposed the early 'streaming' of girls and boys towards domestic and technical subjects respectively).[52] As the education budget was doubled in the fiscal year 1961/62, money became available to expand boarding and education facilities for girls. By 1963 girls for the first time equalled the number of boys in high school.[53] The government also instituted bursaries for young women to attend university leading, in 1962, to the graduation of Lesotho's first female bachelor of science.[54] Money was also made available for 'adult education' for women through their own autonomous voluntary groups such as the Homemakers Association, including financial support for international travel for the leaders. In this regard, the administration had clearly learned from its disastrous experience with the HIO (where women were effectively marginal to leadership). Now it positively appreciated the long-term political benefits of leaving 'progressive' women to handle their own affairs. Looking admiringly at government-sponsored courses for 'progressive women' in Bechuanaland, for example, G.M. Hector noted that the hands-off approach to women's organizations definitely encouraged 'group discussions to overcome suspicions of government'.[55]

The idea behind the HIO, never actually questioned in the technical analysis of its debacle, was also dusted off once again, albeit on a far

more modest scale. The position of Part-time Supervisor of Craft Schools was created to oversee the activities of the 913 girls or women enrolled in craft courses at the mission schools. In 1958, six of these graduated and were sent to set up their 'Home Units'. At the same time, construction began on a 'Home Industries Centre' in Maseru where women who chose not to return to their villages could market their crafts for tourists without having to leave the territory altogether.[56]

These changes were designed to provide leadership and career opportunities for educated Basotho women who might otherwise resent and resist government initiatives. It was hoped that an educated and cooperative elite of 'progressive' women would have a stabilizing or moderating influence on the *batsoelopele* men upon whom power would almost certainly devolve. Ironically, however, in its obsession to foster a politically reliable class of Basotho men, the colonial state continued to marginalize the economic and political interests of the mass of Basotho women. In important ways this trend was actually exacerbated. While fulsomely praising Basotho women's homemaking groups, for example, the state remained noticeably stingy with them, and continued instead to channel the bulk of its 'development' funds into projects where women participated in decidedly subordinate capacities to men. The most grandiose schemes, such as the 'Farmech' mechanization project in the Mafeteng district, sought at huge expense to concentrate resources, new technology and decision-making powers in the hands of *batsoelopele* men.

Given their obvious political intent, such 'development' schemes (and local government in general) became highly politicized and open to nepotism or other forms of corruption. New tractors, for instance, besides being expensive and inappropriate for most existing conditions in the territory, fuelled tensions among the Basotho. They became identified not only with men (whereas women were the backbone of the agricultural sector) but with a specific class (the *batsoelopele*), a specific church (the PEMS), and a specific political party (the Congress, or BCP as it had by then become known). As one peasant farmer remarked, 'The tractors have brought trouble and I do not see their good.'[57]

The particular impact upon women of these class and sectarian tensions has not been seriously investigated in scholarly assessments of the whirl of partisan politics which accompanied them. However, before examining Basotho women's specific reactions to economic and political liberalization, it is important to consider some of the alternative development strategies which competed for women's attention, or which the women asserted themselves in this modernizing era. Towards that end Chapters Eight and Nine focus, respectively, on Basotho women's independent initiatives and on the 'anti-capitalist' vision of the Roman Catholic mission.

Part Three

Basotho Women's Struggles and the Critique of Modernity

Basotho women's voluntary associations

The *Manyano* [*kopano*] gives her hope and a sense of purpose, and herein lies the paradox of this whole strange manifestation of African religious life, for the average *Manyano* is singularly lacking in utilitarian purpose. (Brandel-Syrier 1962, 231)

Each village has a leader, chosen by themselves. They work systematically with a chairman, treasurer and secretary. The village groups meet once a week to learn something of gardening or sewing or nutrition – it's different each time. The rest of the week we practice on our own. Once a month the parish group meets, which can be several hundred people. We can identify a problem, like a *donga*, which we want to solve, then we can discuss ways to do that and perhaps go to the authorities to seek help. We plan. Once a quarter, the executive meets to check on how the different village groups are progressing. (Interview, Priscilla Fobo)

Somewhere between these contrasting views of women's pious associations (*kopanos*) lies a rich history of African women's experience. Yet, partly because of their apparent other-worldliness and 'private-sphere' (or 'homemaking') activities, few scholars of Lesotho have considered them to be of interest. Discreet allusions here and there as well as recent literature from elsewhere in the region suggest, however, that the *kopanos* had much greater social, economic, and even at times partisan political influence than hitherto suspected.[1] The contemporary developmental work which the *kopanos* are engaged in also suggests that Christian women's consciousness may not have been as 'strange' as some commentators have asserted, nor homemaking as small and uncontroversial as it sounds. This chapter explores the origins, ideals, goals, and evolution of Basotho women's voluntary associations, beginning with the pious associations of the Christian churches and then moving to secular homemaking organizations. The focus is on the period of modernizing indirect rule from the 1930s to the early 1960s when women's groups became directly, if discreetly, engaged in the critique of colonial developmental praxis.

8.1 Pious associations

By far the largest, most widespread and most visible of women's groups in Lesotho today are the pious associations or prayer unions of the Christian churches (in Sesotho, *likopano* or *kopanos*, sometimes also known by the Xhosa term *manyanos* and as 'sodalities' among Catholics). These also have the longest continuous history, having been established in each of the three major churches over a century ago. The Roman Catholic Mission (RCM) led the way in this regard. Father Joseph Gérard, one of the founders of the Catholic mission, actually made the conversion of women a priority. Of his first seven converts in 1865, six were women.[2] These he formed into a pious association called Women of the Holy Family, 'the scope of which is to contribute to the upkeep and decorum of the altar'.[3] Gérard stressed 'a cult of obedience and manual work' among the women.[4] From the outset, therefore, prayer was understood to involve both meditation and unpaid labour for the church. As the mission expanded, this practical expression of piety also expanded, from the simple upkeep of the altar to the maintenance of the buildings and grounds of the mission, including the home and garden of the priest. In addition, the women were supposed to act as 'apostles' to draw converts to the RCM.

In practice, at least in the early years, Catholic *kopano* women tended to be isolated from the wider community and to come from the margins of society – widows, neglected junior wives of polygynists, suspected witches and so on. Moreover, little or no connection existed between the *kopanos* as they were established in each new parish. Father Gérard was criticized in this regard by the Bishop, especially for showing a proprietary attitude towards 'his' women at the expense of coordinated proselytizing efforts.[5] Yet this parochial tendency continued until at least the 1920s when the principle of institutionalized, coordinated 'Catholic Action' was first asserted. Even then, and despite the institution of mass gatherings and the widespread embrace of Catholicism by leading chiefs, the Catholic *kopanos* remained primarily parish-oriented in scope until the 1950s, the led rather than the leaders in matters of national concern to the mission.[6]

By contrast, the Protestant *kopanos* assumed a significant leadership role in their churches from the very beginning. The first Protestant *kopano* was established by the PEMS in 1889 under the direction of Alina Dyke, the wife of the pastor at Morija. The Bo-'Ma-bana meant, literally, 'Mothers of the Children'. In contrast to the Catholic *kopanos*, the Bo-'Ma-bana began as a Bible study group. Literacy was assumed and, as a result, its members tended to be educated women married to the territory's nascent *batsoelopele* elite. This pattern was maintained as the Bo-'Ma-bana spread from the centre of the mission throughout the colony.

PEMS prayer groups were set up by the wives of missionaries and Basotho evangelists who hoped that a nucleus of literate Basotho women could act as a conduit of modern ideas into the mass of the female PEMS population. The large-scale apostasy of Basotho men converts in the mid-nineteenth century gave these educated women a critical importance in the PEMS mission strategy. As one European missionary commented towards the end of the century: 'we are obliged, due to the shortage of men, to replace them with women, both for public prayer and for evangelization'.[7] This very willingness to engage Basotho women as well as men in mission work may have contributed to the cohesion of the PEMS, quite striking in a region where other Protestant missions often suffered debilitating Zionist schisms. The literate and leadership bent of the Bo-'Ma-bana also led them to found Lesotho's first 'women's magazine' in 1924. *Leeba* ('The Dove') featured articles on 'religious matters, hygiene, care of babies, education problems, and anti-alcoholism', interspersed with quizzes on the Bible and recipes.[8]

The women's association of the Anglican church was of much the same pattern. Because of the Anglicans' close association with the colonial regime, the Mothers' Union may originally have put even greater emphasis than the PEMS on the formation of a 'progressive' women's elite who could inspire loyalty to the Queen and instil Protestant values among the mass of the female congregation.

Despite their differences in origin, theology, and class membership, in practice the *kopanos* of the three major Christian churches functioned in strikingly similar ways throughout the whole of the period under study. Theoretically under the guidance and control of the local priest, nun, missionary or minister's wife, the women were in practice largely autonomous. They were organized hierarchically, by age above all, and geographically, with chapters and sub-chapters in each village as numbers warranted. They all wore uniforms. And they all emphasized women's primary role in maintaining the family through a combination of 'practical and pious Christianity'.[9] Family ideals included chastity before marriage for girls, women's devotion to 'mothercraft', and women's service of their men's legitimate needs.

The piety of *kopano* women has certainly drawn the most attention – praiseworthy and otherwise. Public expressions of this piety included determining who of the brides in the village was entitled to wear white at a wedding (certified virgins only), who could speak at a meeting and when, and who sat where in church. Attendance at church and meetings was a must, and certain prayers or hymns were dictated for certain specific occasions. Piety also included long hours, or even days, devoted to prayer. Such devotion was understood to be a form of labour for the church and community as well as communion with God. Indeed, women

often deeply believed that prayer would bring divine intervention to achieve the same results as more mundane forms of work:

> When you talk to the elder women, many of them say we are getting worse, for in the past there were some really great worshippers. Women then knew how to sacrifice which they say we no longer are doing. For example, it used to be that only four women would come together to pray endlessly, fervently, all day and all night saying the novena for nine days in order to get a priest. And they succeeded. Now these women query why we don't pray like that any more.[10]

The emphasis which the *kopanos* placed on public demonstrations of piety led some observers to conclude that they blocked real development efforts by causing women to devote so much energy to other-worldly concerns. As such, they were increasingly the butt of criticism by men eager to harness women to their economic projects. The priest at Auray, for example, while praising his *kopano* members as 'the most active, most universal, most numerous' of his congregation, complained that 'the only thing they know how to do is to hold meetings'.[11] The President of the Bo-'Ma-bana in the 1950s also publicly criticized her own association for 'sermonizing and hymn-singing to the neglect of practical issues'.[12] Women's loyalty to their uniforms was also notoriously 'irrational' from the point of view of many church modernizers, even to the point of allegedly denying their children school fees or clothes in order to buy their own uniforms.[13] In other ways as well, the formalistic, almost legalistic piety among *kopanos* could be taken to lengths which sometimes dismayed European observers. One visiting Canadian nun remarked that: 'What strikes me most, is that these women tolerate absolutely nothing unseemly. They act exactly the same way in their own villages.'[14]

These characteristics have led many observers to assume that the *kopanos* were oppressive to women and obstructive to modern or practical ideas:

> The Mothers' Union is an old women's organization. They enjoy coming together, singing and preaching to each other. There's nothing outside that. Oh, they are expected to do some handwork. It's old girls who think of nothing else. Young women might be attracted if it had a purpose and if they felt they had a place. The old ones are inclined to dominate. For example, once some young women tried to get them to sing the hymns a bit faster but they refused. They just wanted their own slow, low, dead way of singing.[15]

It is clear, however, that women of all ages were attracted to the *kopanos* in very large numbers. By 1961, there were over 10 000 members in Bo-'Ma-bana alone, while at least that many Catholic women came together

every year at Ha Ramabanta for several days of celebration and mass prayer (the procession of Fatima).[16] Far from a generalized feeling of oppression by rules, women in the *kopanos* were attracted by them. Attempts by their priests and pastors to do away with rules they adjudged abusive or immodest were steadfastly resisted. According to one priest, for example, an attempt by the RCM to ban uniforms in his parish in the 1950s led 'many' women simply to leave the church in protest.[17]

The chief reasons for this insistence on rules and rituals are not difficult to surmise: adherence to them gave women a sense of perfectibility, achievement, and power in a situation which was otherwise almost relentlessly disempowering. Moreover, as even contemporary critics noted, the rules provided a framework which supported an extraordinary range of uninhibited and non-traditional behaviours. The women might insist on carrying a coffin and speaking publicly at funerals or even reading the epistle in service. They might take the most prestigious front seats in church, ahead of senior men. They might stay up all night or even for several nights, singing, dancing, and preparing for special occasions such as saints' days among the Catholics and Anglicans. As early as the 1930s women were leaving their villages and husbands to travel long distances to meetings or ceremonies on their own, sleeping in the church.[18] The prayer meetings themselves were often the apparent antithesis of order. Describing a *manyano* in neighbouring South Africa, Brandel-Syrier noted that:

> The general atmosphere of a *manyano* is one of weeping and sighing. The air is heavily charged with intense emotion. Women stand up and speak out their troubles, sometimes wailing or screaming, sometimes in frenzied whisperings. Their bodies tremble. Their eyes are tightly closed or fixed heavenward. There is talk of miracles, of the sick and the dead.[19]

The women of the *kopanos* also certainly did not see themselves as otherworldly or hidebound by rules to the exclusion of day-to-day concerns. On the contrary, piety from the women's perspective was often eminently practical. First of all, it gave them respite from the endless demands of domestic work and a chance to share feelings with other women. *Leeba* states explicitly that one of the main tasks of the Bo-'Ma-bana is 'to fight loneliness', a practical consideration given the potentially disastrous consequences of the few other options available.[20] In the words of a former member: 'Women tend to need something reliable in their lives which the church provides. Men tend to be very unreliable and the church therefore offers consolation to women for the inability of men to provide the love they need. That is why there are many women's organizations in the all of the churches.'[21] To another:

PL: Before I joined the Sodality, I couldn't get time to meditate or just reflect on the problems of my life. Now I have an excuse to make the time and I find that work and prayer sort of complement each other. In fact, it is stipulated that I make the time, which helps a lot.

ME: What do you pray about?

PL: In our meetings we learn prayer To Be, reflect, meditate and even to seek advice on material things. What issues we talk about depends on the size of the group. That can be in the hundreds but women are not afraid to speak out. I don't know what happens but the Sodality makes you feel so much at home, so full of love that women will not be afraid to speak up, either to solicit or give advice. Then they find that they are not alone in their problems but these are shared by many.[22]

Nor were the uniforms an irrational obsession in this context. On the contrary, they helped to erase some of the class lines which were being drawn in the early part of the century. While the uniforms frequently indicated subtle but 'complicated gradations of status',[23] the hierarchy so denoted depended upon the women's contributions to the church and meritorious behaviour in the community. Even the poorest women could thus rise to positions of status and respect which were otherwise unattainable. As an astute Catholic priest explained: 'These women can, without shame, hide their poverty in their official dress.'[24]

'Prayer' could also provide relatively effective support in dealing with the very practical problem of men's violence against women:

In these meetings we ask for prayers in our different problems. Mothers always have problems either with fathers or husbands or children. We come together to open our hearts about these things and then we gain strength by prayer. By open our hearts, I mean we would talk about the things that are worrying us. That is why some young men don't like it – they feel the criticism.[25]

On occasions when neither catharsis nor advice were sufficient, the *kopanos* made provision for action:

PL: With serious family problems, a woman will usually go to one of the older women, perhaps to two or three of them, and discuss it privately. Those women may then volunteer to approach a man if he is causing troubles. That is why the LSA is the most disliked organization (by men). It has a bad reputation because it is believed to interfere too much in family affairs. The men complain and sometimes have even threatened to beat them but all the same that doesn't stop them.

ME: Can you give me an example?

PL: Yes, because I recall one incident of a woman where her husband burnt her uniform to stop her going to meetings. He was a cruel man so we advised her to stay home. She was really miserable and most of the time was in tears. She cried for two or three years. Then he relented and bought her a new uniform. Well, I don't know if it was our prayers or what. We didn't have any direct confrontation with him because we knew he was a violent man, but we used to sneak around to keep her informed and pray with her.[26]

To another Catholic *kopano* woman: 'If a man is being a neglectful husband we may try to talk to him but we won't be rough on him. We keep talking in a pleasant way that will make him ashamed after some time. We always win out through perseverance.'[27] According to Philomena Lesema, 'You see, men they are usually quite resistant and refuse to change their habits. With time however, they soften and yield.'[28]

Such perseverance contributed to an aura of power around the *kopanos* which far exceeded both their modest public demeanour and the women's own acceptance of the principle of respect for male authority. In other words, the women clearly had no aspirations of feminist-style equality or justice, and indeed they typically and wholeheartedly accepted the patriarchal ideals shared by Sesotho and the Christian missions. Yet *kopano* women were not averse to letting men think that they did in fact hold ambitions to power. One man put it this way: 'In fact, women rule the world. They are very, very strong here although they have a funny way. You can't trust which way they will go . . . The Bo-'Ma-bana too, although they were never disobedient before, yet they were quite stubborn. They are always murmuring about something.'[29]

For all his authority by custom and by law, a man would indeed think twice about incurring a second visit from a group of senior women, who, dressed in their austere uniforms and murmuring about damnation, might suggest that they had the power to make his life hell on earth. There were even stories which gave a mythic substance to female vengeance: 'Heh, yes! There was a time when the women in the village at Roma got together and they castrated a man who was sexually harassing them.'[30] Or, in the matter-of-fact words of an Anglican nun:

Not all Basotho men are useless. Some come home to help plough if their contract allows. In bad cases though, the wife can come to the weekly Mothers' Union meeting to complain or ask advices. The Mothers' Unions do a lot of visiting. All the women who are available at the time go there, wearing their uniforms of course, to give their prayers. And I think the men respect our visits because there's a lot of

talk of poison these days. Sometimes it's not blame – it's true – women kill their husbands. There was one woman who complained to us that her husband was thrashing her and that she wanted to leave him. Well, that very week he died.[31]

Preserving the virginity of their daughters in this context of gender struggle was not only symbolic of virtue. A family's welfare and perhaps even survival could often depend on receiving the fullest amount of cattle which could be negotiated as *bohali* for a daughter. Premarital pregnancy reduced *bohali* by half or more and was therefore seriously detrimental to the family as a whole. Since migrant labour and the culture of predatory masculinity which often accompanied the men back from the mines were increasing the incidence of abduction or forced elopement, and since the fathers and uncles who had customarily maintained discipline among the youth could no longer be relied upon, the *kopanos* assumed a crucial, practical role for women to support each other in controlling or protecting their daughters.

The *kopanos* also policed the behaviour of their own members. At the weekly meetings, women who transgressed social convention could be 'disciplined or reprimanded'.[32] The Catholic Ladies of Sainte Anne (LSA) meetings were observed in the 1940s to be acting precisely as women's courts had done in pre-Christian days: 'It sometimes happens that they hold their judicial courts where public misdeeds are discussed and where one or the other is determined to be guilty.'[33] The priest of Auray in 1953 also praised the LSA both for converting new members and for 'regulating marriage cases'.[34]

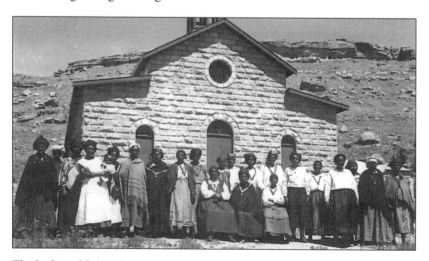

The Ladies of Sainte Anne express possession of their church at Loretto, c. 1930s. (Deschatelets archives)

Public reprimands of transgressors of propriety included, above all, loss of the right to wear the uniform. Usually this threat of ostracism was punishment enough. Yet *kopanos* were also capable of more dramatic action if the errant woman did not mend her ways:

If we had problems with our members, as women we would first go to discuss them with the minister's wife. We would pray together and only after, if necessary, go to the minister. That was not often. Usually, we did such things within the Bo-'Ma-bana. To show you how it worked, I can tell of one time when there was a woman and a man here who were committing adultery. We all went to her place and beat her up. The man ran away and returned to his wife.[35]

The enforcement of discipline among women was therefore not simply because older women 'seemed to like being the boss'.[36] It was also a strategy to protect women who were vulnerable to men's neglect or sexual predation. Indeed, by the 1930s a piety which propagated and in some cases enforced 'discipline' within the family was one of the few respectable options women had to protect themselves and their families from the effects of male migrant labour. The President of the Mothers' Union understood her *kopano* this way:

SH: The Mothers' Union helps the church and it helps to make good families. By that I mean it tries to teach the proper ways to bring up the children and to help the husband to be a good father. We don't talk to him usually but we have a special prayer for him. We can talk to the wife to advise her what to do to win back his favour. We always win by prayer and discipline. I think we are so successful that we fight to get Mothers' Unions everywhere in the country. In that way, Lesotho will improve.

ME: What do you mean when you say 'discipline'?

SH: When I say discipline, I mean by that that a mother must set a good example to other women by her dignified behaviour. It is the responsibility of the woman to see that the family is well-organized, for example, by sending the children to school. The man's responsibility is to send money but since they don't always do that, we teach women ways to earn on their own.[37]

The women of *kopanos* also believed that the 'little' tasks they performed demonstrated their faith:

In my opinion we work hand in hand with the Bible. We teach women the practical way of living the Bible. For example, you help your neighbours, visit the hospital, you approach the needy to do jobs for

them like fetching water, washing, cooking, smearing huts, taking sick people to the clinics, distributing old clothes etc. We go to people who are so poor that they need help in the fields. This way people who are better off can share with those who are not, and that includes men as well.[38]

This ideal of combining prayer and praxis was by no means revolutionary or even necessarily subversive. On the contrary, it related directly back to traditional religion and, indeed, frequently implicit in the self-image of *kopano* women was a critique of Christian hypocrisy and of the forces of 'progress' that were undermining the traditional sense of community. Christian *kopanos* could thus be almost nostalgic about the passing of customs which had previously given women succour and sustenance in a patriarchal society:

We used to have our own Sesotho religion you know. It was a practical one. People looked after each other because if not, they feared the ancestors were watching. Christianity now says you just don the uniform and go to church on Sunday and the rest of the week doesn't matter. But what is your religion worth if you can't put it into action? Even just a little bit, like cleaning up or smearing mud.[39]

The ability of Basotho women to organize and discipline themselves and to interpret, adapt or select aspects of Christian dogma in sometimes 'muddy' ways was frequently disturbing to the mission hierarchies. The priest at Auray, noting that the LSA were 'everywhere' and that they went on with their business regardless of whether a priest was there to direct them or not, was deeply concerned that 'they rarely report on their activities'.[40] The former president of the Bo-'Ma-bana described an even more disturbing independence:

[Those women] could be very exclusive . . . The wives of missionaries for the most part did not attend their meetings for they could be ostracized. They were also disturbed by the women's 'mysteries' which were a bit dangerous from the point of view of church doctrine. Their secretive attitude extended even to such affairs as how to make soap or cakes. Attempts by the European women to have some professional Basotho women accepted into the organization were just rejected.[41]

Brandel-Syrier also quotes a white missionary in South Africa who regarded the *kopanos* in a similar vein: 'They are independent and want to be independent. They do not allow a European. My wife is probably titular head of the *manyano* here, but in fact, they resent her presence.'[42]

For many decades, missionary misgivings about the independent or assertive behaviour of women in the *kopanos* were largely assuaged by

the amazing ability of these women to raise money and recruit new members for the churches. The first catholic *kopano* in Roma raised £20 in its first year, an enormous sum in a peasant community in 1865.[43] Nearly a century later, the seemingly tireless devotion of the LSA led the priest at St. Michael's to describe its members as 'forming here, as throughout Lesotho, the most disciplined, the most active and the most apostolic association' in his parish. In this devotion, they were 'rallying thus thousands of other people of good will' to the cause of the church.[44] The Bo-'Ma-bana were also termed the 'backbone of the church' and 'our Church's chief support' on account of their prodigious fund-raising abilities.[45]

Yet church leaders did not tolerate the independent attitude of the *kopanos* because of their good works alone. They often had no choice. The *kopanos* were in fact capable of resisting even direct orders from the church leadership with a formidable tenacity: 'The priest would disband [the local chapter of the LSA] only to find that these women would have none of it. In three weeks they were back together, the very same group!'[46] A missionary in South Africa described another favoured, and highly successful, tactic:

This 'sitting down' is the most exasperating reaction of African women when they do not like a thing. I know all about it. It means that they do not come to meetings, they do not resign, and they do not give any explanations. They just wait. What are they waiting for? They wait for the next priest or the next bishop to come. After all, this one will not stay forever.[47]

Such behaviour was, by the 1950s, 'driving certain Fathers towards the suppression, pure and simple, of the Ladies of Ste. Anne'.[48] Chapter Nine shows how the development of increasingly critical attitudes towards the *kopanos* as they had construed themselves can be closely linked with the missions' realization that Lesotho was reaching a state of economic and social crisis. This crisis augured potentially dangerous politics. The calamitous years of 1929–33, in particular, exposed the need for urgent development efforts by the churches if political radicalism or racial hatred were to be averted. The domination of the *kopanos* by older women came to be seen as an obstacle to those efforts by alienating young and educated women. The different churches adopted different strategies to address this. Young educated Protestant women were encouraged to channel their 'practical Christianity' into such secular organizations as the Homemakers Association. And while the RCM at first supported this alternative for their educated female converts as well, by the late 1940s they opted for an ambitious attempt to reform and outmanoeuvre their most gerontocratic *kopano*. In both cases, the

effects upon Lesotho's economy, society, and political struggles were ultimately profound.

8.2 'Homemaking'

Basotho women's development-oriented *kopanos* stemmed from a long tradition of mutual assistance with child care, domestic labour and agricultural chores. First, women's traditional tasks demanded cooperative labour at key points in the production process – tasks that were regarded as shameful for men to assist in. Secondly, in a virilocal society, new brides commonly left their home villages upon marriage and found themselves socially isolated. They turned to other women for companionship and help in place of their families of origin. Once male migrancy became fully entrenched, with new brides often finding themselves 'grass widows' after a few weeks or even days of marriage, the need for female friends and workmates increased. The spread of Christianity and concomitant demise of large polygynous households, also well-advanced by the first decade of the twentieth century, further contributed to the growth of mutual aid *kopanos*.

Apart from church groups and temperance associations like the Blue Cross, such *kopanos* were generally informal, local, and often quite ephemeral. *Kopaneng* societies, for instance, meaning 'let's pull together' (to give each other assistance for burials, ploughing, and emergency cash or labour requirements) could involve as few as three or four women and may only have been active in years of particular hardship. Another form of *kopano* in the pre-Depression era was the *setokofele* (from 'stock fair'). A *setokofele* operated as an informal bank, making credit available to members on a rotating basis. *Maholisana* operated in a similar manner but focused on the provision of entertainment. This tradition of women helping each other to cope with life in a strange new village was also observed among women in the camps and in South Africa. Much to the chagrin of the police, female brewers helped each other, among other things, to avoid detection and arrest. They operated without constitutions, membership lists, or formalized leadership.[49]

Batsoelopele Basotho women began to form their own more formally-constituted, 'respectable' *kopanos* in the early 1930s. While these were secular in their objectives, their membership commonly overlapped with Christian prayer groups. The missions, the PEMS in particular, regarded them with approval. For example, the Morija Native Women's Farmers' Club was composed predominantly of the wives of leading lights in the Protestant church. Its goal was to serve as a conduit for the knowledge men gained about 'progressive' farming in PEMS schools to the women who actually did most of the agricultural labour. By 1935, there were four such clubs in Lesotho. The administration consid-

ered that they had 'a great future' on account of the women's 'great keenness for agriculture, especially gardening'.[50]

This recognition of the potential of women's *kopanos* to contribute to economic revitalization of the territory did not translate into significant government support. On the contrary, to a government keen on maintaining the migrant labour system and cheap administration through the chiefs, progress was undoubtedly admirable in theory but potentially dangerous, and often subtly discouraged, in practice. *Batsoelopele* expectations for land reform, more democratic government, freedom to market their agricultural products in South Africa, as well as property and inheritance rights, threatened customary and colonial patriarchy alike. Progressive women farmers, like progressive men, were consequently treated with underlying suspicion by the British. Typically, the sole submission by Basotho women to Sir Alan Pim's investigation into the colony's economic predicament was entirely ignored in Pim's final report. Sir Alan relied instead on the testimony of experts such as the notoriously retrograde Resident Commissioner, whose submission was simply published verbatim in lengthy sections.[51]

Suspicions in the colonial mind about the class aspirations of female progressive farmers were definitely compounded by androcentric blindspots or positively sexist prejudice. For instance, the first attempt to enumerate women as farmers and learn precisely what they were doing did not come until 1949. Even then, the women's behaviour (specifically, their distrust and fear of government officials) seemed to cause more amusement than serious concern.[52] At no time during colonial rule did agricultural census-takers even bother to count 'women's cattle', although as early as the 1940s the government had noticed that pigs were a significant money-spinner in some districts. This blind-spot was nothing if not persistent. As late as 1966 one official wittily commented that 'vegetables grown by women is a contradiction in terms'.[53] Despite the fact that by then women were responsible for the majority of ploughing and gardening as well as their traditional agricultural tasks, the government's extension officers remained all male.

Such androcentrism was quite typical of colonial development planning throughout Africa in these years and in important ways was even more pronounced in South Africa (making the Basutoland authorities seem enlightened by comparison). Given that the environmental degradation and economic collapse in some of the reserves in South Africa was even more severe than in Lesotho, South African efforts to 'better' these reserves by channelling 'improvement' through men was certainly extremely inappropriate. Moreover, to cope with the exodus of women from the countryside being swelled by inappropriate betterment, police powers to arrest and deport women in towns were strengthened. Amendments to

Women and gardening – a 'contradiction in terms'. (Deschatelets archives)

the Urban Areas Act in 1930, in particular, made it virtually impossible for unmarried 'alien native' women to leave their rural homes legally. After a long hiatus, the South African government also began once again to deport Basotho women back to Basutoland – this time with considerably more commitment than had been the case in the 1900s.

The homemaking movement arose from this combination of economic crisis and the hostility, apathy or blindness towards African women *as producers* by the governments on both sides of the border. Its specific origins were at Fort Hare College, a shady, well-watered island of privilege in the desiccated countryside of the eastern Cape Province. At that time, few of the wives of African staff were allowed to work, and educated African women commonly faced a life of enforced un- or under-employment. Bernice Mohapeloa was one of them. Although she was one of the few Basotho to hold a high school diploma, she remained 'just a housewife' at Fort Hare. Her restlessness with the tedium of petty bourgeois domesticity grew as consciousness of the emerging economic and social crisis in the surrounding district deepened. The onset of the Depression made her position all the more absurd, indeed, 'unchristian' – people were starving to death just a village or two away. This at last provided both the excuse and the opportunity to put her education to use. In 1933 together with an American missionary (a Mrs. Yergan) and other staff wives, Mohapeloa helped to launch the Unity Club. For these relatively privileged women, the new club had 'the express purpose of going out to the villages to teach their less fortunate womenfolk the art of house-keeping, including gardening, sewing, family and community hy-

giene etc'.[54] Its unexpressed purpose was to provide a sense of mission to the women who led it.[55]

'House-keeping' in this context centred on practical efforts to avert starvation and malnutrition. The Unity Club thus propagated basic survival skills to the women of the impoverished communities which encircled the college campus. It drew direct inspiration from the PEMS dogma of individual salvation through hard work, self-discipline, and the application of rational intelligence to problem-solving: God rewards those who help themselves. As a PEMS missionary later explained, the two major objectives were intimately entwined, 'to encourage a Christian conception of family life' and to 'render household tasks more efficient'.[56] Yet despite its mission origins and its abiding Protestant discourse, the homemaking movement which grew from the Unity Club was determinedly secular. Indeed, from the onset it distinguished itself as a non-sectarian association. The injunction to 'uphold Christian standards in the home', for example, was interpreted in a remarkably tolerant and non-dogmatic manner: 'We didn't push our beliefs but perhaps they [non-Christians] were indirectly influenced towards Christianity because when they saw something successful, they wanted to copy it.'[57]

This, in fact, is exactly what brought the homemaking movement to make the leap from the eastern Cape to Lesotho in 1935. Rather than primarily a means to cope with starvation, however, the initiators of homemaking in Lesotho saw it as a way to work against migrancy and the 'moral looseness' which came with it. As Mohapeloa explained:

> The idea of the Homemakers came from the Basotho girl students at Fort Hare. What they wanted was for me to start something like what I was doing there in the villages around Lovedale because they noticed the problem that many of the Basotho boys were not going home during the holidays. They preferred to spend time wandering in different places in the Republic rather than to go home to the poor villages in Lesotho. Even some girls, they also did not return, especially in the short holiday in June, but would visit friends or what-not in the Republic.[58]

The Basotho students at Fort Hare came almost entirely from families which belonged to the PEMS and few, if any, were truly poor by the standards of the day. Particularly the girls were in a privileged position in a society where higher education for females was still generally considered an extravagance. The mothers who came to Lovedale to pick up their children at the end of the first term in 1935 were not, therefore, suffering in the same way as the women being served by the Unity Club. But they did understand its potential:

ME: So it was not necessarily a question of starvation or poverty [that first made the Basotho women interested in homemaking].

BM: Yes, not quite. But poverty can also be in the appearance of the house and not having anything to do. So they were poor in that sense.

ME: So . . .

BM: So, I agreed to talk to the students and some of their mothers who came and I explained to them that you had to try to make your home a place where your sons would look forward to coming home. Food was the main thing. They had to give at least one good meal a day . . . But I also emphasized that you needed to make the house look beautiful. You could make nice cloths to cover the furniture.[59]

'Me Mohapeloa's pragmatic message to these mothers addressed primarily their sense of helplessness at seeing their children become lost to a life of debauchery in South Africa. In response to subsequent requests to her, Mohapeloa began to write lessons in gardening, nutrition, and 'housecraft' to send to interested individual mothers back in Basutoland. As the demand grew, she accepted an invitation to visit her home town of Mafeteng to assist in setting up a club which would disseminate the information she was providing. This done, members of the new club obtained some waste land at the edge of the camp and started a communal garden. At the end of the season, they entered some of their products in the annual agricultural fair, much to the 'amazement' of Basotho men and British officials alike.[60] 'Soon after that, I started getting letters from all over the country requesting clubs and by now, the Homemakers are everywhere.'[61] So rapidly did the clubs spread that in 1945, when the Mohapeloas returned to live in the territory for good, links with the Unity Club at Fort Hare were severed and an independent Basutoland Homemakers Association was formed. 'Me Mohapeloa acted as President for the next three decades.

The Homemakers Association operated over this period as a federation of autonomous groups of twenty to one hundred and twenty members each. Each club developed its own activities at weekly meetings and invited 'experts' to come to the village to address its members. These experts included agricultural extension officers, domestic science teachers, nurses, and the wives of government officials and missionaries, as well as the founding members of the Homemakers. Clubs also shared information on the successes and failures they encountered, most importantly at an annual national meeting. This three-day affair, attended by eighty to two hundred women from all over the territory, included a training course and conference, and culminated in a display of the women's produce and crafts. Beginning in Mokhotlong in 1958, the

Homemakers Association also conducted 'regional courses' at missions or camps which brought together women from different clubs. It published and distributed leaflets 'for information necessary to clubs', ranging from organizational matters to Department of Agriculture propaganda. The Homemakers who travelled around the country addressing groups and forming new clubs did so on a part-time and purely voluntary basis, their expenses met by a combination of a membership fee (25d per member and 7/6 per club), the hospitality extended by village women, and their own independent resources.[62]

Because each club started by the Homemakers adopted its own policies and organization, the gardens they established were run in a variety of ways reflecting the inclinations of each local group. Some garden plots were worked on an individual basis, others cooperatively, and still others communally. Many were worked in a combination of these. For example, the Mafeteng garden provided each woman with an individual plot for subsistence while several larger plots were worked cooperatively for market production. Profits from the cooperative section were distributed according to the number of hours each woman contributed to it.

In addition to food-centred activities, the Homemakers taught women non-traditional crafts such as making rugs, linoleum, soap and candles. All of these were ostensibly to foster cleanliness and an 'appreciation of beauty in the home'. This, the early leaders of the Homemakers believed, could enhance women's sense of achievement and self-worth and so improve overall morale in rural families. In that same vein, nursery schools, drama clubs, singing and other activities were organized for children and youths. Again, much of this was motivated by the desire to provide a countervailing influence to the poverty and barrenness of social life in the villages which otherwise led children to delinquency or emigration, and women to 'misbehaviour'. The government approved wholeheartedly. Although its praise may sound condescending to the modern ear ('bringing people together and making them happy by singing and dancing with them, because people in the villages need this'),[63] the Homemakers themselves expressed much the same sentiments: 'Women are responsible for the good upbringing of children so if they set a poor example by drinking or what-what, it will weaken the nation. If women can make a good home, there will be more and more educated people and the country will be developed.'[64]

Notwithstanding the similarities between government and Homemaker ideals, in practice the Homemakers were considerably more successful than government attempts to improve Basotho women. This may be explained by the Homemakers' lack of bureaucratic dogma or centralizing leadership. The federation was thus open to adaptation to meet individual women's differing needs and changing circumstances. Sim-

ilarly, despite a patina of Christian rhetoric, the Homemakers took a decidedly pragmatic approach to their work which focused on attractive deeds. Demonstration, rather than alienating speeches, was the key to their success. 'With us when we were visiting people, the main thing was not to tell them but to show them.'[65] Or, as another venerable homemaker expressed it:

> We live on these things so we have to practice. You see, we don't have to sit at a desk. Our method is to look and do which is how we get our members. They see the results we get and spread the word. Like, someone will come and see this crochet I'm doing and say it's nice, and then I tell them that I can sell it for ten rands. One day's work will earn ten rands which women understand very well. So we teach by demonstration. We don't cram, which is a waste of time. The ladies come to see, then they try and by so doing, they learn very quickly.[66]

This pragmatic attitude enabled even the most devout Protestants among the Homemakers to recognize and uphold the value of some Sesotho customs – lengthy post-partum abstinence from sex as a means of child-spacing, for example. Similarly, while they were eminently progressive in their overall philosophy, they understood the need to alert women to the dangers of some aspects of 'progress'. Declining standards of hygiene and nutrition, for example, were understood not as the result of the incompetence or 'natural' carelessness of Basotho women, but as a recent development directly associated with the colonial policies that abetted male migrancy and rural impoverishment: 'Of course women traditionally knew how to raise their children but because of the economy getting worse, something had to be done. Before there used to be abundant milk – everyone had a cow or a few of them. Only later people began feeding the children *papa* only . . .'[67]

The appearance of pellagra in the mid-1930s was a dramatic example of declining health which could be directly linked to progress – specifically, the spread of commercial roller mills throughout the country and of trader propaganda that associated the whitest, most refined meal with 'civilization'.[68] Such refined meal eaten with store-bought (wilted, chemical-dusted) vegetables was nutritionally inferior to the traditional diet. The Homemakers thus made counter-propaganda to this aspect of 'progress' an important element in their lessons. '[We] encouraged the use of wild vegetables', recalls Mohapeloa, while her 'nutrition' lessons would start with a laywoman's explanation of how the commodity market undervalued women's production and undermined self-sufficiency and good health: 'I tried to explain how you didn't need to go spend money at the shops to make good food and that you could do it with your own

garden. In fact, some women who grew wheat were exchanging that for mealies only because they were used to *papa* only. So we just explained that with wheat you can make wholesome bread.'[69]

The Homemakers did not condescend to the women, preach at them, deny the obvious, or accept as given or immutable what Basotho women commonly experienced as the root of the problem. Hence, where government extension officers assumed the ultimate beneficence of market forces, Homemakers advocated the cost-effectiveness of subsistence production. Also in the interest of weaning women from dependency upon the consumer market, the Homemakers sought 'to keep alive indigenous crafts such as pottery, grass work and wall decorations'.[70]

Opinions about the ultimate objectives of all these activities varied considerably among Homemakers and from place to place. Some women saw homemaking as a means to win the loyalty of wayward husbands (not children). In the context of many women's growing dependency upon men's wage earnings, this was a sensible strategy: 'Our main idea was to concentrate on making the home happy. The home is a holy city to everyone and if the wife can succeed in feeding her family well and keeping her house beautiful, then the men will never desert.'[71]

Missionaries also tended to stress this house*wife* aspect of homemaking, putting enhanced service to the husband at the top of their lists of women's priorities and 'Christian standards'.[72] In the words of one Anglican nun: 'The men here are no good. Our men are useless, well and truly. They drink, they go off with other women. If a woman is wise, she should manage the house well and make good meals. Then, even if her husband is a drunkard, he will come back. Many families break up because the woman doesn't know handiwork.'[73]

Yet for many Homemakers, homemaking as a means to pander to the desires of their husbands was naive and, ultimately, a waste of effort. This reflected a more phlegmatic attitude towards men and marriage than most missionaries would have liked. To some the concept of 'home' did not even necessarily include a man at all: 'We did not really think that homemaking would keep our husbands happy since if a man wants to run away, there are plenty of other reasons he will find.'[74] To such women, pleasing a negligent husband was little more than a possible side benefit of homemaking. Their elemental objective was, instead, to provide themselves and their children with some concrete guarantee against men's unreliability: 'We love our dear men but, you know, some of them are becoming too clever.'[75]

In adapting to this reality of its members' lives, the real watch-word of the Homemakers rather quickly became 'self-help' or 'self-reliance'. Homemakers thus branched out from seeking to improve nutrition and rural morale to encouraging members to earn cash independently. Home-

maker clubs instructed women to market their garden products so as to maximize income and to ensure that it was distributed fairly among members. Lessons included how to keep prices up by controlling the number of women selling produce on any given day. Homemakers were also among the first and most dedicated converts to the benefits of soil erosion control through afforestation. They thus encouraged the planting of trees – to reclaim ravaged land, to prettify the homestead, and to exploit it for subsistence and profit. At a time when even published government reports lamented the poor performance of the government's own erosion control projects, officials were describing women's 'spontaneous' afforestation projects as 'impressive', and one of the country's 'few signs of latent energy and enthusiasm waiting to be tapped'.[76] Peach trees were especially valued by the women and indeed, much of the enchanting pink hue of Lesotho's villages in August and September today can be attributed to the tree husbandry of the Homemakers since the 1930s.

Aesthetics aside, homemaking clubs also provided an avenue to generate capital which could be used either for expansion into new and more profitable areas of production or to protect existing assets. The construction of fencing and sheds were especially important 'infrastructural' projects which required women's pooling of resources:

> All these projects we organized needed some capital to get started. In the beginning that was very difficult. But the women themselves saw it as something new and were willing to put in their own money. They had concerts and raffles to help each other. With other means, like *setokofele*, they could raise enough to buy a sewing machine or chickens and four months of feed, that is, enough to last until the chickens started to lay and you can repay.[77]

The Homemakers' Association also encouraged housecrafts and other income-generating projects based on the domestic science skills which were then being taught to girls in school. 'And definitely I put my schooling in home economics to use. I still profit. I do a lot of dressmaking. I get orders to cater for *moketes* [traditional feasts], you know, cakes, scones and so on. I think I'm cheaper than the bakeries. Of course I'm better, but it varies. Some people prefer to buy from the shops.'[78]

By the 1960s, Homemaker 'domesticity' had even begun to colonize the masculine domain of cattle: 'Of course many men were not happy with women having cows but the women, they were determined. They wanted to show the men they could do it.'[79]

The most visible and immediate effect of Homemaker propaganda was the huge jump in the number of terraced gardens in the territory.[80] From 339 in 1935, the number of terraced gardens grew to 809 in 1936,

while in the following year alone, nearly 1 000 more were laid out. Even during the war, when more men than ever were out of the country, the spread of gardens continued apace. In 1942 there were 7 665 of them, and by 1948 this had nearly doubled again to 13 280. By 1953 Homemakers accounted for nearly a third of all displays at the annual agricultural show and, over the next decade, began to win prizes ahead of male farmers.

In membership terms, the Homemakers counted approximately 3 000 women in 110 clubs in 1950, including 15 on the Rand and in the Orange Free State. Three years later, the number of clubs had increased to 160, and by the time of independence, over 200 clubs counted nearly 13 000 members.[81] As it became so big, a number of offshoot organizations were formed, principally Boiteko and The Women's Institute. The very success of homemaking also brought even the most hidebound pious associations to emulate it. As the venerable president of Roma's LSA expressed it: 'We are [nowadays] very little different from the Homemakers – in fact we do the same things. We admire them because they really keep to their work.'[82]

The Homemakers' rapid spread throughout Lesotho and then to chapters in the urban areas of South Africa owed much to the fact that: 'we based most of our activities on profit-making'.[83] Even the nursery schools ultimately had this objective at least partially in mind for, behind the discourse of providing healthy food and stimulating play for the children, lay the goal 'to provide mothers more time for their housework or employment'.[84] Attuned to the market at a highly localized level, and able to shift production in a flexible and cooperative manner, Homemakers were able to extract a livelihood from their homes and gardens which could be 'very profitable'.[85] As a clearly impressed Director of Agriculture affirmed in 1938: 'Many of these Associations have substantial cash balances deposited in the Post Office Savings Bank and their finances are now well-managed.' In this regard, women's clubs provided a stark contrast to the 'often very disappointing' results of the men's agricultural associations.[86]

The Homemakers originally attracted almost nothing but praise from men, whether missionaries, colonial officials, chiefs, or husbands. Certain specific aspects of Homemaker style and discourse contributed to the wide appeal of the movement, even among *matekatse*. To begin with, the pragmatism of 'homemaking' outweighed ideological or sectarian tendencies which could have alienated supporters: 'Yes, I suppose the kind of home we talked about was of a Christian type, but we were open to all women, even those non-Christians . . . Now, with those women who brewed beer, we understood them. They did it from economic need, so we didn't preach to them.'[87]

This tolerance contrasted sharply with both the government's attitude and the PEMS leadership. In Morija, for example, the heart of the PEMS mission, one member opened a shebeen right on the premises of the Homemakers' new clubhouse. In an era when church members could be excommunicated for even consuming let alone brewing and selling *joala*, the local president recalled the event without rancour: 'The Homemakers built that house as a place for the women to come and work on their projects but that certain woman started brewing beer right there. Well, it led to noise and the men were bothering us so we closed her down. Well, she is still a Homemaker but she set up her shop across the street.'[88]

Tolerance was extended even to members who clearly engaged in prostitution: 'It was one of our major topics to discuss how women could maintain themselves where they are in the villages. We did not like to see women forced to go to South Africa or to lead lives based on prostitution and such but [we understood] they did that because of starvation.'[89]

The potentially subversive message of female self-reliance was meanwhile all but buried in the decidedly non-controversial discourse of homemaking. Like 'prayer', the words 'home improvement' and 'housekeeping' tended to convey something small and non-threatening to even the most patriarchal ear. With chiefs, for example, Homemaker organizers always approached them for permission before they came to give a demonstration or to establish a new club. After explaining their intentions, they would humbly request a plot of land to start their garden, often the most ravaged, eroded field which nobody else wanted – 'impossible sites', according to one colonial official.[90] They also always invited the (usually disinterested) men to their shows and, once the harvest was in, made the customary *limpho*, or gifts, to the appropriate village authorities. As a result: 'Our relationship was very, very good with the chiefs. They liked it that we promised to give women something to do, we kept them in their homes so they didn't have to run away or turn to selling beer.'[91]

Good relations with the colonial government were cultivated in a similar way. To this audience, the Homemakers stressed the goals long dearest to the hearts of colonial officials. They promised in particular to correct the 'too bookish' learning which girls supposedly received in mission schools and which, it was asserted, tended to spoil them of any useful economic role in the rural areas. In emphasizing how they sought to 'form a connecting link between the education which girls receive in the schools and the practical application in the home of the learning thus obtained', the Homemakers were telling officials precisely what they most wanted to hear.[92] The Catholic church, which normally did not like its members to join secular organizations, also at first gave the Homemakers its 'full support' and encouraged Catholic women to join.[93] So

benign did the Homemakers make themselves appear that these women, if not the *matekatse* they were reaching out to, were even welcomed by authorities in South Africa. Men who otherwise had little good to say about Basotho women in general actually facilitated Homemaker proselytization in the Union. As the founder of the Morija branch states with some nostalgia: 'I was the first to set up a Homemakers club here in 1939. Then I travelled all over the country and to Kimberly and Johannesburg to set up new clubs. Oh! Everybody liked me so much.'[94]

Husbands, too, were generally appreciative of homemaking to the extent that it promised to increase household income, provide healthier and more varied meals and clothes, and add to a man's prestige by making him look like a good provider. Yet much as homemaking conformed to traditional gender relations, it also subtly enhanced Homemakers' bargaining power within the household. This the women sometimes used to press upon men somewhat radical changes to the traditional sexual division of labour and gender relations: 'Those who are interested, who care about their wives, we always try to encourage them to help more at home, especially when their wives are pregnant or nursing. Some even do cooking and baking bread and we like that very much. There are many men who are stubborn about this, however, so we only try to coax them.'[95]

More controversially, leading Homemakers began in the 1960s discreetly to promote discussions about family planning. Migrant men in particular regarded birth control as synonymous with freedom for their wives to have adulterous relations. In addition, the Catholic church had an absolute ban on artificial birth control. In venturing into the area of women's reproductive rights with such formidable opposition, Homemakers did not seek to challenge women's primary role as mothers, and even less to promote licentiousness. Rather, they saw the high mortality rate of childbirth and the expense of having many children as burdens upon women which undermined the best efforts at 'self-reliance'. Typically, they arrived at a compromise:

> Another touchy question was birth control. We introduced it in our discussions as far back as the 60s although we were divided. Some women were in favour and some were against it, especially the Catholics who refused to consider it. They said, why would God have made women so that she can have many children if that was not what she was required to do? Yet many women die. So we encouraged child-spacing.[96]

Backlash from men could meanwhile be contained by blaming the controversy on foreigners, especially Western women: 'Husbands were never worried about their wives coming to our meetings except once when an expatriate woman tried to introduce family planning. We explained to the

men that this was not from us and they were satisfied. They were usually very happy.'[97]

This desire – and ability – to avoid controversy served the Homemakers well, particularly after the formation of political parties in the 1950s and the obvious co-relation that arose between church, class, and partisan affiliation. Central to the Homemakers' self-image in this era was that they were not political. Discussions about religion and politics in their meetings were therefore explicitly banned. 'That was one of the things we were always very strong about – no politics in our meetings. If we overheard some women talking that way, we would ask them to stop.'[98] In the words of 'Me Mohloboli: '*K'ore*, we just wanted to support the government.'[99] Or, as one of the founders of the umbrella organization of homemaking associations insisted: 'Of course people are human. They did sometimes bring in discussions about politics but we told them to stop it. We have always been non-denominational. A woman has to leave all that baggage behind when she comes in our door. We are non-political. We are non-, non-, non-.'[100]

Despite this strong injunction, Homemaker organizers tended to be educated women who were aware of debates and developments in the wider world and who tended to be receptive to the ideals of African nationalism. The contradiction between government words and deeds towards them almost certainly encouraged this tendency. For example, comparison was unavoidably noted between what government gave the Homemakers' Association as an annual subsidy (£100) and what it essentially squandered on the Home Industries Organization (£25 000) or the Farmech Mechanization Scheme in Mafeteng (£45 000). Similarly, not until 1964, and only upon the personal intervention of the Paramount Chief, did the government see fit to assist in the creation of a coordinating body of women's homemaking activities. The Lesotho Federation of Women's Voluntary Organizations (which later became the Lesotho National Council of Women or LNCW) was assigned two junior African bureaucrats in the Department of Local Government.[101]

Frustrated that there was so 'little tangible help except promises from the powers that be which seem to take a long time to materialize', the Homemakers began increasingly to look abroad for assistance.[102] In 1961, they joined the Associated Countrywomen of the World, a London-based organization, which put them in contact with a wide variety of other non-government aid agencies, including UNICEF and Oxfam. 'Me Mohapeloa and others began to travel extensively and to win significant recognition and donations for their efforts from abroad. The first major such donation was a Landrover in 1962, which the Homemakers used to get up into the mountains to hold courses at the most remote villages.[103] In 1963, the Homemakers re-established their old links with similar organ-

izations in South Africa. In that year another important connection was established with women's groups in Israel. Aside from facilitating expansion within the territory, such foreign connections sometimes opened up new opportunities for income generation. One of the most promising in that regard was provided by the acquisition of large numbers of sewing machines.

As Homemakers ventured into new areas, geographically and socially, they also ventured into discussions among themselves about the injustices of society and law:

> We did try to talk about equal rights for women and men. Nowadays we can talk boldly but even in the 1960s, in our annual meetings we were not prevented from speaking. We discussed such things as why should a woman with qualifications not receive equal pay. Another very solid question was why shouldn't a woman be able to get a loan without getting her husband's signature? We disagreed that a woman, even a businesswoman, should be a junior.[104]

Such discussions were not understood as 'political', in the usual partisan, masculinist sense that 'politics' was construed. In one Homemaker's adamant assertion, 'No, we never talked about politics . . . Socially though, we were very active.'[105] In retrospect, some of the leaders of the Homemakers now admit that this social activism was in fact quite political and that, in the context, it could have been perceived as left-leaning or radical:

> I would say now that we did a lot to instil political consciousness in women. Politically we were organizing women, I mean, in consumer awareness or to demand their rights. Women in Lesotho are tough, sincere, generous, useful – even the poorest and least educated deserves to be treated like a human being, you know. We owe them dignity, respect.[106]

More explicitly:

> MS: The Homemakers and such organizations included more educated women who were all BCP. They were much more interested in raising up the ignorant women which was necessary in those days before most people could read. They normally concentrated on cooking, sewing, and canning meat but they also could give a subtle or disguised political message.
>
> ME: Can you give me an example?
>
> MS: Yes. I once invited some Boiteko women up to my village. They demonstrated their wares and showed how to can a chicken. 'But

what is the use of that?' some women asked, 'since it is easy to kill a fresh chicken every day?' The Boiteko women then introduced the idea that their husbands may one day be forced into exile because of government repression and so the women would have to be able to support their families on their own. This was a clever way of making women aware that the people in authority could become their enemies. They therefore encouraged women to be able to stand on their own two feet.[107]

Even without explicit lessons, working for 'self-reliance' could be conscientizing in a manner which we may, with hindsight, fairly describe as both proto-feminist and proto-nationalist. The following chapter shows how this was particularly worrisome to the Catholic church. By the early 1960s the RCM had actually come to regard the Homemakers as nothing less than 'satellite organizations of the Basutoland Communist Party'.[108] Yet the influence of the homemaker movement was felt even within the RCM itself, and its *kopanos* after the 1950s became increasingly preoccupied with improved gardening, income-generating projects, erosion-control, the construction of roads and bridle-paths, and economic 'self-reliance'. As one member of the LSA recollected:

> In the past the Canadian priests did everything for the church. In fact, now I can say that they made us dependent, sort of non-productive, even to the point of wiping out our thinking . . . That is why we wanted to organize ourselves as women, to show that we had to take responsibility for our church. We wanted to show that the church is in everyone's interest. You see, we looked to the Protestants and admired the way they did everything themselves. So, besides prayers, we can do some practical things for the church and not just rely on the church doing things for us. We want to show that the church is us, the people, and not the priests only.[109]

8.3 Conclusion

No way exists to quantify the contribution of women's *kopanos* to Lesotho's development. To begin with, the production that they engaged in was often primarily for subsistence. In so far as it reduced consumer purchases, homemaking may have actually detracted from the normal indicators of economic growth. Moreover, those petty commodity products which entered the market, generally did so informally, outside the purview of colonial bean-counters. This invisibility was compounded by androcentric assumptions about what counted as production. Nonetheless, the evidence of the rapid spread of gardens suggests that homemaking had an important, perhaps crucial role in revitalizing the mori-

bund rural economy. Recent statistics are suggestive in this regard. One study from 1986 found that home gardening accounted for nearly a quarter of all vegetable consumption, and that a quarter of all rural households derived income from their gardens. In the drought year of 1991/2, the value per hectare of home garden production was as much as 1 700 percent that of dry-land cereal production.[110]

Likewise, no figure and certainly no public statement by any Homemakers can capture the profound extent to which the homemaking movement affected the development of Basotho women's political consciousness. Behind the veneer of apolitical domesticity, Homemakers propagated a subtly anti-colonial and anti-patriarchal message. While generally accepting a gender ideology based on women's subordination to men, homemaking gave women crucial support to enhance their *de facto* autonomy from men. The homemaking movement helped to provide a sense of direction, accomplishment and pride for Basotho women in what was an otherwise demoralizing and deteriorating socio-economic setting. In these ways, women's ostensibly apolitical *kopanos* helped prepare the ground for women's active participation in partisan politics in the late 1950s and early 1960s.

An alternative vision
Catholic patriarchy and the 'anti-capitalist' legacy of Bishop Bonhomme, 1933–47

The economic and social crises of the Great Depression, and the govern-ment's attempts to contain them primarily through administrative reforms and erosion control, were of compelling concern to all the Christian missions. The two largest, the PEMS and RCM, held significantly differ-ent perspectives on the nature of the problems at hand and they adopted quite different strategies to cope with them. The PEMS stood for merito-cracy regardless of race or gender, for individual achievement, and for prosperity through hard work and thrift. In the words of one missionary 'we were the church of free enterprise'.[1] The RCM, by contrast, came to be associated with the chieftaincy and seemingly tolerant or outright approval of 'feudal' ways. This included acceptance of key Sesotho customs and institutions, and relative disinterest in the cultivation of literacy. Because of its celibacy rule and consequent difficulty in recruit-ing a male clergy, it also appeared to critics as diverse as Josiel Lefela and the reformist Bishop Bonhomme, to be excessively paternalistic or even racially discriminatory when compared to the rapidly Africanizing PEMS. The impression of social and political conservatism was then immensely compounded in the era after the Second World War by the flourish of anti-communist rhetoric coming from the church. The 'notori-ous pro-Verwoerd, pro-Hitlerite, pro-Colonialist' 'settler political-priests' were especially reviled by the radical nationalist Basotho politi-cians who garnered the sympathies of most Western academics in the lead-up to the 1965 elections.[2]

Little investigated in such characterizations of Catholic reaction are first, the missions' *actual* policies toward socio-economic development, as opposed to their rhetoric; secondly, changes in mission orientation over time, and how this specifically affected Basotho women; and thirdly, Basotho women's perspectives on the matter. This chapter therefore ex-plores the implications for women and gender relations of the RCM's alternative vision of society during the critical years of the 'moderniza-tion' of indirect rule.

9.1 Catholic patriarchy revisited

In Lesotho, as worldwide, the Roman Catholic church was an intensely and explicitly patriarchal institution. The specific group of men in charge of the mission to Basutoland from 1930 may, in fact, have been even more overtly hostile to women's legal emancipation and other social advances than typical of the era. In that year, responsibility for the administration of the mission was handed over from the almost-bankrupt OMI of France (which had founded the mission but had over-extended itself in the rapid expansion of the 1910s) to Canada (most of which was comprised of the predominantly francophone province of Quebec). Literally hundreds of French-Canadians flooded into the territory over the next three decades. They brought with them both an eagerness to revitalize the mission in Lesotho and their own long history of struggle against a 'colonial' power (anglophone, Protestant and liberal Canada). Indeed, the Catholic church in Quebec saw itself as leading the struggle to preserve the 'French race' in America after its conquest by the English in 1763. A key aspect of that struggle had been 'la révanche du berceau' – 'the revenge of the cradle'. Pulpits rang with admonitions for good Catholic francophone women to devote themselves to reproduction (and so demographically to reverse the military defeat of New France). As a result, there were few opportunities for women outside the role of prolific mother which did not bring an enormous weight of social disapproval. Women of Quebec did not receive the right to vote until 1940, while they remained essentially legal minors until 1964.[3]

The Reverend A.M. Granger's definitive tome on marriage provides the clearest and most extensive articulation of the oppressive nature of the Canadian OMI's ideals of 'proper' female behaviour in that era. Granger's book, published in 1945, became the basis for the marriage preparation course offered by the RCM in Lesotho in the 1960s. In his candid words, the good Father adjured the young woman: 'to accustom herself to a free and loving subordination, to a faithfulness that is beyond question, and to an unselfish devotion if later, when her call has come, she wishes to be the companion, spouse and mother she ought to be'.[4]

To Granger, once a woman had become a wife, her 'obligatory' conjugal 'debt' demanded that she not only 'fear her husband' but learn as well 'to hide certain feelings of repugnance' against him, quelling her understandable revulsion at the sexual act to which she must submit without demonstrating pleasure. For the man, his power over his wife should be tempered by love, self-control, discipline, and resolution, the want of which would reduce him to 'a mere woman . . . a weak and spineless character'. The problem of modern immorality was, for Granger, both that men failed to live up to such rigorous demands upon them and that shameless modern women would:

forget their proper place, their own role. Carried away, as they are, by a modern mentality towards a false freedom, an unbridled liberty, they have stepped down, of their own accord, from the pedestal to which the Church has raised them and where she wishes them to remain. For everyone knows what woman was before the Church came to place the crown of dignity and respect upon her brow.[5]

Granger asks rhetorically: 'How much more homage and respect would women receive from the "stronger sex" if, instead of trying to resemble them, they would endeavour to remain the "weaker sex"?'[6]

The Oblates in Lesotho certainly evinced these attitudes in their relations with the sisterly orders of the church. The Sisters were required to show 'docile submission to the Father' at all times, for 'the will of the Superiors is the will of God even if we have to crush our hearts'.[7] To incur the displeasure of the Bishop was theoretically tantamount to incurring the wrath of God. While priests and brothers were also subject to authoritarian and arbitrary 'obediences', disciplinary action against women in the mission enforced a quite distinct form of humility. One Sister of the Holy Cross, for example, was transferred out of the territory in 1936 for having had the audacity to drive an automobile. As the Bishop veritably thundered: 'I would never have thought also that the dignity of a sister would allow her to be the driver of a motor car. I will never permit that in my vicariate.'[8]

There were quite direct material advantages for the mission to such an overtly patriarchal ideology, above all by normalizing the routine exploitation of women as cheap labour. The women's *kopanos* were encouraged to show their piety by working the priests' gardens and, prior to 1912, the Sisters received no salaries at all for their professional work. As late as 1939, the Catholic Education Secretary noted with satisfaction that 'A teaching Sister costs me only six pounds a year whereas a [male] lay teacher costs me forty to fifty.'[9] Not surprisingly, 'lay teachers were wherever possible replaced by Nuns'. The self-serving belief that nuns enjoyed and desired ascetic conditions also justified the extraordinary discrepancy between the salaries of nuns and the OMI Brothers. In 1953, a Catholic Brother earned on average five to seven times the amount of a Sister.[10]

As retrograde and repugnant as these views may strike the modern ear, they need to be understood in context. First, other than their startling explicitness, these views were at base not so different from the sexist expectations and assumptions about women which also pervaded Protestant and secular ideology. Despite their relatively well-educated female congregation, for example, even some of the most ostensibly enlightened Protestants remained deeply worried about the 'fatal tendency' of edu-

cated girls to become so 'proud and conceited' that they forgot their true vocation – motherhood and service to men.[11] The perceived 'serious problems and grave dangers for the future' of inappropriate (that is, relatively too much) education of girls were also expressed by two progressive academic observers at the time:

> Western nations know something of the difficulties and danger which arise from leaving their womenfolk in mental darkness while their men monopolise education, but what can these be compared to those of a society whose women have been led to look outside and beyond its boundaries, to new values and foreign institutions which they inevitably come to regard as superior, while its men remain weighted with tradition and sunk in ignorance. It is a situation that scarcely bears contemplation . . .[12]

Secondly, as restrictive as Catholic patriarchy was, it also created entirely new spaces for the assertion by women of autonomy from men. The institution of the Sisterly Orders, above all, provided a route for Basotho women both to reject oppressive aspects of Sesotho as well as to struggle against European racism and misogyny. In 1932 there were sixty-five Basotho nuns. By the time of independence in 1966 this figure had grown to five hundred.[13] These women were not just subordinates or lackeys to the white Sisters. On the contrary, a Mosotho was appointed as Mother Superior to a convent as early as 1939 and, thereafter, Basotho Sisters commonly rose to positions of power and influence within the considerable spheres allotted to them. Entering a convent was in fact one of the few clear avenues available for women to develop or exercise their intellectual, artistic, managerial and even mechanical skills. By the 1930s, nuns did the bulk of teaching, ran schools, operated dispensaries and provided the crucial support which made the missions attractive centres. One innovation of theirs was to offer special courses for Basotho women who had been unable to complete regular schooling. These 'marriage preparation courses' focused almost exclusively on providing simple but practical household, gardening and income-generating skills.[14] According to one Mosotho nun, the consequence of their quiet work was that:

> People now respect nuns very much. It was a long process for them to understand but it began 125 years ago and gradually, gradually people have come to see them as great women. The nuns have dedicated their lives to the service of the people and to God. They build schools and convents, they help the poor. That sacrifice is very important since it is not the government but the church, especially the nuns, who initiate and educate the children. It was the church that was carrying the people. It was the backbone of the nation. And the nuns in a quiet way were the backbone of the church.[15]

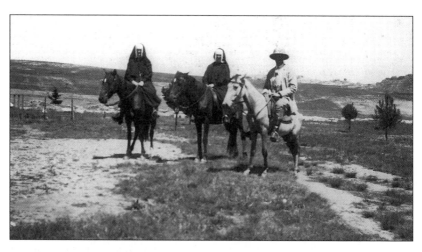

The Sisters of the Holy Family, around and about in the 1930s. Note that these ladies are not riding side-saddle. (Deschatelets archives)

In addition to a vocation, convent life offered something rare for Basotho women in secular life – time: 'I began to admire the way the Sisters lived. I liked the way they had time to sit together and pray. When I saw the way the sisters were free to do that, not having children, I wanted to do that also.'[16]

If entering a convent was to escape from arranged marriages or abusive and exploitative relatives, it also provided channels to struggle against abuses of power by white men and women. This is reflected in the current of disenchantment and resistance that runs through the Sisters' correspondence with the OMI. On the whole the Sisters embraced the sacrifices of their vocation and the notion that the bulk of their remuneration would come from God, not the Bishop. However, by the 1930s they were becoming increasingly hardheaded in negotiating for improved salaries and working conditions. They sent letters of grievance directly to the Bishop or Apostolic Provincial, and even conducted 'strikes' or threatened to strike against specific interfering or inconsiderate priests. When Bishop Bonhomme first arrived in 1933 he was astounded to find that 'certain abusive practices had crept in the Vicarariat' as a result. On some missions, he discovered that 'the Sisters seem to own everything'. Moreover, they 'seemed to remain under the impression that they could live and develop themselves according to the ancient customs of the Vicariat, customs which have been modified according to the needs of the times'.[17]

One of Bonhomme's first campaigns as Bishop was to reassert his proper authority over the Sisters, primarily through a series of stern warnings and sharp disciplinary interventions. At the same time, how-

ever, he regarded the work of the nuns as absolutely essential to the rapid expansion of the mission which he desired. He therefore contracted the services of five new orders to come from Canada. Yet these Sisters, too, gently, politely insisted on their autonomy and indeed exploited Bonhomme's dependency upon them to fulfil his vision. Thus, while professing apologies 'for this independent attitude of ours',[18] the nuns did not mince words in their complaints against interference or Oblate misrule.[19] One priest, driven to anger by the assertiveness of the Sisters who were theoretically under his command, referred to them bitterly as 'Prussians' and their school as a 'concentration camp'.[20]

Without exaggerating the 'incipient feminist' element among the nuns, or the amount of discretion which they were given within a highly patriarchal and hierarchical church structure, it is important to balance prevailing assumptions about the passivity and selflessness of the nuns. The five orders who came to Basutoland from Canada in the 1930s had a long tradition of struggling for the advancement of women in their own society. In the 1920s and 30s they were at the height of their popularity and prestige in Quebec. Many were also notably and publicly sympathetic to laywomen's feminism, including adopting a pro-suffrage stance in the 1920s which earned them disciplinary action from the Bishop there.[21] Indeed, the nuns who came to Lesotho may in some cases have been *too* 'feminist' for their Basotho postulants. In one instance at the Holy Cross Convent in 1934, the Basotho Sisters took their grievances against the white Sisters to the Bishop, protesting that the latter showed 'lack of respect' to the priests. 'They make a strike and refusing [*sic*] to go to confessions', the Basotho nuns wrote, urging the Bishop that he discipline them.[22]

The post-1930 regime of the Canadian OMI was particularly favourable to the Basotho Sisters since it made Africanization of all branches of the clergy a top priority. Not all the European Sisters appreciated or cooperated in this. The Sister in charge at Sebetia, for example, accused the 'unbearable' Father Lefevre of 'taking the affairs of the [Basotho] Sisters to the pulpit' and of 'familiarity with the girls' as a tactic to undermine her own authority.[23] Sister Fransisca Clara of the Holy Cross Convent was likewise disturbed by Father Letsie who 'stirred up the pride of the [Basotho] Sisters and made them dissatisfied and rebellious'.[24] His replacement was not much better, 'giv[ing] very bad advice to our Sisters and Postulants and undermin[ing] our authority'.[25] A year later, two more Oblates had aggrieved Sister Fransisca Clara:

Our Parishpriest [*sic*] is speaking in Church against the Sisters. He instigates the boarders against us and makes them congress. He helps them to get their correspondence off secretly by letting them type

*Sisters of the Holy Names of Jesus and Mary at St. Theresa's mission, Koening,
Leribe district, 1931.* (Deschatelets archives)

their addresses in his office. We cannot run a boarding school under
such circumstances . . . Also in Emmaus the sisters suffer a lot. Rev.
Fr. Montreuil interferes in community matters and undermines the
authority of the local Superior.[26]

There is evidence to suggest that the priests who interfered in these
incidents may have been scapegoating the white Sisters for resisting
indigenization of the clergy when they themselves were considerably
more at fault.[27] The fact is that Basotho women had greater potential to
achieve positions of responsibility than either Basotho men within the
church or the vast majority of Basotho women in secular society. The
RCM in Lesotho cannot be judged without taking into account this con-
tradiction between its ideals of male authority on the one hand, and on the
other its facilitation of practical avenues for women's advancement.

Contradictions also emerged in the propagation of Catholic patri-
archy among the lay population. The contrast between official and folk
doctrines of 'Mariology' is a suggestive case in point. The Oblate priests
made a virtual cult out of the worship of Mary. Their 'Marian ideal' of
humility, self-sacrifice, charity, and unquestioning obedience was in-
tended to inspire Basotho women. Basotho women themselves, however,
preferred to venerate a carnal, tough, and determined Mary, a single
mother who raised her child without the help (or hindrance) of a husband.
The Mary of African women was most certainly not a submissive and
smiling doormat – 'she did not always confine herself to her room', wrote

L.P. Vilikazi, 'but sometimes came forth into the public [as] the defender of the rights and dignity of womanhood'.[28] As Chapter Eight showed, *kopano* women often took this advice to heart, sometimes to the exasperation of their priests.

A final point which must be stressed in order to contextualize Catholic patriarchy is that in key ways the RCM was more accommodating to the rights and autonomies which Basotho women enjoyed in Sesotho than either the government or the PEMS. Tolerance or even encouragement of *bohali* as an impediment to divorce, separate schools for boys and girls, and support for the principle of the chieftaincy are all cases where the RCM appreciated the value of Sesotho customs in protecting girls and women from exploitation. In addition, the 'very exacting' demands upon catechists which the original missionaries had imposed were progressively slackened under the Canadian regime. The net for converts was cast wider through the adoption of a style of religious expression much more in tune to Sesotho than the PEMS in those days:

> An extraordinary popular piety was developed which favoured great crowds of people and presented a magnificent spectacle, filled with joy with its splendid singing by all the participants, a spectacle which attracted people to the Church, called forth admiration, gave the Church an image of joyous and powerful confidence and security. Devotion to the rosary, the way of the cross, medals of all kinds, especially of the Virgin Mary, were extremely popular everywhere.[29]

By contrast, the PEMS tended to appear as an austere and intellectual church, denouncing Catholic ceremonies as idolatry and relic-worship scarcely better than the paganism they purported to supercede.[30] Indeed, where the PEMS could excommunicate its members for indulgence in *joala*, the French-Canadian priests must have seemed positively sportive: 'The Basuto like them, for they have a fundamental friendliness which extends enough to allow them to be present at Basuto tribal feasts, and even to enjoy refreshment from pots of beer brewed by the women.'[31]

Such idiosyncrasies in Oblate behaviour and doctrine provided small cracks in the edifice of Catholic patriarchy through which women could both assert new behaviours (such as independent income-generation or a career outside marriage) and defend old rights (such as *ho ngala*). Yet an even more significant 'crack' emerged with the advent of the Canadians. Particularly under the leadership of Bishop Joseph Bonhomme (1933–47), the RCM began a vast expansion in which 'social action' took precedence as the preferred means to proselytize the gospel. In the dismayed words of a leading Protestant observer, the RCM in the 1930s seemed to be 'placing itself like the future before what might indeed seem like a thing of the past', the PEMS.[32]

9.2 'Social action'

The Pope's call for 'social action' was first made in 1921. This was the church's response to the economic malaise and spiritual vacuum of Europe after the First World War. It feared that without concrete action to improve people's material conditions of life, people would be attracted to communist or extreme nationalist propaganda. The first step taken toward organizing such action was to coordinate and revitalize the innumerable parochial pious associations. In Basutoland, territory-wide 'sodalities' were created, including the Ladies of Sainte Anne, Men of the Sacred Heart, the Children of Mary, and the *Lebotho* of Mary. (*Lebotho* means 'companions' or 'a band of people of the same age'. In effect, it was the Catholic alternative to 'initiation school' for teenage girls.)

The activist approach to addressing the poverty and injustice engendered by capitalism and colonial rule specifically through developmental work began in southern Africa in 1926. In that year, Rev. Bernard Huss established the Catholic African Union (CAU) at Marianhill, Natal. The CAU's objective was the 'co-operative self-education of the people'. It aimed to inculcate among Africans the skills and resources they would need in order to resist the 'disastrous' laws which made them 'slaves' of South Africa's 'great exploiters'. The CAU and other related 'social projects' launched by the Catholic church in southern Africa were regarded as 'the principal rampart against the bolshevization of the Blacks'.[33]

The first convert to social action in Basutoland was the RCM's first Canadian missionary, the 'hyperactive' Odilon Chévrier. Soon after his arrival in 1923, Chévrier established a farmer's association at his own mission of Masitise, drawing upon the Catholic cooperative model then being pioneered in Canada. In 1931 he was instrumental in bringing the ideas of Rev. Huss to Basutoland, helping to form a local version of the CAU known as the Catholic Economic Association (CEA). The CEA aimed to: 'encourage thrift and economy; to improve the quality of agriculture in Basutoland including under this term afforestation, farming and gardening and also to develop home industries in the territory'.[34]

The CAU/CEA was comprised of three mutually supportive elements – an organization to promote cooperative 'improved' farming (the African National Cooperative Society), the People's Bank to make small, low-interest loans available to individual men who desired to upgrade their farming or establish small businesses, and the Buyers and Sellers Association. The latter operated explicitly to enable Africans to avoid the high prices charged by the then almost exclusively European retail

traders. It imported bulk quantities of 'farm implements, soft goods, school requisites, groceries, hardware and any other commodity' ordered by its members. These were then sold at cost to its members, providing a very significant saving on key consumer and productive items.[35] Until the mid-1940s, the buying and selling was frequently conducted in the church buildings themselves, while members' orders were taken after Sunday service.[36] Not surprisingly, the PEMS complained that the CEA was a devious attempt to attract converts to the RCM.

The avowed principal aim of Catholic cooperation was 'to make MEN'.[37] By this was meant to provide an organizational framework for African men to learn (or re-learn) cooperative rather than exploitative behaviour, and to acquire the material means to honour their obligations to their family, community and church. This reflected Oblate assumptions about the desirability of male-headed families, as well as their belief that men were by nature more 'efficient [and] business-like' farmers than women.[38] As with colonial development planners, therefore, the OMI preferred to teach men the techniques of cooperation and improved farming.

However, the OMI recognized that in the short-term in the prevailing conditions and while decidedly regrettable in theory, in practice it was in the interest of Basotho 'yeomen' that women's autonomous ability to make economic or managerial decisions be enhanced. Put simply, female self-reliance would enable women to withstand the poverty (and immorality) arising from the migrant labour system. This, in turn, would remove a major impetus for men to seek earned income outside the country. Therefore, despite the Oblates' obvious preference for a 'woman's place to be in the home', from the beginning they encouraged Basotho women to take part in the CEA.[39] Technically-minded Brothers and Sisters imparted new skills to women as farmers and horticulturists while women's pious associations like the Ladies of Sainte Anne were gently nudged beyond simple prayer meetings into taking an interest in learning gardening skills and other activities along the lines of the secular Homemakers Association. As Miss L.P. Vilikazi informed the CAU Annual General Meeting in April 1931:

> We agree that the first place for women is in the home. But we women also claim a place for ourselves in the social and public life. The married woman should not be forced either by poverty or by other circumstances to leave her home and look for work in order to find the means of living for herself and her children. In this respect we hope very much that the CAU will help us, by encouraging our menfolk to be saving and thrifty, and by helping us to establish profitable home industries.[40]

An early, ultimately unsuccessful experiment in development – raising ostriches for export at St. Jame's mission, early 1930s. (Deschatelets archives)

In addition to these economic projects, the Canadian Oblates regarded propaganda in the secular sphere as a key component of 'social action'. Towards that end, Bishop Martin established a printing press at Mazenod and launched *Moeletsi oa Basotho* (*The Advisor of the Basotho*), a weekly paper dedicated 'to the native point of view'.[41] *Moeletsi* subsequently became renowned for its strident anti-communism. However, in its early years it was more typically character-ized by letters and editorials which denounced the practices of 'monopoly capital'. Indeed, *Moeletsi* provided a platform for outspoken attacks not only upon the racist, exploitative *status quo* in South Africa, but also against the 'robbery . . . monopoly . . . [and] unjust credit manipulation' of European traders and labour agents within the ter-ritory.[42] A few examples can illustrate the tone of the paper in those formative years of nationalist sentiment:

> Capitalism is an open perpetration of injustice. It is a gross violation of the natural right of man to live . . . To arms, therefore, country-men.'[43]

> In the struggle to shake off the intolerable joke [*sic*] of Capitalism . . . none will succeed so well and as simply as trade Unionisms. This is the weapon that saved Europe from the oppression and grinding poverty inflicted by Capitalism.[44]

... monster corporations and the growing evil of the concentration of wealth in the hands of a few, a few who are bleeding both the farmer and the labourer.[45]

Molisana (*The Little Shepherd*), a monthly, was also launched from Mazenod as the organ of the CAU. While filled with less overtly political articles and more oriented to technical questions of cooperative development, its motto reflected the same sense of urgency in the new breed of Catholic priest – 'Delay begets perdition'.[46] So too did the RCM's construction programme. In 1930 alone, 80 new schools were opened and by 1934 their number had tripled (to 368).[47] The RCM opened the first three hospitals in the rural mountain districts between 1936 and 1938 – at Roma, Paray and Ntoate's – as well as dozens of dispensaries where medicine was sold at cost.[48] Much of this expansion required the construction of new roads, which was also undertaken by the RCM with predominantly female labour.[49] In contrast to the generally derelict state of the PEMS churches and schools, the RCM missions turned from bustling construction sites in the 1930s to often towering stone edifices in the 40s. In cases like Roma and Mazenod, the missions were surrounded by sprawling complexes of well-constructed schools, convents, scholasticates (schools for priests), hospitals, farm buildings, dams, grain mills, and power-generating units.

Bishop Martin was succeeded in 1933 by the ambitious Joseph Bonhomme. Bonhomme was born in Ste. Camille, an impoverished francophone village in the eastern townships of Quebec. This area had historically been dominated by a patrician – Quebec nationalists say racist – anglophone elite. Before entering the OMI seminary in Ottawa, Bonhomme worked as a labourer. His first job as a priest came at the onset of the Depression in a working-class district of Hull, a pulp and paper town where the workers were overwhelmingly francophone and the bosses overwhelmingly English-Canadian. In short, he was no stranger to either manual labour or racist discrimination. He thus brought to Africa a passion for workers' rights, a keen consciousness of English liberal hypocrisy, and 'a specialization in the formation and direction of workers' syndicates'.[50]

Bishop Bonhomme stepped up the effort to establish cooperatives and to inundate the highlands with Catholic schools. At his invitation five new orders of Sisters arrived from Canada who, by 1940, had helped to pepper the country with a further hundred Catholic schools. Bishop Bonhomme also relentlessly pressed for the indigenization of the mission, taking his missionaries and nuns to task at every occasion when he suspected racism or procrastination in their efforts to promote Basotho.[51] He first proposed a Catholic college for the territory in 1934, and founded a new order of

Basotho Brothers in 1940.[52] In 1939, he launched Catholic Action, an umbrella organization intended, on the one hand, to coordinate the activities of lay Catholic groups such as CEA and the Ladies of Sainte Anne and, on the other, to challenge 'unjust legislation' of the colonial government.[53] Bonhomme made several goodwill tours of the country to shore up the loyalty and support of progressive-minded chiefs in these efforts.

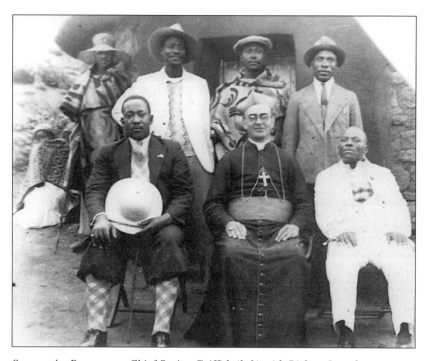

Soon-to-be Paramount Chief Seeiso Griffith (left) with Bishop Joseph Bonhomme (centre), other prominent Catholic chiefs, and an unidentified woman modestly seated in the background (1939). Griffith's death after scarcely a year in power led to the appointment of his principal wife 'Mantsebo as regent. (Deschatelets archives)

Bonhomme returned to Canada in 1939 to organize a fund-raising campaign to pay for all these new projects. In this he was extremely successful. By the end of his sojourn in his home province, congregations throughout Quebec were being regaled with the suffering of 'notre négrillons' in Basutoland. In 1939 alone, over $75 000 was raised for the RCM, an amount nearly equivalent to the Basutoland government's entire revenue that year from income tax.[54]

With the outbreak of the Second World War, Bonhomme felt hampered from returning to Africa from Canada. As hostilities spread, how-

ever, and particularly as the Soviet Union gathered power and prestige in the battle to defeat fascism, it became clear to Bonhomme that urgent efforts were needed to foster a lay Catholic elite which could influence political developments in the post-war era. Of key concern in this regard was the historical advantage the Protestants held in producing educated men. From afar, therefore, Bonhomme pressed ahead with the most ambitious of his projects yet, the establishment of a university. Against all odds, this culminated in 1945 with the opening of the first institution of higher learning in the High Commission Territories, the University College of Pope Pius XII. It would be years before the college began to achieve its goal of producing a Basotho Catholic elite (in 1945 there were not enough graduates of Catholic high schools to fill it). Nonetheless, it was a major propaganda coup for the RCM, a 'Little Canada' which came to be hailed in the liberal South African press as 'the answer to academic apartheid' and 'an important experiment in internationalism'.[55]

The contrast between this type of social action and PEMS attitudes were initially quite stark. Indeed, for all their belief in meritocracy and salvation through hard work, PEMS leaders could be strikingly passive, even fatalistic in their acceptance of the injustices of capitalism. These, including the burgeoning unemployment and bankruptcies among Basotho in the early 1930s, were simply 'les conséquences inévitable du progrès [the inevitable consequences of progress] . . . Rien ne peut s'y opposer [Nothing can oppose it]', as the mission's international journal expressed it.[56] Nonetheless, the RCM 'onslaught' had to be met and the PEMS did ultimately respond with its own brand of social action, notably, opening its first mission in the mountains (at Sehonghong, 1932) and inaugurating its own hospital (Scott Hospital in Morija, 1940). The self-supporting PEMS simply could not begin to match the Catholics in financial resources, however, and an air of gloom settled over the mission which pervaded even their published propaganda:

> When a visitor was spending a few days with us, he told us he got a dark impression about our church . . . As an answer, I took him to an outstation from which we had a wide view of the surrounding country. From where we were, we could see four of our main churches and a great many outstations and schools. We also saw some shining new iron roofs, viz., the new Roman Catholic schools. He understood the situation at once.[57]

Government attitudes towards the RCM's expansion and social action were ambivalent. On the one hand, the British appreciated the efforts of the church to build hospitals, and generally to 'civilize the Natives' in a cost-effective manner. The government especially praised the RCM for its attention to girls and its emphasis on 'industrial' education as opposed

to the 'bookish learning' of the PEMS.[58] In the case of Pope Pius XII College, the government could boast about 'Basutoland's' commitment to high standards of education while making only a token contribution towards it.

On the other hand, the Basutoland authorities took a very dim view of the RCM's 'commercial' activities. The CEA evoked vociferous complaints from the European traders who resented both its anti-capitalist rhetoric and the loss of business it represented. Specific animosity was focused on the Buyers and Sellers Association, which, the traders charged, undercut 'legitimate' business by not having to purchase a general trading licence. In response to relentless pressure from the trading community on this matter, the government first politely urged Bonhomme to curtail the activities of the CEA. When he refused to do so, it discreetly threatened legal action against the church. Similar threats were made to restrict the mission from dispensing cheap drugs.[59]

Such 'unfortunate and bitter opposition from the Government', as Bonhomme termed it, effectively brought Bonhomme's ambitions for the Catholic cooperative movement to a halt. By the end of the 1930s, the People's Bank was defunct and the Buyers' and Sellers' Organization reduced to conducting its activities covertly.[60] Frustration and disillusionment with the government in this tussle over the CEA rapidly deteriorated to a sense among the Canadian Oblates that the government was actively hostile to them. The freeze in 1940 upon government grants to education and on the construction of new schools strengthened this view. Although the freeze affected all the missions, the over-extended RCM was hit hardest and within a year had been forced to close almost two hundred of its schools. Bonhomme interpreted this policy as the 'persecution against British subjects in favour of French Calvinists' and he enraged the ever-sensitive administration by invoking questions about it in the Canadian parliament.[61]

Meanwhile, in Lesotho, French-Canadian priests expressed their frustrations in ways which skirted the boundaries of treason. They allegedly harboured military deserters and also 'indulged in some highly undesirable anti-war propaganda designed to dissuade the natives from joining the forces'.[62] Relations between the church and state were further strained during the war years by the mission 'weighing in against' the government's plan to introduce a Native Treasury. On the grounds that the Native Treasury as proposed would undermine the traditional obligations of chiefs to their people, the RCM encouraged, if not actively counselled 'Mantsebo to resist administrative reforms.[63] Largely as a result of such 'subversive activities', by 1946 the administration held the view that the French Canadian missionaries 'have been a constant source of trouble to the Government'.[64]

Bonhomme returned to Lesotho in 1945 in a combative mood which only made matters worse. In his first public address, Bonhomme reminded the Catholic community that: 'From the beginning, the Basotho have been exploited in the most crying fashion by the merchants of the country and now, missionaries, we know it more than ever . . . they are held in poverty, even in misery, the better to be dominated.'[65] Bonhomme accused the government of holding, as 'its principal goal', the compulsion of men to the mines. Moreover, by its corruption of the chiefs through the National Treasury reforms and its refusal to respect 'Mantsebo's calls for national consultation, the government had 'forgotten the most elementary laws of democracy'. He urged his missionaries to redouble their efforts to resuscitate the cooperative movement. This, he maintained, was the most powerful means to 'work intimately for a people in slavery'. At the Annual Theological Conference of 1946, the OMI adopted 'social action' as its most urgent priority, with a special emphasis on the goal of 'a more equitable distribution of wealth'.[66]

Bonhomme urged prudence and discretion in this project in order to avoid the 'traps' of the government and traders. His own tact, however, was notably lacking, even in one-to-one meetings with top government officials. Indeed, as time progressed, Bonhomme's swings between polite avowals of loyalty on the one hand and 'vituperative' outbursts on the other became ever more extreme and his expressions of outrage ever more provocative.[67] The final explosion came in June 1946, over the government's refusal to lift the wartime freeze on grants-in-aid to the missions. Bonhomme vented his spleen by making a direct appeal over the head of the Resident Commissioner to the Dominions Office. His six-page 'Report on Basutoland' is a classic document of anti-colonial rage which began with an attack on the apparent collusion between the administration and the merchants: 'Traders are exploiting the people, selling their goods to the Basutho [*sic*] at a price three times more than to any European. Nothing has been done by the Government to check this. It is therefore commonly said that Government works hand in hand with the Traders against the Nation.'[68] Bonhomme next attacked government policy on migrant labour:

> . . . The Mines! A calamity for the Basutho people. Sent there by the Government, they inherit all the lowness of the outcast. The [South Africans] admit themselves that the compounds have become dens of sodomy, scandal and immorality. Venerian diseases [*sic*] are caught and brought back to the country . . . In short, all these disorders have arisen among the Basutho because the Government has failed to respect the moral laws of nature to help the Basutho financially, and to respect the authority of the chiefs.

Next came the administrative reforms: '. . . The Native Parliament is a comedy . . . People say that they are labouring under a fierce dictatorship . . . It seems that while the Missionaries are doing their utmost to inculcate respect of authority and ease the financial position of the people, the Government is carrying out a policy of oppression.' Bonhomme even attacked the personal merits of the authorities themselves: 'The present Resident Commissioner and the Officials – many of whom have showed themselves very incompetent – are not personae gratie [*sic*] in the eyes of the Nation.'[69]

The Dominions Office's response to Bonhomme's diatribe was unprecedentedly swift and decisive. First it requested the Canadian government to use its influence to have its 'immoral' and 'unbalanced' citizen removed back to Canada.[70] Then, when the Canadian government proved reluctant, the Vatican was approached directly. Within two weeks Bonhomme was forced to resign, and his departure was followed by a purge of his more radical supporters within the OMI.[71]

This expulsion did not go unnoticed by Lesotho's nascent political left-wing. In the words of J.M. Kena, one of the founders of the first trade union in Basutoland and later a member of the Lesotho Communist Party, Bonhomme 'was deported because of his progressive stand in the workers' struggle'.[72]

Bonhomme's successor as Bishop of Basutoland was the cultured and intellectual Joseph DesRosiers. His diplomatic approach towards the administration won almost immediate benefits for the mission, above all, an end to the freeze on school expansion. Moreover, under DesRosiers there was a dramatic shift in the public discourse of the clergy. In place of Bonhomme's earlier anti-capitalist rants, *Moeletsi* after 1947 increasingly lent its editorial support for such 'anti-communist' struggles as the French war in Algeria. This change in tone not only ingratiated the RCM to the colonial authorities but also made it an easy target for derision among Basotho nationalists. Yet behind DesRosiers' 'conservative' or 'anti-communist' discourse, many of the exact same policies which Bonhomme had initiated were carried on or even expanded, including the indigenization of the clergy and 'social action'. The need to step up social action among Basotho women as a means to influence political developments actually became the focus of RCM strategizing in the late 1940s through to the 1960s.

One noteworthy innovation in the DesRosiers years was the introduction of a new *kopano*. The Ladies of Sainte Anne had acquired a well-deserved reputation for piety and fund-raising. They were, however, notoriously resistant to outside leadership and 'modernization' and they appeared, especially in relation to the Protestant-dominated Homemakers, to be ineffective or disinterested in practical development ques-

tions. The Legion of Mary was launched specifically to address these problems. Styled as an 'elite' formation, the Legion was to be composed of educated, young women. Its structure was more democratic, allowing for the expression and implementation of new ideas regardless of the age of their proponents. Its focus was explicitly oriented towards the type of practical development work which the church hierarchy considered to be most effective in alleviating rural poverty and despair. In this, the Legion of Mary was intended to offer educated, young women who were frustrated with the LSA an alternative to secular, supposedly communistic women's organizations like the Homemakers. It would also, by its example, prod the LSA in a similar direction. Indeed, by obviously enjoying the blessings of the mission hierarchy, the Legion would teach the older women 'a spirit of humility'.[73]

As with other Catholic *kopanos* from the beginning of the mission, the Legion of Mary was first and foremost concerned with raising 'moral' children. With Catholic Action, however, this task acquired very specific political connotations. In place of the conspicuous (some would argue self-indulgent) piety of the LSA, Legion of Mary mothers were expected to channel their piety towards the development of politically-conscious and 'responsible' sons, the latter meaning boys who could understand and reject the temptations of anger or the materialist ideologies which arose in reaction to racism and poverty. With so many fathers absent at the mines, women also had to assume responsibility for instilling in their boys the virtues and ideals that were essential for the development of an indigenous clergy. This included, above all, dedication to life-long chastity, something that remained quite alien and threatening to Sesotho culture. Its acceptance as an ideal could only be achieved, so it was argued, by the 'Marian and apostolic formation' of girls and young women. Only they, as 'Good Marian mothers', could inculcate the necessary self-discipline and self-denial in boys from the youngest age: 'Since the indigenous clergy is the principal hope for the establishment of the Church in this country, MOTHERS have a very important, if not fundamental part to play in the establishment of the Church in Basutoland.'[74]

The new generation of men raised by Marian mothers would not only master the self-control to become priests. As lay members of the church they could also launch themselves into the 'hard, Christian battle' against the perceived tide of communism and ultra-nationalism. Skilled and self-confident, these men would begin to redress the 'calvinist advantage' (gained through over a century of superior education) in winning positions of influence or command as the process of devolution of political power unfolded. The rapidity of that process after 1956, and the extent of the advantage of the Protestant churches, gave the RCM a sense of urgency, even panic – 'the future welfare of the whole Church in

Basutoland, and indeed in many parts of the Union' depended upon suitably motivated and disciplined mothers and wives.[75] The potential of the Legion of Mary to do all this was taken from experience elsewhere. Indeed, one priest quoted approvingly the alleged words of a Chinese Communist leader during the revolution in China: 'the Legion of Mary is more dangerous to our country than an army of wild bandits'.[76]

The first Legion of Mary in southern Africa was set up in Port Elizabeth in 1951, followed soon after by a branch in Roma. In 1957, the RCM in Basutoland decided that a branch should be established at every mission in the territory. The organizer of this effort, Francois Mairot, began by requesting priests and nuns to identify 'quality' candidates to comprise the core of this elite force. These women were then coached in Catholic homemaking skills. While it is difficult to know whether 'Marian' mothercraft ultimately had the desired effect upon Basotho boys, it is clear that in some cases the new climate prodded the LSA into action almost immediately. According to one venerable member, 'Our sodality has improved a lot since the 1960s, although we did begin development work in the '50s, about 1955, I think.'[77] Others put the transition later in time but vividly recall a sense of revitalization which captures the reforming spirit of the 1950s:

> There were about forty of us who joined all at the same time so that it seemed pre-arranged but it wasn't at all. We were nurses (like myself), teachers, younger working women with some mature women, although not old. It was quite exciting. We moved in like that onto the committees and in this way the older women who like to dominate are now having to change their ways. We are getting to be balanced between the old and the young.[78]

Many other social action projects were undertaken during the DesRosiers regime with special attention to the development of a lay Catholic elite. Courses were initiated for chiefs in Public Administration and scholarships offered for Basotho to study cooperation in Canada.[79] 'Social Studies Clubs' (*Lithuto ea Bosechaba*) were set up in villages throughout the country in 1959 in order to stimulate discussion of social and political issues (such as the Catholic 'duty' to vote). *Moeletsi* expanded to become the largest circulation newspaper in the country, and the RCM set up the country's only radio station. Sundry other local organizations, such as the Medico-Social Work Department of St. Joseph's Hospital (1961), the *Mater et Magistra* Organization (1963), and the Association of Mutual Help (1964) all sought to develop local handicrafts, cooperative agriculture, gardens, dam and road-building, and working groups for 'the dissemination of knowledge'.[80] By 1965, when Caritas Lesotho was formed to coordinate all these activities, the RCM was running four hospitals,

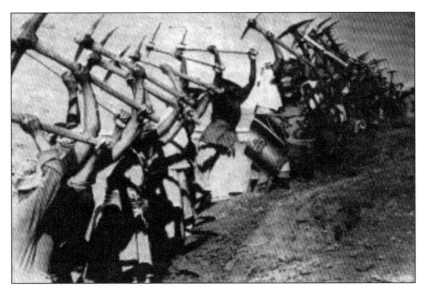

Likhofu tse matsoele – *'bulldozers with breasts' at work on a mountain road.*
(courtesy of Fr. André Dubois)

eight out-stations, thirteen maternity clinics, forty-seven dispensaries, 'Homecraft centres' in several villages, hostels for Catholic girls in Maseru and Johannesburg, and a huge farm in the Orange Free State to supply the mission.[81] Over four thousand Basotho were employed by the RCM. Indeed, so vast were the RCM's social and economic development enterprises that one of the first British technicians to arrive in the country after independence termed their coordinator, Father Gareau, 'one of the most powerful men in the country'.[82]

9.3 Conclusion

Bishop Bonhomme's fiery rhetoric against 'the slavery of the trusts and ambitions of the dictatorship'[83] was backed by a dynamic, relatively well-funded, and imaginative programme of 'social action' designed to build a viable economic alternative to the migrant labour system. While the RCM's anti-capitalist propaganda died down after his departure, the mission continued to expand its social welfare initiatives in the late 1940s to 60s, and in many ways enhanced its reputation as one of the only institutions in the country which actually worked for social and economic justice for the poor.

Some of the church's critics within Lesotho recognized this. W.M. Mokete of the BCP, for example, asked rhetorically in 1965, 'Who is more communistic in Basutoland than the Canadian Party?' (meaning the

Basutoland National Party, which had the open support of the Canadian priests). In their untiring efforts to address Lesotho's inequitable distribution of wealth and power, the Canadian missionaries were indeed 'communists at heart'.[84]

Similarly, behind their Old Testament ideals about the subordinate place of women to men, the French Canadian priests and nuns brought direct material benefit to the predominantly female rural population. They also generated new opportunities for women to assert meaningful autonomy from traditional and colonial structures which sought to inhibit them. The loyalty and activism of some Catholic Basotho women on behalf of their church which was decisively demonstrated in the watershed elections of 1965, cannot be properly understood outside this apparent paradox.

'Women, mothers of the nation, should not be made slaves'

Women and politics to 1965

Political analysis of Lesotho has tended to be weakened by two major conceptual flaws and the faulty assumptions which underlie them. First, the often arbitrary dichotomy between private and public spheres has had the effect of rendering so-called private matters (such as male chauvinism, women's spirituality, and gender conflict in general) invisible or incidental to the great sweep of history. Politics narrowly conceived as the exercise or pursuit of power in the so-called public sphere has also tended to render the day-to-day activities and perceptions of economically disadvantaged women inconsequential compared to the concerns or obsessions of elite males. One informant, a respected nationalist politician, put it this way: 'I can't tell you much about women in politics because there weren't any . . . I suppose the Ladies of Sainte Anne did some behind the scenes politics where they went from house to house, but they never came out in the open. So there is nothing else to say about women in politics.'[1]

Basotho women themselves commonly adhere to this view and for the most part regard their activities as outside 'politics', the latter a somewhat disreputable, masculine pursuit by definition. Yet, as we have seen, women's supposedly private activities frequently forced the political and economic agenda, not least of all by massively 'voting with their feet' against the colonial regime. They also constantly challenged definitions of custom, home, prayer, self-reliance, chief, and so on, that men sought to impose upon them.

The second flaw in Lesotho's political historiography is the uncritical or uncontextualized use of judgemental terms to describe or categorize people's politics – 'progressive' or 'modern' as opposed to 'traditional' or 'customary', and 'conservative' versus 'radical'. Moreover, in the hands of most scholars the terms conservative or traditional have a derogatory implication of closed-mindedness, backward-thinking, or lack of

logic. Yet, in the case of Lesotho, and as has been shown abundantly elsewhere in Africa, tradition was a highly fluid concept which often disguised quite dramatic social and political change. A conservative or purposefully modest, non-threatening discourse could, at times, belie assertions of fairly radical challenges to the status quo. Deployed selectively, custom could also represent an important defence against the destructive tendencies of colonial rule and so-called progress. Thus, for example, Basotho women's sometimes notorious insistence upon *bohali* was not, in the context, an irrational love of tradition. On the contrary, it was an eminently sensible defence from a position of great vulnerability against the profound assaults upon marriage and community engendered by the male migrant labour system. In other cases where women insisted upon tradition and the patriarchal controls and privileges inherent in it, this was commonly a pragmatic choice given that the options presented by the colonial state and a racial capitalist economy in the region were so patently inferior or dangerous.

This cautionary preface to the concept of 'conservatism' is necessary because the term has been used so frequently and uncritically to describe Basotho women's political behaviour. Often women's purported conservatism is simply assumed as inherent or arising naturally from their 'role' as homemakers or churchgoers. Or, it is deemed to be the result of the influence of 'conservative' men such as chiefs and Roman Catholic priests. These men allegedly cajoled or exploited women's imputed false consciousness in order to win their votes for the 'conservative' Basutoland National Party (BNP) – a 'party of women' in Machobane's ill-considered phrase.[2] Conversely, it is commonly assumed that Basotho men, because they were accustomed to political discussion and practice through the traditional courts and because they had experience in the degrading conditions of work under apartheid, held a better grasp of the large ideological issues addressed by the BNP's main rivals, the Basutoland Congress Party (BCP) and the Marema-Tlou Freedom Party (MFP). Men were supposedly more able, therefore, to understand and support the long-term strategy for the liberation of South Africa and the demi-socialist rhetoric of the 'radical' parties. Women's supposed preference for the BNP carried the day in 1965 because, with over 100 000 men working in South Africa and unable to vote, women comprised two-thirds of the electorate.[3]

This chapter casts a critical eye upon both this interpretation of the 1965 elections and, in general terms, upon the public/private and conservative/radical dichotomies. It examines what motivated Basotho women to enter the characteristically masculine domain of partisan politics in the myriad ways which they did, and how gender and class considerations influenced the perceptions of the majority of Lesotho's voters.

10.1 Women in politics: 'conservatives' and 'radicals'

Lesotho's first female politicians were its regents, 'caretakers', or 'chieftainesses' (*mafumahali*). Women in these positions of power had been present in southern Sotho society since before Moshoeshoe I but, as previous chapters have shown, they were advancing their and their family and class interests with increasing vigour after the 1920s. With the support of male advisors and relatives, they pressed their ambitions through the courts and by innovative interpretations of Sesotho custom. They also resorted to violence or threats of violence. For example, in 1926, Maletapata of Quthing was found guilty of having 'maliciously incited' a small-scale war to seize new lands for herself, while in 1929 the widow of Chief Jonathan of Leribe threatened the Resident Commissioner with 'bloodshed' to resist an unfavourable choice of succession.[4] In the 1940s and 50s, female chiefs were also widely believed to be using 'sorcery' to advance their interests and several were executed for *liretlo*. As Jingoes phrased it, 'power seems to be a terrible thing and in Lesotho today you often find mothers who fight desperately to cling to power'.[5]

To assess the political behaviour of these female chiefs, like that of male chiefs, we must consider the bewildering and contradictory demands made upon them by the colonial state in the modernizing era of indirect rule (after the Pim Report, from the 1930s to the late 1950s). On the one hand, chiefs were expected to enforce codified customary law, to collect taxes, and to police unpopular improvement schemes at the village level. On the other hand, they were expected to remain 'of the people', listening to their subjects' legitimate concerns and providing the kind of 'feudal welfare' which had formerly maintained social stability. The contradiction was often impossible to reconcile. Many chiefs succumbed to the temptations created by the British system of parallel rule and so became instruments of oppression and underdevelopment. Others, however, sought to appear cooperative with the state even as they defended their subjects' resistance to the state. Gender relations provide a compelling example of this. Chiefs often and loudly professed that they shared the government's concerns about women's increasingly non-traditional, and sometimes outright subversive behaviour. They urged the government to give them the legal powers to keep women in place. Yet when actually given those powers, the chiefs commonly failed to use them. Indeed, in practice chiefs often encouraged or defended women's migration to the camps, women's litigation against negligent or abusive husbands, and women's right to brew and sell beer. One of 'Mantsebo's first acts as regent was to overturn a law that the colonial administration had introduced in its efforts to harass female brewers. She argued, correctly, that the government was simply trying 'to cause a great deal of trouble'

for women in order to force them out of the urban camps. She also adamantly opposed government efforts to impose a 'town rate' of taxation which would boost the strength of the police in their efforts to keep 'vagrants' (mainly women) out of the camps.[6]

The contrast between the dominant image of chiefs as traditional, reactionary or conservative and the reality of diverse and often relatively progressive or populist decisions is clearly evident in the case of female chiefs. These women certainly never claimed to be feminist or even particularly interested in women's specific concerns. Many denied that they were women at all, perpetrating the patriarchal fiction that they had become honorary men (*bo'ntate*) by virtue of their position. When female chiefs first entered the BNC in the 1940s, they also cultivated a reputation for caution, for adopting strongly 'anti-communist' or arch-Christian rhetoric, and for keeping a low public profile. 'Mantsebo, for instance, rarely addressed the Council herself, but spoke through a male representative.

Yet behind the facade of 'conservatism' or honourary masculinity, female chiefs at times forthrightly rejected certain aspects of custom. 'Mantsebo first defended her claim to the regency by refusing her brother-in-law's customary right to *kenela*. Thereafter she actively encouraged the practice of appointing female regents and appears to have been behind the BNC's move in 1950 to recognize female chiefs as equal in status and salary to male chiefs. By the 1960s she was advocating even more radical innovations. In 1962 'Mantsebo and fellow 'chieftainess' 'Makopoi Api both argued that the law should be revised to allow women independent access to credit. Women, they testified to the Select Committee on Wills, Estates and Inheritance, should be given freedom to use their deceased or absent husbands' property 'without taking into consideration the usual Sesuto customs' – 'the mother must have the final word where there is a disagreement' with the legal heir.[7] 'Mantsebo extended this principle to include young widows or orphans in order to protect them against exploitation by their customary legal guardians: 'Nowadays even the girls work hard to maintain their parents . . . The uncles no longer provide for the old-time maintenance. I have reached the conclusion that the cattle paid as dowry [*bohali*] for a girl constitute her contribution to family wealth'; *ergo*, the daughter should be allowed to inherit.[8]

In terms of partisan politics, 'Mantsebo's off the record behaviour also significantly contradicts the conservative or weak image of her which is predominant in the historiography.[9] Certainly, she came to her position as regent without any formal political training or even schooling. Her motives and methods in expanding her power base may not always have been honourable. Yet 'Mantsebo's scepticism and resistance to

reform as conceived and pressed by the British was not blind reaction but was shared by many other Basotho, including the leaders of all three of the main nationalist parties. Indeed, the leader of the BCP wondered at the time of her death in 1964 whether his party would have survived the early years of British hostility had it not been for 'Mantsebo's regency. Weisfelder has interpreted this to mean that she was too weak and incompetent to crush the party. However, Ntsu Mokhehle himself explained it to me in this way:

> NM: 'Mantsebo was not weaker than any previous paramount chief. I would even say that of all the paramount chiefs I have known, which is four, she was the strongest. She was more progressive. She was very liberal. She was the only one of the chiefs who agreed with our democratic ideas because she based her attitude on what the people say, what the people want. That is not stubborn. She was very liberal and progressive because she was of the opinion that the people must be allowed to say their views. Neither the British nor the Catholics liked her very much. She was a Catholic but she was too independent.

> ME: Can you give me an example?

> NM: Of course. In the days of 'Mantsebo, she allowed freedom of gathering. It was her regulation that said the political parties had to advise (not ask) the chiefs about holding a *pitso*. All the chief could say was you hold it there or there or there. They no longer had the right to stop a meeting which was very radical. She released the parties from that [custom], which is an example of her rather progressive ideas.[10]

Whatever judgements are ultimately made about 'Mantsebo's leadership abilities and style, it may at least be affirmed that she acted as a role model and indisputably spurred the movement of women into the chieftaincy and partisan politics:

> From our cultural background women are always looked down upon. Women have never been in the forefront of anything so it was something out of the usual in this country that the Paramount Chief became a woman. Women felt a little stronger after that, they could express themselves more boldly and, after 'Mantsebo, it became almost expected that the mother would rule. She was indeed respected. The country was much better ruled in those days. You see [laughter], women have a way of doing things. If she didn't like the British, she would say so.[11]

Some of the clearest articulations of this inspirational effect can be seen in women's testimony to the Constitutional Commission in 1962. The

female chiefs who addressed it spoke unanimously in favour of giving women the right to vote and to run for political office. At a *pitso* (public gathering) in Teyateyaneng 'Mamathe Masupha spoke over the heads of men directly to the women at the back of the audience. She mocked the men's assertion that women should be denied political rights on the grounds that they were 'children' by custom and financially irresponsible. On the contrary, she argued:

> women, mothers of the nation, should not be made slaves. They should be given the right in the country to vote and also to stand for election. [The laws] will be made for everybody, men and women, in the country. These laws will oppress the women more than anybody else, because the men will go to the mines and be away for ten years ... I would like you women to take note of this, and to note that if you are not careful, politics will make you slaves.[12]

'Mamathe Masupha, ('Women, mothers of the nation, should not be made slaves') with fellow regent Makopoi Api immediately behind her, at an MFP rally in 1975. (courtesy of Richard Weisfelder)

Mofumahali L. Bereng also spoke to the Commission:

We women of the age of 21 and more should be allowed to vote or to stand for election . . . We do not like to be slaves as we are now. If we have to pay a fee for the franchise we would then rather pay for it in order to free ourselves from slavery. Many women are widows who have great responsibility.[13]

Female *bo'ntate* were not the only Basotho women to speak up in public on political matters. Commoners also did from at least as early as the 1920s. Indeed, organizations which criticized the colonial administration counted women among their most enthusiastic supporters. For example, police reports on Lekhotla la Bafo meetings mention women standing up in public to denounce the government in the most vehement language. The president of the Progressive Association, meanwhile, was greeted with cries of 'Moses!' by crowds of women believing he would deliver the people from oppression.[14] As workers, Basotho women also established an early independent reputation for militancy and dramatic action – Lesotho's first political 'strike' was conducted by female nurses in 1943. The nurses had protested the blatantly racist policies of the Maseru hospital administration and then, when patronized and reprimanded for their 'trivial' concerns, quit en masse, 'a severe setback' to the hospital according to the official report.[15] Women as workers in the Free State in those years were also conscious of their rights and courageously resistant to the exploitation and brutality of Afrikaner bosses. In the proud recollection of one: 'When we were on the way [absconding from an especially bad employer] we saw them on horseback, trying to force us back. When they prevented us we decided to sit down . . . we defeated them.'[16]

Both the BPA and LLB spoke to women's specific grievances against the colonial system, notably the dispossession of widows from their fields. On this basis, Josiel Lefela later proposed himself as a special representative of women's interests in the BNC.[17] *Batsoelopele* men, however, often displayed highly ambivalent attitudes towards the women whose causes they championed, and neither the BPA nor LLB made women's grievances more than a passing footnote in their campaigns against colonial injustice. Furthermore, Lesotho's early 'radical' tradition evinced an aggressive machismo against the belittling tendencies and prejudices of colonial and missionary regimes. While most of the men's posturing was directed against whites, they also sometimes lashed out against Basotho women whom they regarded as benefitting from colonial domination at the expense of black men. Lefela set the tone in 1920 with a diatribe against 'Christian whores' which earned him official censure. His reactionary line on Sesotho custom also led him to implacable hostility towards 'Mantsebo and the RCM. Both the regent and Catholics in

general, in Lefela's view, condoned female rebellion against proper male authority.[18]

Despite the fundamental hostility to women's emancipation by early 'radicals' such as Lefela, as well as the customary taboo against Basotho women addressing public gatherings, Basotho women did increasingly appear in the ranks of the early nationalist movement. The formation of the Basutoland African Congress in 1952 was a turning-point in that regard. Inspired by the Youth League of the ANC in South Africa and the Pan-Africanism of Ghana's Kwame Nkrumah, the BAC – or BCP as it became – quickly attracted almost universal support among the *batsoelopele*, particularly teachers, traders, and nurses. Its essentially liberal (meritocratic) demands included justice for the accused in *liretlo* cases, an end to the unofficial colour bar, equal pay for equal work, an end to the white trader monopoly, and (crucial to the nurses) the right to decent housing for civil servants. The party's unrelenting anti-colonial and anti-apartheid propaganda, together with the impressive credentials and personal courage of the leaders, rapidly won it widespread respect among the mass of the people.

Among the earliest converts to the BAC/BCP were the daughters of prominent Protestant families who felt let down or betrayed by the promises of colonial and Christian ideologies. Despite being educated, they were denied jobs (often justified by white employers on the grounds that Basotho men would not accept women working).[19] Taught to be demure ladies, they saw their husbands and sons undermined by less competent expatriates or compelled to leave the territory for work. Told to believe in Western ideals, they were confronted daily with the reality of an opportunistic, racist state which abetted and exploited oppressive tendencies in customary patriarchy. Ntsu Mokhehle, a young, dynamic and articulate leader, explained the contradictions to these women in terms which electrified their support. As a result, by 1955 (when the BCP was still the only political party in the country) a visiting South African Mosotho observed that, 'The first thing that strikes a visitor's eye in Basutoland is the predominance of women over men at any public meeting place.'[20]

In addition to attracting women as followers and listeners, the BCP also provided a platform for the first commoner women to emerge as partisan leaders in their own right, beginning with Ellen 'Maposholi Molapo. Originally from South Africa, Molapo in the late 1950s played a key role in the tough task of organizing the BCP among the notoriously apolitical Basotho miners in the Transvaal. She was instrumental in the establishment of the BCP Women's League. She also instilled fighting morale among Basotho: 'A tremendous Congressite was Mrs. Molapo. When she died, men praised her as a man. She came from the Republic to wake women up to fight for their rights. And when she harangued men,

Ellen 'Maposholi Molapo singing at an MFP rally, Maseru 1965.
(courtesy of Richard Weisfelder).

they thought she had guts. She injected guts into women and thereafter women could voice their opinions.'[21]

Molapo's personal example was also a revelation to Basotho women who tended at first to blame themselves or each other for inviting political repression:

> But it's strange how the Basotho women are still meek compared to those from the Republic. Mrs. Molapo was the only one to come to me to offer help when my husband was expelled from the high school [for political reasons]. The local women were saying under their breath that we brought it on ourselves but she came to me, a total stranger, to say we are at war, there is no turning back. And then she offered me any support she could give. This young woman – she was tall and very attractive – was the only one not to blame us for our stupidity.[22]

Basotho women did not have the right to vote in Lesotho's first elections, the District Council elections of 1960. However, even by that time the BCP Women's League was making a distinctive contribution to political gatherings by whipping the crowd into a state of excitement with their singing and fiery speeches or praise poems. Frequently, they adopted deliberately provocative behaviour such as brandishing a knobkerry (*koto*), a traditional male weapon and the symbol of the party. They were known to mock publicly the dignity of male authorities, including missionaries, officials and chiefs. In other cases they drew upon women's traditional weapon of non-cooperation in the face of abuse in order to venture where male politicians feared to tread. In 1961, for example, BCP women closed down the Anglican school of St. Agnes in Teyateyaneng for several days with a sit-down strike to protest tuition hikes.[23]

As the pre-independence campaign heated up, Congresswomen were at the forefront in creating the impression in the villages and camps throughout the country (even the highlands) that 'everyone was Congress'.[24] A hint of their radicalizing influence on the atmosphere of political meetings and disturbances in this tumultuous era also comes through in police testimony after the 1961 anti-colonial riot in Maseru: 'I did not notice any men out there, only a lot of women screaming and throwing stones at the policemen', testified one witness. 'Some of the women were armed with bottles, big bottles . . .' testified another. 'They got up and attacked us with stones and bottles.'[25]

Like the LLB before it, the BCP's 'radicalism' in these years had a pronounced 'conservative' side, from the party's early defence of the chieftaincy to its attacks upon colonial anti-erosion schemes. The BCP also sometimes made explicit and direct appeals to reactionary interpretations of custom, even allegedly advocating the revival of circumcision schools. It did so in part to foster pride in Sesotho and national identity in opposition to colonial values and racism. But appeals to custom were also meant to reassure male migrant labourers who were fearful of any further erosion of their control over their wives and daughters. The public unruliness of some Congresswomen was certainly full of potential to alienate that core constituency of the party. In recognition of this, BCP rhetoric on the whole underplayed (or even denied) the importance of women's emancipation in favour of respect for 'tradition'. Rather than equality, for example, it spoke of 'equal rights' for women, the implication being that some things (like a culture of male domination) lay outside the sphere of law or state intervention. Even the accomplished (and often self-supporting and maritally unattached) leaders of the Women's League trod very gently around issues of custom for fear of evoking a backlash against the party. 'Equal rights' for women was deliberately left vague enough so

as to be essentially meaningless. As 'Makali 'Masiloane, the leader of the Women's League and a member of the BCP executive explained it:

Long ago, Basotho women didn't do anything but cook and such but we didn't see why now they couldn't do the very same jobs as men. When I addressed the public on this, I found that the men agreed very much with equal rights. Our customs though, we like them. We can't ignore them so we never attacked *bohali* or other customs like that [that is, customs which subjected women to oppression or exploitation by men].[26]

This vagueness about equal rights was not simply an electioneering tactic. The Women's League also appeared of its own accord to accept a role in the party that was non-threatening to men's right to power over women. Hence, the constitution of the Women's League explicitly affirmed the domestic nature of women's contribution to the anti-colonial revolution. It stated among its objectives 'to protect and raise children as good citizens of the country' and 'to give proper care to all the guests of the Party'.[27] The Women's League 1961 convention also revealed a demurely feminine set of priorities: of the eight resolutions adopted, five were related to health, education and family maintenance, traditional 'women's issues'. Politics in the masculine (real) sense merited but one resolution – a demand to change the constitution to reduce the number of chiefs in the BNC. There was no resolution requesting that women be empowered to vote.[28] Neither did Congresswomen specifically raise issues of sex discrimination at political gatherings, nor even protest policy shifts which directly affected women. The BCP remained silent, for example, when South Africa in 1963 finally imposed and enforced strict border controls and passes for women. This resulted in the enforced return of as many as 20 000 Basotho women, in many cases to abject poverty and often with great bitterness.[29]

Such a self-limiting, supportive role in politics reflected the BCP faith in the two-stage theory of liberation, that is, that improvements to the conditions and treatment of women would flow more or less automatically from BCP policies after it took power. More profoundly, it also reflected the hegemony of the ideology of women as essentially domestic. Congresswomen can hardly be blamed for failing to surmount ideals of femininity that were so thoroughly overdetermined by custom, by Christianity, and by modern secular discourses alike. Nonetheless, it remains striking that leading Congresswomen never publicly questioned the primacy of women's domestic role or challenged male prerogatives, notwithstanding their personal achievements and aspirations in independent careers and politics. Also striking is that many Congresswomen were also leaders in the Homemakers or related associations. As we saw in Chapter

Eight, these associations were potentially subversive of some elements of patriarchy. By the 1960s, however, homemaking had become an important element in the colonial regime's strategy to stabilize the male migrant labour system and to 'modernize' and 'moderate' the male nationalist leadership. The leader of the Women's League did not perceive the contradiction:

> There was no contradiction between the Homemakers and being a politician. In the BCP we were fighting for the rights of the people – all the people, both men and women. In the Homemakers that was something altogether different . . . The Homemakers tried to do a little bit here and there to build up the home. They were fighting for the life of the people. But in the BCP that was a fight for the rights of the people, against oppression, against the whites. So of course there was no conflict. I was a member of both![30]

Some Homemakers among the Congresswomen did believe that they were using homemaking to propagate subtly subversive political ideas. For others, however, probably the majority, the adoption of a cautious and domestic-oriented approach to politics was not a choice. Rather, it appeased the assumptions, desires and, ultimately, the demands of the male leaders of the party. The majority of these men had been through PEMS or Anglican schools at a time when Protestant rhetoric about meritocracy was belied by powerful and pervasive ideals of women's humble domesticity. Many of them regarded the participation of women in politics as fraught with danger to that ideal. In Ben Masilo's frank opinion, political women raised 'delinquent' children and, by attending *pitsos*, they 'destroy[ed] the peace of the family'.[31] The reactionary streak in 'progressive' men like Masilo also showed itself in the striking caution the BCP expressed towards female education. On this issue, the BCP-dominated teachers' union seemed to weigh in to the political right of even the colonial government. Specifically, it criticized the government for abandoning a narrow emphasis on girls' education for domesticity: 'We need girls who know better methods of cooking, who are able to wash and iron our clothes, who can do efficient mother-craft.'[32]

The newsletter of the BCP-dominated Department of Local Government similarly reflects the ambivalence of party members and sympathizers toward women doing anything other than what they had been directed to by the men who 'owned' them: 'the emancipation of Basotho women is threateningly imminent', warned the editor after a 'Miss F. Makoae and her Foso women' built a community centre entirely on their own initiative.[33] 'Tips to housewives', in the June 1962 issue even came with a strong implicit threat of violence: 'Do washing once a month,

clean your house once a month, speak once a month, cry once a month, AND YOU WILL BE LEFT ALONE.'[34]

Such opinions did not become an issue of any serious contention within the party, in part because women clearly recognized the implicit threat not to exceed their designated role. The lone dissident voice against this reticence to stand out in favour of women's full emancipation actually came from a man, Robert Matji. Matji was a South African refugee and 'self-styled Marxist' who in 1960 became the BCP District Councillor from Qacha's Nek. He was expelled from the party scarcely two years later in part for taking the principled stand that women's equality should be an integral aspect of the struggle for democracy, within the party as well as in the nation as a whole. In his opinion: 'I don't think the women in the [BCP] were as concerned about it as they ought to have been. I think they accepted their position and the rights of men over them. There was never any debate by them. The only time women were useful was at the annual general meeting where they could shout slogans and sing.'[35]

Caution around gender politics undoubtedly spared BCP women from conflict with their male leaders. However, the contradiction between this short-term acceptance of male dominance and the long-term objective of a meritocratic society became a definite liability as the country moved towards independence. Two specific issues, leadership and the franchise, exposed this glaring weakness and made the BCP vulnerable to effective opposition attacks.

10.2 Women and politics: the 1965 general election

After a huge triumph in the District Council elections in 1960, and with its educated, articulate, internationally-travelled and ambitious leaders, the BCP appeared to many observers (including the British) to be the government-in-waiting as preparations for independence advanced. The other parties seemed disorganized, divided, and out of touch with nationalist sentiments – 'shepherds', 'bumpkins', and 'feudal fanatics' beholden to their priests in the case of the BNP, and 'toadies' and 'sell-outs' in the case of the BPA and MFP.[36] Yet the BCP lost the election in 1965, undone primarily by a split of the 'radical' vote with the MFP. This split allowed the BNP to sweep the mountain constituencies and, with a minority of the total votes cast, to gain a slim majority of seats in the new parliament. The BNP then went on to form the first government of an independent Lesotho.

Many plausible reasons have been advanced to explain this stunning upset, including BCP over-confidence, neglect of the highlands, South African meddling, British fraud and, simply, the illogic of the first-past-the-post constituency system. Basotho women's first exercise of the right to vote has also commonly been cited as an element in the unexpected

triumph of 'conservatism'. We have seen, though, that Basotho women were not essentially or consistently conservative in the sense of nostalgia for an idealized past. On the contrary, the opposite is likely much closer to the truth. While no exit polls were conducted and no statistics can prove it, Weisfelder's tentative conclusion that women likely 'leaned towards the militant BCP' appears correct.[37] For example, women's 'conservatism' can be judged against the polling results in Lipelaneng, a border district where females of all ages outnumbered males by 30 percent (and the imbalance among voters was even higher in women's favour). In this hugely female-dominated constituency the two 'radical' parties together polled over 86 percent of the votes cast (4 300 versus 675 for the BNP). Conversely, the BNP won its seats in the highland constituencies where the rate of male migrancy was lowest and the proportion of male voters the highest.

The resilience of this myth of women's 'conservatism' begs the question, whose interest does the myth serve? A close examination of contradictions in the behaviour and political tactics of 'radical' leaders in the lead-up to the fateful election suggests possible answers.

To begin with, the double-standard of 'radical' politicians towards women's rights was not as invisible to the Basotho as it was to foreign scholars. The contradictions between BCP ideology and practices were in fact eagerly seized upon and exploited by its opponents in order to equate 'progressive' or 'radical' politics with increased vulnerability and exploitation for women. The alleged sexual misconduct of Mokhehle and other leaders of the BCP provided the most prominent case in point. The allegations against BCP leaders included treating scholarship candidates as 'a personal harem', squandering party funds on mistresses, and endangering party unity by struggles over young women's 'favours'.[38] Obviously, such allegations should be taken with a pinch of salt. Nonetheless, the whiff of scandal was widespread and eminently plausible in the 1960s: 'The leader of the Congress Party wasn't a bad man, not at all. But we did hear rumours about his private affairs, that he was womanizing. We heard from the people and even on the radio we learned this. It surely did affect us because we thought if a person could be like that he won't be leading us well. This thing discouraged me a lot.'[39]

The scandals which surrounded BCP leaders were of deep concern to the many Basotho, men and women, who feared for the sanctity of the family. Those fears were especially sharp among Basotho mothers who depended on *bohali* and other customary male obligations for their precarious well-being. In particular, the loss of cattle represented by any improperly-married daughters gave powerful resonance to the wildest of rumours about BCP intentions, including the 'nationalization' of women: 'We heard it said that those girls who went to Ghana [on BCP scholar-

ships] were sent there just to bear children. We heard other stories like the BCP would put us in rooms with our picture posted on the outside so men could come and choose which one they liked then come inside to take us. The children we would bear would be taken from us.'[40]

Innuendo about the girls who went to Ghana on scholarships was also published in the Anti-Communist League's paper, *'Mesa-Mohloane*. In one informant's hyperbolic retrospective, 'the BCP Youth League said that daughters will be the property of the party. From that time we Basotho morally went down. Illegitimate children increased.'[41]

It would be easy enough to dismiss such rumours as hysteria or as spread through the cynical ploys of the BCP's political enemies. However, the rumours were clearly of sufficient concern within the party itself that the president of the Women's League ultimately saw fit to urge restraint upon Mokhehle:

> It is true that Mr. Mokhehle was loving these young girls too much. All Basotho, that is their weakness, even the chiefs. It did not make me angry but I tried to talk to him once. He laughed, he took it easy. Well, you can't change people's characters easily. We have a saying in Lesotho that a man has many women. I tried to talk [to caucus] about this. The men just laughed.[42]

Other Congresswomen kept their peace about the peccadilloes of the party leadership. In hindsight:

> MAPEETE: Mr. Mokhehle's private life was not a party concern. It is untrue that we ever requested the Youth League to punish him for making love to girls. That was his own business. And besides, how can you say that?

> ME: I just read it somewhere. A Pan-Africanist Congress guy, Bernard Leeman wrote it.

> MOSALA: Anyway, what does it matter how many girlfriends a man has? Mr. Mokhehle's personal affairs don't enter into politics. Besides, how do you measure too much? Who says he did that too much?[43]

Tolerance of a man's unbridled right to exploit women sexually, as well as the rigorous separation of public and private spheres, would have not have carried much currency among the majority of Basotho, women or men. Indeed, as is still the case in many of the most literate Western societies, the public persona of politicians counted as much or more than the party slogans. At least one Basotho woman is on record for challenging Mokhehle about the discrepancies she discerned between his personal and political ideals:

The Leader of the Congress Party appealed to every woman who attended the meeting to join their [sic] political party, because they believe it is the right party. One of the women asked him where his wife was, in reply she was told that the wife of the Leader of the Congress Party is in England. Then this woman said, 'How is it possible that you can let your wife to go and study in the country of the blood-suckers?' This woman went on to say, 'If you have failed to control your own wife, how can you control us?' Then the women told him that they were unable to join his party because they were more concerned with the management of their households.[44]

The limited and contradictory 'equal rights' which BCP-style national liberation promised for women was also exposed during the debate over who should have the right to vote. The unavoidable fact is that the BCP determinedly and hypocritically opposed the franchise for women. At the United Nations in 1962 Mokhehle condemned the British for having restricted the franchise in 1960 to tax-payers only. He explicitly pointed out that by so doing the government had eliminated all but fifty-six women in the entire country from the voting roll. Yet only months later, as the Basutoland Constitutional Commission toured the country, Congress members testified almost unanimously against changing this discriminatory arrangement. The reasoning was as follows: 'We opposed the vote for women in 1962 because we believed women were not matured in politics. They knew nothing about independence because they didn't understand and we knew they could be used by certain people. Our position was that women could learn after independence, and I agreed fully with that.'[45]

Opposition to the universal franchise was thus portrayed as a short-term electoral expediency and not a betrayal of principles. Yet the sometimes nakedly misogynist language of some BCP leaders undermines this argument. To thwart the 'terrible misfortune' and 'great danger' of universal franchise,[46] for example, many BCP members appealed to a fundamentalist vision of 'tradition' and family peace. Typically, BCP Legislative Councillor Simon Fokotsane asserted that giving women the vote: 'would be an insult to the people of Basutoland . . . Here in Basutoland we know that a woman is a child and is the property of her husband.'[47] Or, as BCP District Councillor L. Shoepane brutally put it, 'these ladies [who want to vote] are stupid'.[48]

Given his control over the caucus, it is inconceivable that Mokhehle did not approve of the expression of such sentiments. The fact that none of the leading Congress women appeared before the commission (as did, by contrast, women of the MFP and BNP, both of which parties supported women's suffrage) suggests that the BCP Women's League was specif-

ically directed by the party executive not to put forward any witnesses. Mokhehle himself implicitly made his position clear in, for example, his sharp dressing down of K.J. Mosaase, a peasant who had ventured the opinion that 'there are quite a number of women who understand politics even better than certain men'.[49] That he was personally, adamantly opposed to women's suffrage is confirmed by Robert Matji: 'The leadership seemed bent on ignoring the fact that women needed to play a role, indeed, for a long time already had played a role in politics. Women were very active in the BAC. I wrote against the fact that the leader in particular seemed bent on preventing women to exercise a role.'[50]

Even after the BCC had found that the majority of opinion in the country strongly favoured a universal franchise, Mokhehle was reportedly still attempting to block it, claiming that the mass of the people opposed votes for women because they wanted to preserve their traditions.[51] Robert Matji, the sole member of caucus to criticize this stance (in the privacy of caucus) received a surprisingly sharp rebuke: 'This matter of women voting was an extremely important issue. Women were going to be left in the lurch. We would be hypocrites. My intention therefore was to compel the leadership to change its position. For that I did not resign, I was expelled from the party.'[52]

Not so discreetly underlying the 'traditionalist' arguments against universal suffrage was the fear that women would be bullied or tricked by their chiefs and priests into voting against the BCP. This fear rested upon assumptions about women as 'weak vessels' – politically naive and customarily submissive. The evidence of decades of women's *de facto* resistance to colonial rule should give pause before assuming that Basotho women saw themselves in this way. Indeed, why should we assume that Basotho who heard the contemptuous words spoken about women by BCP leaders did not take note or were not offended by this attitude? After all, the few women who did go on record before the constitutional commission almost all denounced the BCP position and the fact that 'we are deceived by the men'.[53] Such comments were greeted with ululations, cheers and applause.[54] The BCP's position was also widely publicized through the media opposed to the BCP, especially the Catholic weekly *Moeletsi* and the MFP *Mohlabani*. As one educated woman put it: 'I knew very well that the BCP was very much against women voting. They were sexists. Congress still had an old mentality. They wanted to keep women in the kitchen. Even though they had a Youth League where the majority was young women, they still treated women in that old-fashioned way.'[55]

Eventually the party lost its fight to keep women from voting. However, during the subsequent campaign, BCP leaders did not adjust their tactics accordingly. Rather, they redoubled their efforts to capture the

male vote. This they did in part by appealing to symbols which tapped into the deep sense of grievance and emasculation among male migrant labourers. The campaign style became increasingly 'macho', even 'anti-woman',[56] with some BCP leaders 'boasting that a Mosotho man, by tradition, had the right to five or six wives' (implying that this would be restored under a BCP regime).[57] The strident, hero-worshipping tone of the BCP paper, *Makatolle*, added to the growing unease among many Basotho about the party: 'The BCP wanted to boss it, even in the family. They believed that a man should have that power over women and this caused clashes in the family because, *ka'nete*, most women supported the National Party. They wouldn't change their vote just because of their husband so there were many clashes, even with children against their mothers.'[58]

'Makoloi Koloi, with koto, singing behind her leader Ntsu Mokhehle at a BCP rally, 1965. Koloi was horribly murdered during the government's reaction against a BCP coup attempt in the mid-1970s. (courtesy of Richard Weisfelder)

Seriously exacerbating this clash were BCP attacks upon the Christian churches, above all the Catholic church. As nationalists the BCP had ample reason to be upset by the increasingly open interference of expatriate priests in the elections. Its response, however, reflected more than straightforward nationalistic outrage. Particularly worrisome – even to Protestant sympathizers of the party – was the focused hostility to nuns which emerged as the campaign progressed: 'The BCP threatened nuns a lot, I don't know why . . . There was a lot of emotion over politics in those days.'[59] To a Catholic nun:

> That was not rumours about the BCP, it was true. They said they would turn the convent and churches into stables and marry us. We went to the *pitsos* just to hear what the people were saying and we could also hear them in here because they had loudspeakers. The BCP members were also rude to us. When we were travelling by public transport they would just challenge us and speak ill things . . .[60]

Even Anglican nuns also experienced BCP hostility:

> It's completely true that they threatened us. Really, they didn't know what they were talking about. They said anything. They had these vans with loudspeakers going up and down the street saying things like you won't have to go to South Africa if you elect us – you'll find gold and diamonds right here, under the street. I heard that with my own ears. They objected to grass strips [erosion control]. And I was told by a BCP man that they were going to kill all the chiefs and chase out all the whites. What about me, I joked. Oh, not you – we'll marry you.[61]

Words spoken against nuns were definitely not part of official policy and, indeed, there were 'gentlemen' in the BCP who tried to stop them.[62] It would seem, however, that such words were unofficial expressions of a profound and widespread sense of resentment among men in the party. Such resentment arose not only because the Basotho nuns' achievements and relative autonomy were threatening to customary male controls over women. The nuns' successes also starkly contrasted with the diminishing prospects for the average male Mosotho migrant labourer. By the time of the election campaign, miners' real wages were actually lower than at any time since the 1880s. The traditional path to social manhood of acquiring land, status, and submissive wives was thus less realizable to young Basotho males than ever before. The years of social boyhood for these men, including as despised adult herdboys, 'squatters' (*liquata*) or even as 'wives' at the mines stretched longer and longer. The nuns – apparently free, literate, respected by the community, and utterly sexually unavailable – were potently symbolic of this unmanning. For ambitious

politicians, it was a very deep well of grievance to draw upon for votes.

A further element of class tension added to BCP hostility to the Catholic church in particular. Lesotho's *batsoelopele*, from among whose number came the core of the BCP leadership, had long had ambitions to step into the political and commercial shoes of the white traders. These ambitions were threatened to a significant degree by the RCM's expanded development and cooperative movement. To many *batsoelopele*, including entrepreneurial BCP members, attacks upon the RCM were thus not just a cynical tactic to win support from disgruntled miners. They were also an expression of profound class anger. This issue, taken up by the LLB as early as the 1940s, appeared in the pro-BCP media in the late 1950s: 'Every Roman Catholic mission in the country is a retail shop', complained *Mohlabani*, which will 'strangle the small Basotho trader'.[63] The Sisterly Orders, an especially visible part of an institution which supposedly imperilled the masculinity and the 'progress' of Basotho men, became a lightning rod to some members of the BCP.

By contrast, the party of 'conservatism' led by Chief Leabua Jonathan (the BNP) was able to portray itself as the party which would both protect and emancipate women. Regardless of whether Jonathan was sincere or simply politically astute, the fact is that he did 'openly and repeatedly appeal to the women for support right through his campaign in practically every one of his speeches'.[64] While BCP candidates spoke disparagingly of women, Jonathan constantly praised them. The development work of both the nuns and of the lay *kopano* women was a favourite topic – 'bulldozers with breasts' he called the women in a memorable phrase that was offered, and understood, as a compliment.[65] The party manifesto made specific promises that a BNP government would emphasize expanded girls' education, build health-care centres for women, abolish unequal wages for men and women, and guarantee (undefined) 'rights for women'.[66] During the campaign, Jonathan continuously reminded women of the duplicitous BCP stance on the franchise, distributing thousands of translations of Matji's letter of protest against that stance as proof that the BCP could not be trusted.[67]

This is not to suggest that the men of the BNP were paragons of male virtue. Undoubtedly, many went along with Jonathan's strategy for purely opportunistic reasons, when in fact their real feelings were closer to those of the Fokotsanes and Shoepanes of the BCP. Many others, however, were accustomed as chiefs to working with women as equals: 'We talked openly of women's equality because we never thought they were inferior. As you know, we had women as chiefs for a long time and they were very good . . . They were listened to with respect.'[68] As for Jonathan, even Basotho who were opposed to the BNP have acknowledged his personal integrity on this matter, his loyalty toward 'Mantsebo at the end of her

regency, and his relative openness to the promotion of women and to accepting ideas from women.[69] His public persona in this regard went a long way towards overcoming the BNP's many organizational and image disadvantages.

Jonathan also exploited the growing suspicions of many Basotho Christians about BCP intentions. He prayed publicly, spoke reverently of God, and praised the works of the white missionaries. That this allowed him to build up his party's support rapidly should not be taken as proof of his supporters' false consciousness or blind faith in trusted church leaders. In fact, and without demeaning the power of faith, Christian and particularly Catholic women also stood to be badly affected in a material sense by attacks upon Christianity. The RCM's cooperative movement and other development enterprises were for poor Catholic women a 'bread and butter' issue at least as important as the smooth flow of male migrant remittances. Loyalty and defence of the church was therefore not simply loyalty and defence of white missionaries but was also loyalty and defence of the institutions and 'traditions' which had economically benefitted women most over the previous decades. For that reason, Catholic women were among the most highly motivated to mobilize themselves in support of the party which promised to defend the church. In the event, they provided a decisive edge to the BNP campaign in the mountain districts.

Some Catholic women (including influential regents) joined the BNP and worked as party canvassers. The main outlet for their political activism, however, was the Catholic pious association, the Ladies of Sainte Anne. The LSA's political work began 'accidentally' as early as 1959, when they distributed copies of the 'pastoral letter' from the bishops which instructed Catholics on the necessity of voting.[70] The LSA, who numbered from twelve thousand to fifteen thousand in total at that time, also travelled to remote villages, 'using their influence upon the men of their families as well as the women of their villages in order that all Catholic men or sympathizers do their duty'.[71] As the campaign progressed in 1964, the LSA expanded its activities in the discreet manner to which they were accustomed to operating as a *kopano*: 'It's true that the Santa Anna became involved in politics but they did it privately. They have ways of spreading a word quickly and they travelled a lot. They used to go from place to place quietly, not making noise, but in each house talk to the people.'[72] To another: 'How can you not organize the people when there is a problem to be faced? The organization of women is very simple and cheap. They hear about some development and ask, could you help us? We learn, we put it into practice. If we see a lovely garden, we ask what happened? In that way women spread new ideas very quickly and the same applied in the elections.'[73]

In their visits, senior LSA women would explain sermons and polit-
ical speeches, perhaps elaborating how a BCP win might imperil church
and family, co-ops and *kopanos*. To back up their argument, the LSA
distributed the Catholic newspaper *Moeletsi*, whose fifteen thousand
copies per week reached a far larger audience than any other paper,
including to some of the most remote parts of the country. The LSA also
surreptitiously distributed other BNP propaganda and, allegedly, party
membership cards.[74]

This mobilization took place largely outside the ken of the priests and
sisters, whose subsequent claims not to have known beyond a rumour or
two are entirely plausible given the traditions of Basotho women's
kopanos. The priests and sisters, however, remained under the closest
scrutiny by the LSA. Indeed, some church leaders appeared to feel pres-
sure by the LSA, not the other way around. This came either by subtle yet
unrelenting requests by the women for more explicit guidance, or by
humble offers of uncalled-for advice: 'We also wanted to calm down our
fathers who sometimes got over-excited. We asked them not to use strong
language.'[75]

Politicians of the BCP tended to dismiss LSA activism with the
special condescension they often reserved for Basotho women and 'the
ignorant Christian flesh of the country'.[76] The Youth League portrayed
the LSA as a mindless gaggle of geese being herded by Jonathan and their
priests. In the leader's words: 'The LSA were not organized by the BNP –
they were drilled by the missionaries.'[77]

This condescending attitude and the attacks upon the church did not
entirely erase the respect which most Basotho held for the education and
achievements of the BCP leaders. Nor did it detract from the powerful
appeal of the party's official platform – justice, economic development, and
national dignity. Support for the BCP thus remained strong on election day,
especially in the lowlands where the party was best able to get its clear anti-
colonial messages out. In the impoverished mountain districts, however,
where the RCM was paramount and its predominantly female congregation
comprised the poorest and most vulnerable sector of the population, the
BCP's evident lack of interest in these women's specific anxieties ulti-
mately proved fatal to its electoral hopes. Respected in their communities,
united, and forthright in spreading their political message far and wide, the
LSA's quiet work was crucial in getting out the vote for the BNP (male and
female). On election day, this enabled the BNP to squeak by in six key
constituencies with pluralities of less than five hundred votes. Those six
seats alone, representing less than two thousand out of a total of nearly two
hundred and sixty thousand votes cast, gave the BNP the edge over the
BCP and the right to form the government. As one educated Catholic
woman retrospectively summed up:

Mr. Mokhehle is a super man and a very powerful speaker. But he made the biggest mistake of his life when he said, if you vote for me these women who are nuns, we'll marry them. I heard him say that with my own ears. He did and if he says no, it's because he's afraid. It was the leader who said that and you know, Christians were shocked and annoyed. Many of them voted for the BNP because of that and he lost the election although he would have won.[78]

10.3 Conclusion

After coming to power the BNP regime did not live up to many of its pre-election promises, a story beyond the scope of the present study. However, what can be noted in conclusion is that after 1965 even Catholic Basotho women were not unaware of the BNP's progressive betrayal of the principles upon which it forged its first narrow victory. In 1968, *Mofumahali* 'Mamathe Masupha led the wave of disillusionment when she broke from the BNP to form her own United Party. In 1970 women and men of all denominations then voted convincingly to eject the BNP from power. This election was annulled, the constitution suspended, and over two decades of disastrous authoritarian rule ensued. At the next elections in 1993, the BCP swept to power by winning every single constituency in the country, massively supported by both women and men.

This short epilogue underscores the main conclusion I draw from analysing the history of women and politics in the pre-independence era. Basotho women were in general astute political observers and actors. To dismiss their voting behaviour as evidence of a special female naivety, manipulation or fickleness is factually incorrect. It also detracts attention from important contradictions in the behaviour of self-styled radical and 'pro-women' politicians.

Conclusion

The overview of the history of women and gender in colonial Lesotho which this book has undertaken leads to six major conclusions. First, women were important, autonomous actors in Lesotho's history. They made prominent, if generally unsung, contributions as workers, as chiefs, as farmers, as mothers, as migrants, as Christians, as political campaigners, and more. Indeed, without their labour in its many forms it is difficult to imagine that Lesotho would still exist as an independent country. This is particularly true of the period after the Great Depression when 'homemaking' began to compensate at the village level for the utter failure of development at the level of colonial policy. Similarly, the leadership of the regent 'Mantsebo at a crucial moment in the political evolution of the country played a key role in bringing together the squabbling chiefs and nationalist politicians to resist Britain's more cynical intentions for the colony.

Secondly, gender was a central organizing principle in the political economy as it changed over time. The colonial state manipulated gender ideologies and intervened in Basotho gender struggles in its efforts to foster a hierarchical class and racial structure that was beneficial to Britain's larger imperial and commercial interests in the region. Thus, for example, gender ideology was of key importance in defining 'civilization' and 'moral standards' in such a way that Europeans could justify both colonial rule and the paternalistic dominance of white missionaries long after Basotho nationalists had begun to demand independence. Similarly, the equation of 'efficiency' and 'modernity' with self-flattering fictions about Western, bourgeois masculinity underlay misguided attempts to reform (bureaucratize) the chieftaincy. The British also clearly feared that Basotho women's non-traditional behaviour was a threat to the social fabric (and balanced budgets) of territory. Given the assertive reputation of Basotho women, this was not a paranoid view. However, attempting to enforce specific ideals of femininity and masculinity for Africans compelled the cash-strapped administration to use coercion and to squander its resources and political capital, hastening the collapse of its plans to 'modernize' indirect rule.

Thirdly, Basotho women did not simply react to circumstances imposed from above or outside. Rather, they constantly and often imaginatively challenged the constraints upon them, adopting varying strategies

212

to assert their autonomy or simply to survive outside of male controls. They did so at considerable risk in many cases. Indeed, women's assertions of autonomy were commonly met with opposition and harassment by the state, as well as violence from individuals who resented the loss of control over women. Nonetheless, some Basotho women were able to find enough cracks in the edifice of colonial patriarchy to slip through and carve out a better life for themselves. Similarly, the Christian churches provided a space for Basotho women to organize and assert *de facto* autonomy in whole new areas, frequently to the chagrin of their ostensible emancipators.

Fourthly, Basotho women's behaviour should not be romanticized or 'homogenized'. The strategies which women adopted, and the successes or failures they encountered, depended upon their different class positions, stage in life cycle, and a host of other sometimes idiosyncratic factors. Although the dominant tendency was for women to resist exploitation and indignity, the forms of resistance could sometimes be self-defeating or exploitative to other women. Hence, mothers-in-law and *kopano* women could be formidable oppressors of younger women. Likewise, women as chiefs were not necessarily more sympathetic to women than male chiefs. Some actively bolstered the patriarchal system which benefitted them and their family at the expense of women and men as a whole.

Regardless of class, Basotho women normally shouldered primary responsibility for the welfare of their families through their productive and reproductive labour. As the *de facto* primary 'breadwinners', they often saw through the self-serving or idealistic statements and policies of male elites. A fifth conclusion, therefore, is that Basotho women's perspectives on the types of modernization which were imposed upon Lesotho often radically call into question some of the most commonplace assumptions in Lesotho's historiography. They blur such misleading dichotomies as modern versus traditional, public versus private, conservative versus progressive, political versus 'bread and butter', nationalist versus paternalist, and even men versus women. This blurring in turn compels us to question the dominant paradigms of economic development, nationalism, and progress which have typically coloured the subjectivity of Western observers. Basotho women's standpoints on controversial issues exposes contradictions in seemingly progressive or radical positions which are obscured by elite discourses or simply not visible from the dominant perspective. Similarly, understanding Basotho women's standpoints leads to a more respectful (that is, honestly critical) consideration of institutions which have hitherto been scorned or ignored by scholars, notably the *kopanos* and the Roman Catholic mission.

The final conclusion, therefore, is that scholars and political actors need to investigate further the material factors and cultural dynamics of domestic struggle which underpin even (or especially) women's most apparently bizarre, patriarchal or self-destructive decisions. More research can uncover women's contributions to history, can provide insight into a range of subaltern standpoints, can destabilize androcentric and Eurocentric assumptions and discourses in our subjectivity as scholars, can open areas for investigation which have hitherto generally been considered outside of history (sexuality and masculinity, for instance), and can relate findings to contemporary struggles for social change. Notwithstanding blindspots and other formidable difficulties with the sources, such research is both feasible and hugely promising to African studies.

Appendix: Biographical sketches of informants

Ashton, E. Hugh (interview, Bulawayo, June 1996). Anthropologist whose research in the 1930s produced the seminal study of the Basotho.

Blanchard, Rev. Gérard (personal correspondence 19 August 1990, and interview, Maseru, 2 September 1990). Teacher and former Secretary of Education for the RCM.

Brutsch, Rev. Albert (interviews, Morija, 14 and 28 August 1990). PEMS missionary originally at Cana in the 1940s. Former Secretary of Education and LEC archivist.

Brutsch, Alina (interview, Morija, 10 July 1990). PEMS missionary and former president of the Bo-'Ma-bana.

Damane, Mosebi (transcript of interview with Gwen Malahleha courtesy of Kate Showers). Historian, former member of BPA, BNC and editor of *Letsatsi*.

Fahy, Rev. Desmond (interview, Roma, 22 September 1990). RCM Professor of theology, NUL.

Fobo, Priscilla (interview, Roma, 23 September 1990). President of the local chapter of the LSA.

Hall, Rev. Anthony (interviews, Ottawa, 19 June 1989 and 3 November 1990). Chief negotiator for the transfer of Pope Pius XII College from the OMI to secular authorities, 1963–65.

Hector, Gordon M. (personal correspondence, 9 May and 28 June 1991). Deputy Resident Commissioner, 1956, Government Secretary 1956–60, Leader of the House 1960–65.

Khaketla, Bennett M. (interview, Maseru, 20 September 1990). Founding member of BANTA, editor of *Mohlabani*, member of the BAC/BCP executive 1955–62, founding member of MFP, author.

Khaketla, Caroline 'Masechele (interviews, Maseru, 8 and 20 September 1990). Co-founder and Headmistress of Iketsetsing Primary School, member of (Anglican) Mothers' Union.

Khitsane, Rakali (interview, Maseru, 10 March 1990). Former BCP member and mineworker.

Lapointe, Rev. Eugene (interview, Ottawa, 17 June 1989). Professor of Divinity, St. Augustine Seminary, St. Paul's University, author.

Lehloenya, Patrick (interview, Ha Lehloenya, 17 August 1990). Leader of

the Catholic teacher's union, MFP Member of Parliament for Thabana-ntsonyana 1965.

Lesema, Philomena (interview, Roma, September 1990). Nurse, member of LSA.

Lesenyeho, 'Mamookho (interview, Teyateyaneng, 24 August 1990). Founder of Boiteko, co-founder of LNCW, teacher.

'Me Lethunya (interview, Masianokeng, 17 August 1990). Member of Women's Institute, manager of Basotho Canning Corporation.

Mairot, Rev. Francois (interview, Roma, 23 September 1990). Former editor of *Moeletsi*, head of Catholic Action.

Majara, Matete (interview, Ha Majara, 24 August 1990). Senior Bakoena chief, member of BNC, BNP executive 1962–91.

Makuta, Cecilia (interview, Roma, 24 September 1990). LSA treasurer, businesswoman, came to Lesotho in 1965 from South Africa.

'Me Mamohlatsi (interview, Morija, 30 July 1990). Domestic worker, member of Bo-'Ma-bana.

'Me Mamosala (interview, Morija, 30 July 1990). Homemakers Association.

Manyeli, Anthony (interview, Roma, 20 September 1990). Professor of Theology, NUL, son of former BNP executive member.

'Mapeete, 'Makhosi (interview, Maseru, 3 September 1990). Women's League of BCP, Member of Parliament 1973–83.

'Me Masholungu (interview, Morija, 28 August 1990). A Xhosa woman born in Johannesburg who came to Lesotho with her husband to become one of the first African female high school teachers in the country.

Masiloane, Gertrude 'Makali (interviews, Mohale's Hoek, 10 August and 26 September 1990, personal correspondence). Lesotho's first female manager, first and long-time president of BCP Women's League.

Matji, Robert (interview, Maseru, 11 September 1990). Refugee from South Africa (1956), former ANC member and 'self-styled Marxist', District Councillor for Qacha's Nek (as BCP, 1960–62 and independent, 1962–65), unsuccessful MFP candidate (1965), businessman.

Mohapeloa, Bernice (interview, Mafeteng, 21 August 1990). Born c.1898, teacher, founder and long-time president of the Homemakers Association.

Mohloboli, 'Mathato (interview, Morija, 7 August 1990). Founding member of Homemakers Association and LNCW.

Mokhehle, Ntsu (interview, Maseru, 8 September 1990). Founder BAC/ BCP, leader of the Basotho Congress Party, former Prime Minister of Lesotho.

Mokokoane, 'Malikeleli (interview, Upper Thamae, 30 September 1990). President of the Homemakers Association, former president of the

Women's Bureau under Leabua Jonathan until her resignation in 1983.

Mosala, E. 'Mathabiso (interview, Maseru, 3 September 1990). Founder and president of the LNCW.

'Motseko' (interview, Motimposo, 16 March 1996). A young gay Mosotho.

Nketu, Lineo (interview, Khubetsoana, 16 March 1996). Poultry farmer, founding member of *Selibeng*, Maseru's shelter for battered women.

Ntakatsane, Limakatso (personal correspondence, 1992). Teacher, founder and president of *Kopaneng Basotho* (the so-called 'The Women's Party' in the 1993 elections).

'Peter' (interview, Motimposo, 16 March 1996). A middle-aged gay Mosotho.

Phohlo, 'Maneoana (interviews, Teyateyaneng, 2 June and 4 October 1990). Domestic worker, farmer, member of Legion of Mary.

'Me Pholo (interview, Matsieng, 17 August 1990). Lesotho's first female minister (African Episcopal Methodist Church, 1965), matron of Moshoeshoe II High School.

Ntate Sekhesa (interview, Morija, 29 July 1990). PEMS/LEC elder and former member of the *Seboka*.

'Me Sibolla (interviews, Morija, 21 July and 10 August 1990). Head-mistress of Morija English Medium Primary School, former member of BCP Women's League, LEC member.

Sister Antoinette (interview, Leribe, 25 August 1990). Nun at St. Monica's mission (RCM).

Sister Hilda (interview, Leribe, 25 August 1990). Nun at St. Mary's mission (Anglican), Mothers' Union member.

Sister Hyacinth (interview, Roma, 12 September 1990). Head nurse, St. Joseph's Hospital (RCM).

Sister Margie (interview, Leribe, 25 August 1990). Nun, St. Mary's mission (Anglican), an Englishwoman who arrived in Lesotho in 1965.

Sister Raphael Monyako (interview, Leribe, 25 August 1990). Nun at St. Monica's mission (RCM).

Sister Victoria 'Mota (interview, Roma, 20 September 1990). Nun and teacher at St. Mary's convent school (RCM).

Tlaba, Rev. Gabriel (interview, Mazenod, 17 August 1990). RCM priest.

Notes

Introduction

1. Lesotho, *Census 1966* (Maseru, 1966); A.C.A. Van der Wiel, *Migratory Wage Labour: Its Role in the Economy of Lesotho* (Mazenod, 1977).
2. See, notably, Hugh Ashton, *The Basuto* (London, 1952); Sebastian Poulter, *Family Law and Litigation in Basotho Society* (Oxford, 1976); Colin Murray, *Families Divided: The Impact of Migrant Labour in Lesotho* (Cambridge, 1981); David Coplan, *In the Time of Cannibals: The Word Music of South Africa's Basotho Migrants* (Chicago, 1994); Judy Gay, 'Basotho Women's Options' (Ph.D. diss., Cambridge, 1980); Debby Gill, *Lesotho: A Gender Analysis* (Maseru, 1992); Andrew Spiegel, 'Rural Differentiation and the Diffusion of Migrant Labour Remittances', in Philip Mayer, ed., *Black Villagers in an Industrial Society* (Cape Town, 1980); *idem*, 'Christianity, Marriage and Migrant Labour in a Lesotho Village', in T.D. Verryne, ed., *Church and Marriage in Modern Africa* (Groenkloof, 1975); and Caroline Wright, 'Unemployment, Migration, and Changing Gender Relations in Lesotho' (Ph.D. diss., University of Leeds, 1993). Many of the themes explored in these academic works are also told in narrative form in Kathryn Kendall, ed., *Basali! Stories by and about women in Lesotho* (Pietermaritzburg, 1995) and Mpho 'M'atsepo Nthunya, *Singing Away the Hunger: Stories of a Life in Lesotho* (Pietermaritzburg, 1996), and powerfully portrayed in the videos, Don Edkins, dir., *Goldwidows* (New York, 1980); and *idem*, *The Color of Gold* (New York, 1991).
3. Basutoland National Council, *Report of Proceedings* (Maseru, 1948), 352.
4. Anonymous, cited in Colin Murray, 'The work of men, women, and the ancestors: social reproduction in the periphery of South Africa', in Sandra Wallman, ed., *Social Anthropology of Work* (London, 1979), 354.
5. Belinda Bozzoli, 'Marxism, Feminism and Southern African Studies', *Journal of Southern African Studies* 9/2 (1983): 171.
6. See, for example, D.F. Ellenberger and J.C. MacGregor, *History of the Basotho, Ancient and Modern* (New York, 1969); Peter Sanders, *Moshoeshoe, Chief of the Basotho* (London: Heinemann, 1975); Leonard Thompson, *Survival in Two Worlds: Moshoeshoe of Lesotho, 1789–1870* (Oxford: OUP, 1975); Robert Edgar, *Prophets with Honour: A Documentary History of the Lekhotla la Bafo* (Johannesburg, 1988); Bennett Khaketla, *Lesotho, 1970: An African Coup under the Microscope* (London, 1973); L.B.B.J. Machobane, *Government and Change in Lesotho, 1800–1966: A Study* (London, 1990) and Stephen Gill, *A Short History of Lesotho* (Morija, 1993).

7. To use the inimical language of Lesotho's radical press (*Basutoland Newsletter* 21 May 1965).

8. Elements of this betrayal or dependency thesis can be found in works by authors as ideologically varied as Sir Alan Pim, *The Financial and Economic Position of Basutoland* (London, 1935); Nosipho Majeke [Dora Taylor], *The Missionary Role in South Africa* (Johannesburg, 1952); Richard Weisfelder, 'Defining National Purpose: The Roots of Factionalism in Lesotho' (Ph.D. diss., Harvard, 1974); Jack Spence, *Lesotho: The Politics of Dependence* (London, 1968); R.P. Stevens, *Lesotho, Botswana and Swaziland* (New York: 1967); Judy Kimble, 'Clinging to the chiefs: Some Contradictions in Colonial Rule in Basutoland', in H. Bernstein and B. Campbell, eds., *The Contradictions of Accumulation in Africa* (Beverly Hills: Sage, 1986), 25–69; Bernard Leeman, *Lesotho and the Struggle for Azania* (London, 1985); Kate Showers, 'Soil Erosion in the Kingdom of Lesotho: Origins and Colonial Response, 1830–1950s', *Journal of Southern African Studies* 15/2 (1989): 263–286; and James Ferguson, *The Anti-Politics Machine: 'Development', Depoliticization and Bureaucratic Power in Lesotho* (Cambridge, 1990).

9. Ellenberger, *History*, an unpublished volume cited by Sanders, *Moshoeshoe*, 50.

10. Coplan, *Cannibals*, 110.

11. Judy Kimble, ' "Runaway Wives": Basotho Women, chiefs, and the colonial state, c.1890–1920', Women in Africa Seminar, SOAS (London, June 1983).

12. *Liretlo* file, LEC archives, Morija, Lesotho.

13. Maloka, 'Basotho and the Mines', vi.

14. Overviews of the feminist critiques of Western or modern epistemology can be found in Alison Jaggar, *Feminist Politics and Human Nature* (Totowa NJ, 1983); Nancy Hartsock, *Money, Sex and Power: Towards a Feminist Historical Materialism* (Boston, 1985); Rosemarie Tong, *Feminist Thought: A Comprehensive Introduction* (Boulder, 1989); and Donna Landry and Gerald MacLean, *Materialist Feminisms* (Cambridge MA, 1993). For applications of this critique to a specifically southern African context, see Bozzoli, 'Marxism, Feminism'; Linzi Manicom, 'Ruling Relations: Rethinking State and Gender in South African History', *Journal of African History* 33 (1992): 441–465; and Ruth Meena, ed., *Gender in Southern Africa: Conceptual and Theoretical Issues* (Harare, 1992); and extended to the construction of masculinities, Robert Morrell, 'Of Boys and Men: Masculinity and Gender in Southern African Studies', *Journal of Southern African Studies* 24/4 (1998): 605–630.

15. Martha Mueller, 'Women and Men: Power and Powerlessness in Lesotho', *Signs* 3/1 (1977): 154–166.

16. Mueller, 'Women and Men', 47.

17. Gay, 'Basotho Women's Options'; Robert Fatton, 'Gender, Class, and State in Africa', in Jane Parpart and Kathleen Staudt, eds., *Women and the State in Africa* (Boulder, 1990), 47–66.

18. Kimble, 'Runaway wives'; and *idem*, 'Labour Migration and Colonial Rule in Southern Africa: The Case of Basutoland' (Ph.D. diss., Essex, 1985), 299–324.

19. Sandra Burman, 'Fighting a Two-pronged Attack: The Changing Legal Status of Women in Cape-ruled Basutoland, 1872–84' and Phil Bonner, 'Desirable or Undesirable Basotho Women?' in Cherryl Walker, ed., *Women and Gender in Southern Africa to 1945* (Cape Town, 1990). Walker's chapter in this same collection, 'Gender and the Development of the Migrant Labour System, c.1850–1930', draws significantly from Kimble's research; Tshidiso Maloka, 'Khomo lia oela: canteens, brothels, and labour migrancy in colonial Lesotho, 1900–1940', *Journal of African History* 38/1 (1997): 101–122.

20. Jean and John Comaroff, *Of Revelation and Revolution: Christianity, Colonialism and Consciousness in South Africa* vol. 1 (Chicago, 1991); Parpart and Staudt, *Women and the State*, 6; Theresa Barnes, 'The Fight for Control of African Women's Mobility in Colonial Zimbabwe, 1900–1939', *Signs* 17/3 (1992): 586–608; Diana Jeater, *Marriage, Perversion and Power: The Construction of Moral Discourse in Southern Rhodesia, 1890–1930* (Oxford, 1993); Frederick Cooper, 'From free labour to family allowances: labour and African society in colonial discourse', *American Ethnologist* 16/4 (1989): 745–765; Belinda Bozzoli with Mmatho Nkotsoe, *Women of Phokeng: Consciousness, Life Strategy and Migrancy in South Africa, 1900–1983* (Portsmouth, 1991); Karen T. Hansen, ed., *African Encounters with Domesticity* (New Brunswick NJ, 1992); and Paul Landau, *The Realm of the Word: Language, Gender and Christianity in a Southern African Kingdom* (Portsmouth NH, 1995). On African women's experiences with colonial law, Martin Chanock, *Law, Custom and Social Order: The Colonial Experience in Malawi and Zambia* (Cambridge, 1986) remains a seminal monograph.

21. Elizabeth Eldredge, 'Women in Production: The Economic Role of Women in 19th Century Lesotho', *Signs* 16/4 (1991): 707–731; *idem*, *A South African Kingdom: The Pursuit of Security in Nineteenth Century Lesotho* (Cambridge, 1993).

22. See, for example, Joan Wallach Scott, 'The Problem of Invisibility', in S. Jay Kleinberg, ed., *Retrieving Women's History: Changing Perspectives of the Role of Women in Politics and Society* (Paris, 1988); Joan Kelly, *Women, History and Theory* (Chicago, 1984); Margrit Eichler, *Nonsexist Research Methods: A Practical Guide* (New York and London, 1991); and Marc Epprecht, 'Feminist method and the asking of questions about masculine sexuality', in *Men, Feminisms, Africa: Debates and directions in anti-masculinist scholarship.* (Unpubl. ms., Trent University, 1999). An important qualification to the use of class analysis in Lesotho is laid out in Colin Murray, 'Class, Gender and the Household: the Developmental Cycle in Southern Africa', *Development and Change* 18/2 (1987): 235–249.

23. These interviews were conducted principally during my original stay in Lesotho (1990) and in a subsequent visit (1996). In addition, I also con-

tacted a small number of informants by mail, to which they responded with written replies. Details of the interviews, correspondence and the informants themselves are provided in the appendix.

24. Critical reflections on feminist oral history include Susan Geiger, 'What's so feminist about doing oral history?' in C. Johnson-Odim and M. Strobel, eds., *Expanding the Boundaries of Women's History. Essays on Women in the Third World* (Bloomington, 1992), 305–318; Kathryn Anderson, Susan Armitage, Dana Jack and Judith Wittner, 'Beginning where we are. Feminist Methodology in Oral History', *Oral History Review* 15 (1987): 103–127; Marjorie Mbilinyi, ' "I'd have been a man". Politics and the Labor Process in Producing Personal Narratives', Personal Narratives Group, eds., *Interpreting Women's Lives: Feminist Theory and Personal Narratives* (Bloomington, 1989); and Allison Goebel, 'Life Histories as a Cross-cultural Feminist Method in African Studies: Achievements and Blunders' (Paper presented at 15th biennial SAHS conference, Rhodes University, Grahamstown, 1995). On Sesotho oral history see David Coplan, 'History is Eaten Whole: Consuming Tropes in Sesotho Auriture', *History and Theory* 32 (1993): 80–104.

25. See, for example, Chandra Mohanty, Ann Russo and Lourdes Torres, eds., *Third World Women and the Politics of Feminism* (Bloomington, 1991); Aihwa Ong, 'Colonialism and Modernity: Feminist Re-presentations of Women in Non-Western Societies', *Inscriptions* 3, 110: 4 (1988): 79–83; Marnia Lazreg, 'Feminism and Difference: The Perils of Writing as a Woman on Women in Algeria', *Feminist Studies* 14/1 (1988): 81–107; Jane L. Parpart, 'Who is the "Other"?: A Postmodern Feminist Critique of Women and Development Theory and Practice', *Development and Change* 24 (1993): 439–464.

26. Joyce Appleby, Lynn Hunt, and Margaret Jacob, *Telling the Truth About History* (London, 1994). Please refer back to note 14 for overviews of these methodologies.

Chapter One Sesotho custom

1. Henri Duvoisin (1885), cited in R.C. Germond, *Chronicles of Basutoland: A Running Commentary of the Events of the Years 1830–1902 by the French Protestant Missionaries in Southern Africa* (Morija, 1967): 540.

2. Interview, 'Makali Masiloane.

3. For a regional perspective of social and political change before and during the *mfecane* era, see in particular Jeff Guy 'Gender Oppression in Precolonial Southern Africa', in Walker, *Women and Gender*, 33–47; Eldredge, *A South African Kingdom* and Coplan, *Cannibals* remain the most thorough studies of the invention of Sesotho traditions in this early period.

4. Resident Commissioner's submission to the Pim Commission, p. 11, PRO DO 119/1051.

5. Ashton, *The Basuto*, 57.

6. Kowet, *Land, Labour Migration and Politics*, 162; Weisfelder, 'Lesotho', Potholm and Dale, eds., *Southern Africa in Perspective* (New York, 1972), 135.

7. Eugene Lapointe, *An Experience of Pastoral Theology in Southern Africa* (Rome, 1986); Eldredge, *A South African Kingdom*; Showers and Malahleha, 'Oral Evidence'.

8. Eldredge, *A South African Kingdom*, especially 126–146.

9. Bearing in mind the dangers of the 'ethnographic present' with its implication of an ahistorical continuity to an 'exotic' culture, the following discussion of Sesotho up to the early colonial period is based principally upon Cape Colony, *Report and Evidence of the Commission on Native Laws and Customs of the Basutos* (Cape Town, 1873) and *Report of the Government Commission on Native Laws and Customs* (Cape Town, 1883); Germond, *Chronicles*; Ashton, *The Basuto*; Poulter, *Family*; Patrick Duncan, *Sotho Laws and Customs* (Cape Town, 1960); S. Jason Jingoes, *A Chief is a Chief by the People: An Autobiography of S.J. Jingoes* (Cape Town, 1975); Gay, 'Basotho Women's Options'; S.M. Seeiso, L.N. Kanono, M.N. Tsotsi and T.E. Monaphathi, 'The Legal Situation of Women in Lesotho', in Julie Stewart and Alice Armstrong, eds., *The Legal Situation of Women in Southern Africa* (Harare, 1990): 47–74; Eldredge, *A South African Kingdom*; Coplan, *Cannibals*; Robin Wells, *An Introduction to the Music of the Basotho* (Morija, 1994); Francois Laydevant, 'Etude sur la famille au Lesotho' (Roma, n.d.); and information garnered from my oral informants.

10. Eldredge, *A South African Kingdom*, 75–76.

11. See, for example, the case of Mosala v. Tsisa (CR 1/1877). In a case the following year, Desemelo described her husband's heartlessness in, first, driving her away from the home during a famine. Afterwards, 'he passed me when I was sick on the road without doing anything for me. The whole of the [subsequent] experience of bringing up my children has been borne by me.' Her husband's family clearly did not see that this was blameworthy and expected her to return when the famine was over. Indeed, the case was not brought to court by the woman seeking damages but by a man claiming to be a brother of the husband. When she did not return to her husband as expected, the family demanded Desemelo's father return the cattle which had been paid to him as her bride-wealth. This, it was argued, should by custom be returned if the woman absconded without just cause. (CR 9/1878. The plaintiff's argument was rejected in this case as the judge decided that Desemelo in fact did have just cause to divorce.)

12. Ellenberger describes the accomplished and revered 'Manthatisi in a depressed and browbeaten state after handing power over to her tyrannical son, Sekonyela, in the 1820s. 'Mamohato, as mentioned above, died after a savage thrashing by her husband in 1834.

13. Phoofolo, 'Kea Nyala! Kea Nyala! Husbands and wives in 19th century Lesotho', Mohlomi seminar paper, National University of Lesotho, 1980: 40; Eldredge, *A South African Kingdom*, 135.

14. Hlongane v. Masaka, Civil Court, Mafeteng, 7 July 1878.

15. That is, why should a man work hard if his wife could appropriate his savings based on his moral obligations to her? (Eldredge, *A South African Kingdom*, 123, citing Rev. Stenson in 1877.) The same obligation to consult

with his wife applied to decisions about the children's labour, discipline, and betrothal.

16. Eldredge, 'Women in Production', 722.

17. Ellenberger, *History*, 279, a point supported by another PEMS missionary, H.E. Mabille in 'The Basutos of Basutoland', *Proceedings of the British and South African Association for the Advancement of Science* 3 (1905): 185. Phoofolo also asserts that extramarital sex for women was 'common' in the pre-colonial period (Phoofolo, 'Kea Nyala', 36). Another form of sexual intimacy which escaped the notice of commentators until very recently but which likely existed in tradition (and which may help explain the relative durability of loveless or instrumental heterosexual marriages) was sex between women. Intimate friendships in this sense may well have been 'lesbian-like' to an extent which enabled women to fulfill their sensual needs without making difficult or 'excessive' demands for men's attentiveness. See Judy Gay, ' "Mummies and Babies" and Friends and Lovers in Lesotho', *Journal of Homosexuality* 11/3–4 (1985): 93–116; Nthunya, 'When a Woman loves a Woman', in *Singing Away the Hunger*, 69–72; and Kendall, 'Women in Lesotho and the (Western) Construction of Homophobia', in Evelyn Blackwood and Saskia Wieringa, eds., *Culture, Identity and Sexuality: Cross-cultural Perspectives on Women's Same-Sex Erotic Friendships* (New York: Columbia University Press, 1998).

18. '*Mosali ea nyetsoeng ha a tsoale sekhaupane*', S. Poulter, 'Marriage, Divorce and Legitimacy in Lesotho', *Journal of African Law* 21/1 (1977): 75.

19. The provenance of the custom of female wives is difficult to date, although it has famously been recorded among the Lovedu, a Sotho-speaking people in the Venda area, from the nineteenth century (Eileen Kriger, 'Woman-marriage with special reference to the Lovedu', *Africa* 44 (1974): 265–293). Its possibility among the peoples who became the constituents of the Basotho is at least implied in the case of Moshoeshoe's great-grandmother from the beginning of the eighteenth century. In this case, the widow refused to be *kenelaed* but took a (male) lover of her own choice (Eldredge, *A South African Kingdom*, 131).

20. E.A.T. Dutton, *The Basuto of Basutoland* (London, 1923), 79.

21. Interview, Sister Hilda. Details of this and all subsequent interviews are given in the appendix.

22. Komane v. Ramokoele, Civil Records, Mafeteng, 9 Dec. 1874.

23. Duvoisin, cited in Germond, *Chronicles*, 540.

24. 'Ma-Mathetsa, for example, partially paid for three wives for her husband (including her own *bohali*, Kapane v. Mosulukane, 17.12.1875, cited in Burman, 'Two-pronged attack', 62–63).

25. Cited in Germond, *Chronicles*, 515.

26. Hugh Ashton, 'Notes on Native Authority and Native Courts', May 1936. PRO DO 119/1073.

27. BNC, *Commission on Liquor*, 35.

28. See Eldredge, *A South African Kingdom*, 131–139.

29. Sanders, *Moshoeshoe*, 276.

30. Ashton, *The Basuto*, 285.
31. Perrot, Claude, 'Les sothos et les missionaires européens aux XIX siècle', *Annales de l'Université d'Abidjan* (ser. F, tome 2), 161–162; 'Report on *Mathuela' Vinculum* 4/9 supplement 14 (Oct. 1948).
32. Jingoes, *A Chief*, 89.
33. Thomas Arbousset, *Missionary Excursions,* edited and translated by David Ambrose and Albert Brutsch (Morija, 1992 [first published in Paris, 1840]), 73. Gay, 'Basotho Women's Options', 59–61.
34. Clearly male homosexuality is beyond the scope of the present research. Raising its possibility, however, prepares us to wonder about nationalist claims of an essential Basotho virility. As will be explored later, those claims played a significant role in the independence struggle. They have, moreover, been uncritically accepted in much of the scholarship on Sesotho (see, for example, Coplan, *Cannibals*, 139). Future researchers may wish to pursue the enquiry, but for now let me simply note that I was able in a matter of days to locate a Mosotho informant who described his own rape as a herd-boy by other herd-boys, and another who maintained that 'our grand-fathers did this' (that is, homosexual behaviours without taking lessons from the mines or Europeans; interviews with 'Peter' and 'Motseko', Motimposo). As well, an obscure reference alludes to possible pederastic relationships in pre-colonial Lesotho: Adolf Bastian, *Die Rechtsverhalt-nisse bei verschiedenen Volkern der Erde* (Berlin, 1872), 173, n.1, a theme taken up for sub-Saharan Africa in general in Stephen O. Murray and Will Roscoe, eds., *Boys, Wives and Female Husbands: Studies in African Homo-sexualities* (New York, 1998).
35. O.C. Chévrier, *Croyances et Coutumes chez les Basotho* (Mazenod, n.d.), 73, which can be taken to support the suggestions of female-female sexual intimacy in Gay, '"Mummies and Babies"' and Nthunya, *Singing.*
36. Wells, *Music*, 99. See also Weizacker, 'La Donna Fra I Basuto'; Chevrier, *Croyances*; Francois Laydevant, *The Rites of Initiation in Basutoland* (Mazenod, 1971 [reprint and trans. article from *International Review of Ethnology and Linguistics*, vol. XLVI, 1951]); Ashton, *The Basuto.*
37. See Elizabeth Eldredge, 'Slave Raiding Across the Cape Frontier', in Eldredge and Fred Morton, eds., *Slavery in South Africa: Captive Labor on the Dutch Frontier* (Pietermaritzburg, 1994), 93–126
38. Hence the Sesotho aphorism, 'Cousin, marry me, that the cattle return to my kraal.' Ashton, *The Basuto*, 63. Women are also said to have favoured this type of marriage as it tied them closer to the male relatives traditionally most responsible for their protection – the *malome* (who now became in-laws as well as maternal uncles). Gay, 'Options', 39.
39. Arbousset, *Missionary Excursion*, 133. See Kimble, 'Clinging to the Chiefs', for an assessment of the class ambitions and tactics of the Bakoena chiefs, and Eldredge, *A South African Kingdom*, for a critique of Kimble's analysis.
40. Poulter, *Family Law*, 70.
41. Cape, *Customs*; BNC 1948, 457.

42. Arbousset, *Missionary Excursions*, 112. See also Thompson, *Survival*, 212 and, for a later period, Jingoes, *A Chief*, 178–183. Jingoes describes a chief cowering in his hut while his brother was sjambokked by irate villagers after announcing a new tax at a *pitso*, and another case of commoners vetoing the rightful headman in favour of his younger son.

43. Eldredge, *A South African Kingdom*, 133.

Chapter Two Christianity

1. A considerable historiography on the PEMS exists, including Victor Ellenberger, *A Century of Mission Work in Basutoland* (Morija, 1933); Perrot, 'Les sothos et les missionaires'; Eldredge, 'The role of the Société des Missions Evangéliques'; Weisfelder, 'Defining National Purpose', 125–136; and Machobane, *Christianization and African Response*. For views of the early missionaries themselves, I have relied principally upon R.C. Germond, *Chronicles*; Eugene Casalis, *The Basutos* (Cape Town, 1971 [reprint of 1861 edition]); Thomas Arbousset, *Missionary Excursions*; and the two major periodicals of the PEMS, *Journal des Missions Evangéliques* and *Leselinyana*.

2. Cited in Andrew Ross, *John Philip: Mission, Race and Politics in South Africa* (Aberdeen, 1986), 169. The first Protestant missionary, Eugene Casalis also compared the Basotho as a race favourably to the 'Boers' (cited in Germond, *Chronicles*, 266). This affinity of the PEMS for the Basotho is reflected in the fact that their other major mission in the region was among the Kololo (later, Balozi or Barotse), an off-shoot of the southern Sotho which had migrated north of the Zambezi in the 1830s.

3. Moshoeshoe, defending the practice of *sethepu*, cited in Germond, *Chronicles*, 515–516.

4. *Leselinyana* 18 August, 1937, 3.

5. Cited in Eldredge, 'The Role of the Société'.

6. Cape Colony, *Report and Evidence of the Commission on Native Laws and Customs of the Basutos* (Cape Town, 1873). For a much later but strikingly similar perspective on the demoralizing effects of polygyny upon Basotho men according to the PEMS, see Victor Ellenberger, *Sur les Hauts Plateaux du Lessouto* (Paris, 1930), 72.

7. Cape, *Native Laws and Customs*, 36; Germond, *Chronicles*, *passim*.

8. Cited in Ashton, *The Basuto*, 66; and *Basutoland Witness* 4/3 (Sept. 1950), quoting Dieterlin's 1912 *Livre d'Or*.

9. Rev. E.W. Stenson cited Eldredge, *A South African Kingdom*, 123.

10. L. Bezançon describing the early history of PEMS-style feminism in 'Women in the Church of Basutoland', *Basutoland Witness* 3/2 (March 1949): 17.

11. *JME* 1890, 291, cited in Perrot, 'Les sothos et les missionaires', 159.

12. Alexander Kerr, *Fort Hare, 1915–48: The Evolution of an African College* (Pietermaritzburg, 1968), 31.

13. V. Ellenberger, *A Century of Mission Work in Basutoland*, 310.

14. Perrot, 'Les sothos et les missionaires', 159; Godfrey Lagden, *The Basutos:*

The Mountaineers and Their Country (New York, 1969), 636; Eldredge, *A South African Kingdom*, 94; Machobane, *Christianization*, 22.

15. Census 1936, 9; Weisfelder, 'Defining', 125–147; personal correspondence with John Gay, 29 May 1991. Several other churches were subsequently established in Lesotho, including charismatic Zionists. Prior to the 1960s their congregations were miniscule, and highly ephemeral.

16. *Basutoland Witness* 1/6, Nov. 1947, 13. Weisfelder, 'Defining National Purpose', raises this issue of PEMS paternalism towards Basotho men as a factor frustrating the development of a truly indigenous church in the late nineteenth century.

17. Kerr, *African College*, 31.

18. Mohapeloa, *Government by Proxy*, 94.

19. Deaconness Maria S.B. Burton, *Happy Days and Happy Work in Basutoland* (London, 1952), 51.

20. *Leselinyana*, 5 August 1931, quoting approvingly from and endorsing the Colonial Office 1925 report on girls' education in Africa. Interestingly, the earlier phrase – 'a curse rather than a blessing' – is precisely echoed in both these sources (evangelical and secular).

21. *Leselinyana*, 4 May 1935, 3.

22. Motseko v. Adrian Maphathe and Makubutu, Mafeteng Court Records, 8 Nov. 1876.

23. *JME* 1935/1, 211 (my translation). Luckily, it should be added, the poor young woman came to her senses quickly: 'But suddenly, my horizon enlarged; I realized that in accomplishing all these routine little things of life with conscientiousness and gaiety, one can find a certain pleasure, and then I take the decision that they shall not suffocate me.' Recalling that same period, several of my informants described being pressured by teachers, ministers, and husbands alike to give up their career or intellectual interests in favour of maintaining the appearances of petit bourgeois domesticity. Interviews, 'Mamookho Lesenyeho, 'Me A.P. Pholo, Bernice Mohapeloa.

24. Ladgen, *Basutos*, 636.

25. Sechaba Consultants, *Lesotho's Long Journey: Hard Choices at the Cross-roads* (Maseru, 1995), 21. Interviews with Ntate Sekhesa, Stephen Gill.

26. Weisfelder, 'Defining'; see also Howard St. George, OMI, *Failure and Vindication: The Unedited Journal of Bishop Allard, OMI* (Durban, 1981).

27. Bernard Albers, 'Father Joseph Gérard OMI: Apostle of the Basotho', *vie Oblate life* Dec. 1982, 240.

28. St. George, *Failure and Vindication*. See also, Mother Marie Joseph Angot, 'Journal of the Mission of Motse-oa-'Ma-Jesu' (Unpublished mimeograph, The Social Centre, Roma).

29. See Theresa Blanchet-Cohen, 'The Corporate Structure of the Catholic Church in Lesotho, 1930–56' (M.Phil., London, 1976) for a critical analysis of the RCM.

30. Bishop Allard, 'Tableau of Mission of the Apostolic Vicariate of Natal, Apr. 1, 1864' Deschatelets Archives Microfilm (henceforth DAM) Reel 44.

31. Sister Saint-André, Corsini, *Trente Jours en Mer, Trois Jours sur Terre, Trente Heures dans l'Air: Relation d'un Voyage au Basutoland et au Nyasaland* (Ottawa, 1947), 197. The Anglican mission also had the same problem which was ultimately overcome in a similar way: 'Other than those first two whose parents brought them [in the 1920s], all of us had run away.' Interview Sister Hilda; also Sister 'Mota and Sister Margie.

32. St. George, *Failure and Vindication*.

33. On accepting polygynists into the church, Catholic priests were enjoined to do so only if they had 'moral certainty' that the men, at that time, would honour Christian custom. If a man subsequently lapsed, it was he, the polygynist, and not the priest or the Church, who had to answer to God (Matrimonial cases, DAM 12). In Basotho eyes, this distinction may have been somewhat too legalistic since the 'anulled' wives of many polygynists commonly remained in the same huts that they had lived in before (Interview, Rev. Brutsch). On Catholic attitudes toward Sesotho customs, see P.G. Martin. 'L'Eglise Catholique au Basutoland' (1934), Deschatelets Archives LS 4003.B33R 10; P. 'Mabathoana, 'Lobola', *African Digest* 13 (1961): 28; Lapointe, *An Experience of Pastoral Theology in Southern Africa* (Rome, 1986), 93–94; Ashton, *The Basuto*, 73.

34. Martin, 'L'Eglise Catholique au Basutoland'.

35. Supporting this perspective, see A. Lehe, 'Traits de moeurs Basutos', *Petites Annales des Missionaires Oblats de Marie Immaculée* (1912) 22: 101–104; Lapointe, *An Experience*, 93–94; interview, Rev. Brutsch, as well as the complaints raised by a Mosotho trader who felt the RCM's sale of malt to women 'undercut legal trade' (BNC 1954, 378). Oblate opposition to the commodification of strong liquors, however, was adamant. See, for example, Martin, 'Les Basotho dans les centres miniers', among a number of articles on the subject in *Bulletins des Missions*, 18/1 (1939).

36. 13 April 1941. (DAM 47).

37. Tableau of the Missions of the Apostolic Vicariat of Natal, 1 April 1864. (DAM 44): 95.

38. LNA High Commissioner Letters, Resident Commissioner to High Commissioner re: Sargant report 1905.

39. Cited in Blanchet-Cohen, 'Corporate Structure', 185.

40. Sargant, *Report on Education in Basutoland 1905–6*, 110; Bishop Bonhomme to Mother Provincial of Sisters of the Holy Family, 3 Feb. 1933 (DAM 76). The 1946 Commission on Education criticized the RCM again on this language issue. Sir Fred Clarke, *Report of the Commission on Education in Basutoland* [henceforth, *The Clarke Report*] (Maseru, 1946), 35.

41. This was also one of the few points about Catholic education which the colonial administration found consistently praiseworthy: *Annual Report of the Director of Education* (Maseru, 1929), 4; *The Clarke Report*, 5; CAR 1950, 42.

42. Chief Solomon Mapathe, BNC 1935, 157.

43. Basotho became a majority of nuns sometime in the 1940s. Blanchet-Cohen, 'Corporate Structure', 257.

44. Ian Linden. *Catholic, Peasants and Chewa Resistance in Nyasaland, 1889–1939* (London, 1974), 168. Interview, Sister Victoria 'Mota; Corsini, *Thirty Days*; Un Soeur de St. Joseph, *Un Voyage au Basutoland* (St. Hyacinthe, 1946). See also *Moeletsi* and J.D. DesRosiers, *Basutoland* (Namur, 1947) for photographs of nuns at work.

45. Census 1921, 9. This disproportion did tend to even out over time so that, by the 1950s, no difference remained in the proportion of girls to boys in either missions' schools.

46. Marta Danylewyzc, *Taking the Veil: An alternative to Marriage, Motherhood and Spinsterhood in Quebec, 1840–1920* (Toronto, 1987), 32.

47. For an analysis of the development of the Catholic economic vision see Lapointe, *An Experience* and Giles Brossard, 'The Food Problem'.

48. Census 1936, 27; Lesotho Catholic Information Bureau, *Centenary: The Catholic Church in Basutoland, 1862–1962* (Mazenod, 1962); Blanchet-Cohen, 'Corporate Structure', 198.

Chapter Three Class formation and the emergence of racial capitalist patriarchy

1. Thompson, *Survival*; Elizabeth Eldredge 'Land, Politics and Censorship: The Historiography of 19th Century Lesotho', *History in Africa* 15 (1988): 191–209; *idem, A South African Kingdom.*

2. Norman Etherington, 'Labour Supply and the Genesis of South African Confederation in the 1870s', *Journal of African History* 20 (1979): 241; Eldredge, *A South African Kingdom*; Kimble, 'Some Aspects', and *idem*, 'Labour Migration'.

3. Eldredge, *A South African Kingdom*, 150; Cape Colony, *Native Laws and Customs*, 53.

4. Peter Hadley, ed., *Doctor To Basotho, Boer, and Briton, 1877–1906: The Memoirs of Dr. Henry Taylor* (Cape Town, 1972), 16.

5. BNC 1903, 34. See also the retrospective on the wondrous influence of 'Trade and Money', *Leselinyana* 6 March 1931, 3.

6. Census 1911, 43; 1936, 25.

7. R.U. Sayce, 'An Ethnographic Essay on Basutoland', *Geographical Teacher* 12 (1924): 285.

8. Burman, 'Two-pronged Attack', 63.

9. Ibid.

10. Cape, *Blue Book on Native Affairs*, 1881, 13.

11. See below. Chapter Four, as well as John Comaroff, 'Images of empire, contests of conscience: models of colonial domination in South Africa', *American Ethnologist* 16/4 (1989): 666. See also, Cooper, 'From free labour'; and Ross, *John Philip*, for discussions of the missionary and liberal, interventionist view that was prevalent in mid-nineteenth century South Africa. The influence of the PEMS upon the thinking of Cape officials in Lesotho is discussed in Mohapeloa, *Government by Proxy* and Sandra Burman, *Chiefdom Politics and Alien Law*, 53–55.

12. G.M. Theal, *Basutoland Records* vol. 3B (Cape Town, 1964 [reprint of 1883 edition]), 876.

13. Ladgen, *The Basutos*, 641. Lagden had an obvious self-interest in hyperbole on this matter, however, even after the Great Depression even intensely critical colonial sources perceived the territory to be 'on the whole prosperous' and 'comparatively wealthy and progressive'. (*The Pim Report*, 32; Lord Harlech, Visit to Basutoland 1942, 3, PRO DO 35/1172/Y701/1/1). According to Pim, 'conditions were in fact too easy' prior to 1929. By this he meant that an unusually favourable market for wool had allowed Basotho to acquire riches without adequate planning or agricultural and industrial discipline.

14. Census 1921.

15. For contrasting scholarly interpretations see Kimble, 'Clinging to the Chiefs', versus Eldredge, *A South African Kingdom*. Contemporary views on the crisis of the chieftaincy and its impact upon gender relations are explored in Chapters Five and Six below.

16. Timothy Keegan, 'Trade, Accumulation and Impoverishment: Mercantile Capital and the Economic Transformation of Lesotho and the Conquered Territory, 1870–1920', *Journal of Southern African Studies* 12/3 (1985): 201; Edgar, *Prophets with Honor*, 15. Hagiographical accounts of the Frasers can be found in James Walton, *Father of Kindness, Father of Horses: The Story of Fraser's Ltd.* (Morija, 1958); and Christopher Danziger, *A Trader's Century: The Fortunes of the Frasers* (Cape Town, 1979).

17. Kimble, 'Labour Migration', 50.

18. As late as 1934, only 3 of the 194 general traders in the country were Basotho (*The Pim Report*, 60).

19. Assistant Commissioner, Mafeteng, to Resident Commissioner, 13 Jan. 1932. LNA S3/19/77.

20. See Lagden, *The Basutos*, 642, and H.V. Meyerowitz, *Report on the Possibilities of the Development of Village Crafts in Basutoland* (Morija, 1936), 26.

21. Eldredge, 'An Economic History', 336; Keegan, 'Trade, Accumulation and Impoverishment', 196–216; Walton, *Father of Kindness*, 31; Rosenthal, *African Switzerland*, 196; Taylor, *Doctor*, 24, also speaks of boycotts of white traders led by chiefs as early as 1895. A scathing, fictional account of the trading elite can be found in Robert Keable, *Recompense* (London, 1923).

22. Background paper to Sir Patrick Ashley-Cooper's visit, 18 Nov. 1952. PRO DO 35/4461/154/11/1.

23. Cited in Walton, *Father of Kindness,* 30. This is supported by Duvoisin's observations as well, cited in Germond, *Chronicles*, 404. See also a *Leselinyana* article from 1872, cited in BNC 1947, 455, as well as Lord Hailey's Olympian assessment in Hailey, *Native Administration*, 74–75. Given that anti-chief propaganda so closely served the interests of Basutoland's Protestant missionaries, administration and nascent *batsoelo-*

pele elite, and given the evident loyalty of the Basotho to their chiefs in the fighting of 1881–2 (and beyond), allegations against the chiefs in this period must be treated with great caution.

24. Hailey, *Native Administration*, 16; J.H. Sims, 'The Story of My Life', 88; Ashton, *The Basuto*, 176 and 206–220; *The Pim Report*, 42.

25. Hugh Ashton, 'Some Notes on Native Authority', May 1936, 8. PRO DO 119/1073; see also BNC 1931, 89–91.

26. Louis Mabille, PEMS submission to the Pim commission, 18 Oct. 1934. (Pim papers, Rhodes House). For other diatribes against the the chiefs, see *Basutoland News* 24 March 1937, or *Leselinyana*, 2 Sept. 1930, wherein a colonial official is quoted blaming everything from starvation to venereal disease on 'the wealthiest stock owners'. Jingoes, *A Chief*, also gives anecdotal evidence of the chiefs' apparently irrational obsession with cash in this period, particularly pp. 191–192.

27. To avoid the implication of a consistent or predictable 'essence' in their class position and politics, and to avoid misleading analogies to European class structures, I shall stick to the Sesotho terms. For thoughtful and nuanced definitions of the petty bourgeoisie in the marxist literature elsewhere in southern Africa in this period, see Phil Bonner, 'The Transvaal Native Congress, 1917–1920: the radicalisation of the black petty bourgeoisie on the Rand', in Marks and Rathbone, *Industrialisation and Social Change in South Africa* (London, 1982), 270–314; Alan Cobley, *Class and Consciousness: The Black Petty Bourgeoisie in South Africa, 1924 to 1950* (Westport, 1990).

28. See in particular *Mochochonono*, a 'progressive' newspaper established in Maseru in 1911.

29. See, for example, Assistant Commissioner, TY to Resident Commissioner, June 18 1929, LNA S3/19/72, who boasts of an interview with Thomas Mofolo in which he made the BPA leader apologize for his 'insolent' attitude before Mofolo had even spoken! See also the files on Josiel Lefela, LNA S3/22/25. One of the vilest published expressions of contempt for *batsoelopele* that I came across was penned by a woman, the wife of a colonial official at the turn of the century. See Martin, *Legends and Customs*, 87.

30. Census 1911, 43. As late as 1958, agriculturalists deemed worthy of these modern epithets (in contrast to 'peasants') were still but 176 in number (CAR 1960, 10).

31. Census 1936, 23. The figure for housewives (525) represents the number of women whom census-takers described as engaged in 'household duties' (as distinct from 'domestic servant' or 'peasant' which accounted for the overwhelming majority of Basotho women). This category of housewife never reappeared on any subsequent census, and it may be a mistake to read too much into it. On the other hand, it may suggest a fleeting recognition of a petty bourgeois ideal – women who did not need to seek employment nor sully their pretty hands in the fields. The size of the 'middling class' is also suggested by membership in commoner political associations. Notably, the BPA numbered approximately 1 500 at its peak in 1924.

32. Machobane, *Government*; Weisfelder, 'Early Voices of Protest'; and Edgar, *Prophets with Honour*. Colonial correspondence and police reports on the LLB in the 1920s and 30s are found in LNA S3/22/25.

33. Census 1911, 1921, 1936, 1946, 1956, 1966. The World Bank report of 1975 reiterates the same proportion as well (World Bank, *A Development Challenge* [New York, 1975], 1).

34. Douglas and Tennant, *Agricultural Survey*, 79. The origins of the term *liquata* may also lie in the Afrikaans word 'kwaad' ('to be sulky or angry'). Coplan, *Cannibals*, 75.

35. Census 1921, 6; 1936, 5. In the mountain districts, comparable figures were much lower but also showed a dramatic rise over this period. In Mokhotlong, from one in twenty in 1921, the number of male migrants to South Africa had risen to one in seven in 1936. Total figures, of course, include male children and men beyond the age of recruitment.

36. A compelling first-hand account by a Mosotho woman, from which I shall draw quite heavily in Chapter Five, is Malimpho Seotsanyana, 'Basotho Female Farm Labour in the 20th century' (BA Hons. diss., NUL, 1984).

37. *Sebhunu moroa* meant, literally, 'buttocks to the back', but figuratively, 'they show only their asses to Lesotho' (Coplan, 'Emergence', 365). For discussions of working and living conditions at the mines, and their effects upon Basotho men's consciousness and behaviour, see in particular, AIM, *Another Blanket*; Jeff Guy and Motlatsi Thabane, 'Technology, Ethnicity and Ideology: Basotho Miners and Shaft-sinking on the South African Gold Mines', *Journal of Southern African Studies* 14/2 (1988); Coplan, *Cannibals*; Maloka, 'Basotho and the Mines', especially pp. 164–165.

38. Maloka, 'Khomo lia oela', 105; Resident Commssioner to P.C. Griffith, 18 June 1929, LNA S3/5/1/24.

39. Kimble, 'Aspects', 153.

40. For example, the scandalized account by PEMS member N. Khouthu in *JME* 1938/1, 353.

41. Moodie with Ndatshe, *Going for Gold*. See also Patrick Harries 'Symbols and Sexuality: Culture and identity on the early Witwatersrand Gold Mines', *Gender and History* 11/3 (1990): 318–336.

42. Medical Director H. Dyke to the BNC, 1940, 4.

43. Harries, 'Symbols and Sexuality'; Moodie with Ndatshe, *Going for Gold*. In their study from the late 1970s, Blair and Gay found 'sodomy' at the mines to be 'very common' ('Growing Up in Lesotho', 109) while at least one of Coplan's informants found the topic amusing and taken-for-granted, rather than embarrassing or threatening (*Cannibals*, 138–141), an attitude I also found (interviews with 'Peter' and 'Motseko'). Placing a date when so-called mine marriage first appeared among Basotho migrants, however, is difficult, probably impossible. 'John of Basutoland' certainly knew about it in 1908. A repeat offender for sodomizing 'picannins', John alias Shubela appeared before the magistrate's court at Hartley, Southern Rhodesia (National Archives of Zimbabwe, Criminal Court Records, D3/21/2, case 132 of 1908 and 390 of 1909). In South Africa, the first explicit reference to be

published of a 'Sotho' miner with a preference for boys dates from 1919 (Moodie, 136), while Bishop Bonhomme in 1946 specifically cited sodomy as one of the attendant evils of migrant labour (PRO DO 35/4160).

44. See 'Russians' file, June 1957, PRO 35/4421/112/251/1; *Mohlabani* 4/6 (Aug. 1958). See also Philip Bonner, 'The Russians on the Reef, 1947–57: Urbanization, Gang Warfare and Ethnic Mobilisation', in Bonner et al., *Apartheid's Genesis, 1935–62* (Johannesburg, 1993).

45. The theme of male migrants as socially reactionary runs throughout missionary and colonial documents and publications of the period throughout the region. See, for example, J.F. Holleman 'The Changing Roles of African Women', in Holleman, *Issues in African Law* (The Hague, 1974), 174 and Lapointe, *An Experience.*

46. M.S. Mohasi, BNC 1961, 10.

47. Ashton, *The Basuto*, 65; Poulter, *Family Law*, 107; BNC 1931, 89–91, and BNC 1934, motion 27.

48. BNC 1928, 24.

49. BNC 1929, 19. The British actually left it to independent Lesotho to do the delicate (and ultimately bloody) work of imposing compulsory deferred pay in 1974.

50. *JME* 1930/2, 180.

51. South Africa, *Native Economic Commission* [henceforth, NEC] (Pretoria, 1932), 8–10 and *passim*; *The Pim Report*, 38–42. Interestingly, Pim considered that the mother-child relationship 'was not seriously affected' by migrant labour.

52. Sayce, 'Ethnographic Essay', 288. Bearing in mind the strong possibility of wishful thinking in this regard, similar allusions to individualism as 'progress' can be found throughout Ellenberger, *Sur les hauts plateaux du Lessouto* (Paris, 1927).

Chapter Four Colonial rule, 1868–1929

1. Henri Dieterlin cited in Germond, *Chronicles*, 531.
2. Burman, 'Two-pronged Attack', 57.
3. Germond, *Chronicles*, 531.
4. Burman, 'Two-pronged Attack', 725.
5. See Ross, *John Philip*; John Comaroff, 'Images of empire, contests of conscience: models of colonial domination in South Africa', *American Ethnologist* 16/4 (1989); and Stanley Trapido, '"The Friends of the Natives": Merchants, Peasants and the Political and Ideological Structure of Liberalism in the Cape, 1854–1910', in S. Marks and A. Atmore, eds., *Economy and Society in Pre-Industrial South Africa* (London, 1980), 247–274 for discussions of Cape assimilationist ideals and frustrations.
6. Comaroff, 'Images of empire', 666.
7. Sandra Burman, *Chiefdom Politics and Alien Law* (New York, 1981), 53–55. See also *idem*, 'Two-pronged Attack', and J.M. Mohapeloa, *Government by Proxy: Ten Years of Cape Colonial Rule in Lesotho, 1871–81*

(Morija, 1971). Rolland himself later became a magistrate in the Cape administration and in at least one case (LNA Civil Records 7 Jan. 1875) explicitly identified himself as part of 'a Christian government'.

8. Ian Hamnett, 'Some Notes on the Concept of Custom in Lesotho', *Journal of African Law* 15 (1971). The latter did not actually ever happen until 1948. However, appeals to the High Court against decisions by chiefs were common.

9. Burman, 'Two-pronged Attack', and *Chiefdom Politics*.

10. Cape, *Native Laws and Customs*, 65.

11. Anthony Atmore, 'The Moorosi Rebellion: Lesotho, 1879', in R. Rotberg and A. Mazrui, eds., *Protest and Power in Black* Africa (New York, 1970): 3–36.

12. Mohapeloa, *Government by Proxy*, 91.

13. Burman, 'Two-pronged Attack', 73.

14. Burman, *Chiefdom Politics*, 95; Machobane, *Christianization*, 14–15; Cape, *Native Laws and Customs*, 5.

15. Machobane, *Christianization*, 13–15.

16 . Burman, *Chiefdom Politics*, 95–97.

17. Mohapeloa, *Government by Proxy*, 90; Cape, *Native Laws and Customs* (1883), 386.

18. Cape, *Native Laws and Customs* (1873), 66.

19. Seeiso, et al., 'The Legal Situation of Basotho Women'; M.P. Mamashela, 'Divorce Law in Lesotho: A Critical Appraisal of the 'Guilt' Principle and the Present Grounds for Divorce', *Lesotho Law Journal* 7/1 (1991): 21–48.

20. Testimony of J.H. Bowker, Cape, *Native Laws and Customs* (1883), 219.

21. LNA 21/1878.

22. Arone Mpatsa v. 'Ma-Mookho, LNA HC 36/1877.

23. Motsteko v. Maphathe and Makubutu, LNA Civil Records Mafeteng, 8 Nov. 1876.

24. Ibid. This appears to be the self-same Makubutu who, only the year before, had been described as 'one of the richest women in Basutoland' by her former lover, a man aggrieved that she had milked him of cattle and other livestock which by custom should have been his. That case is discussed at length in Burman, 'Fighting a Two-pronged Attack', 59–61, and is again noteworthy for Makubutu's deployment of Sesotho to justify radical acquisitiveness by a woman (indeed, radical even for a Mosotho man).

25. Atmore, citing both an oral informant and a Wesleyan missionary in 'The Moorosi Rebellion', 23.

26. A decade later, there were nearly two thousand, still less than 2 percent of the adult female population. Census 1921, 10.

27. Deputy RC to all ACs, 27 Jan. 1917. LNA Leribe misc. correspondence.

28. Judy Kimble, 'Concepts in Transition: Labour Migration in Southern Africa, 1890–1910', Seminar on Peasants, Institute of Commonwealth Studies (1980), 13.

29. Bishop Webb, commenting on Sir Lagden's speech to the Royal Colonial Institute, 'Basutoland and the Basutos', *Proceedings* vol XXXII (1901): 276.

30. Ibid., 273.
31. Martin, *Legends and Customs*, 114–117.
32. RC to High Commissioner, 28 Dec. 1905, LNA High Commission Letters to 1905 (Out).
33. Assistant Commissioner Qacha's Nek on the deportation of G.C. Greyling, 8.5.1932. LNA S3/14/9/7.

Chapter Five 'Loose women' and the crisis of colonialism

1. LNA Civil Records, Mafeteng, 15 Dec. 1874, and 4 March 1880; on liquor smuggling, see 20 Sept. 1890, 1 May 1890, and case number nine of 1899.
2. Mabille, 'The Basutos', 185.
3. LNA Mafeteng Civil Record, 21 August 1874. Testimony to other early cases, including 'Ma-Moloi's (as above 22 Nov. 1876), can be found in 4/1874, 2/1877, 14/1878, 18/1878, 21/1878, and 2 Sept. 1878. See also Kimble, 'Runaway women'.
4. Seotsanyana, 'Basotho Female Farm Labour', 11.
5. CAR 1932, 15; NEC, 196.
6. Seotsanyana, 'Basotho Female Farm Labour', 54; Bonner, 'Undesirable Women'.
7. Berea Miscellaneous correspondence, Resident Magistrate, Orange River Sovereignty to Assistant Commissioner, Berea, Sept. 1908.
8. Seotsanyana, 'Basotho Female Farm Labour', 11.
9. Coplan, *Cannibals*; Wells, *Basotho Music*, 110; Maloka, 'Khomo lia oela'. See also Madamme Henderson-Ramseyer, 'Parmi les femmes Bassoutos de Johannesbourg' (*JME* 1936/2, 477), a PEMS missionary who believed that 'adventure and fortune' were drawing women to the Rand.
10. Seotsanyana, 'Basotho Female Farm Labour', 54.
11. Resident Commissioner's submission to the Pim Commission, 1934. PRO DO 119/1051. Belinda Bozzoli also discusses this notion of a 'proto-dowry' among the Bafokeng in Bozzoli with Nkotsoe, *Women of Phokeng*, 97; while Luise White, *The Comforts of Home: Prostitution in Colonial Nairobi* (Chicago 1990), makes the case for the positive aspects of prostitution in the similar setting of colonial Nairobi.
12. An unnamed, 78-year-old informant quoted in Matora Ntimo-Makara, 'Women as Migrant Workers: Lesotho Case Study', Women in Africa Seminar, Institute of Commonwealth Studies, London (March 1985): 29.
13. Kimble, 'Labour Migration', 198 (footnote 32).
14. Census 1911, 1936.
15. Cited in Bonner, 'Desirable or Undesirable Women', 230.
16. National Archives of Zimbabwe, Case 68/1924, D3/5/62.
17. A.G.T. Chaplin, Memo on migrant labour, 1 Sept. 1942, PRO DO 35/1178/y847/1/1.
18. *JME* 1934/1, 312 (my translation).
19. D.E. Millichamp (constable-in-charge, Leribe) report of 23 Aug. 1919 (LNA S3/21/4/4).
20. Ibid.

21. *Basutoland Witness* 7/4 (Oct. 1953): 54.
22. Matora Ntimo-Makara, 'Women as Migrant Workers', 29; Resident Commissioner's submission to the Pim Commission, PRO DO 119/1051. See also, David Coplan, 'Musical Understanding: The Ethno-aesthetics of Migrant Workers' Poetic Song in Lesotho', *Ethnomusicology* 32/3 (Fall 1988); and G.M. Malahleha, 'Liquor brewing: A Cottage Industry in Lesotho Shebeens', *Journal of Eastern African Research and Development* 15 (1985): 45–55.
23. Cited in Maloka, 'Basotho and the Mines', 333.
24. Ibid.
25. To the present-day, the district of Maseru where her eating house was located is known by her name. David Ambrose, *Maseru: An Illustrated History* (Morija, 1993), 159.
26. *Select Committee on the Liqour Proclamation*, 47.
27. Judy Gay, 'Wage Employment of Rural Basotho Women', *South African Labour Bulletin* 6/4 (Nov. 1980).
28. Interview, Sister Hilda.
29. CAR 1892 cited in Bonner, 'Desirable or Undesirable Women', 228.
30. Despatch 12 of 1899, referred to by the Resident Commissioner in a letter to the High Commissioner, 14 Feb. 1907 (LNA High Commissioner Letters). In this correspondence, the Resident Commissioner was actually seeking to make a 'reasonable case' for reimbursement of legal expenses on behalf of an aggrieved Mosotho husband. The man's request, however, was ultimately dismissed when it emerged that some of his testimony was perjured (LNA S3/5/5/5).
31. Assistant Commissioner, Maseru, in a letter to the Government Secretary dated 23.3.1928 (LNA S3/5/1/22).
32. Maloka, 'Khomo lia oela', 107.
33. BNC 1903, 55. See also Bonner, 'Desirable or Undesirable Women', 228; Burman, *Chiefdom Politics*, 183.
34. BNC 1903, 19.
35. OFS archives, CO 404/2364/2/06; CO 404/2364/1/06.
36. OFS archives, CO404/2364/16/06; see also the cases of Matashe and Elizabeth Manapo cited above.
37. Gérard Martin, 'Les Basotho dans les centres miniers du Transvaal', and 'Chez les Basutos du Transvaal', *Les Bulletins des Missions* Tome XVIII/1 (1939), 62. In light of the tensions which emerged at the bridge at Ficksburg, it is interesting to note that border controls were originally (1904) relaxed to allow Basotho women to cross for shopping at the request of Ficksburg authorities and merchants (Resident Commissioner to High Commissioner, 3 Jan. 1924 LNA S3/5/11/6). On some of the contradictions and struggles among whites over black migration to the cities both in South Africa and in a similar settler community in Southern Rhodesia, see Belinda Bozzoli, ed., *Labour, Townships, and Protest* (Johannesburg, 1979); Julie Wells, *We Have Done with the Pleading: The women's 1913 Anti-Pass Campaign* (Oxford: Oxford University Press, 1993); Schmidt, *Peasants, Traders, and Wives*; and Jeater, *Marriage, Perversion, and Power*.

38. See Charles van Onselen, *Studies in the Social and Economic History of the Witswatersrand, 1886–1914*; Jeater, *Marriage Perversion and Power* and John Pape, 'Black and White: The "Perils of Sex" in Colonial Zimbabwe', *Journal of Southern African Studies* 16/4 (1990): 699–720, show evidence of the same thinking in the analogous context of Southern Rhodesia.

39. BNC 1914, 7.

40. Chief Motsoene, BNC 1914, 7.

41. *The Pim Report*, 45.

42. Assistant Commissioner, Quarterly Report, Sept. 1927. LNA S3/5/18/10.

43. T. Verdier, 'L'Alcoholisme au Lessouto', *JME* 1930/1, 291 (my translation).

44. RC to HC 23 Jan. 1915, memo on article in *The Friend* (17 June 1915, which had denounced the Basotho as immoral trouble-makers). LNA S3/5/11/6.

45. Maloka, 'Basotho and the Mines', 298–304. According to the Report of the Native Economic Commission of 1932, the Basotho were 'much more heavily syphillized than the Union labourers on the mines'. An infection rate of between 25 and 30 percent of all recruits from Basutoland compared to only 2 percent among Xhosa men (*NEC*, 214). See also N.M. McFarlane, *A Record of Medical Work and of the Medical Service in Basutoland* (Ladybrand, 1934).

46. Union Director of Native Labour to Resident Commissioner, 23 April 1929. LNA S3/5/18/2.

47. Resident Commissioner response to E.H. Stephens Ltd., 20 May 1929. LNA S3/5/18/2. For earlier correspondence on this issue, see National Recruiting Corporation to Resident Commissioner, 22 August 1922. LNA S3/5/18/7.

48. Mr. Keytor, MLA, report to Prime Minister 5 May 1923; see also correspondence between Assistant Commissioner (Leribe) and the Government Secretary in LNA S3/21/4/4.

49. Resident Commissioner to High Commissioner, 8 May 1916. LNA S3/5/11/6.

50. F. Foord to RC, 25 Aug. 1924. LNA S3/5/11/6.

51. BNC 1932, 64.

52. AC Quthing to RC, 12 Oct. 1925, LNA S3/5/1/9.

53. BNC 1928, 58. The motion was defeated.

54. LNA Berea Letters Despatched 1910–1913, letter of 17 April 1913.

55. BNC 1914, 7.

56. Basutoland, *Official Gazette*, 1915.

57. BNC minutes 1914, PRO CO 646/2, cited in Kimble, 'Runaway Wives', 15.

58. See PRO CO 323/1320/4 and PRO DO 35/402/11207 on official efforts to 'cover-up' the proclamation from British feminists (who in fact do not seem to have learned of it until the 1930s).

59. As happened in the 'whore' case cited above. Resident Commissioner to PC Griffith, 18 June 1929, LNA S3/5/1/24.

60. Bonner mentions this as a commonplace practice in the 1940s, presumably with its commercial origins much earlier. 'Undesirable Women', 246.

61. RC Sturrock to PC Griffith, 31 Aug. 1928. LNA S/3/5/1/9.

62. Basutoland, *Proclamations and Notices, 1928.*
63. 21 June 1928. LNA S3/5/18/10. It was a job well done, too, considering Griffith's own 'insatiable thirst for alcoholic beverages of every variety'. (High Commissioner to Sec. of State for Dominions Affairs, 2 Dec. 1927, LNA S3/5/14/2).
64. Simon Phamotse et al., petition of 6 Jan. 1916, LNA S26/3/31.
65. Petition of 2 May 1919. LNA S26/3/31.
66. Quarterly Report, 21 May 1928. LNA S3/5/18/10.
67. BNC 1938, 183.
68. Sims, 'The Story of My Life', Rhodes House, Oxford (n.d.), 83.
69. Ibid., 47.

Chapter Six Gender and the modernization of the colonial state

1. *The Pim Report*, 32; Report of Bishop Bonhomme, *MMO* 1936, 432; CAR 1931; Bonner, 'Desirable or Undesirable Women?'
2. A.G.T. Chaplin to Resident Commissioner, 'Labour emigration: Conditions on the Witwatersrand', 1 Sept. 1942 (PRO DO 35/1178/Y847/1/1).
3. Chaplin (Ibid.) put the number of Basotho women in the Johannesburg area at fourteen to twenty-one thousand (versus seventy thousand men). Other, higher estimates are made or implied in 'Report of the PEMS conference of 1933', *JME* 1/1934, 294; P.G. Martin, 'Chez les Bassoutos de Transvaal', *MMO* 1939, 332. The drop in female population between 1936 and 1946 compared to a natural increase of nearly 25 percent in the decade of 1911–21 (Census 1946, 6–7).
4. G.T. Chaplin, 'Labour emigration: Conditions on the Witwatersrand' 17 Aug. 1942. (PRO DO 35/1178/Y847/1/1). To put such losses in perspective, they totalled about 200 percent of the annual administrative budget. See also United Kingdom, *Basutoland, the Bechuanaland Protectorate and Swaziland: History of Discussions with the Union of South Africa* (London, 1952).
5. CAR 1938, 53.
6. *The Pim Report*, 49.
7. Specifically, the chiefs' almost unanimous vote against the British proposal that women be required to obtain passes to travel to South Africa (BNC 1952, 462).
8. Round table conference on *liretlo* 1953, 1 (*Liretlo* file, Morija).
9. BNC 1945, 151.
10. BNC 1916, 6. See also the file on the suppression of canteens at Leribe ('The bridge to Ficksburg', LNA S3/21/4/4). Chief Motsarapane Molapo's rationale for failing to respond to government pressure is revealing. As he wrote in a letter to the Assistant Commissioner, 'The habit [custom?] is that such an order is usually worked and enforced by one who makes it.' If the government wanted him to do something to 'stop this thing which causes *you* unpleasantness' (my emphasis, Molapo clearly suggesting that the government was alone in being displeased). It would either have to do it itself or give him financial assistance (19 Oct. 1923).

11. BNC 1928, 41.
12. Jones, *Medicine Murders*, 41.
13. BNC 1937, 3.
14. BNC 1932, 61.
15. BNC 1914, 2.
16. *JME* 1930/2, 261 (my translation). A number of debates on this issue later took place in the National Council. See in particular, BNC 1948, 467; BNC 1949, 229; BNC 1950, 287.
17. CAR 1934, 22.
18. Quotations from, respectively, BNC 1932, 63; BNC 1932, 62; BNC 1932, 173.
19. BNC 1936, 125–126.
20. BNC 1936, 128.
21. In the event, the poison was distributed and no sudden outbreak of viricide occured. In fact, with the return of the rains in 1934 the murder rate declined again. By 1943 there were only seven cases in the whole territory. BNC 1936, 125–126; CAR 1948, 88.
22. Lord Harlech, Report on Basutoland tour, 7 Jan. 1942. PRO DO 116/8, 112. The 'Cleon' whom Harlech almost certainly had foremost in mind was Josiel Lefela of the LLB.
23. Lord Harlech to Resident Commissioner, 7 May 1943. PRO DO 35/1176; Despatches from Lord Harlech, Report on the Basutoland tour, 7 Jan. 1942. PRO DO 116/8.
24. Resident Commissioner to regent's advisors, 7 June 1944, PRO DO 35/1176.
25. Sturrock's proposals, although rejected in 1929, were published six years later, possibly in preparation for the arrival of the Pim Commission. Basutoland. *New Native Court Regulations* (Morija, 1935).
26. RC submission to Pim, 4 PRO DO 119/1051. The Resident Commissioner went on to blame the lack of character development among Basotho boys, with all its disastrous social and economic consequences when they grew to manhood, to the fact that women now 'monopolize' their upbringing and the affection of the father is consequently reduced (page 14). Nostalgia for the superior, 'quasi-military' discipline of *lebollo* schools continued to be voiced by colonial officials as late as the 1950s, for example, during the Round Table Conference on *Liretlo*, *Liretlo* file, LEC archives.
27. Sims to High Commissioner, 27 April 1935. PRO DO 119/1053, 3–4.
28. Lord Harlech to Clement Atlee, on visit to Basutoland, 1942, PRO DO 35/1172/y701/1/1.
29. BNC 1938, 186. See Hamnett, 'Some Notes on the Concept of Custom', for an overview of colonial perspectives of Sesotho law.
30. LNA HC 27/1942.
31. Sophia Lethaha v. Komoreng, LNA HC 22/1943.
32. See, for example, LNA HC 61/1950; LNA HC 92/1940.
33. LNA HC 14/1942.
34. As was reported in a murder trial where the judge actually saved the accused from his own damning testimony. *Basutoland News* 27 May 1958.

35. LNA HC 22/1941.
36. LNA HC 3/1933.
37. Hamnett, 'Some Notes', 270–271.
38. LNA HC 27/42.
39. BNC 1950, 115.
40. LNA HC 3/1951.
41. Hammett, 'Some Notes', 270–271. See also, Seeiso, et al., 'The Legal Situation of Women in Lesotho', for an overview of the 'progress' of women's rights since the 1950s.
42. LNA HC 222/1939, cited in 'Documents and Letters exhibited in Chief Bereng v. Chieftainess 'Mantsebo' LNA HC 27/1942.
43. Lord Harlech, Visit to Basutoland, 1942. PRO DO35/1172/y701/1/1.
44. Eldredge, *A South African Kingdom*, 131–132.
45. PRO DO 119/1055; Lord Harlech, *Report on Basutoland Tour*, 7 Jan. 1942, 102, PRO DO 116/8.
46. LNA HC 27/1942.
47. LNA HC 27/1942, 27.
48. Interview, 'Masechele Khaketla, Maseru, 8 Sept. 1990; Robert Matji, Maseru, 11 Sept. 1990. In a related discussion in the BNC, Lyon Mahau argued that 'a widow is looked upon as the father of the minor child' and therefore regents should be entitled to the same benefits as male chiefs. BNC 1947, 641.
49. LNA HC 6/1943.
50. BNC 1949, 196.
51. Hailey, *Native Administration*, 90.
52. Lord Harlech (High Commissioner) to Resident Commissioner, 7 May 1943, PRO DO 35/1176; and Harlech, *Report on Basutoland Tour*, 7 Jan. 1942, PRO DO 116/8, 102.
53. Paramount Chieftainess to Resident Commissioner, 16 Dec. 1943, PRO DO 35/1176/y832/3; C.G.L. Syers to W.A.W. Clark (Commonwealth Relations Office), 4 Oct. 1949, Hector Papers Box 2/4, Rhodes House.
54. Resident Commissioner, Interview with Paramount Chieftainess, Sept. 1944, PRO DO 35/1177/y832/5.
55. Resident Commissioner interview with Paramount Chief, 25 Sept. 1944. PRO D0 35/1177/y832/5.
56. Resident Commissioner's comments on Lord Harlech's visit to Basutoland, 1942, PRO DO 35/1172/y701/1/1.
57. The alleged immorality stemmed from 'the late Paramount Chief's wives consorting with the present self-seeking counsellors' who were 'mainly commoners'. Arden-Clarke to the District Commissioners' Conference, Maseru 21–22 Dec. 1942; T.B. Kennan to Arden-Clarke, Report on meeting with the Paramount Chieftainess, June 1943. PRO DO 35/1176.
58. Correspondence on the Native Treasury, 10 Dec. 1943. PRO DO 35/1176.
59. H.B. Lawrence report on meeting between Paramount Chieftainess and Resident Commissioner, 14 Nov. 1944. PRO DO 35/1177/y832/5.

60. Ibid.
61. Paramount Chief letter to Resident Commissioner, 23 June 1944 PRO DO 35/1176.
62. Paramount Chief to Resident Commissioner, 20 June 1944, PRO DO 35/1176.
63. Resident Commissioner interview with Paramount Chief, 27 June 1944, PRO DO 35/1176.
64. Arden-Clarke, District Commissioners' Conference, 21–22 Dec. 1942. PRO DO 35/1172/y708/1.
65. Arden-Clarke, District Commissioners' Conference, 21–22 Dec. 1942. PRO DO 35/1172/y708/1.
66. T.B. Kennan to Arden-Clarke, 15 June 1943. PRO DO 35/1176.
67. Ibid.
68. Resident Commissioner interview with 'Mantsebo, 25 Sept. 1944. PRO DO 35/1177/y832/5.
69. H.B. Lawrence report on Resident Commissioner interview with Paramount Chieftainess, 14 Nov. 1944. PRO DO 35/1177/y832/5.
70. Ibid.
71. Chief Bolokoe, memo of interview between Paramount Chieftainess and Resident Commissioner, Sept. 1944. PRO DO 35/1177/y832/5.
72. Brian Marwick to E.P. Arrowsmith (RC) 28 July 1954. Arrowsmith papers, Box 3, Rhodes House.
73. Interview, B.M. Khaketla.
74. R. Turnbull, Notes of Chief Secretary's Visit to Basutoland, Mar. 1952. Arrowsmith papers, Box 3/2, Rhodes House.
75. Interview, Patrick Lehloenya.
76. Ibid.
77. 'Mantsebo to Rev. Michael Scott, including a copy of her letter to King George, 9 Sept. 1949. Africa Bureau papers, Box 219/1, Rhodes House.
78. 'Mantsebo letter to Forsythe-Thompson (1952), cited in Machobane, *Government*, 251–252.
79. Marwick to Arrowsmith, 23 August 1954, Arrowsmith Papers, Box 3/2, Rhodes House.
80. Ibid.
81. D.H. Wilson file, Rhodes House.
82. Arrowsmith to T.V. Scrivener, 30 May 1956. Arrowsmith papers, Box 3/2, Rhodes House; Personal communication, G.M. Hector.
83. Interview, B.M. Khaketla.
84. Notes of Chief Secretary's Visit to Basutoland, March 1952, page 4. Arrowsmith Papers, Box 3/2, Rhodes House.
85. 'A chief is a chief by the people.' Interview, Patrick Lehloenya.
86. Notes of Chief Secretary's Visit to Basutoland, March 1952, page 4. Arrowsmith Papers, Box 3/2, Rhodes House.
87. Arrowsmith to Scrivener, 10 Feb. 1954. Hector papers, Box 2/4, Rhodes House.
88. That is, approximately one hundred out of eight hundred. Basutoland, *List*

of Gazetted Principal and Ward Chiefs, Chiefs and Headmen as at 1st January, 1955 (Morija, 1955). The trend toward feminization of the chieftaincy continued thereafter. By 1977, over a quarter of all chiefs and 'headmen' were women (Gay, 'Basotho women's options', 41) and by the 1990s, over a third (thirty of eighty-five gazetted Area Chiefs, Gill, *Lesotho: A Gender Analysis*, 15).

89. LNA HC 6/1943.
90. BNC 1950, 87.
91. BNC 1949, 196.
92. BNC 1950, 93.
93. BNC 1950, 95–96.
94. Chieftaincy Act 22 of 1968 recognized women as chiefs in their own right for the first time. This delay is suggestive. Blatantly ignoring a BNC recommendation in such a fashion was unusual for the government in this period – the most recent previous example of the administration flouting a Council decision was its refusal to implement the BNC recommendation of equal salaries for female and male chiefs (BNC 1947, 648). I believe this illustrates both the strength of British feelings against the feminization of the chieftaincy and the low priority 'women's rights' were given by Basotho men who were unwilling to pursue the question.
95. Henry Moor [*sic*], *Report of the Administrative Reforms Committee* (Maseru, 1954), 12 [henceforth, *The Moore Report*].
96. Despatches from Lord Harlech, Report on the Basutoland tour, 7 Jan. 1942. PRO DO 116/8. See also Resident Commissioner's submission to the Pim Commission, PRO DO 119/1051.
97. Evelyn Baring, 'Economic Development under the High Commission in South Africa', *African Affairs* 1952, 230.
98. Sir Henry added that 'women were ordinarily weaker vessels, and liable to be unduly influenced by a favourite or advisor'. *The Moore Report*, 8.
99. Of ninety-three suspected victims listed in the official report on *liretlo*, forty were females. G.I. Jones. *Basutoland Medicine Murder: A Report on the Recent Outbreak of 'Diretlo' Murders in Basutoland* (London, 1951).
100. The official inquiry into *liretlo* by the anthropologist G.I. Jones supported pre-existing assumptions. Indeed, as early as 1946 (that is, prior to either the police or the official investigation) the Dominions Office already assumed that it was 'a Chief (or Chiefs) at the back of the trouble' (Memo on ritual murder, 17 Dec. 1946. PRO DO 35/1177/y835/1). Despite Jones' worthy academic reputation, therefore, it is hard not to escape the feeling that he was used by colonial authorities to prove what they already suspected and hence to justify what they already wanted to do. Suggestions have been made recently that Jones was in fact forced to suppress his real views (which would have indicted the British and 'Mantsebo or her key advisors – see footnote 103 below). Thus far at least the evidence circulated for this claim is, to my mind, not supported by rigorous research.
101. Round Table Conference on *Liretlo* (Morija, 1954, 1). *Liretlo* file, LEC archives.

102. Ibid., 23.
103. This confidence was published in Gunther, *Inside Africa*, 574–575. Jones and Hailey, who both drew prepoderantly upon official sources, also reiterate this innuendo against 'Mantsebo (Jones, *Medicine Murder*, 34; Hailey, *Native Administration*, 90, 98). More recently, Coplan alludes to this once again, apparently drawing upon Jones' unpublished papers (which, in fact, were probably authored by Hugh Ashton who later became the Private Secretary to the High Commissioner). I was unable to find any documented evidence to corroborate this accusation (in, for example, internal police reports such as the Resident Commissioner's Report on Ritual Murder, 9 March 1949, PRO DO 119/1376). Indeed, logic seems to exonerate her. Were she in fact guilty, why would she have pressed the government to invite an independent United Nations commission of inquiry (which the British refused)? And why would she have proposed increasing police powers to investigate the crimes since this risked uncovering her own guilt? And why, given the obvious difficulty of the government's relationship with her, would they find it expedient to cover-up her activities so thoroughly? In an interview, Hugh Ashton speculated that it was because they were simply tired of the whole affair and wished to put the lid on a nasty can of worms.
104. BNC 1953, 90–91; Jingoes, *A Chief*, 152–155.
105. See for example, BNC 1953, 90.
106. BNC 1952, 443.
107. Baring to Resident Commissioner, n.d. 1949. PRO DO 35/4025.
108. BNC 1949, 31; *Mohlabani* 3/7&8 (Aug. 1957), 11–13. Proclamation 5 of 1948 stated that 'all adult men shall be deemed to have committed an offence' unless they had a watertight alibi or turned crown witness (*Proclamations and Notices 1948*). Jones' report emphasized the need for even more, unspecified 'punitive measures to suppress the murder'. Jones, *Medicine Murders*, v.
109. Justice DeBeer (4 Dec. 1946) quoted in *Mohlabani* 4/10–12 (Dec. 1958), 10. He added that crown witnesses were 'apparently eager to lie about any point where they think such a lie would prejudice the accused'. Nevertheless, executions were carried out. Even Jones admitted (but then dismissed) that the chiefs regarded the British to be using 'underhand and immoral' methods in their anti-*liretlo* campaign. Jones, *Medicine Murders*, 64.
110. Interviews, Ntsu Mokhehle, Matete Majara, Patrick Lehloenya. See also *Makatolle* and *Mohlabani* for contemporary views.
111. R.E. Turnbull, PRO DO 35/4631/61/11/1.
112. Interview, B.M. Khaketla.

Chapter Seven 'Improving' women

1. 1. CAR 1932, 18. There were no asphalt or tarred roads in the territory at all. Funds for maintenance of the gravel and dirt roads dropped from £21 000 to £13 500 from 1930–32. CAR 1932, 19; CAR 1930, 10. See Showers, 'Soil Erosion' and Kate Showers and Gwen Malahleha, 'Oral Evidence in Historical Environmental Impact Assessment: Soil Conservation in Lesotho in the 1930s–40s', *Journal of Southern African Studies* 18/2 (1992): 276–296.

2. All of the above figures are garnered from official annual reports and are to be taken with a pinch of salt. For example, while the investment was unquestionably increasing, Basutoland still received less than the other High Commission Territories (whose populations and objective needs were smaller). United Kingdom, *The High Commission Territories and the Union of South Africa* (London, 1957), 5.

3. Seeiso et al., 'The Legal Situation of Women in Lesotho', 57.

4. Basutoland, *Official Gazette* (1949, 1956, 1959); CAR 1955, 84.

5. BNC 1937, 13; CAR 1948, 88; CAR 1958, 92; Census 1936, 5; Census 1956, 74–75. Again, the number of unofficial migrants, while impossible to establish, was certainly much higher.

6. Harlech, Report on Basutoland, 1943, PRO DO 116/8; see also CAR 1938, 46; CAR 1948, 28.

7. BNC 1946, 487.

8. LNA CR 30/1938. See also BNC debates on the issue BNC 1936; BNC 1938, 97; BNC 1946, 424; BNC 1947, 570.

9. The strips and their connected diversion furrows may also have exacerbated erosion on the field which remained. Showers, 'Oral Evidence and Soil Conservation' and personal communication.

10. As, indeed, Pim noted but then dismissed as unimportant. *The Pim Report*, 6.

11. BNC 1942, 76.

12. BNC 1947, 579.

13. *Moeletsi* 25 Sept. 1945. For similar angst see *Leselinyana* 14 July 1943 and 10 Feb. 1943; *Moeletsi* 31 July 1945; Francois Laydevant, *The Rites of Initiation in Basutoland* (Mazenod, 1971). (Laydevant's research was carried out in the 1940s and first published in 1951.)

14. So records the private diary of Bertha Hardregger, a doctor in the mountain district. Baerlocher, *Hardregger*, 39 (30 Sept. 1949).

15. Laydevant, 'Initiation Rites', 36, 53. The PEMS missionaries also noted an 'astonishing pagan offensive' at this time, although the PEMS international journal emphasized the anti-white rather than misogynist aspects of it. *JME* 1944, 18; *JME* 1945, 93.

16. *Vinculum* 4/9 supplement 14 (Oct. 1948), 2 (my translation).

17. The translation, according to one Mosotho Protestant (*Basutoland Witness* 8/2, 1954, 27). The 'excessive pre-occupation with *bohali* . . . especially by mothers' was also noted by the RCM and blamed as one cause of the rising incidence of *chobeliso* (abduction). *Vinculum* 4/9 (Oct. 1948).

18. Even the regent, whose salary was deliberately inflated in order to 'buy off' her opposition to the Native Treasury, took a cut in her revenues from an estimated £11 000 to 15 000 per annum to £9 500 (Resident Commissioner to High Commissioner, 6 Apr. 1944, PRO DO 35/11).

19. Chief Theko Bereng, BNC 1949, 347.

20. Mention is made of Basotho 'headmistresses' in Mafeteng (24 Jan. 1930, LNA S3/12/3/1–7) and St. James Anglican school in Maseru (H.V.

Meyerowitz, *Report on the Possibilities of the Development of Village Crafts in Basutoland* [Morija, 1936], 7).

21. *JME* 1945, 93.

22. Mary Blacklock, 'Certain Aspects of the Welfare of Women and Children in the Colonies', *Annals of Tropical Medicine and Parasitology* 30/4 (1936); Lord Hailey, *An African Survey* (London, 1938), 1231; Memo on the Education of Women and Children in the Colonies, 22 Jan. 1937 PRO CO 323/1418/0.

23. Advisory Committee on Education in the Colonies, 1939. PRO CO 323/1418/10.

24. 'Report of a Sub-Committee on the Education and Welfare of Women and Girls in Africa', Advisory Committee on Education in the Colonies, 11 (PRO CO 879/146).

25. Ibid., 11–12.

26. The Advisory Committee on Education in the Colonies, 1939. PRO CO 323/1418/0; BNC 1939, 6.

27. *The Teachers' Magazine* 23 (April 1947): 21.

28. *The Clarke Report*, 4.

29. *The Teachers' Magazine* 23 (April 1947): 21.

30. Basutoland, *Annual Medical and Sanitary Report* (Maseru, 1933), 16.

31. BNC 1942, 56.

32. BNC 1936, 27.

33. BNC 1942, 56. Two decades later, nurses, including those who were married and had children, were still not allowed their own accommodation but lived in supervised dormitories (*Report of the Select Committee on Salary Scales and Conditions of Service of the Basutoland Civil Service*, 1961, 161).

34. Resident Commissioner's submission to the Pim Commission, 14, PRO DO 119/1051.

35. H.V. Meyerowitz, *Report on the Possibilities of the Development of Village Crafts in Basutoland* (Morija, 1936).

36. Meyerowitz, *Village Crafts*, 9.

37. Basutoland. *Memo of Development Plans* (no place of publication indicated, 1946), 8.

38. BNC 1949, 92. In other words, repeat exactly what Meyerowitz had done already but, hopefully, come up with less radical recommendations.

39. CAR 1950, 44.

40. 'Home Industries Report', BNC 1949, 94.

41. Meyerowitz, *Village Crafts*, 15, 7–9.

42. 'Home Industries Report', BNC 1949; CAR 1949, 13.

43. CAR 1948, 65.

44. Interview, Lineo Nketu.

45. 'Home Industries Report', BNC 1949, 91.

46. CAR 1951.

47. Interview, 'Me Sibolla.

48. Notes of the Chief Secretary's visit to Basutoland, Mar. 1952, page 5, Arrowsmith Papers, Box 3/2, Rhodes House.
49. Among over three hundred informants were two (unnamed) women, both chiefs. Andrew Cowen, *Report on Constitutional Reform and Chieftainship Affairs* (Maseru, 1958), 81.
50. Basutoland, *Basutoland* (Morija, 1960), 7.
51. Danziger, *A Trader's Century*, 3.
52. CAR 1960, 65.
53. CAR 1963, 55.
54. CAR 1962, 52.
55. G.M. Hector, 'Rural Development in Basutoland, 1956', Hector papers Box 3/1, Rhodes House.
56. CAR 1958, 59.
57. Sandra Wallman, *Take Out Hunger: Two Case Studies of Rural Development in Basutoland*, (London, 1969), 140.

Chapter Eight Basotho women's voluntary associations

1. Debbie Gaitskell, 'Devout Domesticity? A Century of African Women's Christianity in South Africa', in Walker, *Women and Gender*, 251–272; *idem*, 'Housewives, Maids or Mothers: Some Contradictions of Domesticity for Christian Women in Johannesburg, 1903–1939', *Journal of African History* 24/2 (1983): 241–256; *idem*, ' "Wailing for Purity": Prayer Unions, African Mothers and Adolescent Daughters, 1912–40', in Shula Marks and R. Rathbone, eds., *Industrialisation and Social Change in South Africa* (London, 1982); Barbara A. Moss, 'Holding Body and Soul Together: The History of the Zimbabwean Women's *Ruwadzano/Manyano* in the Methodist Churches, 1890–1980' (Ph.D. diss., Indiana, 1990). Lapointe, *An Experience*, specifically alludes to the political influence of Catholic *kopanos* in Lesotho's 1965 election. See Hansen, *African Encounters with Domesticity* for comparative studies of African women's secular associations; and William Beinart and Colin Bundy, eds., *Hidden Struggles in Rural South Africa* (Johannesburg, 1987) for studies of the conditions that nurtured women's development-oriented associations in similar South African contexts.
2. J.P. Martin, 'Educating the Sotho, 1833–1884', (Ph.D. diss., Columbia University, 1983), 164.
3. *Tableau of Missions of the Apostolic Vicariate of Natal*, 25 July 1865, DAM 44, 164.
4. Martin, 'Educating the Sotho, 1833–1884', 166–167. See also Albers, 'Father Joseph Gérard', 241.
5. Martin, 'Educating the Sotho', 166–167.
6. See Chapter Nine on the transformation thereafter.
7. *JME* 1890, 291.
8. *Basutoland Witness* 3/2 (March/April 1949): 17.
9. Interview, 'Masechele Khaketla.
10. Interview, Cecilia Makuta.
11. Catholic Action report, 1953, DAM 61 (my translation).

12. Alina Brutsch cited in *Basutoland Witness* 15/2 (Apr.–Aug. 1961): 13.
13. *L'Apostolat Laic* Oct–Dec. 1958, 4. For other examples spanning the modernizing decades see Emille Schloesing in *JME* 1937/1, 27; Corsini, *Thirty Days*, 234; Brandel-Syrier, *Black Women in Search of God*, 30 and *passim*; interview, Alina Brutsch.
14. Corsini, *Thirty Days*, 234 (my translation).
15. Interview, 'Masechele Khaketla.
16. *Basutoland Witness* 15/2 (1961): 13; Francois Mairot, *Centenary Guide* (Mazenod, 1962), 290.
17. *L'Apostolat Laic* Jan.–March 1959/1, 44.
18. For accounts and anecdotes regarding *kopano* women's activities, see Bernadette 'Manyeoe Pelea, 'La femme Mosotho: élément dynamique de la nation', *Vivant Univers* (1973); Limakatso Charakupa, 'The Roman Catholic Mission of Our Lady of Laghetto, Leribe District, Lesotho' (BA diss., National University of Lesotho, Roma, 1978), 20; Mairot, *Centenary Guide*; Codex of Butha Butha 1945, page 31, DAM 15; Corsini, *Thirty Days*, 142; and interviews with 'Me Khaketla, 'Me 'Mohloboli, Sister Hilda, 'Me Phohlo, 'Me Khaketla. In South Africa, Gaitskell also records instances of *manyano* women as early as the 1920s travelling hundreds of miles across South Africa to attend their meetings. Gaitskell, 'Devout Domesticity', 265.
19. Brandel-Syrier, *Black Women in Search of God*, 34.
20. *Leeba* 1965/4, 4.
21. Interview, 'Me Sibolla.
22. Interview, Philomena Lesema.
23. Gaitskell, 'Devout Domesticity', 260.
24. *L'Apostolat Laic* Jan.–Mar. 1959, 44.
25. Interview, 'Masechele Khaketla.
26. Interview, Philomena Lesema.
27. Interview, Priscilla Fobo.
28. Interview, Philomena Lesema.
29. Interview, Ntate Sekhesa.
30. Interview, Father Anthony Hall, OMI.
31. Interview, Sister Hilda.
32. Interview, Philomena Lesema.
33. Corsini, *Thirty Days*, 153.
34. DAM 61.
35. Interview, 'Me Mohlaboli.
36. Interview, 'Me Sibolla.
37. Interview, Sister Hilda.
38. Interview, Cecilia Makuta.
39. Interview, 'Masechele Khaketla.
40. Catholic Action report, 1953, DAM 61 (my translation).
41. Interview, Alina Brutsch.
42. Brandel-Syrier, *Black Women in Search of God*, 32.
43. Tableau of Missions of the Apostolic Vicariate of Natal, 25 July 1865, DAM 44, 164.

44. Marcel Ferragne, *Au pays des Basotho: les 100 ans de la mission St. Michel, 1868–1968*, (Mazenod, 1968), 97 (my translation).
45. Interviews Rev. Albert Brutsch, Alina Brutsch, 'Me Sibolla; *Basutoland Witness* 7/1 (Jan.–March 1953): 8.
46. Interview, Father Desmond Fahy.
47. Cited in Brandel-Syrier, *Black Women in Search of God*, 96.
48. *L'Apostolat Laic* Jan/Mar 1959/1, 23 (my translation).
49. Phil Bonner, 'Desirable or Undesirable Women?'; Coplan, 'Emergence', 364; interview, 'Masechele Khaketla.
50. CAR 1935, 10.
51. PRO DO 119/1051.
52. A. Douglas, and R. Tennant, *Basutoland: Agricultural Survey 1949–50* (Maseru, 1952), 36.
53. Austin Coates, *Basutoland* (London, 1966), 88.
54. B.T. Mohapeloa, 'Basutoland Homemakers Association', *Basutoland Witness* 7/1 (1953): 5.
55. As another of the founding members of the Homemakers in Lesotho put it: 'At first I was a teacher but when our children arrived, my husband didn't allow that to continue. He said I should stay home to raise his children. Then I had a lot of time on my hands so I had to find a sideline. That's when I started making things to sell.' (Interview, 'Me Lesenyeho.)
56. 'Une association familiale au Lessouto', *JME* (1959): 41.
57. Interview, 'Me Lethunya.
58. Interview, 'Me Mohapeloa.
59. Ibid.
60. Ibid.
61. Ibid.
62. Interviews, 'Me Mokokoane, 'Me Mohapeloa.
63. CAR 1962, 65.
64. Interview, 'Me Mohloboli.
65. Interview, 'Me Mohapeloa.
66. Interview, 'Me Fobo.
67. Interview 'Me Lethunya. *Papa* is the porridge-like staple of the Basotho diet made from ground maize. It becomes virtually devoid of nutrients when the husk of the grain is completely removed by machine milling.
68. As the Chief Medical Officer himself later conceded, *Annual Report of the Medical Department, 1947*, 7.
69. Interview, 'Me Mohapeloa.
70. Mohapeloa, 'Homemakers', 5.
71. Interview, 'Me Mohlaboli.
72. See, for example, Sister Mary Lucy's priorities in her discussion of the importance of handwork in *Roma College Review* 1/1, Oct. 1939, and Sister Odilia on 'Industrial Training in the School', *Roma College Review*, 1/2 (1939): 33.
73. Interview, Sister Hilda.
74. Interview, 'Me Lethunya.

248 *Notes*

75. Interview, 'Me Mohloboli.
76. Basutoland, *Annual Report of the Director of Education* (Maseru, 1949), 19; *Annual Report of the Department of Agriculture, 1953*, 25.
77. Interview, 'Me Lesenyeho. See also Scott P. Rosenberg, 'Promises of Moshoeshoe: Culture, Nationalism and Identity in Lesotho, 1902–1966', (Ph.D. diss., Indiana University, 1998), for his interviews of 'Me Mohapeloa and other homemakers about their craft (and money) making activities.
78. Interview, 'Me Lesenyeho.
79. Ibid.
80. Official reports do not specify how many of these new gardens were worked by women, but it can be reasonably assumed that the majority were. Vegetables were traditionally the woman's responsibility and colonial discourse suggests this continued to be the case in the 1930s. When referring to men and the production of grain, colonial reports employ such terms as 'farmer' or 'agriculturalist'. By contrast, when referring to gardening, the same reports employ the term 'Basuto families'. See, for example, CAR 1948, 48 and CAR 1950, 33. Debates in the BNC also mention Basotho women's special interest and competence in gardening. See, for example, BNC 1950, 349.
81. *Annual Report of the Department of Education, 1950*, 39; Mohapeloa, 'Homemakers', 5; interview, 'Me Mokokoane.
82. Interview, Priscilla Fobo.
83. Interview, 'Me Mokokoane.
84. 'Mathabiso Mosala, 'Activities of the Lesotho National Council of Women', unpublished paper, (Maseru, n.d.), 12.
85. Interview, 'Me Mohloboli.
86. Basutoland, *Annual Report of the Department of Agriculture, 1938*, 40.
87. Interview, 'Me Lethunya.
88. Interview, 'Me Mohlaboli.
89. Interview, 'Me Mokokoane.
90. Basutoland, *Annual Report of the Dept. of Agriculture, 1938*, 41.
91. Interview, 'Me Mohapeloa.
92. 'The Homemakers Association' in E. Chapman, ed., *Basutoland Yearbook* (Maseru, 1958), 151.
93. Chapman, *Yearbook*, 151; interview, 'Me Mohapeloa.
94. Interview, 'Me Mohlaboli.
95. Interview, 'Me Lesenyeho.
96. Ibid.
97. Interview, M. Mosala.
98. Interview, 'Me Mohapeloa.
99. Interview, 'Me Mohloboli.
100. Interview, M. Mosala.
101. E. Chapman, ed., *Basutoland Year Book* (Maseru, 1958), 151; interviews, 'Me Mosala, 'Me Lesenyeho.
102. Mohapeloa, 'Basutoland Homemakers Association', *Basutoland Witness* 7/1 (1953): 6.

103. Interview, 'Me Mohapeloa.
104. Interview, 'Me Lesenyeho.
105. Interview, 'Me Mosala.
106. Interview, 'Me Mokokoane.
107. Interview, 'Me Sibolla.
108. *Vinculum* 18/4 (Oct.–Dec. 1962): 127.
109. Interview, Philomena Lesema.
110. Sechaba, *Lesotho's Long Journey*, 117. The drought in that year would tend to overstate the relative value of irrigated vegetable farming. However, these figures do not include fruit production, another major source of income and subsistence which enhances the value of home gardening.

Chapter Nine An alternative vision: Catholic patriarchy and the 'anti-capitalist' legacy of Bishop Bonhomme, 1933–47

1. Interview, Albert Brutsch.
2. See *Makatolle* April 1965, 2; 19 June 1965, 3 and *passim* for some of the stronger diatribes against the Canadian priests, reiterated in only slightly less strident tones by, for example, Leeman, *Azania*. Other notably critical accounts of the Canadians can be found in Weisfelder, 'Defining National Purpose', 141–146; Lawrence Frank, *The Basutoland National Party: Tradition, Authority and Neo-colonialism in Lesotho* (Denver, 1971).
3. See Danylewycz, *Taking the Veil* and Clio Collective, *Quebec Women: A History* (Toronto, 1987).
4. Granger, *Preparation for Marriage*, 18–19. This was adapted to Sesotho as *Bophelo bo bocha* (Mazenod, 1962) by Gabriel Manyeli, a founding member of the BNP and Lesotho's first minister of education.
5. Ibid., 32; 90; 121.
6. Ibid., 124
7. A 1939 directive to the Head Nurse at Roma quoted in Blanchet-Cohen, 'Corporate Structure', 155; and Rev. Emile Pageau 5 August, 1953, attempting to soothe a furious Mother Provincial, DAM 41.
8. Bonhomme to Sister Dominic Goebel, 22 March 1936, DAM 76.
9. Blanchet-Cohen, 'Corporate Structure', 162.
10. Ibid., 171.
11. Alice Bowie, Headmistress of the PEMS' Thabana Morena Girls' School, *Leselinyana* 4 May 1935, 3.
12. Margaret L. Hodgson and W.G. Ballinger, *Indirect Rule in Southern Africa: Basutoland* (Lovedale, 1931), 18–19. African female mobility was also a considerable anxiety to the Protestants. Tellingly, it was an Anglican minister, and not some reactionary chief or Catholic priest, who first called upon the government to erect a fence across the mountain passes in order to keep Basotho women from migrating illegally to South Africa (Rev. Leonard Polisa, BNC 1937, 13). As for colonial officials, the bottom line of their own contradictory views on educated and 'emancipated' women is perhaps best encapsulated by the fact that they typically referred to their own wives as 'girls'. See, for example, Sims, 'The Story of My Life', or the patronizing

language used pervasively in the newspaper of the white community, *Basutoland News*.

13. Blanchet-Cohen, 'Corporate Structure', 257.
14. Joseph Bonhomme, *Noir Or: Le Basutoland, Mission Noir, Moisson d'Or* (Montreal, n.d.), 177.
15. Interview, Ceclia Makuta.
16. Interview, Sister Raphael Monyako.
17. Bishop Bonhomme's address to the Sisters of Basutoland, 1935. Bonhomme Correspondence, DAM 48.
18. Sister Dominic Goebel to Bonhomme, 30 Mar. 1936, DAM 76.
19. The Mother General of the Grey Sisters, for example, protested to the Bishop that the priest in charge of the mission 'doesn't understand the Sisters and is not understood by them'. (DAM 76 [no date but probably 1932]). Complained another, 'he ignores the Superior in the Community' (Sister M. Pauline to the Bishop regarding Father Ménard, 13 Oct. 1943, DAM 41), while to another, the Sisters were suffering under the 'displeasure and abuse of [the] intolerable Blais regime' (12 July 1953, DAM 41).
20. Rev. Benoit to Bishop DesRosiers, 19 May 1950, DAM 41.
21. Danylewycz, *Taking the Veil*, 139, 153.
22. Bishop Bonhomme to the Mother Provincial of the Holy Cross Sisters, Aliwal North, relating a letter he had received from the 'Native Sisters', 15 Jan. 1934, DAM 76.
23. Sister Ann Maureen to Emile Pageau, 16 August 1951, DAM 41.
24. Sister Fransisca Clara to the Bishop, 27 Nov. 1960, DAM 41.
25. 25 Jan. 1965, DAM 41.
26. Sister Fransisca Clara to Father Boivert, 2 Dec. 1966, DAM 41.
27. See, for example, the petition to Bishop Damiano (no date but apparently early 1950s) DAM 41, written by Basotho secular clergy protesting OMI monopolization of vocations to the priesthood. The first Mosotho bishop was not ordained until 1952.
28. L.P. Vilikazi, 'Women's Part' *Molisana* (April 1931): 5–6; interviews, 'Me Lesema, 'Me Makuta. The contrast between the Oblates' Mary and the Mary of the Quebecois nuns who did so much of the mission work after 1930 is also brought out in Danylewycz, *Taking the Veil*, 41–44.
29. Lapointe, *An Experience*, 93–94. Lapointe admits to the Canadian tendency to 'oversimplify' the gospel.
30. Interviews Rev. Brutsch, Ntate Sekhesa; see also Jones, *Medicine Murders*, 27.
31. Rosenthal, *African Switzerland*, 157. Supporting this perspective, see A. Lehe, 'Traits de moeurs Basutos', *Petites Annales des Missionaires Oblats de Marie Immaculée* 22 (1912): 101–104; Lapointe, *An Experience*, 93–94. From anecdotal evidence and personal observation, this seems like a fair comment, especially given the centrality of drinking to much of Basotho social life (see Coplan, *Cannibals*, and Edkins, *Goldwidows*, for illustration). Some priests, of course, did not approve and whole-heartedly condemned alcoholic excess (for example, Martin, 'Les Basotho').

32. Ellenberger, *A Century*, 360. See also G. Mabille, 'The Challenge of the Roman Catholic Church in the Maluti Mountains' *Basutoland Witness* 1/5 (1947).
33. *MMO* 1933, 38; *Molisana*, July 1931, 5; *MMO* 1939, 332. See also, Paul B. Rich, 'Bernard Huss and the Experiment in African Co-operatives in South Africa, 1926–1948', *International Journal of African Historical Research* 26/2 (1993): 297–318.
34. *Molisana* vol.7, July 1931, 21.
35. Ibid.
36. Rev. A. Blais, instructions to priests on Catholic Action, 30 June 1943, DAM 7; Rev. Michael Ferragne, instructions on cooperative business, 7 Sept. 1948, DAM 7; Interview, Rev. Albert Brutsch.
37. *Molisana* 31 Oct. 1931, 5.
38. Brossard, 'The Food Problem', 131.
39. Ibid., 131.
40. *Molisana* April 1931, 4–5.
41. Codex of Mazenod, 24 May 1934, DAM 9.
42. *Moeletsi* 27 March 1945.
43. Simon Lefunyane, *Moeletsi* 18 Sept. 1945, 3.
44. *Moeletsi* 18 Nov. 1945.
45. *Moeletsi* 17 April 1945.
46. '*Tieho e tsoala tahleho*', *Molisana* Oct. 1931.
47. Lapointe, *An Experience*, 88.
48. Baerlocher, *Hardegger*, 34. Dr. Hardegger compares the price of medicine at her clinic (one shilling) to the same at the establishment of a private South African doctor (twenty shillings). It was also noted in the National Council that whereas the government doctors charged five shillings per visit, the RCM hospitals charged as low as sixpence (Majara Mopeli, BNC 1935).
49. The road to Ha Sekake, for example, was built by Father Rousseau in 1946 (Mairot, *A Guide*, 116). In Sebetia the priest observed one hundred women for twelve men working on his road (10 Nov. 1964, Codex of Sebetia, DAM 16).
50. *MMO* 1933, 38.
51. See, for example, his stern lecture to the Sisters of all the orders in 1935, DAM 47.
52. G.W. Ochs to Fr. E. Thomas, 11 May 1944, Bonhomme Correspondence, DAM 48; Blanchet-Cohen, 'Corporate Structure', 100.
53. Rev. L. Sormany, 'A Short Catechism on Catholic Action' 8 July 1934, DAM 7.
54. Bonhomme's fund-raising activities later became a matter of serious concern for the Catholic church in Quebec, which introduced reforms in the 1950s to limit the perceived abuses of the Basutoland appeals. Blanchet-Cohen, 'Corporate Structure', 133–143; CAR 1939.
55. *Contact* 18 Oct. 1958, 6.
56. *JME* 1931/1, 157.

57. *Basutoland Witness* 1/6 (1947): 2.

58. CAR 1950, 42.

59. Resident Commissioner to High Commissioner, 25 Sept 1946, PRO DO 35/ 1177/Y 837/17; Baerlocher, *Hardegger*, 34.

60. Interestingly, when the government attempted to get its own (depoliticized) cooperatives started in the post-war period, it found its efforts undermined by the precisely the same (in its words) 'tacit conspiracy' and 'determined counter-attack against cooperation by the traders'. *Fifth Annual Report of the Registrar of Co-operative Societies* (30 Sept. 1953) PRO DO 119/1468.

61. Bonhomme to his Quebec MP in 1940, cited in Blanchet-Cohen, 'Corporate Structure', 198; see also his letter of 3 June 1941, Bonhomme correspondence, DAM 48.

62. Secretary of State to High Commissioner, 11 Dec. 1946, PRO DO 35/1177/ Y 837/17.

63. Lord Harlech, 'Report on Basutoland Tour, 7 Jan, 1942', PRO DO116/8

64. Memo on Bonhomme's 'Report on Basutoland', 9 June 1946, PRO DO 35/ 1177/y837/17.

65. *Vinculum* June 1945, 23 (my translation).

66. Ibid., 23–24; Annual Theological Conference, 1946 (DAM 12). One innovative project in that regard was to link the *kopanos'* income-generating activities directly to the Canadian congregation. Basotho women began making conical straw hats (*makorotlo*) for export to Canada in the late 1940s (Rosenberg, 'Promises of Moshoeshoe', 172).

67. *Vinculum* 2/5, 1946, 60.

68. Resident Commissioner to High Commissioner, 25 Sept. 1946, PRO DO 35/1177/y837/17.

69. PRO DO 35/1177/Y 837/17; continued in DO 35/4160.

70. Memo on Bonhomme's 'Report on Basutoland' 9 June 1946, PRO DO 35/ 1177/y837/17; Resident Commissioner to Sir Walter Huggard, 13 Mar. 1947, PRO DO 35/4160/y3535/1.

71. High Commissioner Baring to Apostolic Delegate of South Africa, 13 Mar. 1947, PRO DO 4160/y3535/1; Blanchet-Cohen, 'Corporate Structure', 137.

72. Oral interview, cited in Mohlakola F. Mohlakola 'Early Trade Unions in Lesotho' (BA Honours thesis, NUL, 1986), 20.

73. *L'Apostolat Laic* Oct.–Dec. 1958, 4 (my translation). See also François Mairot, 'La Légion de Marie chez les Basotho', *Pôles et Tropiques*, (Nov. 1961), 198–200.

74. Ibid.

75. *Vinculum* (April/June 1956): 57; *Vinculum* 13/3 (Juillet–Sept. 1957): 81; 'Formation of Catholic Mothers' DAM 61 (my translation).

76. 'The Formation of Catholic Mothers', Catholic Action report, 1953, 'Concerning Vocations to the Priesthood and Religious Life in Lesotho: Practical Conclusions', DAM 61.

77. Interview, Priscilla Fobo.

78. Interview, Philomena Lesema.

79. By 1962, the RCM had sponsored eighteen students to attend St. Francis

Xavier University, the centre of eastern Canada's Catholic cooperative movement. *Centenary: The Catholic Church in Basutoland, 1862–1962* (Mazenod, 1962).

80. Lesotho Catholic Information Bureau. *The Catholic Church at the Hour of Independence* (Mazenod, 1962), 26.
81. Ibid., 15.
82. Report of the Director of Statistics, 86. Frank Russell file, Rhodes House.
83. Bonhomme to RC, 14 Feb. 1946, reprinted in *Vinculum* 2/2 (1946): 22.
84. BNC 1965, 122.

Chapter Ten 'Women, mothers of the nation, should not be made slaves': Women and politics to 1965

1. Interview, B.M. Khaketla.
2. Machobane, *Government and Change*, 285.
3. It should be noted that this interpretation is not simply an academic one, but was commonly asserted by Basotho politicians themselves at the time, not least of all by the leader of the BNP, Chief Leabua Jonathan. See Bernadette 'Manyeoe Pelea, 'La femme Mosotho: élément dynamique de la nation', *Vivant Univers* 284 (1973): 34. Some version of this interpretation of the 1965 elections is found in sources as diverse as Lawrence Frank, *BNP: Traditional Authority and Neo-Colonialism in Lesotho* (Denver, 1971), 9; Spence, *Lesotho: The Politics of Dependence*, 44; Stevens, *Lesotho, Botswana and Swaziland*, 81; Bardill and Cobbe, *Lesotho: Dilemmas of Dependence*, 34; Weisfelder, 'Lesotho', 135; Lapointe, *An Experience*, 93; and Leeman, *Lesotho and the Struggle for Azania*. By contrast, in his study of the 1970 elections, MacCartney found virtually no correlation between sex, education or church and voting behaviour. J.A. MacCartney, 'A Case Study: The Lesotho General Elections of 1970', *Government and Opposition* 8/4 (1973): 478.
4. LNA High Court 685/1926; LNA S3/5/15/3.
5. Jingoes, *A Chief*, 153.
6. BNC 1941, 19; Hailey, *Native Administration*, 100.
7. BNC, *Report of the Select Committee on Wills, Estates and Marriages* (Maseru, 1962), 17. The leader of the 'conservative' BNP, Leabua Jonathan, concurred with this recommendation.
8. Ibid., 616.
9. See particularly harsh treatments of 'Mantsebo in Richard Weisfelder, *The Basotho Monarchy*, 49–51, and Leeman, *Lesotho and the Struggle for Azania*, 30. Gunther's near-libellous description of 'Mantsebo ('surly', 'dowdy', 'nervous, grunting', 'fat' and so on), is interesting because his principal source seems to have been A.P. Arrowsmith, the Resident Commissioner with whom he stayed during his visit to Basutoland (Gunther, *Inside Africa*, 577, 917). For the other extreme, see Dr. L. Thikhoi Jonathan (daughter of Leabua Jonathan, one of 'Mantsebo's key advisors and a long-standing supporter), 'The Role of Women in Nation Building during the Moshoeshoe Era and After', 20th Moshoeshoe Day memorial lecture, NUL, 11 Mar. 1993.

10. Interview, Ntsu Mokhehle. 'Mantsebo was also known and respected among Mokhehle's nationalist contemporaries in South Africa. Nelson Mandela cites her as a positive influence upon his political development in the late 1940s. Nelson Mandela, *Long Walk to Freedom* (London, 1994), 96.

11. Interview, 'Masechele Khaketla.

12. Basutoland, *Basutoland Constitutional Commission Verbatim Record of Evidence Heard* [henceforth BCC] (Maseru, 1963), 660.

13. Ibid., 775.

14. Police report of the March 1930 LLB meeting, LNA S3/22/2/4; Machobane, *Government and Change*, 164; Edgar, *Prophets with Honour*, 125–126.

15. Basutoland, *Medical and Public Health Report* (Maseru, 1943). Nearly twenty years later, the Basutoland Nursing Association remained among the most militant in its explicit condemnation of the racist and sexist policies of the colonial administration. BNC, *Report of the Select Committee on Salary Scales and Conditions of Service of the Basutoland Civil Service* (Maseru, 1961), 161–175.

16. Seotsanyana, 'Basotho Female Farm Labour', 50.

17. BNC 1951, 535.

18. LNA S3/22/2/4; Edgar, *Prophets with Honour*, 67–70.

19. Interview, Gertrude 'Makali Masiloane.

20. *Mohlabani* 1/8 (Sept. 1955): 19.

21. Interview, 'Masechele Khaketla.

22. Ibid.

23. *Basutoland News* 28 Feb. 1961.

24. Codex of Ramabanta, Nov. 1964, DAM reel 16.

25. LNA CR 1/A/1–15/1962. This riot expressed rage against the colonial regime and whites in general. It was sparked by the arrest and extradition to South Africa of Pan-Africanist Congress member Mohau Mokitimi.

26. Interview, 'Makali Masiloane.

27. Constitution of BCPWL cited in Leeman, *Azania*, vol. 3, 117.

28. *Leselinyana* 22 April 1966.

29. BNC 1963, 763; interview, 'Me Mamosala.

30. Interview, 'Makali Masiloane.

31. See *Leselinyana* 22 April 1961, 4 (translation from Sesotho).

32. *LANTA Echoes* 27 June 1964, 4.

33. *Litaba le Maikutlo* (1/10) Nov/Dec. 1962, 6.

34. *Litaba le Maikutlo* (1/7) June/July 1962.

35. Interview, Robert Matji. Two other women did leave or were expelled from the BCP, although because of dissent against the lack of democratic leadership rather than the women's franchise issue. Elizabeth Mafeking, a political refugee from South Africa, fell foul of the BCP and subsequently cofounded the Lesotho Communist Party in 1960, a party which for obvious reasons never garnered more than marginal support. 'Maposholi Molapo defected from the BCP two years later to join the MFP. Her role there as one of Lesotho's most dynamic political speakers contributed to the MFP's

moderate successes. Tellingly, she also attracted sexist derision of herself and her party from the BCP's official organ, *Makatolle* (for example, March 1965; April 1965).

36. Again in the colourful terms of the 'radical' press, see *Makatolle* and *Mohlabani, passim.*

37. Weisfelder, 'Defining', 342.

38. The accusations are recounted in Leeman, *Azania, passim* but especially 67, 116–117. The reference to radio in the following quotation is indicative of the need for great scepticism with regard to this issue. The RCM operated the only transmitter in the country. In the eyes of the RCM hierarchy, the BCP was basically a reincarnation of the stridently anti-Catholic LLB. The RCM threw its prodigious weight into the 'war' against the BCP, quite possibly ressurrecting old scandals to serve their own ends of discrediting the BCP.

39. Interview, Sister Victoria 'Mota.

40. Interview, Philomena Lesema.

41. *'Mesa-Mohloane*, Dec. 1961, 2; Interview, Patrick Lehloenya.

42. Interview, 'Makali Masiloane.

43. Joint interview, 'Mathabiso Mosala and 'Makhosi 'Mapeete.

44. BNC 1964, 1114.

45. Interview, 'Makali Masiloane.

46. BCC, 715, 729.

47. BCC, 729.

48. BCC, 776.

49. BCC, 121.

50. Interview, Robert Matji.

51. *The Basutoland Times* 28 Jan. 1964; BNC 1964, 861.

52. Interview, Robert Matji, Maseru, 11 Sept. 1990. Not a single woman in the party came publicly to Matji's support. He subsequently joined the MFP, was roundly defeated in 1965 and then quit politics. Brief as it was, Matji's political career in Lesotho may have had a rippling effect which has been underestimated in the historiography. Mokhehle's bitterness over Matji's criticism of him could partially explain his violent turn against the ANC and Communist Party soon after, itself a cause of further debilitating divisions and defections from the BCP.

53. BCC, 764.

54. BCC, 1111; interviews, Patrick Lehloenya, Ha Lehloenya.

55. Interview, 'Malikeleli Mokokoane.

56. Personal communication, Rev. Gérard Blanchard; interview, Alina Brutsch.

57. Interview, 'Me Mamosala.

58. Interview, Sister Victoria 'Mota.

59. Interview, 'Me Mamosala.

60. Interview, Sister Victoria 'Mota.

61. Interview, Sister Margie.

62. As one Catholic nun ardently insisted that I note, wishing her anonymity preserved. Interview, Sister A.

63. *Mohlabani* 4/5 (1959): 11. See also *Mohlabani* 6/11–12 (1960): 14; and, for the perspective of poor Catholic women, *Moeletsi* 12 Nov. 1960 and 23 July 1960.
64. Personal communication, Rev. G. Blanchard.
65. Interview, 'Masechele Kkaketla.
66. W.J.A. MacCartney, *Select Documents on the Government and Politics of Botswana, Lesotho and Swaziland* (Roma, 1971), 263–274.
67. Interview, Robert Matji.
68. Interview, Matete Majara.
69. Interviews, Ntate Sechesa, 'Masechele Khaketla, 'Malikeleki Mokokoane.
70. *L'Apostolat Laic* 3 (July/Sept. 1959): 59. DAM 61 (my translation). 'Accidentally' in this case means that the church hierarchy did not initiate the activity. The fact that the women took matters into their own hands rather than taking direction from their priests is corroborated by testimony of all of the Catholic priests whom I interviewed (Rev. Desmond Fahy, Rev. Anthony Hall, Rev. Gabriel Tlaba, Rev. Francois Mairot, Rev. Eugene Lapointe) as well as members of the LSA themselves (Cecilia Makuta, Priscilla Fobo, and Philomena Lesema). The Legion of Mary, it should be noted, was never mentioned in any of these interviews, surprising at first, given that it had been established with an explicit political intent. I surmise that the Legion did not participate in 'accidental' campaigning in the 1960s because, as a relatively new *kopano* and as mostly young women, it still did not carry enough respect in the villages to dare enter directly a masculine arena.
71. *L'Apostolat Laic* 3 (July/Sept. 1959): 59 (my translation).
72. Interview, Cecelia Makuta.
73. Interview, Priscilla Fobo.
74. Interview, Cecelia Makuta. On the Catholic media, see *L'Apostolat Laic* 3 (July/Sept 1959): 59; Weisfelder, 'Defining'. Both *Moeletsi* and the even more extreme *'Mesa Mohloane* were replete with stories of atrocities committed by communist and 'exaggerated nationalist' regimes around the world.
75. Interview, Priscilla Fobo.
76. *Makatolle* 4/21 (19 June 1965).
77. Interviews, 'Makhosi 'Mapeete, Ntsu Mokhehle.
78. Interview, Cecelia Makuta.

Bibliography

A Unpublished archival sources

1 Deschatelets Archives of the Oblates of Mary Immaculate (Ottawa)

Microfilm:
Codex Historicus (Mission diaries, sundry reels)
Tableau of the Missions of the Apostolic Vicariate of Natal (Reel 44)
A Short Catechism on Catholic Action (Reels 7, 61)
Catholic African Union reports (Reel 12)
Pius XII College (Reel 24)
Correspondence of J. Bonhomme (Reels 47, 48)
Correspondence between the Sisters and the OMI (Reels 41, 76)
L'Apostolat Laic (Reel 61)
Procès verbaux des réunions de la cour matrimoniale (Reel 12)

Other:
Martin, Paul, 'L'Eglise Catholique au Basutoland' and other clippings from *Le Droit* (LS 4003.B33R 10)
Films and slides of the RCM in Basutoland

2 Lesotho Evangelical Church Archives (Morija)

Liretlo file
Weitzecker, Giacomo. 'La Donna fra i Basuto' (Typed ms., translation from a 1901 published article)

3 Lesotho National Archives (Roma)

S3/5/1/9 Passes
S3/5/1/22–26 Widows
S3/5/1/27 Chieftainship affairs
S3/5/5/5 Martinius v. Sara
S3/5/11/6 Beer canteens at Ficksburg bridge
S3/5/11/10 Chieftainship affairs
S3/5/15/1–6 Chieftainship affairs
S3/5/14/1–2 Griffith's succession
S3/5/18/1–10 Labour recruitment and deferred pay
S3/9/1/1 Church and mission affairs
S3/12/1/11–13 Education
S3/12/3/1–7 Education
S3/14/9/7 Immigration
S3/19/72–77 Miscellaneous

S3/21/4/1 Sale of *joala*
S3/22/2/1/1–25 *Lekhotla la Bafo* and Progressive Association
S3/22/2/6 *Lekhotla la Bafo*
Berea correspondence misc.
Leribe correspondence misc.
High Commissioner letters
Documents and letters exhibited in Chief Bereng v. Chieftainess 'Mantsebo
 (High Court 27/1942)
CIV Civil Court Records
CR Criminal Court Records
JC Judicial Commissioner Records
HC High Court Proceedings

4 Public Records Office (London)
Colonial Office:

CO 323 1320/4 Status of Women (1935)
CO 323 1319/4 Recruitment of Labour
CO 323 1344/5 Minimum age of marriage, *bohali*
CO 323 1354/6 Domestic science as taught in England
CO 323 1355/7 Welfare of women and children in the colonies (1936–37)
CO 323 1361/2 Rehabilitation of prostitutes
CO 323 1365/10 Women's rights
CO 323 1415/3 The place of domestic science (1937–39)
CO 323 1418/10 Welfare of women: replies to circular of 22 Jan. 1937
CO 323 1439/1–2 League of Nations inquiry into women's rights
CO 417/528 Despatches from Basutoland
CO 879/139 Correspondence relating to the welfare of women in tropical Africa
 (1935–37)
CO 879/146 Report of a Sub-committee on the Education and Welfare of Women
 and Girls in Africa (Feb. 1943)
CO 879/148 Mass education
CO 885/67 Certain aspects of the welfare of women and children (1936)

Dominions Office:

DO 35/402/11207 Native Women's Restriction Act
DO 35/1172/y701/1/1 Lord Harlech's visit to Basutoland (1942)
DO 35/1172/y706/6 The future of the protectorate (1944)
DO 35/1172/y708/1 District Council conference (1942)
DO 35/1176/y793/4 Discussion on Native Treasury (1943)
DO 35/1176/y832/3 and 5 Interviews between Resident Commissioner and Para-
 mount Chieftainess (1943–44)
DO 35/1177/y837/17 Report on Basutoland by J. Bonhomme
DO 35/1177/y835/1 Ritual murders
DO 35/1178/y847/1/1 Labour conditions on the Witwatersrand (1942)
DO 35/1181/y981/2 Harlech on the Lansdowne decision
DO 35/4025/y2025/13 Baring memo on High Commission Territories (1949)

DO 35/4014/y2016/1 Turnbull's visit to Basutoland (1952)
DO 35/4110/y3435/5 Baring memo on control of the flow of labour to South Africa (1949)
DO 35/4160/y3535/1 Bonhomme's report on Native affairs
DO 35/4421/112/251/1 Report on the Russians (1956–57)
DO 35/4361/61/11/1 Paramount Chieftainess Regent (1953–59)
DO 35/4461/154/11/1 Background paper to Sir Patrick Ashley-Cooper's visit (1952)
DO 116/8 South African Affairs (1941–44) Despatches from Lord Harlech
DO 119/900 1914 affairs
DO 119/1051 Pim questionnaire
DO 119/1053 Pim questionnaire
DO 119/1055 Confidential reports on chiefs (1935)
DO 119/1071 Confidential reports on chiefs (1936)
DO 119/1073 Notes on Native authority (1936)
DO 119/1117 Notes on Native authority (1939)
DO 119/1135 Confidential reports on chiefs (1940)
DO 119/1239 Report on Jack Mosiane trial
DO 119/1265 Trade unions (1941–42)
DO 119/1268 Migrant Labour and Tribal Life
DO 119/1376 *Liretlo*
DO 119/1375 Circumcision and initiation schools

5 Rhodes House (Oxford)

G.M. Hector papers
E.P. Arrowsmith papers, Mss. Brit. Emp. S.511
Godfrey Lagden correspondence, Mss. Afr. S. 142–208
Sir Alan Pim Africa papers, Mss. Afr. S. 1002
J.H. Sims, 'The Story of My Life', MS Afr. S. 1155
Peter Sanders, 'The Basutoland General Election, 1965 report', Mss. Afr. S. 1308
D.H. Wilson, 'Mantsebo's visit to England, 1958, Mss. Afr. S. 965
Frank Russell papers
Africa Bureau correspondence, Box 219/files 1 and 5

B Published government documents

Basutoland. *Colonial Annual Reports*. London, 1895–1964.
————. *Official Gazette of Proclamations and Notices*. Maseru, 1912–64.
————. *Annual Report of the Department of Agriculture*. Maseru, 1930–64.
————. *Annual Report of the Director of Education*. Maseru, 1929–64.
————. *Annual Medical and Sanitary Report*. Maseru, 1930–41.
————. *Annual Medical and Public Health Report*. Maseru, 1942–64.
————. *Census*. 1904, 1911, 1921, 1936, 1946, 1956.
————. *Memo of Basutoland Post-War Proposals: As Submitted to the Secretary of State*. Morija, n.d.

——. *Memo of Development Plans.* Maseru, 1946.

——. *Basutoland, Lesotho.* Maseru, 1947.

——. *Annual Report of the Registrar of Co-operatives.* Maseru, 1953.

——. *List of Gazetted Chiefs.* Maseru, 1955.

——. *Basutoland.* Maseru, 1960.

Basutoland National Council. *Report of Proceedings.* [Hansard] Maseru, 1907–65.

——. *Report on the Committee to Investigate the Working of the Home Industries Organization.* Maseru, 1949.

——. *Report on the Basutoland Central Agricultural Show.* Maseru, 1954.

——. *Report of the Select Committee on the Liquor Proclamation.* Maseru, 1961.

——. *Report on the Enquiry into the Basutoland Banking Co-operative Union Ltd.* Maseru, 1961.

——. *Report of the Select Committee on Salary Scales and Conditions of Service of the Basutoland Civil Service.* Maseru, 1961.

——. *Report of the Select Committee on Wills, Estates and Marriages.* Maseru, 1962.

——. *Basutoland Constitutional Commission Verbatim Record of Evidence Heard, 1962.* Maseru, 1963.

Cape Colony. *Report and Evidence of the Commission on Native Laws and Customs of the Basutos.* Cape Town, 1873.

——. *Blue Book on Native Administration.* Cape Town, 1881.

——. *Report of the Government Commission on Native Laws and Customs.* Cape Town, 1883.

Clarke, Sir Fred. *Report of the Commission on Education in Basutoland.* London, 1946.

Cowen, Andrew. *Report on Constitutional Reform and Chieftainship Affairs.* Maseru, 1958.

Douglas, A. and R. Tennant. *Basutoland: Agricultural Survey 1949–50.* Maseru, 1952.

Dyke, H.W. *African Pioneer Corps (Basutoland): An Analysis of the Causes of Discharge and Death while on Foreign Service in the Great War.* Maseru, n.d.

Hailey, Lord. *Native Administration in the British African Territories.* London, 1953.

Hennessy, J.P.I. *A Report on the First General Elections in Basutoland.* Maseru, 1960.

Jones, G.I. *Basutoland Medicine Murder: A Report on the Recent Outbreak of 'diretlo' murders in Basutoland* Cmd.8209. London: HMSO, 1951.

Lansdowne, C.W.H. *Judgement in the Case of Chief Constantinus Bereng Griffith, plaintiff, versus Chieftainess Amelia 'Mantsebo Seeiso Griffith, defendant.* Mazenod, 1943.

Lesotho. *Census.* Maseru, 1966.

——. *Socio-economic indicators of Lesotho.* Maseru, 1987.

——. *Basotho Women and Their Men: Females and Males in Lesotho: Statistics Divided by Gender.* Maseru, 1989.

MacCartney, W.J.A. *Select Documents on the Government and Politics of Botswana, Lesotho and Swaziland*. Roma, 1971.

Meyerowitz, H.V. *Report on the Possibilities of the Development of Village Crafts in Basutoland*. Morija, 1936.

Moor [sic], Sir Henry. *Basutoland Report of the Administration Reforms Committee*. Maseru, 1954.

Morse, Chandler. *Basutoland, Bechuanaland Protectorate and Swaziland: Report of an Economic Survey Mission*. London, 1960.

Pim, Sir Alan. *The Financial and Economic Position of Basutoland* Cmd.4907 vii 353. London, 1935.

Porter, R.S. *The Development of the Basutoland Economy*. London: Overseas Development Agency, 1965.

Ramage, Sir Richard. *Report on the Structure of the Public Services in Basutoland, Bechuanaland and Swaziland*. London, 1961.

Sargant, E.B. *Report on Education in Basutoland, 1905–6*. London, 1906.

Sturrock, J.C.R. *New Native Court Regulations*. Morija, 1935.

Surridge, S. *Report of the Salaries Commission*. London, 1959.

Union of South Africa. *Report of the Native Economic Commission*. Pretoria, 1932.

United Kingdom. *Lesotho: Correspondence Regarding Basutoland and Adjacent Territories, 1881–1887. British Parliamentary Papers Colonies, Africa* vol. 47. Dublin: Irish University Press.

————. *Basutoland, the Bechuanaland Protectorate and Swaziland: History of Discussions with the Union of South Africa* Cmd 8707. London: HMSO, 1952.

C Contemporary periodicals

BANTA Echoes (Basutoland Native Teachers' Association newsletter)

Basutoland News (A weekly directed mainly to the 'European' market, published in Ficksburg)

Basutoland Times (Maseru, a 'European' weekly)

Basutoland Witness (Morija, PEMS bimonthly, international propaganda)

Les Bulletins des Mission (A worldwide OMI newsletter)

The Commentator (BCP fortnightly)

Contact (Bloemfontein monthly, a 'liberal' magazine edited by Patrick Duncan)

Journal des Missions Evangéliques (Paris, worldwide PEMS journal)

LANTA Echoes (Protestant teachers' association newsletter)

Leselinyana (Morija, PEMS weekly)

Letsatsi (Morija, Basutoland Progressive Association)

Likhohlong (Lusaka, Lesotho Liberation Army fortnightly)

Lithaba le Maikutlo (Bilingual quarterly roneo from the Department of Local Government, Maseru)

Litsoakotleng (Mazenod, Catholic monthly digest)

Makatolle (Maseru, BCP bilingual fortnightly)

'Mesa Mohloane (Mazenod, Anti-Communist League)

Ministry (Morija, monthly ecumenical theological journal)

Missions de Missionaires Oblats (Ottawa, worldwide OMI journal)
Mochochonono (Maseru, a 'progressive' newspaper established in 1911)
Moeletsi oa Basotho (Mazenod, Catholic weekly)
Mohlanka (Mazenod, organ of the Roman Catholic Mission)
Mohlabani (Maseru, edited by B.M. Khaketla)
Molisano (Mazenod, organ of the Catholic African Union)
Nketu (BNP weekly)
Roma College Review
The Teachers' Magazine (Basutoland Education Department)
Tichere ea Lesotho (Organ of BANTA)
Vinculum (Roman Catholic vicarial newsletter for Basutoland)
Voix du Basutoland (International propaganda for RCM)

D Contemporary books, articles and memoirs

Angot, Mother Marie Joseph. 'Journal of the Mission of Motse-oa-'Ma-Jesu'. Unpublished mimeograph. Roma: The Social Centre.

Arbousset, Thomas. *Missionary Excursions*. Ed. and trans. David Ambrose and Albert Brutsch. Morija: Morija Museum and Archives, 1992. (First published in Paris, 1840)

Ashton, Hugh. *The Basuto*. Oxford: Oxford University Press, 1952.

Baerlocher, Felix. *Bertha Hardegger, M.D., Mother of the Basotho: Excerpts from her Diary, selected and translated by Felix Baerlocher*. Sackville: NB, n.d.

Baring, Sir Evelyn. 'Economic Development in the High Commission Territories'. *African Affairs* 51 (1952): 222–230.

Bastian, Adolf. *Die Rechtsverhaltnisse bei verschiedenen Volkern der Erde*. Berlin, 1872.

Basutoland National Party. *Portrait of a Party: Twenty Years of the BNP*. Maseru: Government Printing Office, 1978.

Bezançon, L. 'Women in the Church of Basutoland'. *Basutoland Witness* 3/2 (March 1949): 17.

Blacklock, Mary. 'Certain Aspects of the Welfare of Women and Children in the Colonies'. *Annals of Tropical Medicine and Parasitology* 30/4 (1936): 221–264.

Bonhomme, Joseph. *Noir Or: Le Basutoland: Mission Noir, Moisson d'Or*. Montreal: OMI, 1934.

Brandel-Syrier, Mia. *Black Women in Search of God*. London: Lutterworth Press, 1962.

Burton, Deaconness Maria S.B. *Happy Days and Happy Work in Basutoland*. London: Society for the Propagation of Christian Knowledge, 1902.

Casalis, Eugene. *The Basutos*. Cape Town: Struik, 1971. (Reprint of 1961 edition)

Chapman, E., ed. *Basutoland Yearbook*. Maseru: British Red Cross Society, 1958.

Coates, Austin. *Basutoland*. London: HMSO, 1966.

*Bibliography* 263

Corsini, Soeur Saint-André. *30 Jours en Mer, 300 Jours sur Terre, 30 Heures dans l'air: Relation d'un voyage au Basutoland et au Nyasaland.* Ottawa: Souers Grises de la Croix, 1947.

DesRosiers, J.D., ed. *Basutoland.* Namur: OMI, 1949.

Duncan, Patrick. *Sotho Laws and Customs.* Cape Town: Oxford University Press, 1960.

Dutton, E.A.T. *The Basutos of Basutoland.* London: Butler and Tanner, 1923.

Ellenberger, D.F., and J.C. MacGregor. *History of the Basotho, Ancient and Modern.* New York: Negro Universities Press, 1969. (Reprint of London: Caxton, 1912.)

Ellenberger, V. *Sur les Hauts Plateaux du Lessouto: Notes et Souvenirs de Voyage.* Paris: SME, 1930.

———. *A Century of Mission Work in Basutoland.* Morija: Sesuto Book Depot, 1938.

Ferragne, Marcel. *Au Pays des Basutos: les 100 Ans de la Mission St. Michel, 1868–1968.* Mazenod, 1968.

Germond, R.C., ed. *Chronicles of Basutoland: A Running Commentary on the Events of the Years 1830–1902 by the French Protestant Missionaries in Southern Africa.* Morija: Sesuto Book Depot, 1967.

Granger, A.M. *Preparation for Marriage.* Montreal: Lévrier, 1945.

Gunter, John. *Inside Africa.* New York: Harper and Row, 1955.

Hadley, Peter, ed. *Doctor to Basotho, Boer and Briton, 1877–1906: Memories of Dr. Henry Taylor.* Cape Town: David Philip, 1972.

Hailey, Lord. *An African Survey.* Oxford: Oxford University Press, 1938.

———. *The Republic of South Africa and the High Commission Territories.* Oxford: Oxford University Press, 1963.

Henderson-Ramseyer, Madamme. 'Parmi les femmes Bassoutos de Johannesburg'. *JME* 1936/2: 477

Hodgson, Margaret L., and W.G. Ballinger. *Indirect Rule in Southern Africa.* Lovedale: Lovedale Press, 1931.

Holleman, J.F. 'The Changing Roles of African Women'. In *Issues in African Law*, by Holleman. The Hague: Mouton, 1974.

Jingoes, S. Jason. *A Chief is a Chief by the People: An Autobiography of S.J. Jingoes.* Cape Town: Oxford University Press, 1975.

Keable, Robert. *Recompense.* London: Constable, 1923.

Kendall, K. Limakatso, ed. *Basali! Stories by and about women in Lesotho.* Pietermaritzburg: University of Natal Press, 1995.

Khaketla, Bennett. *Lesotho 1970: An African Coup Under the Microscope.* Los Angeles: University of California Press, 1972.

Ladgen, Godfrey. *The Basutos: The Mountaineers and their Country.* New York: Negro Universities Press, 1969. (Reprint of 1909 London edition)

———. 'Basutoland and the Basutos'. *Journal of the Royal Colonial Institute* 32 (1901): 452–471.

Laydevant, Francois. *The Rites of Initiation in Basutoland.* Mazenod, 1971. Reprint and trans. article from *International Review of Ethnology and Linguistics*, vol. XLVI, (1951).

————. *Etude sur la famille au Lesotho*. Roma, n.d.

Lehe, A. 'Trait de moeurs Basutos'. *Petites Annales des Missionaires Oblats de Marie Immaculée* 22 (1912): 101–104.

Lesotho Catholic Information Bureau. *Centenary: The Catholic Church in Basutoland, 1862–1962*. Mazenod, 1962.

————. *The Catholic Church at the Hour of Independence*. Mazenod, 1965.

Lesotho Evangelical Church. *Jubile ea Lilemo tse Lekholo ea Mokhalto oa Bo-'Ma-bana*. Morija, 1989.

'Mabathoana, P. 'Lobola'. *African Digest* 13 (1961).

Mabille, G. 'The Challenge of the Roman Catholic Church in the Maluti Mountains'. *Basutoland Witness* 1/5 (1947).

Mairot, François. 'La Légion de Marie chez les Basotho'. *Pôles et Tropiques* (Nov. 1961): 198–200.

————. *Centenary Guide*. Mazenod, 1962.

Majeke, Nosipho (Dora Taylor). *The Missionary Role in South Africa*. Johannesburg: The Society of Young Africans, 1952.

Mandela, Nelson. *Long Walk to Freedom*. London: Abacus, 1995.

Manyeli, Gabriel. *Bophelo bo bocha*. Mazenod, 1962.

Martin, Gérard. 'Les Basotho dans les centres miniers du Transvaal', and 'Chez les Basutos du Transvaal'. In *Les Bulletins des Missions* 18/1 (1939).

Martin, Minnie. *Basutoland: Its Legends and Customs*. London: Nichols, 1903.

McFarlane, N.M. *A Record of Medical Work and of the Medical Service in Basutoland*. Ladybrand: Courant, 1934.

Mohapeloa, B.T. 'Basutoland Homemakers Association'. *Basutoland Witness* 7/1 (1953): 5.

Nthunya, Mpho 'M'atsepo. *Singing Away the Hunger: Stories of a Life in Lesotho*. Pietermaritzburg: University of Natal Press, 1996.

Paris Evangelical Mission Society. *The Basuto at War*. Morija: Sesuto Book Depot, 1944.

Rosenthal, Eric. *African Switzerland: Basutoland of To-day*. Johannesburg: Juta, 1948.

Sachot, Joseph. *Chez les Apollons de Bronze*. Paris, 1946.

Sayce, R.U. 'An Ethnographic Essay on Basutoland'. *Geographical Teacher* 12 (1924): 271–288.

St. George, Howard. *Failure and Vindication: The Unedited Journal of Bishop Allard, OMI*. Durban: Unity Press, 1981.

Soeur de St. Joseph. *Un Voyage au Basutoland*. St. Hyacinthe: Couvent de St. Joseph, 1946.

Theal, G.M. *Basutoland Records* vol. 3B. Cape Town: C. Struik, 1964. (Reprint of 1883 Cape Town edition)

Verdier, T. 'L'Alcoholisme au Lessouto'. *JME* 1930/1.

E Secondary sources: books and articles

AIM (Agency for Industrial Mission). *Another Blanket: Report of an Investigation into the Migrant Situation*. Roodepoort, 1976.

Albers, Bernhard. 'Father Joseph Gérard, OMI: Apostle of the Basotho'. *Vie Oblate Life* Dec. Vol. 41 (1982): 233–248.

Ambrose, David. *Maseru: An Illustrated History.* Morija: Morija Museum and Archives, 1933.

Atmore, Anthony. 'The Moorosi Rebellion: Lesotho, 1879'. In *Protest and Power in Black Africa*, edited by R. Rotberg and A. Mazrui, 3–36. New York: Oxford University Press, 1970.

Bardill, James, and James Cobbe. *Lesotho: Dilemmas of Dependence in Southern Africa.* Boulder: Westview, 1985.

Barnes, Theresa. 'The Fight for Control of African Women's Mobility in Colonial Zimbabwe, 1900–1939'. *Signs* 17/3 (1992): 586–608.

Beinart, William, and Colin Bundy, eds. *Hidden Struggles in Rural South Africa.* Johannesburg: Ravan, 1987.

Bonner, Phil. ' "Desirable or Undesirable Basotho Women?" Liquor, Prostitution and the Migration of Basotho Women to the Rand, 1920–1945'. In *Women and Gender*, edited by Cherryl Walker, 221–250. Cape Town: David Philip, 1990.

————. 'The Transvaal Native Congress, 1917–1920: the radicalisation of the black petty bourgeoisie on the Rand'. In *Industrialisation and Social Change in South Africa*, by Marks and Rathbone, 270–314. London, 1982.

————. 'The Russians on the Reef, 1947–57: Urbanization, Gang Warfare and Ethnic Mobilisation'. In *Apartheid's Genesis, 1935–62*, by Bonner et al. Johannesburg: Ravan, 1993.

————. 'Backs to the Fence: Law, Liquor and the Search for Social Control in an East Rand Town, 1929–1942'. In *Liquor and Labour in Southern Africa* edited by Jonathan Crush and Charles Ambler. Pietermaritzburg, 1992: 269–305.

Bozzoli, Belinda, with Mmantho Nkotsoe. *Women of Phokeng: Consciousness, Life Strategy and Migrancy in South Africa, 1900–1983.* Portsmouth NH: Heinemann, 1991.

Burman, Sandra. *Chiefdom Politics and Alien Law.* New York: Africana, 1981.

————. 'Fighting a Two-pronged Attack: The Changing Legal Status of Women in Cape-ruled Basutoland, 1872–84'. In *Women and Gender*, edited by Cherryl Walker, 48–75. Cape Town: David Philip, 1990.

Chanock, Martin. *Law, Custom and Social Order: The Colonial Experience in Malawi and Zambia.* Cambridge: Cambridge University Press, 1986.

Clio Collective. *Quebec Women: A History.* Toronto: Women's Press, 1987.

Cobley, Alan. *Class and Consciousness: The Black Petty Bourgeoisie in South Africa, 1924 to 1950.* Westport, 1990.

Comaroff, John. 'Images of empire, contests of conscience: models of colonial domination in South Africa'. *American Ethnologist* 16/4 (1989): 661–685.

Comaroff, Jean, and John Comaroff. *Of Revelation and Revolution: Christianity, Colonialism and Consciousness in South Africa.* vol. 1. Chicago: University of Chicago Press, 1991.

————. 'Home-made Hegemony: Modernity, Domesticity, and Colonialism in South Africa'. In *African Encounters with Domesticity*, edited by Karen T. Hansen. New Brunswick, NJ: Rutgers University Press, 1992.

Cooper, Frederick. 'From free labour to family allowances: labour and African society in colonial discourse'. *American Ethnologist* 16/4 (1989): 745–765.

Coplan, David. 'The Emergence of an African Working Class'. In *Industrialisation and Social Change in South Africa*, edited by S. Marks and R. Rathbone, 358–375. London: Longman, 1982.

———. 'Eloquent Knowledge: Lesotho Migrants' Songs and the Anthropology of Experience'. *American Ethnologist* 14 (1987): 413–433.

———. 'Musical Understanding: The Ethno-aesthetics of Migrant Workers' Poetic Song in Lesotho'. *Ethnomusicology* 32/3 (1988).

———. *In the Time of Cannibals: The Word Music of South Africa's Basotho Migrants*. Chicago: University of Chicago Press, 1994.

Danylewycz, Marta. *Taking the Veil: An alternative to Marriage, Motherhood and Spinsterhood in Quebec, 1840–1920*. Toronto: McClelland and Stewart, 1987.

Danziger, Christopher. *A Trader's Century: The Fortunes of the Frasers*. Cape Town: Purnell, 1979.

Edgar, Robert. *Prophets with Honour: A Documentary History of the Lekhotla la Bafo*. Johannesburg: Ravan, 1988.

Eldredge, Elizabeth. 'Land, Politics and Censorship: The Historiography of 19th Century Lesotho'. *History in Africa* 15 (1988): 191–209.

———. 'Women in Production: The Economic Role of Women in 19th Century Lesotho'. *Signs* 16/4 (1991): 707–731.

———. *A South African Kingdom: The Pursuit of Security in Lesotho*. Cambridge: Cambridge University Press, 1993.

———. 'Slave Raiding Across the Cape Frontier'. In *Slavery in South Africa: Captive Labor on the Dutch Frontier*, edited by Eldredge and Fred Morton, 93–126. Pietermaritzburg: University of Natal Press, 1994.

Epprecht, Marc. 'Domesticity and Piety in Colonial Lesotho: The Private Politics of Basotho Women's Pious Associations'. *Journal of Southern African Studies* 19/2 (1993): 203–224.

———. 'Women's "Conservatism" and the Politics of Gender in Colonial Lesotho'. *Journal of African History* 36/1 (1995): 29–56.

———. 'Feminist method and the asking of questions about masculine sexuality'. In *Men, Feminisms, Africa: Debates and directions in anti-masculinist scholarship*. Unpublished ms. Trent University, 1999.

———. 'Gender and History in Southern Africa: A Lesotho "Metanarrative."' *Canadian Journal of African Studies* 30/2 (1996): 183–213.

Etherington, N. 'Labour Supply and the Genesis of South African Confederation in the 1870s'. *Journal of African History* 20 (1979): 235–253.

Ferguson, James. *The Anti-politics machine: Development, Depoliticization and Bureaucratic Power in Lesotho*. Cambridge: Cambridge University Press, 1990.

Frank, Lawrence. *BNP: Tradition, Authority and Neo-Colonialism in Lesotho*. Denver, 1971.

Gaitskell, Deborah. 'Housewives, Maids or Mothers: Some Contradictions of Domesticity for Christian Women in Johannesburg, 1903–1939'. *Journal of*

African History 24/2 (1983): 241–256.

———. 'Devout Domesticity? A Century of African Women's Christianity in South Africa'. In *Women and Gender*, edited by Cherryl Walker, 251–272. Cape Town: David Philip, 1990.

———. '"Wailing for Purity": Prayer Unions, African Mothers and Adolescent Daughters, 1912–40'. In *Industrialisation and Social Change in South Africa*, edited by S. Marks and R. Rathbone, 338–357. London, 1982.

Gay, Judy. 'Wage Employment of Rural Basotho Women'. *South African Labour Bulletin* 6/4 (1980).

———. '"Mummies and Babies" and Friends and Lovers in Lesotho'. *Journal of Homosexuality* 11/3–4 (1985): 93–116.

Gill, Debby. *Lesotho: A Gender Analysis*. Maseru: Sechaba Consultants, 1992.

Gill, Stephen. *A Short History of Lesotho*. Morija: Morija Museum and Archives, 1993.

Guy, Jeff. 'Gender Oppression in Pre-colonial Southern Africa'. In *Women and Gender*, edited by Cherryl Walker, 33–47. Cape Town: David Philip, 1990.

Guy, Jeff, and Motlatsi Thabane. 'Technology, Ethnicity and Ideology: Basotho Miners and Shaft-sinking on the South African Gold Mines'. *Journal of Southern African Studies* 14/2 (1988): 257–278.

Halpern, Jack. *South Africa's Hostages: Basutoland, Bechuanaland and Swaziland*. London: Penguin, 1965.

Hamnett, Ian. 'Some Notes on the Concept of Custom in Lesotho'. *Journal of African Law* 15 (1971): 266–272.

Hansen, Karen T., ed. *African Encounters with Domesticity*. New Brunswick, NJ, 1992.

Harries, Patrick, 'Symbols and Sexuality: Culture and identity on the early Witwatersrand Gold Mines'. *Gender and History* 11/3 (1990): 318–336.

———. *Work, Culture, and Identity: Migrant Laborers in Mozambique and South Africa*. Portsmouth NH: Heinemann, 1994.

Hay, M.J., and Marcia Wright, eds. *African Women and the Law: Historical Perspectives*. Boston, 1982.

Humphries, Jane. 'Class Struggle and the Persistence of the Working Class Family'. *Cambridge Journal of Economics* 1 (1977).

Jeater, Diana. *Marriage, Perversion and Power: The Construction of Moral Discourse in Southern Rhodesia, 1890–1930*. Oxford: Clarendon, 1993.

Keegan, Timothy. 'Trade, Accumulation and Impoverishment: Mercantile Capital and the Economic Transformation of Lesotho and the Conquered Territory, 1870–1920'. *Journal of Southern African Studies* 12/3 (1985): 196–216.

Kendall. 'Women in Lesotho and the (Western) Construction of Homophobia'. In *Culture, Identity and Sexuality: Cross-cultural Perspectives on Women's Same-Sex Erotic Friendships*, edited by Evelyn Blackwood and Saskia Wieringa. New York: Columbia University Press, 1998.

Kerr, Alexander. *Fort Hare 1915–46: The Evolution of an African College*. Pietermaritzburg: University of Natal Press, 1968.

Kimble, Judy. 'Aspects of the Penetration of Capitalism into Colonial Basuto-
land, c. 1890–1930'. In *Class Formation and Class Struggle: Proceedings
of the 4th Annual Conference of the Southern African Universities Social
Science Conference*, 133-167. Roma, 1981.

———. 'Labour migration in Basutoland'. In *Industrialization and Social
Change in South Africa*, edited by S. Marks and R. Rathbone, 119–141.
London, 1982.

———. 'Clinging to the chiefs: Some Contradictions in Colonial Rule in
Basutoland'. In *The Contradictions of Accumulation in Africa*, edited by
H. Bernstein and B. Campbell, 25–69. Beverly Hills: Sage, 1986.

Kowet, D.K. *Land, Labour Migration and Politics in Southern Africa:
Botswana, Lesotho and Swaziland*. Uppsala: Nordiska Afrikainstituet,
1978.

Kriger, Eileen J. 'Woman-marriage with special reference to the Lovedu'. *Africa*
44 (1974): 265–293.

Landau, Paul. *The Realm of the Word: Language, Gender and Christianity in a
Southern African Kingdom*. Portsmouth NH: Heinemann, 1995.

Lapointe, Eugene, *An Experience of Pastoral Theology in Southern Africa*.
Rome: Pontificia Universita Urbaniana, 1986.

Leeman, Bernard. *Lesotho and the Struggle for Azania*. London: PAC Univer-
sity, 1985.

Linden, Ian. *Catholic, Peasants and Chewa Resistance in Nyasaland, 1889–
1939*. London, 1974.

MacCartney, W.J.A. 'A Case Study: The Lesotho General Election of 1970'.
Government and Opposition 8/4 (1973): 473–494.

Machobane, L.B.B.J. *Government and Change in Lesotho, 1800–1966: A Study*.
London: MacMillan, 1990.

———. *Christianity and African Response Among the Barolong and Basotho,
1820–1890*. Roma: Institute of Southern African Studies, 1993.

Malahleha, G.M. 'Liquor brewing: A Cottage Industry in Lesotho Shebeens'.
Journal of Eastern African Research and Development 15 (1985): 45–55.

Maloka, Tshidiso. 'Khomo lia oela: canteens, brothels and labour migrancy in
colonial Lesotho'. *Journal of African History* 38/1 (1997): 101–122.

Mamashela, M.P. 'Divorce Law in Lesotho: A Critical Appraisal of the 'Guilt
Principle' and the Present Grounds for Divorce'. *Lesotho Law Journal* 7/1
(1991): 21–48.

Mann, Kristin. *Marrying Well: Marriage, Status and Social Change Among the
Educated Elite in Colonial Lagos*. Cambridge, 1985.

Mohapeloa, J.M. *Government by Proxy: Ten Years of Cape Colonial Rule in
Lesotho, 1871–81*. Morija: Sesuto Book Depot, 1971.

Moodie, T. Dunbar, with Vivienne Ndatshe. 'Migrancy and Male Sexuality on
the South African Gold Mines'. *Journal of Southern African Studies* 14/2
(1988): 229–255.

———. *Going for Gold: Men's Lives on the Mines*. Berkeley: University of
California Press, 1994.

Mueller, Martha. 'Women and Men: Power and Powerlessness in Lesotho'. *Signs*
3/1 (1977): 154–166.

Murray, Colin. 'High bridewealth, migrant labour and the position of women in Lesotho'. *Journal of African Law* 21/1 (1977): 79–96.

———. 'The work of men, women, and the ancestors: social reproduction in the periphery of South Africa'. In *Social Anthropology of Work*, edited by Sandra Wallman. London: Academic Press, 1979.

———. *Families Divided: The impact of migrant labour in Lesotho.* Cambridge: Cambridge University Press, 1981.

Murray, Stephen O., and Will Roscoe, eds. *Boy Wives and Female Husbands: Studies in African Homosexuality.* New York: St. Martin's Press, 1998.

Pape, John. 'Black and White: The "Perils of Sex" in Colonial Zimbabwe'. *Journal of Southern African Studies* 16/4 (1990): 699–720.

Parpart, Jane, and Kathleen Staudt, eds. *Women and the State in Africa.* Boulder: Westview, 1990.

Pelea, Bernadette 'Manyeoe. 'La femme Mosotho: élément dynamique de la nation'. *Vivant Univers* 284 (1973).

Perrot, Claude. 'Les sothos et les missionaires européens aux XIX siècle'. *Annales de l'Université d'Abidjan* (ser. F, tome 2).

Poulter, Sebastian. *Family Law and Litigation in Basotho Society.* Oxford: Clarendon, 1976.

———. 'Marriage, Divorce and Legitimacy in Lesotho'. *Journal of African Law* 21/1 (1977): 66–78.

Rich, Paul B. 'Bernard Huss and the Experiment in African Co-operatives in South Africa, 1926–1948'. *International Journal of African Historical Research* 26/2 (1993): 297–318.

Ross, Andrew. *John Philip: Mission, Race and Politics in South Africa.* Aberdeen: Aberdeen University Press, 1986.

Sanders, Peter. *Moshoeshoe, Chief of the Basotho.* London: Heinemann, 1975.

Sechaba Consultants. *Lesotho's Long Journey: Hard Choices at the Crossroads.* Maseru: Sechaba, 1995.

Seeiso, S.M., L.N. Kanono, M.N. Tsotsi, and T.E. Monaphathi. 'The Legal Situation of Women in Lesotho'. In *The Legal Situation of Women in Southern Africa*, edited by Julie Stewart and Alice Armstrong, 47–74. Harare, 1990.

Sekhakhane, Jerome. 'The Oblates in Southern Africa'. *Etudes Oblats* 35 (1976): 111–119.

Showers, Kate. 'Soil Erosion in the Kingdom of Lesotho: Origins and Colonial Response, 1830–1950s'. *Journal of Southern African Studies* 15/2 (1989): 263–286.

Showers, Kate, and G.M. Malahleha. 'Oral Evidence in Historical Environmental Impact Assessment: Soil Conservation in Lesotho in the 1930s–40s'. *Journal of Southern African Studies* 18/2 (1992): 276–296.

Spence, J.E. *Lesotho: The Politics of Dependence.* London: Oxford University Press, 1968.

Speigel, Andrew. 'Rural Differentiation and the Diffusion of Migrant Labour Remittances'. In *Black Villagers in an Industrial Society*, edited by Philip Mayer. Cape Town: Oxford University Press, 1980.

————. 'Christianity, Marriage and Migrant Labour in a Lesotho Village'. In *Church and Marriage in Modern Africa*, edited by T.D.Verryne. Groenkloof, 1975.

Stevens, R.P. *Lesotho, Botswana and Swaziland*. London: Pall Mall Press, 1967.

Thompson, Leonard. *Survival in Two Worlds: Moshoeshoe of Lesotho, 1789–1870*. Oxford: Clarendon, 1975.

Trapido, Stanley. '"The Friends of the Natives": Merchants, Peasants and the Political and Ideological Structure of Liberalism in the Cape, 1854–1910'. In *Economy and Society in Pre-Industrial South Africa*, edited by S. Marks and A. Atmore, 247–274. London: Longman, 1980.

Van der Wiel, A.C.A. *Migratory Wage Labour: Its Role in the Economy of Lesotho*. Mazenod, 1977.

Van Onselen, Charles. *Studies in the Social and Economic History of the Witswatersrand, 1886–1914*. Johannesburg: Ravan Press, 1982.

Walker, Cherryl. 'Gender and the Development of the Migrant Labour System, c.1850–1930'. In *Women and Gender*, edited by Cherryl Walker, 168–196. Cape Town: David Philip, 1990.

————., ed. *Women and Gender in Southern Africa to 1945*. Cape Town: David Philip, 1990.

Wallman, Sandra. *Take Out Hunger: Two Case Studies of Rural Development in Basutoland*. London: University of London, 1969.

————. 'The Bind of Migration: Conditions of Non-development in Lesotho'. In *Perceptions of Development*, edited by Wallman, 101–112. Cambridge, 1979.

Walton, James. *Father of Kindness, Father of Horses: The Story of Fraser's Ltd.* Morija: Morija Printing Works, 1958.

Weisfelder. 'Early Voices of Protest: the Basutoland Progressive Association and *Lekhotla la Bafo*'. *African Studies Review* 17/2 (1974): 397–409.

————. 'Lesotho'. In *Southern Africa in Perspective*, edited by C. Potholm and R. Dale. New York, 1972.

————. *The Basotho Monarchy: A Spent Force or a Dynamic Political Factor*. Athens OH: Ohio University Center for International Studies, 1972.

Wellner, Gottfried. 'Mission and Migrant Labour'. *Ministry* 10/1 (1970).

Wells, Julie. *We Have Done the Pleading: The Women's 1913 Anti-Pass Campaign*. Oxford: Oxford University Press, 1993.

Wells, Robin E. *An Introduction to the Music of the Basotho*. Morija: Morija Museum and Archives, 1994.

White, Luise. *The Comforts of Home: Prostitution in Colonial Nairobi*. Chicago: Chicago University Press, 1990.

World Bank. *Lesotho: A Development Challenge*. Washington: IBRD, 1975.

F Unpublished papers, dissertations, and other media

Blair, Arthur, and John Gay. 'Growing up in Lesotho (A Basotho Interpretation)'. Dept. of Education, National University of Lesotho, 1980.

Blanchet-Cohen, Theresa. 'The Corporate Structure of the Catholic Church in Lesotho, 1930–56'. M.Phil., London, 1976.

Brossard, Giles. 'The Food Problem in Basutoland'. D.Sc.Agric., Pretoria, 1958.

Charakupa, Limakatso. 'The Roman Catholic Mission of Our Lady of Larghetto, Leribe District, Lesotho'. Honours paper, National University of Lesotho, 1978.

Chévrier, Odilon, 'Croyances et coutumes chez les Basotho' (Roneo, no date)

Devitt, Paul. 'The Politics of Headmanship in the Mokhokhong Valley, Lesotho'. M.A. diss., University of Witwatersrand, 1969.

Edkins, Don, director. *Goldwidows*. New York: First Run/Icarus Films, 1990.

———. *The Color of Gold*. New York: First Run/Icarus Films, 1991.

Eldredge, Elizabeth. 'The Role of the Société des Missions Evangéliques in 19th Century Economic Change in Lesotho'. LEC archives, Nov. 1979.

Gay, Judy. 'Basotho Women's Options: A Study of Marital Careers in Rural Lesotho'. Ph.D. diss., Cambridge, 1980.

Jonathan, L. Thikhoi. 'The Role of Women in Nation Building during the Moshoeshoe Era and After'. 20th Moshoeshoe Day Memorial Lecture, National University of Lesotho, 11 March 1993.

Kimble, Judy. 'Concepts in transition: Labour Migration in Southern Africa, 1890–1910'. Seminar on Peasants, Institute of Commonwealth Studies, London, 1980.

———. '"Runaway Wives": Basotho Women, chiefs, and the colonial state, c. 1890–1920'. Women in Africa Seminar, School of Oriental and African Studies, London, 17 June 1983.

———. 'Labour Migration and Colonial Rule in Southern Africa: The Case of Basutoland'. Ph.D. diss., Essex, 1985.

Maloka, Edward Tshidiso. 'Basotho and the Mines: Towards a History of Labour Migrancy'. Ph.D. diss., Cape Town, 1995.

Martin, Joseph Paul. 'Educating the Sotho, 1833–1884'. Ph.D. diss., Columbia University, 1983.

Mohlakola, Mohlakola F. 'Early Trade Unions in Lesotho'. Honours paper, National University of Lesotho, 1986.

Mosala, 'Mathabiso. 'Activities of the Lesotho National Council of Women'. Unpublished paper, Maseru, n.d.

Moss, Barbara A. 'Holding Body and Soul Together: The History of the Zimbabwean Women's *Ruwadzano/Manyano* in the Methodist Churches, 1890–1980'. Ph.D. diss., Indiana, 1990.

Ntimo-Makara, Matora. 'Women as Migrant Workers: Lesotho Case Study'. Women in Africa Seminar, Institute of Commonwealth Studies, London, March 1985.

Phoofolo, Pule. 'Kea Nyala! Kea Nyala! Husbands and wives in 19th century Lesotho'. Mohlomi seminar paper, National University of Lesotho, 1980.

Puleng, Alina Thetela. 'Basotho Women's Migration to South Africa, 1930–63'. BA Honours diss., 1987.

Rosenberg, Scott P. 'Promises of Moshoeshoe: Culture, Nationalism and Identity in Lesotho, 1902–1966'. Ph.D. diss., Indiana University, 1998.

Seotsanyana, Malimpho. 'Basotho Female Farm Labour in the 20th century'. BA Honours diss., National University of Lesotho, 1984.

Weisfelder, Richard. 'Defining National Purpose: The Roots of Factionalism in Lesotho'. Ph.D. diss., Harvard, 1974.

Wright, Caroline. 'Unemployment, Migration, and Changing Gender Relations in Lesotho'. Ph.D. diss., University of Leeds, 1993.

G Theoretical works

Anderson, Kathryn, Susan Armitage, Dana Jack, and Judith Wittner. 'Beginning where we are. Feminist Methodology in Oral History'. *Oral History Review* 15 (1987): 103–127.

Appleby, Joyce Lynn Hunt, and Margaret Jacob. *Telling the Truth About History*. London: Norton, 1994.

Bozzoli, Belinda. 'Marxism, Feminism and Southern African Studies'. *Journal of Southern African Studies* 9/2 (1983): 146–171.

Coplan, David. 'History is Eaten Whole: Consuming Tropes in Sesotho Auriture'. *History and Theory* 32 (1993): 80–104.

Eichler, Margrit. *Nonsexist Research Methods: A Practical Guide*. New York and London: Routledge, 1991.

Fatton, Robert. 'Gender, Class, and State in Africa'. In *Women and the State*, by Parpart and Staudt, 47–66. Boulder, 1990.

Geiger, Susan. 'What's so Feminist About doing Women's Oral History?' In *Expanding the Boundaries of Women's History: Essays on Women in the Third World*, edited by Johnson-Odim and Strobel, 305–318. Bloomington: Indiana University Press, 1992.

Goebel, Allison. 'Life Histories as a Cross-cultural Feminist Method in African Studies: Achievements and Blunders'. Paper presented at 15th biennial SAHS conference, Rhodes University, Grahamstown, 1995.

Hartsock, Nancy. *Money, Sex and Power: Towards a Feminist Historical Materialism*. Boston: Northeastern University Press, 1985.

Jaggar, Allison. *Feminist Politics and Human Nature*. Totowa, NJ: Rowman and Allenheld, 1983.

Johnson-Odim, Cheryl, and Margaret Strobel, eds. *Expanding the Boundaries of Women's History: Essays on Women in the Third World*. Bloomington: Indiana University Press, 1992.

Kelly, Joan. *Women, History and Theory*. Chicago: University of Chicago Press, 1984.

Landry, Donna, and Gerald MacLean. *Materialist Feminisms*. Cambridge MA: Blackwell, 1993.

Lazreg, Marnia. 'Feminism and Difference: The Perils of Writing as a Woman on Women in Algeria'. *Feminist Studies* 14/1 (1988): 81–107.

Manicom, Linzi. 'Ruling Relations: Rethinking State and Gender in South African History'. *Journal of African History* 33 (1992): 441–465.

Mbilinyi, Marjorie. '"I'd have been a man." Politics and the Labor Process in Producing Personal Narratives'. In *Interpreting Women's Lives: Feminist Theory and Personal Narratives*, edited by Personal Narratives Group. Bloomington: Indiana University Press, 1989.